The Dream of the
Moving Statue

The
DREAM
of the
MOVING
STATUE

Kenneth Gross

The Pennsylvania State University Press
University Park, Pennsylvania

First cloth edition published 1992 by Cornell University Press.
First paperback edition published 2006 by The Pennsylvania State University Press.

Lines from "Death Paints a Picture," by John Ashbery and Kenneth Koch, Copyright © 1958 by John Ashbery and Kenneth Koch. Originally appeared in *ARTnews* (September 1958), reprinted by permission of the publisher; Georges Borchardt, Inc., on behalf of John Ashbery; and the Kenneth Koch Literary Estate. Lines from Irving Feldman, "All of Us Here," from *Collected Poems, 1954–2004*, copyright © 2004 by Irving Feldman, used by permission of Schocken Books, a division of Random House, Inc.; lines from Richard Howard, "The Giant on Giant-Killing: Homage to the Bronze David of Donatello, 1430." from *Inner Voices: Selected Poems, 1963–2003*, copyright © 2004 by Richard Howard, reprinted by permission of Farrar, Straus and Giroux, LLC; lines from Alexander Pushkin, "The Bronze Horseman," from *The Bronze Horseman and Other Poems*, trans. D. M. Thomas, translation copyright © 1982 D. M. Thomas, used by permission of Johnson and Alcock Ltd.; Rainer Maria Rilke, "Archaic Torso of Apollo," copyright © 1982 by Stephen Mitchell, from *The Selected Poetry of Rainer Maria Rilke*, by Rainer Maria Rilke, translated by Stephen Mitchell, used by permission of Random House, Inc.; lines from Wallace Stevens, "Notes toward a Supreme Fiction," from *The Collected Poems of Wallace Stevens*, by Wallace Stevens, copyright 1954 by Wallace Stevens and renewed 1982 by Holly Stevens, used by permission of Alfred A. Knopf, a division of Random House, Inc., and Faber and Faber Ltd.

Sigmund Freud © Copyrights, The Institute of Psycho-Analysis and The Hogarth Press for permission to reproduce four line illustrations from "The Moses of Michelangelo," taken from *The Standard Edition of the Complete Psychological Works of Sigmund Freud*, translated and edited by James Strachey, volume 13, reprinted by permission of The Random House Group Ltd., and from *The Collected Papers of Sigmund Freud*, volume 4, authorized translation under the supervision of Joan Riviere, published by Basic Books, Inc., 1959, by arrangement of The Hogarth Press Ltd. and the Institute of Psycho-Analysis, London, reprinted by permission of Basic Books, a member of Perseus Books LLC.

Library of Congress Cataloging-in-Publication Data

Gross, Kenneth
 The dream of the moving statue / Kenneth Gross.—1st pbk. ed.
 p. cm.
 Includes bibliographical references and index.
 ISBN 0-271-02900-5 (alk. paper)
 1. Arts—Psychological aspects. 2. Statues—Psychological aspects.
 3. Sculpture—Psychological aspects. 4. Personification in art. 5. Fantastic, The.
 I. Title.

NX165.G77 2006
700'.4357—dc22 2005056694

The Pennsylvania State University Press is a member of the Association of American University Presses.

It is the policy of The Pennsylvania State University Press to use acid-free paper. Publications on uncoated stock satisfy the minimum requirements of American National Standard for Information Sciences—Permanence of Paper for Printed Library Material, ANSI Z39.48–1992.

For John Hollander

Contents

Illustrations

Preface to the 2006 Paperback Edition

When shall these statues, statues of air, breath, Tolstoi and King Arthur,
Be permitted to dream?
 —John Ashbery and Kenneth Koch, "Death Paints a Picture"

Metamorphosis is the keynote of this book. Originally published in 1992, it is a gathering together of stories about statues that come to life. I have tried to make sense of why such stories grip us, as fantasies and as forms of knowledge, as ways of seeing the world and other people as well as things made of stone. It is the threshold moments of transformation that I have attended to most closely here, taking stock of their varied occasions, the different shapes of life that emerge, weighing what is lost and gained there, what is hidden or made clear. One recurring theme is that the fantasy of the animated statue emerges as a response to a life lived among frozen images. Statues come to life in a world where thoughts and words, bodies and gestures, always threaten to turn into statues, where living things become rigid, opaque, and silent. Such stoniness has its attractions. It is a fate we may desire as much as fear. If the idea of a statue's movement seeks to counter the deathly fixity of statues, that fantasy may also reflect our sense of a vitality and a power latent in their very lack of ordinary life.

That paradox suggests why, in so many of the texts examined here, the story of a statue's coming to life is knitted together with a story about living persons who turn into statues. My shorthand for describ-

ing the book's argument has been to say that it is about the marriage of Pygmalion and Medusa. The stories remind us of why what we call life remains such an elusive quantity. In many instances, the life assumed by a dead statue reveals itself as the most fragile of gifts, even a wound, the product of a living person's strange complicity with a thing that lacks life. Statues absorb our ideas of death as well as our ideas of life; they can make death less troubling or less explosive than we fear it is. That is also one reason why statues can seem obscene, outright lies against life, violent even in their stillness, things that we want to throw down or mutilate or from which we want to flee. And yet the idea of bringing them back to life has its own mournful and clownish side. The animated statue very often keeps something of its original chill.

The life of statues comes from the way we move about them, how we stare at, stalk, or neglect them, catching them up in other fantasies or letting them enter our ordinary lives. Among the many things that have struck me only in retrospect about this book, I will mention just one: that it could be read as a book about theater, about the work of living bodies on stage. Many of the stories I explore in this book evoke the mysterious power of theatrical gesture, or speak to the fascination of the actor's crafted movement and stillness, even to the simple pleasures and risks of striking a pose. For an actor to speak can seem of the same order of strangeness as for a statue to speak. The work of theater, like that of sculpture, always courts its own ghostliness; the actor is a living statue that must struggle against becoming wooden and dead, partly because he must make himself a vehicle for a life that is his own and not his own, a life that remains at once hidden and exposed on stage. Studying fables about moving statues has also helped me better understand the ordinary magic by which an actor can lend an independent life to an object, a mere prop—or a puppet—involving it in a dance of relation, giving it intention and voice. Such connections with theater remain mostly latent in this book. Yet it is no accident that the first chapter opens with an account of Charlie Chaplin's artful clowning with statues in the film *City Lights*.

The attention to theatricality suggests just some of the ways that a work of sculpture can, as it must, reimagine its own stillness, materiality, and monumentality, how it stands (or refuses to stand) on a pedes-

tal, how it relates to other statues or bodies, living and dead. It points to why and how a sculpture might seek to avoid becoming the thing we call a statue, even an animated statue. Such questions remain relevant to how we view radically abstract and nonfigurative sculpture, as well as certain kinds of installation art. I have not spoken directly of such forms of sculpture here. There are no references in the book to, say, the work of David Smith, Anthony Caro, Richard Serra, or Joseph Beuys, as there are to sculptures by Auguste Rodin, Alberto Giacometti, and George Segal. This is perhaps because our understanding of the life in nonfigurative sculpture is harder to link to stories of Pygmalion or Medusa. Yet abstract sculptures too must stage a relation with the living bodies that move around them, drawing us to forms of life essentially linked to their stillness. And I have known nonfigurative sculptures that can feel as curiously dead, as much like statues of themselves, as any bronze general on horseback or any plaster cast of the Venus de Milo. The old stories can still serve our purposes in thinking about abstract sculpture. There is more to be said about this, but that will have to wait for another occasion.

Even if it had been possible, I could not easily have revised the original text for this reprint. The arguments are too interwoven to change very much or to add new material without awkwardness. But I want to mention here a few of the books published since 1992 that relate to matters explored in these pages. Deborah Tarn Steiner's *Images in Mind: Statues in Archaic and Classical Greek Literature and Thought* considers how Greek poets and philosophers used statues as tools to think about thought, appearance, and the nature of truth. Leonard Barkan's *Unearthing the Past: Archaeology and Aesthetics in the Making of Renaissance Culture* shows how fantasies of awakened statues play a haunting part in the way that Renaissance artists and writers rethought their relation to time. Marina Warner's *Fantastic Metamorphoses, Other Worlds* explores what one might call our Ovidian modernity, giving close attention to figures of hatching, mutating, splitting, and doubling in literature and art, all relevant to the curious life of statues. A rich investigation of the idiosyncratic and often opportunistic fictions that shape poets' encounters with visual images, from the Renaissance to the present day, can be found in John Hollander's *The Gazer's Spirit: Poems Speaking to Silent Works of Art*. James Hall's *The World as Sculpture*

is an ambitious attempt to map fundamental changes in our ideas about sculpture and its exemplary power for modern artists. Joseph Rykwert's remarkable study *The Dancing Column: On Order in Architecture* traces the poetic or world-making work entailed in the ancient metaphor that compares the column with the human body in ways very relevant to this book. I have also found interesting points of connection in Victoria Nelson's history of the uncanny in modern literature, *The Secret Life of Puppets*; Gaby Wood's *Living Dolls: A Magical History of the Quest for Mechanical Life*, which explores the strange lives of those who have used, made, and lived among automata; and Steven Connor's *Dumbstruck: A Cultural History of Ventriloquism*, which traces the roots of our ambivalences toward the art of giving voice to objects.

I want to thank all those at Penn State University Press who saw this book through to publication, and, most profoundly, my editor, Gloria Kury, without whose care and imagination this reprint would not have been possible.

Preface

These things cannot happen: a statue cannot move or speak; it cannot open its eyes, nod, or call out, cannot tell a story, dance, or do work; it cannot turn on the viewer, or run away, banishing its solidity and repose, shedding its silence. A statue is almost by definition a thing that stands still, and what we call its movement is at best a resonant figure of speech. Yet these things happen; we imagine them happening. Our language requires that they happen. The fantasy of a statue that comes to life is as central a fable as we have. The idea of motion or speech in an inanimate stone is an inescapable possibility, a concept of a sort so basic that we can hardly call it a metaphor. Time and again, we find texts in which the statue that stands immobile in temple or square descends from its pedestal, or speaks out of its silence. Such fantasies are simply part of what we know about statues, and what statues can represent to us; they are part of the way that we stitch ourselves and statues into the world. They are also part of what we do not know about statues, or have yet to know.

The idea of the animated statue appears everywhere. One finds it in fairy tales and philosophy, in ancient magic and romantic novellas, in classical ballet and modern television commercials (for wine, perfume, coffee, soap, game shows, and body building, to name just a few). This book is an attempt to describe the often ambiguous sources of such fantasies, and to consider the parables they offer about things that are not statues. Among other things, fantasies about animated statues can suggest how the reciprocal ambitions of writing and

sculpture animate each other, and the paradoxical figures of life and voice their conflict can generate; they also point to the ambivalent crossings of fear and desire that continue to bind our fantasies and memories to the realm of unliving images and objects.

The pages that follow consider the place of fictive statues in the poetry of Ovid, Blake, Pushkin, Browning, Rilke, and Stevens, as well as contemporaries such as Irving Feldman and Richard Howard; in biblical and nineteenth-century narrative; in Shakespearean drama; in films by Charlie Chaplin, François Truffaut, and Peter Greenaway; in the psychoanalytic writings of Freud and the philosophical texts of Wittgenstein. I also discuss both legendary statues such as the colossus of Memnon and actual statues such as Michelangelo's *Night* and Donatello's *Zuccone*. The reader will encounter many variations on the idea of the animated statue here: oracular statues, bleeding statues, murderous statues, consoling statues; statues that can move and not speak, that can speak but not hear. There are also stories about human beings who have themselves turned into statues.

This book is not, however, an attempt at a systematic iconological history or structural taxonomy. It rather takes the form of a series of linked critical meditations, shifting frequently between broad theoretical speculation, exemplary anecdote, and close reading of individual texts. Some chapters revolve around particular thematic questions—for example, the representation of living statues as objects or sources of violence, the depiction of living statues as objects of desire. Others dwell on more broadly generic matters—how the fantasy of animation plays a part in "ekphrastic" writing, literary texts that describe real or fictive works of art; or how that fantasy relates to our understanding of actual sculpture. But overall the argument unfolds in a rather disjunctive fashion, often circling back on itself, often making considerable leaps within the historical continuum. It is an approach that I hope will reveal, more effectively than any straightforward survey, the sources of the fantasy's complexity and power.

In the process of writing this book, minor cases have presented major questions: things whose meaning might have seemed obvious began to seem not so obvious. Consider, for example, something as simple as a stone fountain, where an arcing stream of water pours from a spout held in a grimacing marble mouth. The moving water

lends a kind of animation to the stone, provides a sense of something moving through it, something it can pass on to others, giving the stone breath, spirit, even speech; yet it can give these only in the guise of something spit out at us through a face whose expression never moves. Or consider how we are still drawn to images of crowds attacking gigantic statues of dead dictators, statues that gain a striking, if sometimes forlorn sort of animation even in the process of being hacked, toppled, hung, burned, defaced; one feels here as if the violence done to such statues becomes an aspect of their peculiar life. Or consider the strange ancient testimonies (found in Pausanias, among others) about Greek temple statues that were fettered to their pedestals, or whose stone wings were clipped, out of a fear that they would abandon their cities during times of crisis. Why is it that the very act of fixing the presence of a god in stone makes that deity oddly mobile, always ready to depart?

Such heterogeneous examples will hardly all yield to a single explanation. But they do form parts of a rough order of ideas and questions which it is the aim of this book to clarify as much as possible.

Many people made possible the writing of this book. My chief debt is recorded in the dedication. Herbert Marks, who has dwelt with the project and the text almost as long as I have, always kept alive the wonder of the subject of statues and reminded me of what counted most in the work. Discussions of the text with Jeffrey Gross and Tenney Nathanson found out a myriad questions that would otherwise have remained hidden and solved many a knot in the argument. Elizabeth Calihan asked that I try to speak about what cannot be spoken about. Joan Dayan, Martha Hollander, James Longenbach, Elissa Marder, Joanna Scott, and Kaja Silverman generously shared stories, ideas, questions, as well as enthusiastic interest. For memorable clues and illuminations, I am also grateful to Daniel Albright, Mary Cappello, Natalie Charkow, Angus Fletcher, Sarah Higley, Perry Hodges, Michael Holly, Ralph Lieberman, and Constance Penley. My thanks to Teresa Winterhalter for her help with research, to Carol Lafayette for her help shooting film stills, and to Joanne Ainsworth and Bethany Hicok for their careful and thoughtful editing. A fellowship from the American Council of Learned Societies

and a Mellon Faculty Fellowship from the University of Rochester allowed me free time for research early on in the project. Bernhard Kendler, Carol Betsch, Linda Wentworth, and others at Cornell University Press offered a sense of shared investment in the book that made a pleasure even of the final work of getting it into print.

Parts of chapters 1, 2, 6, 7, and 9 appeared, in shorter form, under the title "Moving Statues, Talking Statues," in *Raritan: A Quarterly Review* 9, no. 2 (1989).

KENNETH GROSS

Rochester, New York

PART ONE

Signs of Life:
An Introduction

The opening of Charlie Chaplin's film *City Lights* (1931): the scene is a public square, where a group of important citizens has assembled for the unveiling of a statue titled *Peace and Prosperity*. Those on the dais before the statue, whose voices are rendered by the meaningless noises of a kazoo (this is a "talkie" of sorts), give speeches in praise of one another, the artist, and the monument. Finally, with great ceremony, the canvas is pulled back, and the tramp is found sleeping, huddled precariously, in the lap of the central female figure of the group (fig. 1). Cries, confusion; police appear. The citizens are scandalized: that there is a living body on the monument at all; that it appears at the same moment the statue is unveiled; that it is the ragged, sleeping body of a tramp, which calls the bluff of the frigid civic wish. The crowd is also shocked perhaps by the tramp's literalism, by his idea that he could find in the statue a place of human rest and concealment, that he could make the merely symbolic anatomy do the work of a conscious, sympathetic person. Before the eyes of a public for whom a statue is (happily) only a statue, no such metamorphosis is possible. The tramp is a stain, a wound. He wakes slowly, at first unconcernedly stretching and scratching, but he quickly becomes the center of awkward and precise motion. Finding himself exposed to the eyes and shouts of the crowd, trying to escape, he also discovers the statue itself becoming "animated" in a different way (for those who have eyes to see—recall that this is a film about blindness and the recovery of sight). No longer a possible so-

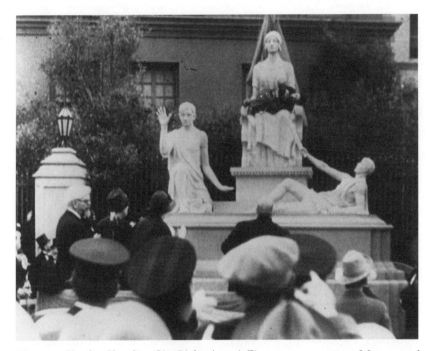

Figure 1. Charlie Chaplin, *City Lights (1931).* Figures 1–3 courtesy Museum of Modern Art, Film Stills Archive.

lace and refuge, but still more than a merely inert, empty symbol of charity, the statue becomes a thing that trips and entraps the tramp as he tries to make his escape from the public eye. As if taking its revenge on him for misusing the statue, the sword of one figure comically catches his pants, impales (or rapes) him as he slides off the lap of the "mother" (fig. 2), leaving him suspended helplessly in midair. The position is made all the more comic when, hanging from the sword, he tries to rigidify (I want to say "statuify") himself for a moment when the national anthem is played. It is against this sword that he briefly raises his fragile, pliant cane when he has finally extricated himself.

The statue, then, becomes an enemy, and the tramp one of "those whom the statues torture and keep down," as Wallace Stevens writes.[1] And yet, perhaps because the statue is not the real enemy, it starts to elicit from the tramp an odd, improvisational, balletlike politesse. He accommodates and charms it. Riding its surface, he moves

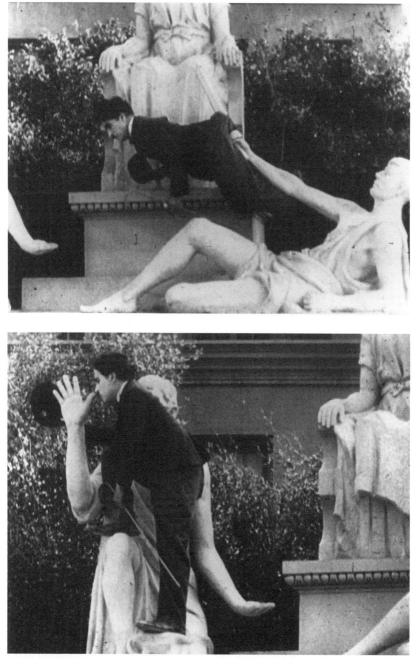

Figures 2 and 3. Charlie Chaplin, *City Lights.*

among the marble forms with courtly deference, apologetically tipping his hat to the figures he bumps into, stumbles over, or sits on, as if they were owed more love or courtesy than the all-but-invisible public. His final ironic mastery of the monumental sign comes when he can make one of the stone figures speak silently *for* him; he places his face next to an upraised marble hand, so that, for a moment before he departs, the statue thumbs the tramp's nose at the alien crowd that berates him (fig. 3). He then disappears behind a high fence. Driven away, but also escaping from the seductive order of the statue, the tramp yet steals the "gift" of the statue with him, or converts its gift into an open question; he is like its departed soul, the only thing that might redeem it, although no one seems to know this. With his disappearance, we can no longer be certain what we have seen, what phantasmic possibilities have been for a moment revealed, and have receded, like the flickering of the images fixed on film.

The scene in *City Lights* can introduce the subject of this book: the fantasy of an animated statue—a statue that moves or speaks, responds to a gesture, calls out, looks back at the person looking at it—coming to life as oracle, enemy, guest, lover, mocker, or monster. Strictly speaking, of course, the fantasy is invisible, or purely figurative in the opening of *City Lights*. It is only the living, if still strongly iconic, form of the tramp that lends life to the dead monument (a rather shabby idol, after all). It is only the tramp's signifying stillnesses and motions that invest the figures with what expressive life they have beyond the brittle public allegory, whether it is the life of a comforter or an attacker. Chaplin himself is there to transform or satirize the stone image as an ekphrastic poet might; he alone makes himself a living companion of the stone, makes himself the one portion of the statue free to leave its pedestal. Yet it is exactly the latent or threshold status of the idea of animation that makes this example so suggestive. Chaplin indicates the protean qualities of the fantasy, the unsettling circumstances of its emergence; he points to both its figurativeness and its odd literalism; he makes clear both its real subversiveness and its potential terror. The scene in Chaplin suggests how the fantasy can ask us to reconceive the living body in its private and its public nature, to think again about the conflicting motives that shape its gestures, its free or compelled theatricality. It suggests as

well the strange complicities of the living body and the dead monument that can feed the fantasy of animation.

The recurrences of the animation fantasy, literary or otherwise, are simply too numerous to catalog adequately, especially if we remind ourselves of its crucial place in masque, opera, ballet, and pantomime, or bring in examples from closely related traditions of stories about automata or living puppets and toys, such as E. T. A. Hoffmann's Olympia or Carlo Collodi's Pinocchio.[2] Some of the most familiar examples may already have come to mind. A sculptor falls in love with a statue he has made of a beautiful woman and finds it miraculously animated (Pygmalion). A jealous husband is asked to admire a statue of his wife, dead sixteen years, and sees her step down from her pedestal to embrace him (*The Winter's Tale*). A skeptical libertine invites to dinner the stone effigy on the grave of a man he has killed in a duel; arriving at the appointed time, the statue refuses to eat and carries him off to hell (Don Juan). The equestrian statue of the founder of an imperial state mercilessly pursues a poor, insane clerk who had once been unwise enough to mock it (Pushkin's "The Bronze Horseman"). These are stories about the history and education of desire, about our relation to what we have made or unmade, about our encounters with the dead, our negotiations with what we call authority and tradition. I say more about all of them in the pages to come. The image of Chaplin's tramp struggling with the monument may suffice here as an introductory emblem, however, since it points to both the volatility and the seductiveness of the fantasy.

Entering further into the subject, I ask the most general sorts of questions about the idea of the animated statue, about the claims it has on us. What, for instance, do such stories reveal about how we imagine the stillness of sculpture? What does that stillness become a figure of? What crisis does the animation of the unmoving statue thereby entail, what is lost or gained, transgressed or restored in that abandonment of stillness or silence? What does it mean after all for a statue to step down from a pedestal (assuming we are sure what a pedestal is), to enter a sphere of exchange and intention? What parable about our relation to other people, objects, words, or institutions might such a fantasy offer? It is difficult to offer simple answers to these questions, because the lure of the fantasy in any period or text

tends to be so complexly mixed, and our attitude toward the fantasy so ambivalent. There are few ideas that can be more immediately haunting than the thought of a statue coming to life, few that tap a more fundamental wish. It is one of our oldest images of the work of magic, one of our most primitive metafictions, something capable of unsettling our accepted versions of the real. But it is also one of the most trite and conventional of our fantasies; indeed, nothing can seem more literalistic, or a better example of what we call kitsch, than the idea of waking up an immobile statue, nothing that enacts a more stupifying violence on certain works of sculpture. The effect of this is that our investments in the fantasy tend continually to be put to the test; the fantasy always invites and continually resists our attempts to make sense of it, to place its motives and seductions.

Consider the mixed impressions that emerge when one watches a child playing with toys; when one observes the whim and ruthlessness, the conviction and improvisational skill (and perhaps the occasional despair) with which a child can spin around those toys a narrative of human life. The toys can come to life even in the very violence that is aimed at them. This kind of activity—attributing life to what has no life—still keeps an aura of innocence about it. It seems an archaic, almost instinctual mode of work, a way for the child to take possession of a still alien symbolic and material world. But at the same time one can sense something more troubling in such play: a haste to enter a world of roles and rituals that will betray the child. One may see an image of children assimilated, trapped, or dispossessed by the toys they play with, hence by whatever it is those toys stand for, whatever they naturalize. Like Baudelaire in his essay on toys, we may see in such play the initial stages in the epic of the child's doubts and disenchantments in the face of a world of living and unliving things, the very toy the child holds becoming a sign of loss.

Similar conflicts of affect, ambivalent feelings of both freedom and limitation, attend fictions about animated statues. A story about the awakening of a work of art may produce a story about the power *of* art, its power to enchant us; it might also be a story about our awakening *from* art, from art's eloquent but objectified versions of our dreams and needs. The idea of a living statue might suggest a parable

about our responsibility to humanly created objects, a sense that there is a life in them that demands our care, which includes the responsibility to other human beings which we systematically invest in objects.[3] But stories about living statues can also suggest, however elliptically, the denials and even coercions that attend certain fashions of humanizing the inanimate. We indeed find many cases in which the humanizing of a nonliving thing can entail, almost as a compensation, a simultaneous objectification of the human, in which the life released in the object entraps us in turn. One interest of this book is the ways in which fictions of animation are tracked by stories of living creatures who turn into stone, whether out of need, wish, or fear, how images of animation and petrification circulate around each other, how they collide and parody each other. Such strict reversals or contaminations are not always explicit. Still, it seems to me that what often draws us to stories about animated images is the sense of some twist, some sign of error or redundancy, in the fantasy. The basic point is perhaps simply that the animation of a statue is not a purely liberating metamorphosis, a trope of release from death, an image of achieved mimetic work; the fantasy can entail a fall as well as a resurrection, both a release from enchantment and its perpetuation, both a transcendence and a descent. The fantasy seems in general to convey the idea of a made, constructed image becoming autonomous but also alien; if it suggests a redemptive gift, the restoration of a dead sign to use and relation, it may also suggest a kind of theft of life, as if something already autonomous was forced to yield to the demands of a life not proper to it.

The fantasy seems to be about restoring a lack. In the last scene of Shakespeare's *The Winter's Tale*, for example, the fiction of a statue come to life becomes a figure for the most profound, gratuitous restitution, the recovery of lost objects of desire, and by extension the recovery or healing of the world—which means both an awakening of the self to its lost, murdered, or abandoned objects and a return of objects themselves from their alienation. The fantasy can suggest more generally a recovery of thought or feeling from oblivion and repression, a recovery of a human voice "from the marble of art and the silence of history" (as Leo Spitzer says of Keats's animating reveries in his "Ode on a Grecian Urn.")[4] This sense of recovery can take

on more political forms as well, suggesting an overturning of the fixed, statuesque mystifications of tyrannical authority, a kind of substitution for iconoclasm—something implied by the stone lion we see at the end of Sergei Eisenstein's film *Potemkin*, awakened at the threshold of revolution by the work of montage. Yet even in such apparently liberating circumstances, the awakening of the statue will be a trial, at times even an occasion for paranoia. It should not be a surprise that many texts depict the statue's life as something not only elusive but threatening, calling into question our naively benign assumptions about animation, or about the nature of what human life entails. Partial, disjunctive, and alien as it often is, the life imagined in the statue may end up by disrupting our conceptual categories; it may entail a violation rather than a recovery of the world; it may perpetuate rather than restitute the lack or loss implicit in the dead image or take revenge on the living for the act of animation itself. The dream of a statue's awakening can be an awakening into delusion and nightmare, a rebirth into what is not life, a kind of death-in-life; its recovered voice may seem not to be a human voice at all. The life of the statue often turns out to be that of a ghost or a galvanized corpse. The animated statue thus becomes as much a form of ruin as of resurrection; rather than being a source of new life, the statue becomes murderous. Pygmalion may be immolated on as well as enchanted by his statue.

The myth of the golem in Jewish Kabbalistic tradition exemplifies such conflicts in all their complexity.[5] The golem, which has been described as an "artificial anthropoid," is a man-shaped figure of kneaded clay which is "animated" by its learned maker. There is some debate over how figurative or how literal such a process of animation was in Kabbalistic writing and ritual praxis, but it is clear from medieval and Renaissance commentaries that the making of such a creature ideally entailed a repossession of the creative power of God, in particular a reactivation of the generative potency embodied in the sacred letters of the Torah scroll itself. The animation of the golem could be seen as drawing on and organizing cosmic or astral influences, like the "living statues" of Hermetic magic, though that work could also present itself as a tacit challenge to the poorer, more illusory spells of gentile magicians. But as scholars have made clear, the golem itself was an anomalous entity, a categorical surd. The

creature constituted less a blessing than a scandal, a threat to stable metaphysical as well as legal definitions of life and death, humanity and divinity, magic and miracle. Not surprisingly, the making of a golem was hedged about by a myriad of rules and taboos. Embryonic, half-alive, nameless, usually speechless, without desire or intention, the artificial golem could look like a blasphemy, a form of idolatry. It could be thought of as posing both a physical and spiritual danger to its maker, and in its very imperfection it could constitute a tangible revelation of his sin and ignorance. There even exists a text in which the golem awakes only to mutilate both itself and the sacred words inscribed on it, instructing its makers as to the spell that will turn it back to dust.[6] Related ambivalences also surface in more popular legends (such as those surrounding Rabbi Loew of Prague), in which the golem, beginning its existence as a magical rabbi's famulus, a helper and guardian of the community, runs amok, or grows uncontrollably, so that it has to be destroyed.

A warning about the more troubled consequences of the animation fantasy can be found in Jean Cocteau's film *The Blood of a Poet* (1932). In an early sequence, we see a young painter, alone in his room, erasing with his hand the mouth of an abstract face he had sketched on a canvas. To his surprise, that mouth soon reappears on the palm of his hand—like a wound—alien but alive, muttering and giving orders. Terrified, he can rid himself of that uncanny mouth only by pressing his hand onto the silent, marble mouth of an armless female statue that has appeared in his room, sneaking up behind it as if to assault or gag the figure (fig. 4). This evasive, aggressive, even censorious gesture is what brings the fragmented statue to life, and gives it a voice. Yet the statue speaks mainly to remind the artist that one cannot get rid of wounds so easily: it becomes a kind of demonic psychopomp, leading him through a nightmarish and ultimately suicidal revery (in which even breaking the statue only entraps him further). As he holds the statue, we hear the film's ghostly voice-over warn, "It is already dangerous to brush up against the furniture; is it not then mad to awaken statues so suddenly after their age-long sleep?"[7] That could serve as an epigraph to this book.

Before proceeding, the reader might pause to consider a book quite different from this one, a book that doesn't exist but that the present

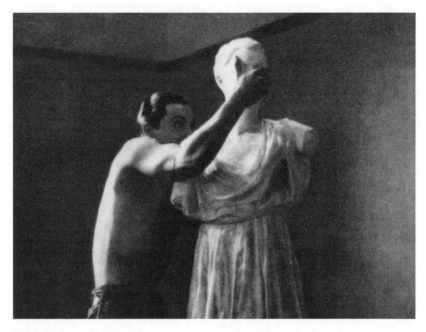

Figure 4. Jean Cocteau, *Le sang d'un poète (The Blood of a Poet)* (1932)

text might seem to demand as its counterpart. The book I have in mind would supplement my own fundamentally speculative argument with some practical advice about how to bring a statue to life. That suggests a handbook of magic, perhaps, but such a book would serve only if it offered a strongly secular magic, something useful for poets and sculptors as well as apprentice enchanters and mad scientists, not to mention literary critics. As I imagine it, the text would combine aspects of a book of spells with elements of a courtesy manual; it would provide us with a catalog of useful metaphors but also a set of formal protocols such as a physician or analyst might consult. We might call it, for lack of a better title, "How to Do Things with Statues."

The book would first instruct us in the proper manner of addressing statues if we wished to animate them, the proper invocations and rituals, what honorifics or insults to employ, how to set the scene or table, what images to hold in our mind. It would specify what season

and time of day would be best, how much we need to know about a statue's ownership, its public and private history, its class affiliations. It would tell us when to address the statue directly and when to keep silent. It would detail how the rules differ for animating statues of marble, bronze, or plaster, whole or broken, modern or antique, standing in a piazza or stored in a basement. Our imaginary handbook would be less technical than the magical treatises of Marsilio Ficino or Cornelius Agrippa, which carefully catalog the distinct virtues of the metals and gems employed in magical images, the specific sorts of music, incense, or inscriptions necessary for their animation. But it might ask the reader to consider things the traditional magus forgets: what difference it makes if we think of the statue as asleep, dead, or enchanted (even with its eyes open, its limbs bravely poised); what difference it makes if we imagine its immobility as that of meditation or hysteria, its silence as something willed or imposed, if we compare its coming alive to an awakening, or a birth.

Some magic books warn practitioners against overestimating their successes, or mistaking demonic influence for angelic (often rationalizing a magician's failures as the result of unacknowledged sins). In lieu of this there might be a warning that we run a risk if we mistake the statue's stillness for that of any living thing, if we project our own limiting constructions of life or death onto it. (To animate a statue, say, on the basis of a questionable dualism such as that of body and soul might yield only a galvanized corpse.) Yet our imaginary handbook would also insist that statues can have their own misconceptions about their birth, death, and rebirth, that we may thus have to disillusion them in turn, or at least overlook the alternative tropes of life written into their poses or modes of finish. It would further warn us that we may be dealing with humans who have themselves turned into statues, and who may neither wish nor know how to awaken themselves. Other chapters would explain how to catch a statue off guard; when it is better to act like a mere tourist, to leave the statue alone, or turn the task of animation over to another magician; how sometimes to put a statue back to sleep. There would also be a chapter detailing when it is best to break or deface the statue, or how just to tap the statue with a hammer, as if with a tuning fork, in order to sound out its hollowness or solidity.

The imaginary handbook would also contain a collection of lost histories: the statue that spoke out of turn; the statue that refused to listen; the statue that came to dinner and would not leave; the statue that ate only moths; the statue that had bad dreams; the statue that was tortured but remained silent; the statue that pretended to be in pain; the statue that sabotaged robots; the statue that went naked; the statue that always danced alone in the garden in moonlight; the statue that left espionage for acting; the statue that remembered everything; the statue whose horse ran away from him; the statue that became a curator; the statue that had feet of clay; the statue that stammered.

The idea of this handbook is an incomplete fiction at best. But what follows should at least suggest why it is more than merely fanciful to imagine Ovid or Shakespeare or Freud as contributing to such a manual. To imagine that book is an oblique beginning to the labor of prying apart the tangle of wishes that work their way into the dream of the moving statue.

The Death of Sculpture

It is hard to say what the fantasy of an animated statue can tell us about actual statues, about their stillness, their opacity, their ghostliness. I want to start making sense of such things by teasing out a simple surmise, namely, that the idea of the statue's coming to life may be bound (as cause or effect) to an opposing fantasy; that the statue I see is not merely the product of the artist's imposing of human form on inert matter but is rather the relic of a metamorphosis, like those undergone by Atlas, Niobe, or Lot's wife. What I see in the statue is really a once-living thing whose life has been interrupted; it is a creature stilled, emptied of life, turned to stone or bronze or plaster; captured, thus possibly needing to escape; dead, thus needing resurrection or galvanization; frozen, thus needing the warmth of hands, or the sun—unless, like a troll, the sun is what freezes it. This sense of something "ended" is what can give to the statue its melancholy and spectral character, lend it the curious deathliness of a *tableau vivant*. Not unlike Roland Barthes's description of the photograph, the statue presents a body or a pose arrested in time, arresting time itself; it marks an absence or a loss through the presence of a thing that is yet irremediably, materially present—though a statue will tend to monumentalize and dehistoricize that arrest, conceal that absence, in a way a photograph does not.[1]

In this surmise, the statue represents a stopping point; it represents the reification of something once living and mutable, its death as it were (though admittedly classical and Renaissance statues are often

conceived so as to suggest a holding of life against death, a moment of balanced pause or dynamic repose, a gathering of potential energy). We might even take the statue as the image of a telos or fate, though whether chosen or imposed is hard to say. If we take such a surmise seriously, however, we may be pressed to a broader question: of the fate of what things in particular can the statue be an image?

We inherit from biblical tradition the idea of the statue as an image of the fate of gods or God, an object that attempts either to supplant or to fix in place an ideally mobile deity, blocking real access to divine presence even as it offers a delusive assurance of presence. Keats gives us a more secular echo of this tradition when he speaks of his fallen Olympians as "postured motionless, / Like sculpture builded up upon the grave / Of their own power."[2] Here it is not gods so much as human ideas about god, human imaginations of power, that are subject to such reification and fall; it is the mind's ability to impose such fixations on itself, on its cultural inheritance, which is of concern. In this sense, the statue has served more generally—from Plato to Bacon, from Emerson and Nietzsche to Stevens—as an image of the fate of living concepts, ideas, and fantasies, an image of their being calcified, codified, hollowed out, or made stupid; the statue provides an image of ideas made into exclusive laws or habits, transformed into agents of compulsion or forms of blank mystery. The statue represents an idea that has been silenced, restricted, or censored, even by virtue of its formal eloquence. Such a fate is partly the result of the bondage of ideas to the unstable yet reifying domain of the word. But their petrifying transformation could also be read as a result of our imperfect *reception* of ideas and words. Language may make ideas into statues, but that they remain statues may depend on our failure to reanimate the language we inherit, our failure of desire or tact, a submission to the contingent priority of our words; it may also be the result of a need to lend an illusory stability to ideas, even at the cost of emptying them out.

This surmise points in turn to three related "images of fate" that the statue can represent. First, we can take the statue as an image of the fate of authority, even if this is (ironically) an image that authority wishes to take upon itself, a public manifestation of its solid self-presence, as if the statue's "standing" could confirm a state's sub-

stance, stability, status, and statutory power. Second, the statue can become an image of the fate of living and acting persons, their peculiar features and gestures isolated and idealized, stripped of both change and rest; persons taking on the look of other statues, perhaps, even clothed in their fictive nudity and thereby made to stand for something larger than themselves, human beings turned into abstract types of Glory, War, Science, Martyrdom, Charity; statues thus become the relics (also victims) of history reduced to a few admirable attitudes, a history thus more fully accessible to appropriation or neglect.

Third, and perhaps most fundamental, we recognize in the statue an image of the fate of bodies, a fate elected out of a desire to deny our vulnerable, penetrable, wasting, and dying physical persons, to provide ourselves with idealized stone mirrors. Unlike paintings, statues occupy the space of bodies, compete with bodies for that space, share the same light and atmosphere; but they neither take things in (food, bullets, air, sounds, or signs) nor put things out (words, blood, excrement, children). Hence they are freed from whatever danger or power we fantasize in such things. Statues are bodies to which nothing can happen, bodies spared from pain or need, even in the face of their fragmentation, bodies in which *we* are spared from having to imagine need, the terrors (and pleasures) of touch or gaze.[3] They are bodies happily resistant to our courtship, breakable but unwoundable, complete surfaces without the troubling depth or interiority of bodies, surfaces whose secretiveness is satisfyingly absolute, perfectly thoughtless; they are bodies stripped, paradoxically enough, of the body's resistant strangeness, its often disorganized animations and reflexes, its soul. Statues can use their mimesis of human form to work a certain figurative magic on stone, no doubt; they can convert the opacity of stone into a fiction of reserve, its muteness into silence, its mere immobility into stilled intensity or repose. But we can also see in statues bodies that are all the more fully overtaken by, or written into, the script of official aesthetics and ideology. They are bodies subjected to the force, sometimes the violence, of a purifying wish, bodies stuck to an idea, struck by our own fears of and desires for the body.

We can find a stark illustration of this use of statues in some well-

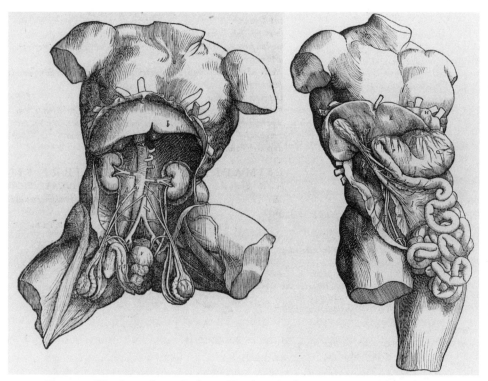

Figure 5. Woodcuts from Andreas Vesalius, *De humani corporis fabrica* (1543). Courtesy Yale Medical Historical Library

known woodcuts from Andreas Vesalius's revolutionary anatomical treatise, *De humani corporis fabrica* (1543; fig. 5). These show the fragile internal organs revealed by dissection suspended within hollowed bodily forms that are designed to look like fragments of antique sculpture, in particular the Herculean "Belvedere torso."[4] At a basic level, such collocations of dissected body and classical statue can remind us of the shared investments of Renaissance artists and anatomists in the human body, which was seen as a place in which they could discover (and invent) the ideal articulations of the "human" in general.[5] But the images in Vesalius also suggest some of the strange subterfuges that may attend such a program. Here, turned into a sculptural shell, the human form is allowed a curiously ironic way of surviving its own decay and dismemberment; though the broken sculpture acknowl-

edges some version of historical loss, the torso is nevertheless purified of the memory of both the dying body and the disturbing scenario of its dissection. At the same time, the vulnerable internal organs, suspended and leaping animatedly into open space, seem to display themselves to our scrutiny (rendering even this partial body strangely whole, redundantly alive beyond its death).[6] The ancient heroic marble is given a new, more immediate, if nonsculptural life, granted an organic interior, its very fragmentariness being recuperated by being related implicitly to the work of scientific dissection. But one might ask, isn't it also the exposed interior, and our knowledge of its original location within a cutable, tearable body or cadaver, that is here phantasmically protected by being placed within that invulnerable, insensitive shell, that idealized carapace that might also be thought of as a crypt or a tomb?

To speak about statues as images of fate risks doing them an injustice, of course. It foregrounds what we perhaps wrongly think of as their lifelessness or their way of standing for losses that they restitute only poorly. As Vesalius's woodcuts indicate, the fantasy of hardening suggests not just fatality but survival. As in other fictions of metamorphosis, especially in the tradition of Ovid, this imagined conversion of a living thing into a statue can seem by turns an evolution and a regression, a finding and a loss, an authentication and a reduction.[7] The emergence of the "statue" thus both preserves and destroys something—god, person, idea, fantasy, or body. The lure of the statue is that it becomes a shield, a wedge between myself and my death, as well as a reflection of my astonishment at death. The statue can be a ghostly, harrowing thing. Yet in the face of other fates, other forms of preservation or destruction, it may become something to desire, to be seduced by. Fate and wish intersect. A friend's four-year-old child once said, "Mama, when I die, I don't want to be buried, I want to be a statue."

I would argue that even the fantasy of the moving statue can coincide with the domain of this wish to be a statue, a wish that is at once self-evident and mysterious. We can begin to gloss it by recalling its satiric elaboration in Robert Browning's dramatic monologue, "The Bishop Orders His Tomb at Saint Praxed's." Here, in what amounts to a parody of romantic elegy, we see a dying cleric surrounded by his

illegitimate children, trying to forestall or at least master his own death, indeed to master the world that survives him, by imagining his transformation into his own monument. This transformation becomes a ghostly, if desperately solipsistic way of securing his continuing influence in a world in which love is already lost, a world that in fact abandons him as much as he it, that indeed seems as ready to devour as to mourn him. So we see the old bishop—dying by degrees, unsure at any point whether he is alive or dead—gathering his robes about him into "great laps and folds of sculptor's-work," crossing his arms in imitation of his own effigy, pointing his feet "straight as stone can point."[8] One might even say he makes of himself his own defensive fetish (especially when he imagines that his statue will hold a lump of lapis "big as a Jew's head cut off at the nape, / Blue as a vein o'er the Madonna's breast," and shaped into a globe like that between God the Father's hands). Nor is the statue he projects quite dead, since it is imagined as having at least sufficient life to see the envy or mockery of other statues about it, to hear the mutter of the mass, to smell the "incense-smoke" that will (ironically) stupefy it; that imagined statue is a figure with enough consciousness to wonder whether it *is* alive or dead, to think about "the life before I lived this life, / And this life too." But the wish to become a monument, to find a resting place between life and death, is itself as unsettled as it is unsettling. This is visible in the mordantly comic way that the bishop demands and rejects so many sorts of stone over the course of his rambling monologue—dark basalt, "peach-blossom marble . . . ripe as fresh-poured red wine," "antique-black," pistachio-green jasper, blue lapis, and so on. One problem is of course that the bishop must depend on the world he does not trust, which he is trying to blackmail, in order to secure the proper stone for the tomb, not to mention the proper Latin inscription. But all his implicit knowledge of such contingencies cannot make him give the wish up. If, by the end of the poem, he seems to acknowledge his mortality as well as his disenchantment, it is still through the image of his tomb: his final, bitter surmise is that his sons will bury him only in a sarcophagus of crumbling and sweating "gritstone," a tomb we must read as a metonymic double for the decaying corpse sealed within it, even though the image of such a tomb allows him to keep some distance from that corpse.

Browning's poem provides us with a dramatic, if often contradictory genealogy of the statue, or the wish to become a statue. He makes clear the fantasies of bodily survival that can be projected into a statue, how the wish to become a statue feeds on the idea of threshold states between life and death. He even suggests how the forms of a tomb effigy can shape our images of the dead or dying body itself.[9] Suggestive as the poem is, I want to supplement its lessons by turning to a very different sort of text, the philosophical anthropology of sculpture worked out in Michel Serres's *Statues*.[10]

Serres's book is not easy to summarize, not only because of its often parabolic mode of argument but because the very word "statues" acquires such a broad range of meaning in the study. One basic aim of this *livre des fondations*, however, is simply to defamiliarize statues, to make us reconsider the strange fact that statues exist at all, that human history is peopled by a supplemental population of wood, bronze, and stone. Meditating on the statue's resolute and disquieting mode of existence, Serres insists that what the statue stands for, what it both conceals and fixes in place, is the dying, entropic, and violable human body. It provides an archaic double not so much for the living body as for the cadaver. All statues thus take on the look of a *boîte noire*, a black box concealing not a soul, not a god or a demon, but a corpse. Or rather, we might say, it conceals what is revealed by the fact of a corpse, our decaying materiality, our being's entanglement with alien, apparently inhuman processes or substances, our bondage to a lifelessness we inhabit or once inhabited. This means that the statue conceals our fear of the living body as well, our anxiety over its wastes and sensitivities. A constructed relic rather than a victim, miming the solidity of both interior skeleton and external armor, the statue for Serres both mimics and helps kill the body's living lifelessness. The corpse—which despite Aristotle we still insist on calling a dead *body*—is for Serres the first *object*, the form in which we first confront our troubled awareness of things outside us, things fading away or in exile. The statue, the second object, becomes a way of stabilizing our relation with the corpse, with the idea of death and the taboos it sets in place. A consolation and a defense, the statue helps us keep our peace with the living and the dead, helps keep peace between the living and the dead. The statue represents not just a way of making visible what is invisible, making present what is

absent; it is as much a laboriously achieved negation. It is a blinding, a burial of something out of sight (even if this is something which, Serres suggests, can never really be seen). The reading of statues thus plays out Maurice Blanchot's suggestion that all human images and idealisms "have no guarantee but a cadaver," that these things are "fundamentally linked to the elemental strangeness and to the shapeless heaviness of the being that is present in absence."[11]

The term "statue" thus defines, or exists within, a complex system of concealments and substitutions; its work can be traced through many realms, many histories. Serres explains that the statue replaces not just the body that is dead by accident but the body killed in a ritual sacrifice; its function is thus parallel to what Serres also thinks of as one primal "statue," that animal-victim whose substitution for a human sacrifice constitutes a founding act of human culture. Marking and concealing the site of the dead body, the statue, on which the words *ci-gît* (here lies) seem always inscribed, also appears to Serres as the foundation of our sense of place, of our knowledge of what makes place significant; the statue is a cynosure, the definer of axes of view, centers of attention, and fixities of memory, the anchor of what is volatile, the guardian of what is ready to flee. As a detached, touchable object, the statue also points to the manner in which human knowledge is predicated on acts of separation, distancing, and expulsion, on our making alien some part of the chaotic, formless continuum of physical and perceptual life, converting it into something readable and accusable; it is a process that makes a thing (*chose*) into a cause.[12] (Not surprisingly, perhaps, Serres elsewhere links the reified, cut-off statue with the Freudian reading of the fetish, such that the statue becomes a version of that object which at once recalls and defends against the originary, signifying wound of castration.)[13] The opaque statue thus becomes the paradoxical ground of our ideas of subject and object, securing the relation of one to the other, and to the fact of death. The dead body, the realm of the inanimate, is thus not simply concealed but reappropriated, even repatriated, in the statue. If the statue is a corpse, it is also a corpus of knowledge; the idol gives birth to our ideas, our words, our very breath, even as it reminds us of their catastrophic origin. The statue indeed represents a paradoxical gift, a form of knowledge and mastery stolen from the

dead. Hence Serres repeatedly reads a parable of the invention of the statue in Plato's fable of the shepherd Gyges (*Republic* 2.359d–60b), who descended into a fissure that opened mysteriously in the earth, only to discover at the bottom a cave containing a huge bronze horse with a gigantic corpse inside it. From this corpse Gyges stole a ring of invisibility that allowed him to usurp a throne through both violence and seduction.

The labile character of Serres's category means that any individual example of sculpture will serve as only a partial interpretation of the larger realm of statues. (Egyptian sculpture, he suggests, gives form to the deep silence of the statue, while Greek sculpture more readily presents the statue as word or idea.) References to actual sculptures or sculptural traditions are indeed scarce in Serres's book; it is in mapping out broader linkages that the text's real work takes place. The word "statue" defines a continuum between the anthropo-morphic Egyptian sarcophagus and the carefully embalmed mummy inside it, things linked in turn to the separate stone effigy into which the priest would ritually transfer the dead man's *ka*, his bodily soul or double, as well as to the theriomorphic vessel containing the body's corruptible viscera. The "statue," again, can be the animal that re-places the human in ritual sacrifice, but also it can be the half-human, half-bestial idol that for Serres always recalls that primal substitution. If the statue reminds us of Gyges's recovery of power from a buried corpse, the vision of the statue as *boîte noire* also recalls the machine used by the semi-mythical tyrant Phalaris, a bronze bull in which guests could be trapped and roasted, their screams transformed by ingenious baffles to mimetic moos. The statue is Lot's wife, turned to salt by gazing at a city destroyed; it is the singing head of Orpheus, gaining a power even in his death and dismemberment to charm inanimate nature. Beyond such mythic types, the category of statue turns out to be broad enough to include funeral effigies, wax dum-mies, puppets, manikins, and scarecrows; the statue is the zombie, the corpse come back to life; but it is also the living body clothed, painted, bejewelled, masked, caught in an attitude, whether by de-sign or surprise; it is the living body absorbing bits of inanimate matter in the form of artificial limbs, metallic pins, or false teeth. Or, again, it may also be the fetish that replaces the presence of the body

almost entirely. The term can also embrace the living statues of myth and fiction, especially since such entities often retain or figuratively supplement aspects of the inanimate statue's silent resonance; a living statue, even if it is no longer quite a statue, is not therefore human, except insofar as humans themselves tend to the condition of statues.

As far as I recall, *Statues* never mentions Medusa, or the Gorgon, that creature whose gaze turns the living to stone. But we can gloss Serres's argument by setting it alongside Jean-Pierre Vernant's striking essay on that mythic character, *La mort dans les yeux*.[14] For Vernant, the Gorgon is the face the ancient Greeks gave to everything that was alien or other, everything chaotic and destructive, especially those violences and harmonies that disrupted what Greek culture tried to define as the domain of the human. Such disruptions could include Dionysiac ecstasy as well as the frenetic rages of battle, the music of the flute as well as the noise of clashing bronze. The face of the Gorgon was also the face of the dead, the face of the demanding revenant or ghost. But Vernant implies that this oft-sculpted face was in addition a mirror; he suggests that the Gorgon mask (this monster being rarely represented as anything but a mask, a daimonic, dead-alive fragment appearing on temple fronts, shields, coins, and so on) reflects our *own* terrified gaze at what we cannot bear to look at. The Gorgon's mythic power to astonish us, or turn us into statues, is thus something we ourselves lend to the Gorgon. This argument resonates in many ways with that of *Statues*, but Serres's text might yet remind us more sharply of one crucial point: how close to home that petrifying otherness is, how ordinary and inextricably bound up with the human such objects of terror are, and thus how endless can be the process of making things alien.[15] The Gorgon's face is an aspect that almost any body or object may turn on us in our turning away from it. Serres's argument might indeed locate in the mask of the Medusa a synecdoche for the face of all sculpture, as if a glance at any statue could turn us to stone.

Serres's reading of the idea of statues is useful to me for several reasons. First there is the tremendous mobility of the category, its crossing of philosophical, religious, psychoanalytic, and poetic apprehensions of the statue. These are linked together, however, by

what remains an aggressively secular account of the function of statues, one that furthermore foregrounds the negative, defensive gestures that create statues, making of the statue simultaneously an evasion and a form of knowledge. Serres's statues are indeed synecdoches for cultural constructs as a whole, versions of what Barthes called "mythologies." His argument hence frequently points to the archaic logic subtending even what we take to be advanced social myths or technologies. Serres's critical genealogy of statues is also useful in considering examples of the animation fantasy proper, since it suggests why such narratives produce creatures that render so ambiguous the threshold between life and death, narratives in which the statue's "life" can seem alternately a fulfillment and a violation of its nature. (These things all play a part in one of the book's larger interests, that of suggesting a less anxious, one might say more Lucretian, apprehension of the domain of the body, and of those makings based on the body.) Often, however, the ironic or leveling character of Serres's picture, even its seductive archaism, seems to preempt certain alternative ways of viewing the figure of the statue, or what I have called "the death of sculpture," ways that would lend it a very different ethical and historical meaning. In order to open up from Serres, I want to turn to a recent American text—a sequence of poems by Irving Feldman titled "All of Us Here"—which suggests a subtly different apprehension of the domain of statues.[16] Feldman's work is as ambitious as Serres's is in its use of the idea of the statue, but it is less a work of genealogy than a satiric and elegiac apocalypse.

Feldman's text unfolds a linked series of meditations, by turns solemn, irreverent, and chilling, on the work of the contemporary sculptor George Segal (fig. 6). Segal's sculptures consist commonly of one or more full-size human figures, made of stark white plaster (indeed, plaster casts of actual persons), set not on pedestals but usually on the bare floor, inhabiting like specters what at least look like authentic fragments of a world of things and signs, posing amid "bits of pulverized place" (as Feldman remarks). For instance, we may see a figure sitting on a bed or a subway seat, standing at a box office, or in a doorway, caught while walking down an airport corridor, stopped at a crosswalk, gazing at a painting or a television. Ghostly, brittle, hyperrealistic, inviting accusations of kitsch, these sculptures yet hark back

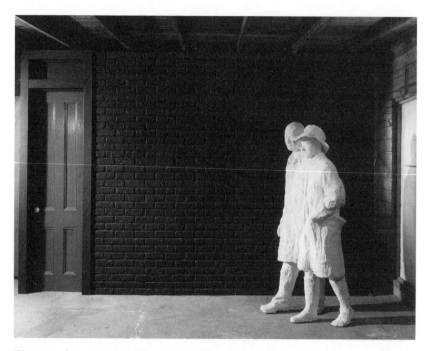

Figure 6. George Segal, *The Brick Wall* (1970) © George and Helen Segal Foundation/Licensed by VAGA, New York, NY

ironically to the studied monumentality of neoclassical statuary, its carefully worked out, intermittent poses; they allude equally to the revisionary experiments of Rodin and Giacometti. It is not clear, at least to me, whether Feldman admires this work in itself; yet its strength as *materia poetica* clearly fascinates him. His poems are an attempt to make sense of the combination of opacity, solitude, ordinariness, and temporal dislocation in these figures, as well as their peculiar lifelessness; the poems try to address their condition as "statues," to imagine what produces and sustains it, and to discover what if anything the statues themselves might have to say to us about it.

Feldman begins by thinking of Segal's figures as cartoon versions of ordinary, anonymous people on the street, inhabitants of the everyday world. While not in any radical way "out of place," they also start to resemble refugees and relics, the exiled victims of great catastrophes, as well as nameless street people, the homeless. The poet in

addition suggests we think of them as angelic messengers in disguise (though from whose heaven is not at all clear). Or else, with an air of slightly casuistical defensiveness, he invites us to think of these white, immobile forms as something more "fundamental" or embryonic, to see in them images of a life unborn, withheld, or waiting for resurrection, a life about to break out of a plaster shell; he even invites us to consider them as portions of "an order of immobility so old / that death itself must seem the junior partner" (5). But what the statues mainly come to resemble, after all, are the merely human dead. At best they have the lives of ghosts or revenants; at worst they are the inhabitants of a kind of death-in-life, not the veritable corpses of history but "plaster casts of persons" that the living accept, invest in, even love. Troublingly, these statues are things we want as well as fear to be. They are not just forms imposed on us by others; they are the "simple shapes" that we out of terror or love impose on ourselves.

At one level these statues of the ordinary are the poet's occasion for interrogating our fantasies of a life other than our own, other than the one we are given. What the statues come to represent is indeed the fate of such fantasies. They show us what has become in the late twentieth century of our inherited images of death, survival, and rebirth, our images of an afterlife, hellish or blessed. They show us the deathly survivals of those fantasies, the delicate forms of their exhaustion and literalization. Combining pathos with blank frigidity, these "enchanted souls in whitewash" (17) show us at once what we have become, what remains in spite of us, and what we still aspire to. They are the shells as much as the sums of human work. They show us what is left of our heroic or eschatological dreams; they show us our frozen, somewhat banalized terror, our "petrification" in the face of those dreams, as well as in the face of their collapse. In a tone at once theatrical and diminishing, one that strives to catch their equivocal claims on us, Feldman speaks of these figures as

> heroes, athletes, titans in everyday clothing
> who come racing in place from all the way back
> to stand in no time at all—all of them, all of us
> together here—at the abandoned finish line,
> our fleet forerunners in prospective elegy,

champions, pioneers of the missing future:
this Laocoön braced against the supple void,
Atlas bearing up under a genocide or so,
and Sisyphus, his sleeves rolled, ready now to start
getting that apocalypse out of the cellar.

(19)

Our romantic, Wordsworthian dreams of the commonplace, dreams of a secular, human, and communal life, have not vanished for Feldman, but they are troubled by the fact that our "fellow citizens" now include the kind of life-size cartoon figures that walk through Disneyland, the living corpses of Auschwitz, and the ashen silhouettes of Nagasaki. Still, Segal's strange statues become not just victims, lost persons, but figures for the "white lies" of our culture; they are the form of our ordinary evasions, distancings, and sentimentalizations; they suggest how much we have converted both the terrifying and the commonplace into something we visit, a museum containing nothing but *"choses manquées"* (22). "Blanching still in the calamitous afterglow," these statues may be something grand, "completed destinies," but they are also ordinary citizens, "just poor people who couldn't get out of the way," figures "whose names have been exalted into allegory: / Exile, Homeless, Refugee, Unknown, Mourner, Corpse" (32). What is most chilling is that "we fit right in" among this equivocal population of signs; "our bodies, at least, have forgotten nothing, / except how deeply they mourned these other bodies" (21).

It is not clear how these creatures might be brought back to life, especially given what Feldman suggests about our strange attachment to such plaster limitation. The poet seems to overhear us (or the statues) saying, "if we should move, the world would end," despite the fact that "the end of the world is us not moving" (26). The dream of resurrection has been reduced to the wish of someone trapped alone, alive in a tomb, hoping not for a savior but merely for a graverobber (25). Even when Feldman, in one later poem of the sequence, speaks of some inchoate need to "flesh out" such a "pastoral standstill," "reviving *cultures mortes* as *tableaux vivants*" (21), the phrasing suggests how thoroughly the act of revival is likely to be confined by equally problematic theatricalizations. Feldman's main effort toward

the close of the sequence, I think, is to find fictions of communion which represent more adequately both our complicity with and distance from such statues, perhaps also our responsibility toward them in both their death and their life. It is a relation that can seem by turns mundane and desperate, inviting both mockery and charity. One poem suggests that we might participate in a kind of sacrificial community, that we might think of these figures as creatures that have been

> led off a little way from life,
> and splashed with white all over,
> symbolizing exsanguination,
> prepared and yet to be offered,
> or offered and not yet taken:
> all of them halted halfway between
> the world and the consummation.
> And we feel we should do something about them,
> bring them back to life, perhaps
> —or step forward with them into the fire.
>
> (28)

Another poem suggests that we might find a kind of life in these statues' very unintelligibility, in a refusal to make themselves clear which can animate our own desire and protest:

> A hidden life—turned low to endure—
> persists in there, and contends with us,
> with itself, with *everything*
> for the meaning of the life.
> And will not let us rest. . . .
>
> (33–34)

Yet even that Rilkean projection seems scarcely more able to withstand the poet's doubt than his comic invocation of a sacrificial bond. The powers that these statues can lend us are at best fugitive. Toward the end of the work, Feldman indeed seems to be striving to invent for us the most spare, the most reticent fictions of communion possible. Hence in the penultimate poem of the sequence he compares

these statues to the absent, nameless, but unnervingly concrete persons we glimpse in the spectral flatness of certain old photographs, about whom he asks not "Who are they?" (a historian's question? a philosopher's?) but only "Who, who is it they remind us of?" and "Did they love one another? Were they good?" (36–37). An even uncannier, but also more tender, fiction frames the very last poem, where we (the imagined viewers) have in a sense turned our gazes away from the statues themselves, ceased to wonder what or who they are, and rather stand together *with* them in a group, quietly handing around between us old family photographs, not quite sure if we recognize anyone, even who is still alive. We and the statues, caught in shared revery, may hope only that some of the faces on the squares of treated paper will "augment in our considering" (40).

There is nothing like a theory of the statue we can abstract from Feldman, even one as paradoxical as that of Serres. Though it possesses a discernible, if complex inner plot, the sequence is too reticent in its formulations, too ambiguous in its sense of its own "aboutness" for that. What we can take away, however, is a lesson about the poetics of petrification, a feeling for the narratives it produces, the rhetorical stances from which we regard it. "All of Us Here" asks how the existence of such statues as Segal's can force us to reorient our perspective on the grammar of so simple a word as "us," our sense of what we already seem to know about ourselves and our relation to things that are not ourselves. It suggests the conflicting ways in which the idea of the statue can be thrown out upon, or fitted onto, parts of the world, what that idea can throw into question, let us fall in love with, or leave us freshly ignorant of.

Eating the Statue

The abstraction of a work of sculpture from the muddled field of bodily and historical life is obviously partial, dialectical. The abstraction remains, as it were, part of that life; it is something the sculptor can both struggle against and use. Nevertheless, the fact that a statue can be said to draw back from time, to stand or defend against time—this is part of what makes statues such ideal homes for those ideals, virtues, aspirations, and accomplishments that we might wish to transcend time, survive history and physical contingency. That very distance is part of what makes them appeal to us as resonant images of a serious *idea*, as things with the look of something meaningful, worthy of a pedestal, but also comfortingly general and nonreferential.[1] Thing and image at once, the statue's very lack of obvious meaning may be what attracts us to it. As William Gass notes, the monument or statue may mark the site of an ongoing cultural struggle between memory and denial; its construction may make possible both a pretense of memory and a de facto oblivion.[2] The statue is often the substance of what we do not remember (no doubt why monuments beget so many diminished replicas of themselves in the form of forgettable "souvenirs"). The statue's saving feature is perhaps that it shows the inevitable bondage of our abstractions to some fantasy of the body's life and may thus help us reknow or relocate that life, though it may also do violence to both the life of the body and the different life of those forms we may need or wish to conceive of as without a body, as hovering within or outside the body.

Considering in this way the statue's conflicted ideality, its uncertain partisanship with time, history, and the body, I find myself faced with a curious paradox. The lure of the statue would appear to depend on its being so resolutely external, so materially present in the world, so opaque and impenetrable. Exposed to the same light, weather, and space as human persons, statues are comfortingly without hidden insides; they void the human body's scandalous interior life, its hidden spasms, desires, reflexes, motions, and noises—even if, like dance, statues lend the body the character of silent speech. Statues would seem to be without those subjective, internal selfhoods that can be extorted by other subjects. The exteriority of statues is again what lets them serve as persuasive figures of *idea* and at the same time as powerful images of literalization, images of the calcification of thought and fantasy. Despite this sense of their exteriority, however, statues can simultaneously attract to themselves a strong, if elusive feeling of *interiority;* statues can become the foci, the troubled bearers of an interior life that is at once their own and not their own.

There is one very particular version of such interiority that I want to describe here. This interiority is not that aura of mystery, that sense of some hidden inhuman life, found most strongly perhaps in Egyptian sculpture but also felt at moments in the most secular of statues set on the most modest of pedestals. It is not that real, if volatile, physiological sympathy that a statue can provoke, its way of "calling out" to the interior life of our nerves and muscles.[3] Nor am I concerned with that illusory feeling of an expressive human character or selfhood residing in a statue, something that depends on particular artifices and conventions of mimetic representation—for example, the ways in which a stone figure invites us to read its features, its complexly coded gestures, and thus to posit a set of emotions or an intentionality behind those gestures. (The haunting smile of an archaic Greek *kouros* is an obvious example here, as is the "sighing" mouth of the *Laocoön.*) Another important version of sculptural interiority depends on the fact that we often project onto unmoving statues those fantasies of perfect, private inwardness derived from our observation of persons asleep, or in contemplation—but it is not this I have in mind either. Nor finally am I recalling the originally Neoplatonic trope of the statue as the ideal core or "soul" carved by labor out of the enclosing

block of stone.[4] My main contention about the statue's interiority is this: that statues, public and external as they are, have the character of those highly cathected psychic images or "internal objects" that people the space of mind. We are not just buried in our statues, our statues are buried in us.

The general image I would conjure up here is that of the mind as a space full of statues, like the space of a sculptor's studio, a museum, a church or a cemetery, or perhaps the basement of an academy of fine arts. The statues peopling such a space would be of diverse origins and character; some would be plaster, others marble and bronze, some modern, others archaic, some on the site of graves, others belonging to victory monuments. Some of these statues might be in fragments, their inscriptions effaced; others might be newly restored. Some might be buried out of sight, or half covered, while others might be freshly excavated. Some of the statues might even be moving. Such an image may suffice to carry part of my meaning, but in speaking of statues as the doubles of "internal objects" I obviously mean to recall certain aspects of a particular "iconography of mind" shared by Freud and some of his disciples, most notably a revisionist such as Melanie Klein, though others as well.[5] While I do not assume that my own critical figures can entirely absorb the technical distinctions of psychoanalysis, or leave them undistorted, there are some aspects of the psychoanalytic picture of the mind I would invoke here as a way of gaining a purchase on our phantasmic intimacy with the sculpted image. I am particularly interested in the ways that psychoanalysis describes the genesis, as well as the place and influence, of such internal objects.

What I am suggesting in general is that the statue in its paradoxical ontology (its opacity, otherness, fixity, also its anonymity and substitutability) resembles those entities that fill, indeed, constitute, the hypothetical domain of the unconscious mind. These internal statues are not to be thought of as portions of some "archetypal" substratum, images that are born with us. Rather, they should be seen as the products or relics of an archaic process of internalization, an "introjection" of images, persons, gestures, and relations derived from our early experience of the external world. For Freud, the ego first emerges as a bodily ego, a phantasmic projection of the body's sur-

face, a structure for whom the boundaries of the body provide the model for all separations between inside and outside. The ego's relations to the external world are thus shaped most fundamentally in terms of fantasies of ingesting and spitting out; these become, as it were, the ego's primitive forms of moral judgment.[6] In this picture, the things that get inside us are objects we have once fantasized swallowing; the world outside us in turn becomes the home of those things our desire has rejected, has refused to recognize as its own. It is important to see here how ambivalent the process of internalization can be. The imaginary swallowing of what is outside us may be equally a response to desire and fear. We may take things inside us in order to preserve sources of pleasure that seem capable of being lost. But this kind of phantasmic mastery can also involve an element of revenge, a kind of cutting off or devouring of that which threatens or frustrates desire. As such, internalization entails renunciation as much as appropriation and identification; the internalized objects that constitute the ego also stand for cathexes with external objects that have been abandoned. Indeed, Freud suggests, the process of internalization is itself one form of that abandonment.[7]

One reason why the description of introjection is conceptually difficult in Freud is that it works at the level of what he calls the primary process, a phase of mental activity where one cannot pry apart the real source or object of desire from the fantasy that gives that desire shape, and where indeed the image of a wish constitutes that wish's hallucinatory fulfillment. Introjection is furthermore an activity that is shaped by the fundamental ambivalence of the archaic ego's relation to its objects of desire and need. In Klein, for example, the fantasized swallowing of the imago of the mother's breast, the source of satisfaction, may register a measure of violence, since a child's desire for that object will be mixed with fear, a fear provoked by the very intermittence of that object's presence, by its externality to the child's will, and by the self-wounding strength of the child's desire itself.[8] The internalization of the imago of the father is equally troubling for Freud, since the father simultaneously demands and repudiates the child's identification with him, and further demands that the child repudiate the form of its earlier attachment to the mother. The statuesque traces of such swallowing that found or structure the ego are

thus inevitably suffused with the often hostile coloring of the child's relation to parental figures. The main point here is that in both the oedipal and preoedipal forms the mechanism of internalization reifies the objects it seizes on, even as the ego abandons them, in a way that both destroys and preserves our relation to those objects. The life such objects live inside us is that of entities that at once shape, animate, and block desire. Such identifications build up our unconscious selves out of that from which they are yet cut off. The outside brought inside, internalized objects may remain strangely alien and opaque, things we cannot know, not only because they may be concealed by repression but because they already *are* our knowledge.

This rough account may suggest how crowded, obscure, and encroached upon that internal space can be. Freud himself repeatedly describes such a space of mind through the metaphorical image of a modern city constructed over buried, more archaic layers of ruins and mutilated fragments. This is a city whose submerged levels not only serve as the foundation of those above, but whose hidden stones turn out to be strangely alive; it is a city whose marble statues, presumed lost, survive virtually intact and continue secretly to address, indeed, control, those citizens who imagine themselves living wholly above ground, in the light of consciousness and reason—the business of analysis being to exhume and if necessary repair those statues, and to allow them to speak more openly.[9] If such archæological analogies are to carry any weight, however, I need to look a little more closely at the psychoanalytic concepts, especially at some of the darker implications of the Freudian picture of introjection.

As originally defined by Sándor Ferenczi, the term "introjection" refers to a process that enlarges the ego, extends its scope, by finding it more anchors in the external world, turning the ego into a kind of colonist.[10] But in other authors, including Freud himself, the process seems a more essentially ambivalent, even "funereal" strategy. It is a process in which the meaningfulness of internal objects is always bound up with a sense of distortion and loss, in which the ego is fragmented, fissured, and even poisoned by the very process that helps to constitute it. Such implications emerge, among other places, in Freud's essay "Mourning and Melancholia," where internalization is construed as a fundamentally defensive response to the real or

imagined loss of a beloved object, a process in which the ego identifies with and takes inside itself that object. Here the uncertain motives and consequences of this process become acutely clear. The strategy of internalization is described in part as means of preserving the lost object, or as a way of mediating and mastering loss, hence a useful phase of the work of mourning. But in the less therapeutic internalizations of "melancholia," the taking of the lost object within the ego means that the ego may become the aim of a repressed aggression once reserved for the object itself; "the shadow of the object falls upon the ego," as Freud puts it.[11] The double valence of internalization is explored even further by Nicholas Abraham and Maria Torok. In the process that they distinguish as "introjection," the internalization involves not a complete swallowing of the lost object but rather a holding of the object (or the fact of its loss) within the mouth, holding it there by means of words that at once confess and test the absence of the object, words that can become part of a shared discourse in which the work of mourning can be carried on. But in what they call "incorporation," the lost, internalized object is not so much suspended in words and fantasy as buried alive; that is to say, the lost object, the fact of its loss, is placed beyond the figurations of mourning, existing rather as a blank space within the ego around which the ego must yet form itself.[12]

Such descriptions of internal objects make them seem by turns nourishing and devouring, comforting and toxic. They can take the form of both persecutors and persecuted, become both the sources and the victims of changing forms of phantasmic violence, as well as the objects of further repression. Fixed and invisible as internal objects are, they can constitute a threat to all future attempts to construct a self, even as they are part of the foundation on which that self must be constructed. It is such objects that will be called upon by any later presentiments of renewal or change in the world of experience; it is these internal statues that will be sought out by whatever external idols seek to organize or take possession of a subject's mental life.[13]

Sketchy as these suggestions are, they may help us understand better the peculiar character of those fantasies that we bring to the contemplation of statues. They may help us understand why statues seem so well fitted to our mourning, why their strange opacity can

make them seem at once so ghostly and so familiar, or lend them a feeling of shared interiority. We can comprehend more fully why the fixity of statues should give them such power and yet such mobility, and also why we inevitably find in fixed images the occasions for fantasizing statues that are at once dead and strangely alive, things that lay claim to our life even in their apparent alienation from it. The resemblance of statues to our internal objects may further account for the conflicting appetites and violences statues attract, their way of eliciting in us more than a simple desire to see, touch, or even speak to them. (Why do children like eating things shaped like persons or animals? Do we desire to eat the statue as well as look at it?) That statues mirror our internal objects may also be part of what makes actual monuments such apt homes for our shifting *projections,* our castings out onto the world of those ideas we cannot bear to keep inside ourselves or recognize as our own; external statues may become the places onto which we project our most intimate opacities. We could say that actual statues allow us to restore to things inside us something of their original exteriority, even as they keep the coloring of the interior. Yet if statues are a place from which aspects of our internal lives are thrown back to us, it is not always in a form we can recognize. Indeed, if statues can be mirrors of our internal objects, they can also become the places where such objects are captured, deformed, and reassembled, as it were, by the very "gravitational pull" of such statues.[14] Statues call out to us with a voice that is not simply our own.

We can locate further points of contact between the categories of psychoanalysis and my own subject by looking briefly at Freud's 1912 monograph *Delusions and Dreams in Jensen's "Gradiva,"* which addresses itself specifically to a romantic novella about a statue coming to life.[15] Jensen's story itself describes a young classical scholar named Norbert Hanold, whose archaeological researches have consumed his investments in ordinary life; he is one for whom "marble and bronze alone lived." He finds himself fixated in particular on an ancient bas-relief that shows a young girl walking with a strangely poised and measured gate, a sculpture he names *Gradiva.* In his attempts to investigate this figure, to find the nature of its power, even to identify its once-living original, his "science" submits itself com-

pletely to his psyche; he is driven first to a nearly fetishistic study of the feet of passing women in his native Germany, and then to a restless, compulsive journey to Pompeii, where, he has speculated, the model for his *Gradiva* originally lived and died. Here, however, his fixation apparently advances into delusion; for walking the streets of the ruined city, he finds himself encountering, in broad daylight, a figure whom he takes to be the ghost or revenant of the young girl represented in an ancient bas-relief, a figure that both troubles and consoles him in his obsession. What the story reveals, however, is that Hanold's fixation with the marble girl is driven by his repressed love for a quite specific, living young woman who resembles the image—aptly named Zöe, "life." His delusion that the ancient marble figure, or its model, is still alive becomes thus more than a mere "mistake." That delusion rather emerges at a site of conflict; it exists as a kind of "compromise formation" that both brings to light and continues to repress the infantile erotic interest. This strangely mutable fixation of the sculptor thus entails an overcoming of a repression that yet takes its form from that repression. What thickens the plot, and Freud's reading, of course, is that the delusion is not simply a delusion. For the ghostly figure whom Hanold encounters wandering the deserted streets of Pompeii is, in fact, Zöe herself, visiting the city with her father. It is she who, with some improvisational genius, elects to play the part of the ghost of Gradiva, speaking in her voice, inventing her memories and counsels, using the very material of Hanold's delusion as a way of releasing him from it, and eventually making a place for herself as the proper object of his desires. In this case the "living statue" paradoxically takes on the role of both phantasm and therapist; Zöe/Gradiva becomes both the site of fixation and the means of its overcoming, resisting the violence that his fixation does both to her and to Hanold's own erotic life. To that degree, this version of the statue fantasy anticipates Freud's later analogy between a patient's delusions and the therapeutic constructions of analysis itself.[16]

If this story presents a rather benign picture of the desires that can be repressed by fixation and delusion, and of the losses such mechanisms seek to restitute, it makes strikingly clear the kind of conflicts that can precipitate, and be partly resolved by, the idea of a moving

statue. We might like to think that the fantasy of a moving sculpture could project an escape from the fixations figured by an immobile statue. But *Delusions and Dreams* makes clear that the fantasy may continue to feed the repressions driving such fixations, that what may seem a way of turning against a dead past may show us that past still at work in another dimension. The text also suggests that, even if the fantasy of a statue's animation reflects some originary demand of the unconscious, the particular shape the fantasy takes will reveal the influence of counter-pressures or resistances that emerge from a different site, from the external site of the material statue itself or from influences with which the statue may be identified, influences that can both take the side of that statue or subtly stand against it. The fantasies about statues emerging from within will encounter physical statues as they find a place within alien systems of meaning and intention that may be as limiting as they are therapeutic. This is mainly a way of suggesting that for all their private, archaic air, fantasies of the animated statue often embody a complex vision of the competing claims of inner and outer realms. That the fantasy so forces us to reexamine the way we divide inside and outside, subjective and objective, that it continually traces and reforms the threshold between them, provides one further key to our understanding the inexhaustible fascination of the idea.

PART TWO

Idolomachia

It should be clear by now why people fight over statues, over their subjects, forms, sites, inscriptions, their ownership, over the rituals that attend them, the stories to be told about their origins. The statue itself can be a form of conflict, or a weapon; it can become an agent of blockage or resistance, its very stillness becoming a kind of violence. What I want to examine here is how certain versions of the animation fantasy give form to that violence, how they translate or rationalize it, a process that often exposes aspects of the statue's nature that are normally concealed. By figuring the statue as an enemy, as a source of death or entrapment, such stories often hold together a feeling for the violence *of* statues with an awareness of the violence that can be directed *against* statues, in particular by suggesting that the latter violence has taken up residence within the statue itself.

My main examples in this chapter are from nineteenth-century texts, but it may help to start with some paradigmatic instances of the kind of figures I have in mind that occur in the Hebrew Bible. There is no literal place for *theomachia*, or a war of gods, in that text, no more than traces of a mythic primal battle between divinities to found or possess the cosmos; there are likewise few direct appeals to the idea of magical or animated images. Not only are the Israelites themselves prohibited from making ritual images, but in what Yosef Yerushalmi calls one of ancient Israel's "mighty acts of forgetting," "the entire rich and awesome world of pagan Near Eastern mythology was sup-

pressed and forgotten," and what was "remembered" in its place was only "its prophetic caricature as mere idolatry."[1] We can find in the text intimations of a more-than-natural power or life in human idols, but these most often emerge parodically, colored with deep irony. The fantasy of animation appears mainly insofar as it feeds the imaginative work of the iconoclast, giving form to the iconoclastic impulse and perhaps veiling less manageable anxieties at the same time.

In 1 Samuel 5:1–5, for example, the Philistine army places the captured ark of the covenant—the mute stand-in for the invisible divinity—in the sanctuary of their god Dagon, thereby displaying their desired possession of the power of that object. But the priests awake the next morning to find their idol fallen on its face before the ark. What happens at night is left blank, almost taboo; what is important is that the invisibly authored act of desecration entails a satiric animation of the statue, whose posture suggests that it worships the material container of the law (an idol turned, in a sense, idolater), confirming the superior power of the Israelite God. Set back on its feet, the image is again prostrate the next morning, further "revealing" the hand of Yahweh by the loss of its hands and head, which are found transported uncannily to the threshold of the temple, making that threshold taboo for later worshipers. The ironic animation of the statue is itself made stranger by this double, incremental fall (especially within an episode that as a whole constitutes a minor, shadowy repetition of the agon between Moses and the mortal god Pharaoh in Exodus). If the theft of the ark indicates something of the troubled relation of Yahweh to his chosen people at this moment in their history, the episode also projects the wished-for failure of Yahweh's enemy to "possess" or reconfigure the power of the Israelite God by placing his ark within their own sacred space. The statue of Dagon is indeed only "animated" as a kind of mask or puppet for the invisible, singular God of Israel, who performs these blunt, flatly disenchanting miracles with it; the idol is animated not by the rituals performed around it, but only (and exactly) in its being cast down, desecrated and disfigured. The text makes the image of Dagon more than a mute idol, by making it act and speak in God's own ironic theater, indeed giving it the power to reshape Philistine sacral practice itself.[2] But it also makes the statue considerably less than an idol, by leaving it a

mere trunk, without the head or hands that help give human shape to the stone.[3]

Such loving attention to the degradation of the idol, the haunting irony of that mocking miracle, suggests that there is more at stake in the story than a merely rationalistic attack on idolatry. The violent rejection of visual representation in the biblical text, and the sense of crisis in the character of divine authority such representation entails, is harder to grasp than is often acknowledged. For one thing, the idea of idolatry depends on both a demystification and a conceptual distortion of the image, its re-mystification one might say. Some have seen biblical iconoclasm as part of the text's continually renewed turning away from, or protest against, all that is outward or materialized; others have read it as a way of opening up the worship of God to the shifting contingencies of history. But in either case we should realize that this iconoclasm depends on the fantastic insistence that those termed "idolaters" are merely fetishists, that they worship the sacred object, the graven or molten image, as itself sufficient. The biblical discourse of iconoclasm does not see the image as something animated through its participation within a larger ritual praxis and mythology, as the partial vessel of a divine reality larger than itself. If the biblical text seeks to lay bare the erring origins of a false belief, it is also true that the magic, the demonology, and cosmic wisdom of its enemies is something that text bluntly fails to know, or knows only as something that at best parodies, at worst blocks, the starker interventions of Yahweh, the negotiations of *his* covenant and law.[4] Yet there are places in the text where, despite this reduction, the suppressed enchantment returns. There are moments, that is, when the myth of idolatry allows the partial reemergence of the magical within the precincts of what purports to be a skeptical, disenchanted vision of false worship.

The "animation" of the idol in 1 Samuel is clearly parodic. But other texts offer less mocking intimations of some autonomous power or tabooed form of life that haunts false representations of the divine. The paradoxical descriptions used in Psalm 115 to dramatize the costs of idolatrous projection suggest such a power, for instance. For that text both marks the emptiness of idolatrous mimesis and yet lends to graven images a Circean or Medusa-like capacity to transform their

makers and worshipers, to render them as mute, senseless, and empty as the things they address:

> They have mouths, but do not speak;
> eyes, but do not see.
> They have ears, but do not hear;
> noses, but do not smell
> . . . Those who make them are like them;
> so are all who trust them.
>
> (5–8)[5]

The hyperbolic depredations and invectives of prophetic rhetoric also sustain some sense of supernatural life in the image, since the prophets' rationalistic mockery of idolatrous projection is often combined with a more extreme conversion of idols into objects of perverse sexual desire, things with which worshipers can "commit whoredom." Such ways of speaking about idols owe much to heightened metaphor, of course; they suggest how the empty power invested in a senseless artifact reflects the worshiper's own emptiness or faithlessness. The fantastic idea of the "idol" assigns a new status to *another's* fantasy, reducing it to the level of an individual or collective spiritual failure. And yet when one reads such texts, the sense of magical contamination, of some real power or autonomy in the idol, is hard to exorcise completely, if only because the fear of idols drives the iconoclasts to such extremes of apotropaic metaphor.

Accounts of physical violence against idols can also lend them reflexively an ironic potency. We see this, for instance, in the account of Moses' destroying the golden calf, the darkest sign of Israel's infidelity: "And he took the calf which they had made, and burnt it with fire, and ground it to powder, and scattered it upon the water, and made the people of Israel drink it" (Exod. 32:20). A displacement of the (repented) wrath of Yahweh, this act both doubles and takes revenge for Moses' earlier breaking of the tablets of the Law, even as it foreshadows the Levites' killing of three thousand of the faithless following the destruction of the idol (32:27–29). A literalizing, shame-inducing sign of the Israelite's participation in idol worship, the forced drinking of the pulverized image is also a travesty of a theology

of internalization, its scattering perhaps a parody of the image in Genesis of God moving over the face of the primeval waters. (There are Rabbinic interpretations that further rationalize Moses' act by making the mixture into a poison, or into a magical, diagnostic potion that tears out the tongues of those who had fallen most fully into idolatry, or else turns their lips and bones to gold, as if to literalize their assimilation by the idol.)[6] Here the violence or violation posited *in* the idol is both recognized and recreated through the complex act of violence done against it. The idol's power further emerges in its ironic use as a tool, even in its dead materiality, to chasten those who worship it, hence to feed and locate the power of the idol's righteous enemy.

The text thus invents and knows idolatry through an image of a deadly life attached to the idol itself; the aggression against the idol takes up residence within it. This critical strategy finds an even more extreme form within the esoteric, propagandistic, and paranoid mode of apocalyptic writing, where the fantasy of the animated idol holds a place alongside a whole population of eschatological monsters. In Revelation, for instance, the Beast of the Land (though only with the divinity's tacit permission) oversees the manufacture of his speaking, demonically "inspired" double: "And [the beast] was allowed to give breath to the image of the beast so that the image of the beast should even speak, and to cause those who would not worship the image of the beast to be slain" (13:15). An even better example is the description of the gigantic statue in Nebuchadnezzar's dream from the Book of Daniel. It depicts a phantasmagoric idol whose head "was of fine gold, its breast and arms of silver, its belly and thighs of bronze, its legs of iron, its feet partly of iron and partly of clay," an image struck on the feet and then broken in pieces and scattered by a stone "cut out by no human hand," a stone that "became a great mountain and filled the whole earth" (2:32–35). This is a dream not comprehended by the idol-worshiping dreamer but retold and interpreted by the oneiromancer Daniel, a Jew living in exile in Babylon. As he reads it, the fantastic statue is an eschatological image of the declining history of the secular empires ruling Israel, from Babylon to Media to Persia to Greece (especially the Seleucid dynasty, which ruled at the time of the book's composition). The statue represents that history in a way

that mocks even as it echoes those kingdoms' claims to trans-historical, supernatural power. Implicitly addressed to the Jews suffering religious oppression and civil strife in Israel itself under the Seleucid king Antiochus Epiphanes, this vision of a gigantic broken image becomes a revolutionary symbol, or at least a reassurance to the pious, placing both the rule and wished-for defeat of a tyrant within a prophetic genealogy, and locating the uncertain political present between the certainties of a declining past and a divinely (if catastrophically) transformed future. The statue gathers all secular history into a single form, so that that form's destruction can dramatize the nature of God's intrusion into that history.

Of course this statue is far from "living"; it is, in ways, grotesquely static, registering both the fixated pride of the enemy and the paranoia of his opponents. "Movement" enters the picture, as one commentator remarks, only with the invasion of the sublime stone.[7] But partly because this dream-statue shows us a constructed thing beyond any human power of construction (though it is a summary of human historical and political orders), and partly because of the more profoundly unnatural character of the power that destroys it, the metallic giant does acquire a strange, commanding, and not wholly inhuman life. We can call this gigantic image a meta-idol, perhaps, its destruction projecting among other things the destruction of the golden image the king forces the Jews to worship in the very next chapter of Daniel, or the fall of the statue of Zeus (the "abomination that makes desolation" [Dan. 11:31]) that Antiochus placed in the Holy of Holies. This vision of the composite statue is itself dismembered and schematically reallegorized in subsequent passages: its four symbolic metals become in Daniel's later vision four demonic and devouring beasts—lion, bear, leopard, and a last, unnamed creature with iron teeth and ten horns, one of which has eyes like a man, and a mouth "speaking great things" (Dan. 7:1–8). But this revision, while apparently alien to the statue, partly reinforces the basic paradox I would dwell on, that is, the need in texts such as Daniel to imagine the enemy as something at once dead and demonically alive, potent and empty, humanly created and yet caught up by a supernaturally controlled history.

The presence of so many compulsive, inhuman, and robotlike crea-

tures in apocalyptic and allegorical texts like Daniel derives, as Angus Fletcher notes, from the need to give dramatic shape to the situation of agents caught up by large-scale conflicts of authority and ideology.[8] The "living statue" figure is an almost inevitable feature of a mode in which humanly created ideas, images, and institutions are fantasized as having a potent life of their own. Its peculiar configuration in Daniel suggests the writer's need at once to embody and to contain a certain skepticism; the apocalyptic narrative, that is, tries to demystify and mock false forms of sacred authority, and yet to register their terror and power, even as that narrative secures its own special claims to speak on behalf of divine revelation, opening up the possibility of a divinely transformed future. The result is a mode of description at once magical and rationalizing, both opaquely esoteric and rigidly clarifying, even deterministic. In what Fletcher would call one of the deep subterfuges of allegorical writing, some of the sense of taboo, the proper awe of sacred authority, and even a certain human pathos are retained by entities like the image of the beast in Revelation and the giant statue in Daniel. This residual and yet palpably ironic animation helps to confirm by contrast the authority of the powers that cast them out, even as those powers are defended in turn from the doubt and contempt heaped on the idol/enemy. Our debunkings require their own countermyths, as Kenneth Burke realized.

Such violent polarizations of friend and enemy, such separatings out of the poles of ambivalence, might suggest that the text is haunted by the troubling possibility that Yahweh himself might be reduced to nothing but a more sublime and elusive idol, as if the seduction of idolatry continued to haunt any representations of the divine. (That fear is continuous enough in Jewish tradition that one is both stunned and elated to find a Rabbinic text that asserts bluntly that God appeared to Israel "as though He were a statue with faces on every side, so that though a thousand men might be looking at the statue they would be led to believe that it was looking at each one of them.")[9] But recognizing this possibility does not mean that one is reduced in turn to some facile relativism, as if such texts proved simply that one person's god is another person's idol. Even a "mythicizing" text like Daniel still inhabits and recalls the severe critique of idolatry that

unfolds throughout the Hebrew Bible. This tradition appears strenuously to reject the literalizing circuit of idolatrous worship, its binding of the worshiper to a regressive yet politically manipulable sense of a god's fullness or presence in the image; it rejects the binding of that divinity to something that is ultimately answerable to the worshiper, as well as the conversion of a god into a lifeless, materialized statue. But the biblical text rejects these versions of idolatry primarily insofar as they foreclose the possibility of the more troubled fidelities, the more uncertain projections and blockages, which attend the covenant with the iconoclastic divinity of Israel. Since the iconoclastic stance depends on its own reductive, projective parody of idolatry, and on a radical mystification of the power that undoes that idolatry, the text's disenchantments remain unsettlingly ambiguous. One result of this ambiguity is that the "enemy" will tend to be pictured as a peculiar composite of idol and demon, as a thing at once dead and uncannily alive.

That a fight against things called idols should generate such an ambivalently magical grammar is not in itself mysterious. We can still find a somewhat rationalized survival of the biblical patterns I have pointed to in Augustine's accounts of the supposedly magical statues of late-classical paganism. Cultic images appear in this context under a double curse: empty idols created by self-deluded men, sites for the projection of selfish human fantasy, these statues are also "animated" by the tribes of objectively real, supernatural demons who use them to tempt and deceive their worshipers.[10] The church's own need to maintain the authority of its sacramental magic—including, especially, the power to drive out demons from living *or* dead homes—makes total disenchantment impossible. Nor is this ambiguous picture of the idol as both dead and demonic necessarily confined to religious traditions. Perhaps because such a picture is animated by a powerfully skeptical component (however mingled with equally powerful mystifications), it remains both common and useful in what would appear to be more fully secular discourses. The biblical visions of the statue as demonic blocking agent can indeed help us understand some of the tensions at work even in apparently disenchanted versions of the animation fantasy (especially texts that analyze and reclaim a realm once dominated by theology and religious myth). To

show this it is best to turn to later examples, mostly from the nine-teenth century.

I begin with a poem that explicitly recalls the giant in Nebuchad-nezzar's dream, and perhaps the broken Dagon as well: Shelley's "Ozymandias" (1817), with its silent and fragmented colossus.

> I met a traveller from an antique land,
> Who said—"Two vast and trunkless legs of stone
> Stand in the desert. . . . Near them, on the sand,
> Half sunk a shattered visage lies, whose frown,
> And wrinkled lip, and sneer of cold command,
> Tell that its sculptor well those passions read
> Which yet survive, stamped on these lifeless things,
> The hand that mocked them, and the heart that fed;
> And on the pedestal, these words appear:
> My name is Ozymandias, King of Kings,
> Look on my Works, ye Mighty, and despair!
> Nothing beside remains. Round the decay
> Of that colossal Wreck, boundless and bare
> The lone and level sands stretch far away."[11]

Ozymandias is the Greek name for Ramses II, as Shelley may have known.[12] But here the image of the pharaoh who challenged Moses and Yahweh merges not just with all prior pagan and political idols but with the face of the father god himself. The poem appears to be a stark reminder of the mortality and impotence of earthly kings, and earthly imaginations of a kingly god, lending to time alone the char-acter of a redemptive, if invisible, iconoclast. The sonnet also re-sponds to Byron's exactly contemporary descriptions of ancient ruins in *Manfred* and *Childe Harold*, especially insofar as Shelley exorcises the slightly sentimental pathos the older poet invested in the ghosts of dead kings inhabiting such ruins. For all such forms of negation or banishment, however, what may disquiet us in the poem is the resi-due of power, the presence of a kind of deathly life, still clinging to this abandoned, hearsay statue. It is a life that remains elusive, es-pecially given Shelley's acute skepticism about the sources of human power and thought, but we may sense it nonetheless. Exiled, dis-placed, unanswered, the ruler's dead voice continues to speak from

the pedestal. It is a voice that, for all its emptiness, its disjunction from both the dead king and stone image, is made to seem, if only by contiguity, responsible for the nothingness, the boundless waste and "wreck" of the world that remains behind and around the statue. That is to say, the lifeless "things" on which the tyrant's "sneer of cold command" is stamped include the desert of human history as well as the broken artifact. The statue here becomes not just the relic of a catastrophic history but also the agent and artist of that history, a history that includes the force of its own iconoclasm. It becomes a testament to the power of things imagined to devastate as well as animate the world, their power to break and erase as well as to imprint (a power in which we ourselves are enrolled, especially given the inscription's invitation to us to "Look"). Here the face of Ozymandias takes on the aspect of Shelley's own enchanting and devastating Medusa, as it does that of Milton's fallen Satan. The face of the statue is a mirror of the things we may fear to possess, as well as those we have lost. If there is a strange consolation or promise in that "nothing" that remains, it is mainly in its resemblance to the unpeopled void of Shelley's Mount Blanc. For there we find a blankness that faces down all human power and wish, a silence that is the source of a posited voice able to undo "large codes of fraud and woe," a vacancy that yet also gives us evidences of the human mind's saving capacity to make *something* out of nothing.[13]

Pushkin's "The Bronze Horseman" (1833) offers a similarly chilling fiction of the life of a statue. Lacking Shelley's biblical subtext, the poem may seem more strictly political and psychological in its implications than "Ozymandias." Shelley's Egyptian ruin is also a far cry from the statue that Pushkin describes, Étienne Falconet's neoclassical image of Peter the Great as a cloaked rider treading on the serpent of Envy, holding out his arm in a gesture of control and pacification from the great height of his pedestal. Yet Pushkin's poem similarly shows a double image of the statue as at once dead idol and living tyrant, using it in turn, like Shelley, to achieve some immensely subtle readjustments of the iconography of ruin and revolution. It is a poem that also raises a series of nearly unanswerable questions about how we might distinguish the official and unofficial character of the

statue's life, about how it is that the statue leads such different or conflicting lives, and about the difficulty of knowing for certain where those lives inhere.

In Pushkin's poem the transformation of this icon—the symbol of the city of Saint Petersburg, its imperial history, its rulers—occurs only slowly. After an introductory movement praising the history and present pleasures of the city itself, the poem's focus shifts to a description of the catastrophic flood of the river Neva in 1823 and then to an account of its effects on a poor clerk named Ivgeny. We do not find out much about this clerk's history or personality, only some few details about a forgotten noble ancestry, his determination to persevere at his modest job, and his reserved dream of domestic happiness, of a "simple shelter" where he, his beloved, and her mother could live in peace and happiness. What we do discover is that the flood shatters this dream. Indeed, it seems to tear his beloved "Parasha" from the fabric of existence (she is never glimpsed in the poem), transporting her hovel from its site on the shore of the Neva to an island in the middle of the river. This loss provokes the clerk's passage into madness, his transformation into a homeless wanderer in the city; and his madness in turn "produces" the animation of the statue, the image of Peter becoming a thing that pursues him in his erring quests. It is not enough, however, as we shall see, to say that the poem frames the statue's life simply as a madman's delusion. Rather, as Pushkin constructs it for us, the fiction of the statue's animation demands that we radically readjust our angle of vision on the relation between the private desires or imaginings of his hero and their larger public context; that fiction throws into radical perspective the relation between local contingencies of self and nature and the large frameworks of cultural history and ideology that shape and get shaped by them. Driven (in part) by the poet's own sense of resistance to, complicity with, and victimization by imperial authority, the fantasy of the bronze horseman's animation becomes both a form of knowledge and a form of protest, articulating a picture of a power that can seem by turns tyrannical and revolutionary, ambiguously human and inhuman.

We must attend here to the subtle staging of the animation fantasy, its multiple occasions, and to the conflicting influences—historical

and natural, objective and subjective—that shape our view of the statue's life. The prelude to this two-part poem offers us an imaginary scene of the city's origins in human imagination, a vision of the young czar Peter as an anonymous, heroic thinker standing "on a shore washed by desolate waves," projecting a great city built on a swamp, a city whose stone walls will contain the threatening waters of river and sea.[14] That projector constructs in his mind "a military capital" from which invasions can be launched, a city that can become as well the seat of an enlightened, imperial state. The present moment of the poem, however, lets us see this heroic stander and imaginer as someone whom history (and Falconet) have converted into the bronze rider, and the text's first section ends with a vision of this monument to Peter's successful work rising above the complete but now flooded city:

> in unshakeable eminence, over
> The angry river, the turbulent Neva, stands
> The Image [or Idol] with outstretched arm,
> on his bronze horse.[15]

The first half of the poem thus opens and closes with a vision of Peter, one archaic, full of a yet unshaped future, the other fixed, empty, statuesque. What fills the space between these two visions, however, is the tragic history of the forgotten clerk. The obvious irony of the lines quoted above is deepened by the fact that within the narrative proper the only possible witness to this vision of the statue seems to be the clerk himself, whom the poet discovers standing in the square before the statue at the height of the flood, in the middle of the night. "Witness," however, is not quite the right word, for at this moment Ivgeny does not really see the statue that the narrator describes. Pushkin rather shows the clerk frozen in terror, sitting astride another statue, one of the stone lions that "stand like living creatures" on the porch of a nearby tower, his living body arcanely contaminated by that figure's stoniness—not looking at the statue of Peter but rather fixated by the destructive violence of the flood and by the stunning fear of his own loss at the hands of nature.

Pushkin's description of the desperate, impoverished clerk at the base of the bronze statue may remind one of the opening of *City*

Lights, but it anticipates even more precisely Wallace Stevens's marvelous comic lyric "Dance of the Macabre Mice"—a poem of winter, in which the titular rodents describe their hungry, mocking, and macabre dance around and over an equestrian statue of "the Founder of the State," with his "arm of bronze outstretched against all evil!"[16] ("Whoever founded / A state [or statue] that was free, in the dead of winter, from mice?" the mice ask.) But the contrasts out of which Pushkin builds up his scene are more elusively ironic. The flooding river is described as an enemy, as a rebellious and violent intelligence mounting a siege on the city, breaking the stone boundaries meant to contain it. Its waves become, in the poet's words, like beasts of prey, vengeful and devouring. But the fascination of the scene does not come just from the plain irony of the heroic statue's impotence in the face of the flood. Rather—and this is something dependent on both large and small details, and especially the presence of Ivgeny—the poem sets up a dream equivalence, a nightmarish contamination, between the contingent violence of the flood and the power embodied in the statue, as if one were the crystallization or double of the other. Both flood and statue represent, in this fiction, agencies of terror, theft, loss, death. That is to say, the powers of the two seem to coalesce, become allied (this being perhaps the thing that drives Ivgeny mad). And it is an alliance that holds even though the flood is also associated with rebellious political impulses such as might topple the statue, and the authority of its figured monarch. (In particular, the flood can be read as a displaced image of the failed Decembrist uprising of 1825, a short-lived revolt led by former military officers, liberal aristocrats, and intellectuals—many of them friends and admirers of Pushkin—that aimed at unseating the newly crowned, authoritarian Czar Nicholas I. The uprising, with which Pushkin had troubled sympathies, and which only chance kept him from being a part of, had its bloody conclusion in the Senate square of Saint Petersburg where Falconet's statue stands. The dead rebellion haunts the empty square in the poem.)[17]

"The Bronze Horseman" offers us no overt image of the waste, exploitation, and oppression that fed the work of the imperial "reformer" and produced his city; it does not show an image of the decay of his *imperium* into a corrupt court and bureaucracy. Nor does it

directly confess any feelings of loss, entrapment, frustration, or complicity that might have troubled the poet himself. Insofar as there is any "knowledge" of oppression in the poem, or protest against it, these are displaced both onto the flood and onto the words and fantasies of Ivgeny. One can sense this displacement to a degree in the scene I have just discussed, but it emerges even more powerfully in the beginning of the poem's second part. Here the clerk's imagining of the statue's life becomes the strangely muddled substance of both the poem's knowledge and its protest, as the distance between the power of the flood and that of the statue seems to collapse even further.

The narrative of the second part picks up the morning after the flood, when Ivgeny finds that the house of his beloved has been completely washed away, without a trace remaining of either the dwelling or its inhabitants. Ivgeny at this discovery seems to lose his mind, becoming a desolate, homeless wanderer through the city. The crucial thing is that this loss of both his sanity and the object of his desire coincides, as Roman Jakobson points out, almost exactly with the animation of the previously unmoving statue.[18] The crisis comes, Pushkin tells us, on a night when Ivgeny unwittingly finds himself back in the square where the statue stands. Turning from Ivgeny for a moment, the poet addresses a more conventional, though subtly equivocal apostrophe to the bronze rider:

> How terrible
> He was in the surrounding murk! What thought
> Was on his brow, what strength was hidden in him!
> And in that steed what fire! Where do you gallop,
> Proud steed, and where will you plant your hoofs?
> O mighty master of fate! was it not thus,
> Towering on the precipice's brink,
> You reared up Russia with your iron curb?
>
> (256)

But soon the poet's attention turns back to Ivgeny himself, wildly circling the statue's pedestal, angered, trembling, "his eyes . . . sealed by mist," "possessed by a dark power." At this point we are

allowed to overhear the clerk's own whispered apostrophe to the statue. His words are fragmentary, obscure: "All right then, wonder-worker, just you wait!" (257). After uttering them he hastily runs away. It is an utterance that both mocks the magical claims of the mythic, "thaumaturgic" founder of the state and implicitly challenges the more romantic rhetoric of the narrator, who had seemed to reinforce those claims. Ivgeny's words themselves may seem desperately impotent. Yet in their ironizing of wonder, and in their opening up to a future apparently *not* under the control of this "master of fate," the clerk's words and his subsequent flight work their own kind of magic. As if in response to a veiled, revolutionary threat, the statue suddenly comes to life for Ivgeny. But it does so only as a kind of voiceless and vengeful bronze robot that pursues him through the city, the ghostly sound of its hooves on the pavement becoming an ironic substitute for the roaring of the flood that filled earlier sections. Ivgeny's vision of this phantom reoccurs, the narrator tells us, whenever he reenters the square; it is a terror that finally converts the clerk himself into a kind of ghost, something "neither beast nor man, neither this nor that, / Not of the living world nor of the dead" (255). Ivgeny is discovered at the end of the poem haunting the ruin of what was apparently his beloved's cottage, now cast up on an uninhabited island in the river. We are told at the close of the poem that this is indeed the site where "my madman" is buried. It is at best a paradoxical kind of justice that the description of Ivgeny's desolate grave occupies a place at the end of the second part of the poem exactly parallel to that occupied by the vision of the statue at the close of the first part.

We can say that Pushkin's narrative psychologizes, hence rationalizes, the fantasy of the statue's animation, that such animation must be seen as the ambivalent projection of both the clerk's hysterical anger and the neurotic guilt brought on by his attacking an image of authority. The statue's reactive life thus emerges at the site of violated subordination, in response to the unsettling of officially sanctioned modes of reciprocity and apostrophe (and officially sanctioned modes of neglect as well). That statue also seems to come to life so as to preempt the threat of some withheld violence *against* itself, or to put off the threat of some unaccommodatable temporality the statue

cannot manage to freeze in its tracks (a threat conveyed by Ivgeny's "just you wait"). The terror associated with the statue is real enough, however, representing as it does at least two distinct agencies of loss—the irrational violence of nature and the otherwise faceless, diffuse forces of political and economic hierarchy that enclose the clerk and that here seem to execute their justice upon him. The statue's animation marks the presence of that loss, if not exactly its causes; the animation marks as well its essential injustice. But the peculiar character of this animation also preempts the possibility of truly mourning for and protesting that loss, especially insofar as that mourning or protest might take the form of an address to the immobile statue. The statue's animation thereby not only drives the clerk mad but strips from the statue any elegiac or heroic aura it might otherwise possess.

One should recall that "The Bronze Horseman" was like most of Pushkin's work composed with the knowledge that, if it were to be published, it would be subjected first to the eye of the official censor. In Pushkin's case, however, at this moment in his career, such censorship entailed not the scrutiny of nameless bureaucrats and lower officials but rather the ambiguous privilege and "freedom" of having his texts examined by the czar himself and his chief minister of state—who distrusted the poet's radical sympathies and yet wanted him to serve as the state's ornament, icon, and even mouthpiece. (The czar on this occasion objected to Ivgeny's outcry as well as the poet's reference to the statue as an "idol"; the poem was never cleared for publication in the poet's lifetime.)[19] Pushkin could defend public censorship as an ironic testimony to the power of the printed word (in a censored essay), but his letters also record his sense of its arbitrariness, intolerance, and stupidity, the crudeness of its literary judgments and its nervous demands for signs of obedience, as well as its corrosive effects on his own and others' creativity.[20] Writing of his own situation, he records his fear of the imperial eye that would be hungry to discern "hidden meanings, allusions, and difficulties," to find subversive intentions in his otherwise "innocent" texts.[21] And yet it seems clear that Pushkin's need to bypass censorship is what helped produce in this poem such a "masterful tangle of allusions, hidden meanings, and allegories," so many displacements of political

protest and accusation—something visible, for example, in the way that the violence of the flood suggests simultaneously the sanctioned violence of the state and the less controlled social violence that might be directed against it.[22] Though it is hard to specify the precise trajectory of such evasions, I evoke the larger situation of censorship to focus a more parabolic surmise: that censorship not only influenced the text but is itself mythologized there. That is to say, the statue's animation can be read as a satiric image of the resentment and paranoia but also the sheer contingency and automatism that feed the work of censorship, its way of taking revenge on those who resist it.

The nightmare of the statue come to life marks both the clerk's madness and his knowledge, his submission as well as his otherwise unvoiceable protest. One question held out by the poem, I suppose, is whether that nightmarish statue could be dreamed of by someone other than a victimized madman, whether it could be a nightmare that the owners and inheritors of the statue could entertain. (Could Nebuchadnezzar know that the statue he dreamed of was his own monstrous double?) As an image of both human mastery and of the inhuman energies it supposedly tames, the statue of Peter (etymologically, the great stone) attains a powerfully ambiguous status. Indeed, in Pushkin the statue gets animated in a way that at once lays bare, sets at a distance, and appropriates the very energies that might seek to pull it down. The dream of the statue's animation includes and puts off the statue's destruction by iconoclasts. The statue of Peter, as an image of order and authority, cannot or will not be broken, perhaps because the poet is more intent on showing us an image of order and authority gone mad, its seductive strength fed by the (catastrophic and abject) strength of its apparent enemies—even though the fiction of animation might also be said to recuperate the violence of image-breaking by translating it to a less literal level.

Shelley's and Pushkin's poems are both strongly secularizing texts; both historicize the idea of demonic life in the statue, and in part psychologize it, even as they make that life seem ambivalently an aspect of both authority and its opponents. One may of course feel that a residual, and not merely ironic, nostalgia for intimations of the sacred or the magical creeps back into such texts. But this apparent

nostalgia is itself a function of more complex attitudes. The handling of the animation fantasy in these poems embodies an implicit doubt of the very secularizations and demystifications on which the poets themselves feed; these poems point to a suspicion that such demystifications may themselves only perpetuate subtler, more covert forms of mystification. We can call such texts iconoclastic, but their imaginings of the animated statue also suggest an awareness that no iconoclasm can be pure, final, or free of fantasy, that gestures of disenchantment or revolution can be fraught with blindness, reduction, and inverted superstition and are all too likely to reanimate the very idolatry they seek to overcome. Jean Cocteau reminds us that "in breaking a statue one risks becoming a statue oneself."[23] In elaborating their intricate, phantasmagoric responses to statues, these texts tell us that both the idol and its demon must be faced down over and over again, and that what passes for iconoclasm (desecration, ruin, decay) must be continually reimagined.

We can illustrate this dilemma by interrogating briefly two "doubles" of Shelley's stone head that appear in successive sections of Wallace Stevens's "Notes toward a Supreme Fiction." In poem 8 of "It Must Change" (the second of the work's three movements) Stevens describes a visit to Shelley's broken statue by the comic, ascetic Nanzia Nunzio, the nonsensical ambassadress or nun of nothing: "On her trip around the world, Nanzia Nunzio / Confronted Ozymandias." This particular tourist or pilgrim courts the stone head as if she were a bride facing a bridegroom, as if that contingently broken image were the source of some final order outside herself that could invest her in turn. She makes of the stone the source of a reality before which she wishes to strip herself of all prior trappings of identity or selfhood, to make herself more naked than nakedness, declaring to it "As I am, I am." Ozymandias reminds her, however, that "the bride is never naked," that in the face of all unveilings "a fictive covering / Weaves always glistening from the heart and mind"—a covering that includes the fiction of iconoclastic *un*veiling.[24] Stevens, who so ambivalently erects and dissolves statues within his poetry, knows the necessity of such wisdom.[25] But he also knows its evasiveness, and perhaps its terrorism, something that comes through when we realize that the statue's monitory words are a strange sub-

stitution for the original Ozymandias's "Look on my Works, ye Mighty, and despair." Stevens tacitly suggests thereby that his own proverb may become as empty, and maybe as threatening, as that prior inscription. As if to reinforce this suggestion, he conjures up another stone head in poem 3 of "It Must Give Pleasure," no lightly comic Ozymandias this time, but one that repossesses the deeper terror marked out in Shelley's sonnet. A tropical rather than a desert statue, it is a figure for the opacity of a tradition of tropes, a picture of the fate of fictions that have become over-read, tedious, nothing but rust or rouge, but that nonetheless seem able to entrap us. As in Shelley, we see the face of the iconoclastic father god shining through that of the idolatrous enemy. Indeed, what we see here is a petrified, if strangely fertile, version of the God that manifests himself in a burning bush, a divinity that refuses all predication save for the equivocal, almost mocking name, "I am who I am" (Exod. 3:14):

> A lasting visage in a lasting bush,
> A face of stone in an unending red,
> Red-emerald, red-slitted-blue, a face of slate,
>
> An ancient forehead hung with heavy hair,
> The channel slots of rain, the red-rose-red
> And weathered and the ruby-water-worn,
>
> The vines around the throat, the shapeless lips,
> The frown like serpents basking on the brow,
> The spent feeling leaving nothing of itself,
>
> Red-in-red repetitions never going
> Away. . . .[26]

This is one of Stevens's most haunting depictions of the statue as demonic blocking agent, a statue deathly even in its unnatural beauty and nourishment, and I am tempted to end this section here. But before closing I want to turn to a text that brings together rather more fully some of the issues I have been discussing—a passage from William Blake's powerful allegorical epic *Milton* (1804). This text too

uses the fantasia of the living statue to provoke a severe reimagining of idolatry and iconoclasm, joining a vision of the making of a statue even more directly to a vision of its unmaking; it marries even more radically the idea of a statue's destruction with that of its animation. It converts a Pygmalion-like scene of magical sculpting into a demonic battle, presenting an iconoclastic sculpting that combines elements of aggression and defense with a strange kind of charity.

In the encounter described below, from book I of the poem, the figure named Milton represents the historical Milton's immortal poetic self or genius; he is shown after he has abandoned a strangely anxious, orthodox heaven in order to descend into the world and undo what he sees as the failure of his epic project in *Paradise Lost*, in particular its reinforcement of the curse of orthodox Christianity and natural religion. Milton's antagonist is the "giant form" Blake calls Urizen. This figure is, at one level, an image of the entrenched authority of religious tradition, a petrified and petrifying idea of God whose power is gained not so much through the weakness as through the projected strength of those human imaginers who abase themselves before him. Urizen is also the god of empty limits, an image of that terrified, defensive rationalism that sets itself up as rule and reality principle; he represents at once a formless, abstract chaos that refuses definite form and a rigid set of rules built upon "the rocks & snows of doubt and reasoning" (3.8).[27] Here Milton confronts this "ancient of days" as he emerges "from his Rocky form & from his snows." It is like a meeting of antithetical ghosts, one seeking to deny time, the other hurling himself into time and in turn hurling it *against* the first:

> And he also darkened his brows: freezing dark rocks between
> The footsteps, and infixing deep the feet in marble beds:
> That Milton labourd with his journey, & his feet bled sore
> Upon the clay now chang'd to marble; also Urizen rose,
> And met him on the shores of Arnon; & by the streams of the brooks
>
> Silent they met, and silent strove among the streams, of Arnon
> Even to Mahanaim, when with cold hand Urizen stoop'd down
> And took up water from the river Jordan: pouring on
> to Miltons brain the icy fluid from his broad cold palm.

But Milton took of the red clay of Succoth, moulding it with care
Between his palms: and filling up the furrows of many years
Beginning at the feet of Urizen, and on the bones
Creating new flesh on the Demon cold, and building him,
As with new clay a Human form in the Valley of Beth Peor. . . .
. .
 . . . Silent Milton stood before
The darkend Urizen; as the sculptor silent stands before
His forming image; he walks round it patient labouring.
Thus Milton stood forming bright Urizen, while his Mortal part
Sat frozen in the rock of Horeb: and his Redeemed portion,
Thus form'd the Clay of Urizen. . . .

If the wounding marble floor and the statuesque demon himself represent at one level the idealizing classicism Blake opposed, the poet's work is seen as a sculptural remaking of that classicism.[28] In working through this image of remaking, we need to pay particular attention to the dense, allusive texture of the scene. The stony Urizen appears, among other things, as the ghost of Moses the lawgiver, whose own concealed *grave* was dug alongside the Valley of Beth Peor (Deut. 34:6). Urizen is also a parodic John the Baptist, a dark version of Milton's own inspiring muse here playing the part of a Medusa, his baptism an attempt to freeze Milton along the path of his purgatorial quest. The account of Milton's resistant sculpting furthermore parodies the Genesis image of a Promethean Yahweh molding the first man out of the red clay of an inchoate earth, and breathing life into his nostrils; it thus gives us a strange image of man remaking a (false) god in the image of God making man. Less obviously it echoes the account of God's supplemental shaping of Eve out of the bone of Adam, especially as described in book 8 of *Paradise Lost*, where the process enacts a simultaneous wounding and healing of the sleeping patriarch. Ovid's version of the Pygmalion story is likewise in the background, with its complex doubling of sexual and artistic touch— suggesting the intimacy as well as the antagonism of the opponents here. The scene also doubles, and in part "corrects," other passages in *Milton* itself, especially Blake's early, grotesque myth of origins in which the creator Los attempts vainly to forge a definite, containing

human form for the formless, solipsistic Urizen, an attempt that, unlike Milton's, causes Los's own fall into self-dividing pity, jealousy, and frustration (book I, plate 3.6–30).

Drawing together all such figures of creation and humanization, however, is a startling, allusive reconstruction of Genesis 32:23–33, the narrative of Jacob's solitary, night-long wrestling match with a nameless adversary at the ford of Jabbok, an episode that ends with the patriarch wounded, blessed, and renamed, even as it leaves the character and intent of his adversary shrouded in obscurity.[29] Blake's text is ironically alive to traditional identifications of this unsettling opponent with God, an archangel, or the Holy Spirit. It might also confirm Harold Bloom's equally ironic identification of Jacob's visitor as an "Angel of Death," a demanding demon of contingent priority and oppressive continuity.[30] But Blake would also know that this "angel" is, in Genesis 32:24, identified as merely "a man." More important, perhaps, is that Blake picks up on and reinforces an implicitly psychomachic element in the biblical text, that is to say, a feeling that Jacob is wrestling with an aspect of himself, with his own "spectral projection" (a suggestion reinforced in the Hebrew text, verse 25, by the troubling ambiguity of pronouns identifying the wrestlers at the moment of the battle's greatest crisis).[31] This sense of confused or exchanged identities is reinforced in Blake by both the identification of Urizen with Milton's muse and the fact that Milton is compared to a sculptor who, like a statue himself, "silent stands" before his image, even as that image is lent a transitively "forming" character. The difficulty in the texts is what to make of such troubled interanimations of the opponents. What is being tested in the biblical text, I would argue, is Jacob's power to lend to something alien, even to a form of death, an answering power to transform that which he already is; what is being tested is his power to steal back from that alien thing a power at once lent to Jacob by the visitor, and given *to* the visitor by Jacob.[32] It describes his capacity to make life out of what could just as well be a death. This is a structure of conflict that Blake mirrors in his own allegory, even though Urizen's claims to divinity are more explicitly parodic than those of the "angel" in Genesis and the answering transformation of Milton less immediately apparent. (That transformation is reserved for later sections of the poem and is

in fact undergone by a different simulachrum of the poet.) If there is a strong difference, it is not so much in the more confessedly fictive character of Blake's narrative as in its lack of the pragmatic finality we see in the biblical text. For there is in *Milton* no break of day, no exchange of speech, no final check or wound (even one as inconclusive in its implications as Jacob's); there is no renaming, no memorial dedication of the site of battle, no departure for a new home. Nor is there any moment of enlightenment such as Luther imagined, when he has Jacob say, "Ego putavi esse spectrum. . . . tu ergo es benedictor."[33] Indeed, the silence of the encounter is emphatic; it reinforces the mutual ghostliness of the opponents, even as it conveys a sense that there simply is nothing to say, that the two already know all they need to know about each other. There are certain ironic parallels one might point to, for instance, the way in which Urizen's baptism can mirror *both* the angel's failed wrestling trick and his proffered blessing. But the most significant accommodation is that the triumphant "holding" and "persisting" of Jacob have been displaced by the more tenuous, inconclusive, silent holding and molding of Milton. Even at the climax of this brief epic the fight remains unresolved; the two remain locked together (as Blake indicates), standing within "the streams of the brooks" (a phrase that reveals just how outlandishly confusing the natural categories of the scene have become).

To catch more precisely what is at stake in this sculptural dance, and in Blake's equivocal iconography of battle, I need to draw a somewhat larger circle. Blake, at his most extreme, seems in protest against whatever binds the idea of the human to anteriority, custom, and tradition, as well as whatever binds it to nature, the natural body, or organic perception, whatever binds the human to contingency and accident. He protests even more fiercely against religious ideologies that seek to rationalize that bondage as law or sin, or to transcend it at the expense of the human. He indeed demands—madly perhaps—that we reimagine such limits and such sublimations as self-created idols, blockages produced by our own terrified, self-defeating, and self-abasing imagination. These limits are ours, they come from us, we alone have lent them the power they have over us (rather than their being, as one might think, constraints imposed in part by a

world into which one simply finds oneself thrown, burdens for which no one but God or sin or biology can be blamed). This intimacy of our own powers with those of our imaginary enemy, this confusion of weakness and strength, however, means that escape must involve more than mere iconoclasm and more than a kind of abstract Gnostic negation. Escape also demands more than the kind of passive and resentful skepticism Blake assigns to the insidious destroyer he calls the "idiot Questioner" (*Milton,* book II, plate 41.12–20). For Blake, the potential of iconoclasm to give way to a subtler idolatry means that any form of skeptical "critique" must proceed by more elusive gestures of recognition and resistance, gestures that must acknowledge the fears that drive our flight from limitation. Such a critique depends on taking the risk of counterinvention, of generating a fiction that bears the burden of our resistance, even if doing so potentially brings forth another idol to the world. The scene in *Milton* is both an example and an allegory of this difficult demand. It shows us a human imaginer struggling with an alien blocking agent, a nearly dead god, a relic of the mind's wasteful work. But Blake has pictured that struggle as entailing both theft and gift. Milton's fight is a purgatorial sculpting, simultaneously a murder and an enforced "resurrection," which attempts to steal the dead god back into the still-problematic realm of the human, the bodily, the temporal. Facing down the facticity of biblical tradition itself, its power to wound or freeze by its orthodox blessing, Milton in this scene of wrestling also renounces the very violence against idols which that tradition so stridently enjoins. That is to say, the struggle with the stony god also breaks with the demand for iconoclasm, or tacitly insists that we remake iconoclasm in another form, joining making and marring in one.

Blake's depiction of Urizen's power recalls John Milton's own vision of his precursor Shakespeare as a petrifying wonder, something that "our fancy of itself bereaving, / Dost make us marble with too much conceiving."[34] Blake's echo of this text suggests that we could read the scene in *Milton* as an allegory of reception, an image of how a poet might humanize the petrifying body of a tradition whose very gaps have become a bony, dead letter, hardened furrows, rather than the soil of fresh invention. We can imagine that to the statuesque Urizen Milton's humble labor in clay will look more like a subversive defile-

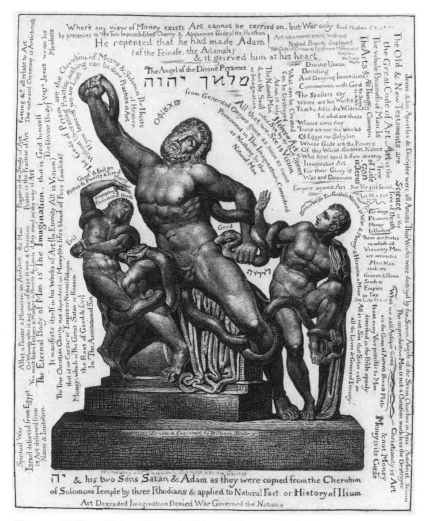

Figure 7. William Blake, "Laocoön" (engraving, c.1815). Courtesy Fitzwilliam Museum, Cambridge

ment, the spreading of so much alien, impure mud over a pure and purifying godhead. Milton's work would thus possess the satiric, anarchic quality of graffiti. We might recall in this context Blake's own remarkable reworking of the image of the ancient *Laocoön* (fig. 7), which takes the form of a series of polemical utterances scribbled mazily around the great neoclassical icon. The interest of this work

lies partly in its outrageous act of allegorical re-titling, which makes the sculpture into a copy of an originally Hebraic image of Jehovah with his sons Adam and Satan, all entangled in the serpentine illusions of natural fact and material war. But the engraving works more mysteriously insofar as it levels the solidly sculptural image and binds its forms to the more fluid and polymorphous domain of Blakean inscription and polemical epigram.[35] If the poet's revisionary graffiti do not make the statue into something wholly new, at least they can work to transform it, to heal as well as mar the prior image.[36]

Blake's narrative in *Milton* can feel like a desperate idealization, especially where it seeks to convert the original scene of Jacob's struggle and divination into something insistently humanizing, literally "anthropomorphic." And even taken broadly as an allegory of reading and writing, a picture of our relation to inherited tradition, of our struggle with anterior idols—even here there is much that remains both evasive and often unintelligible. Still, the grotesque, phantasmic specificities of Blake's text, even its dreamlike clumsiness of imagery, force us to see what can be staked on so ambiguous a battle. What does this fiction claim to reveal, to let us know? It tells us that the real idolomachy must take place in a limbolike state where the reified enemy cannot be simply broken or killed, since he is by turn stone, bone, clay, and flesh, at once idol, corpse, demon, animal, and automaton; that in this battle the gestures of giving life inevitably cross with those of giving death; that the reforming maker is caught in a deforming bondage to the creature he makes or masters; that the statue stalks the sculptor as much as the sculptor the statue; that the poet is changed by, if not assimilated to, what he beholds, shapes, and seeks to destroy. I offer Blake's text, then, as a stark example of the kind of conceptual and imaginative work the fantasy of the living statue can perform. As Blake employs that fantasy here, it suggests the mutual contamination, the shared genealogy of forms of work and change we ordinarily wish to keep apart.

You May
Touch This Statue

Some years ago, walking in a courtyard of the J. Paul Getty Museum, I was confronted with a statue of Venus, a modern copy of an original executed in 1814 by Antonio Canova. The figure stood directly on the pavement by the entrance to the classical sculpture galleries, without a pedestal and free of bars or velvet ropes, with something of the air of a guard or guide, though also a visitor. Now Canova's *Venus* is a curious composite. Its pose is based on a classical type known as the *Venus pudica*, a fully nude figure whose delicately poised hands hover in front of her breasts and genitals, marking rather than at all hiding the sites of her sexuality. But the dramatic attitude of Canova's statue recalls rather the Ovidian image of Diana surprised in her bath. The statue's hands, though positioned similarly to those of a Venus pudica, are clearly pressed against her so as to conceal her nakedness, while she glances sideways in search of an invisible, voyeuristic intruder. Histrionically vulnerable as the figure is, its stillness becomes a trope of surprise, shame, astonishment, and guarded exposure, rather than one of poise, self-control, and seduction. The statue's mimesis of shame indeed seems a strange joke about the *un*embarrassability, the unblushing candor, we expect of marble nudes. What I wondered while at the Getty was whether these things had influenced the choice of the Venus for the spot it occupied, since the figure was flanked by an official sign that read, "YOU MAY TOUCH THIS STATUE." The sign instructed visitors to let their hands enjoy the delicate carving, the polished surface, the nuances of

form and volume that might escape the eye. But the invitation also tied any pleasure or knowledge gained by touch to an implicit warning: that visitors exhaust their impulses to touch on this less valuable statue before entering the gallery proper. For there, among precious, mostly fragmentary relics of classical sculpture, touch was prohibited; there pedestals, bars, guards, museum rules, and a web of cultural taboos, were present to keep one back, restrain one's touch. The sign explained further, "ancient statues suffer . . . if you touch them."[1]

Perhaps one should not make too much of this. The display did risk inviting a more immediate, tactile knowledge of the sculpture and happily lightened the high seriousness of museum-going. But I recall that touching the figure, even the bare invitation itself, provoked a curious, mingled feeling of complicity and loss. For one thing, actual contact with the "real" surface of stone seemed to banish, or undo, the more labile, phantasmic sense of touch (with its minglings of tactile, visual, and even oral) that conditions our responses to sculpture. Also, one realized that the studied lifting of the taboo in the invitation to touch was only partial and opportunistic. No one was allowed to try his or her hand at graffiti or iconoclasm, to explore what knowledge of sculpture those acts might convey. I was struck by how readily the domain of touch could be literalized, desexualized, and deconceptualized, how the idea of touching the statue was made innocent of any fetishistic or necrophiliac coloring.[2] Perhaps the image of the threatened goddess registered the unspoken ambivalences of the situation, if only through her theatrical modesty. (I wondered how different the effect would have been with the statue of a male god, a hermaphrodite, or a half-bestial, half-human faun.) There was finally a certain comic forlornness about the statue,—an acknowledged copy, clearly marked as "inauthentic," stripped of the taboos that might grant it a greater aura of seriousness. It was more like a dress-shop mannikin, or like one of the enlarged, "living" cartoon figures that walk the utopic streets of Disneyland.

The best thing to do might have been to recall other encounters with statues. Could one imagine oneself as Winckelmann, who, in Walter Pater's words, "fingers those pagan marbles with unsinged hands, with no sense of shame or loss"?[3] Or Flaubert, who found himself passionately kissing Canova's "Cupid and Psyche" at a public

exhibition?[4] Or Leopold Bloom, who admires classical statues, and even fantasizes about their speaking, but also makes a trip to the vestibule of the Dublin Library to investigate whether the marble goddesses there have anuses like living, eating humans?[5] Could one imagine oneself as the dreamer in a poem by James Merrill, put to flight by the claustrophobic, frozen eloquence of a sculpture museum, thinking that "it began snowing because of the statues, perhaps"?[6]

I intend my anecdote as an entry into certain literary texts, but I might at least pause here to suggest the need for a more imaginative and precise analytic of the domain of touch in our considerations of sculpture. By this I mean at once the working touch of the sculptor, the touch of the viewer, as well as that fictive touch of which the statue itself may be made capable. We might begin by considering the different tactile qualities of certain materials, how they can be emphasized or transformed, how the traces of touch may be exposed or concealed in a particular work. We might go on to consider the different stories an individual artistic tradition spins around certain materials, not to mention the mythic as well as practical differences that attend carving as opposed to modeling. Equally interesting are the more elusive fantasies of touch that can be mobilized by works of sculpture, and how the way we touch a statue might differ from the way we touch a living hand, a wound, a skull, a hammer, or a keyboard, how touch registers or subdues their strangeness, makes use of them, translates one's knowledge and skill. We might even examine the parables of intellectual and moral *tact* that the idea of touching a statue can provoke. As a model, I think in part of Henri Focillon's meditations on "touch" as a term of aesthetic value.[7] For this critic, writing about the "life of forms" in artistic work, touch refers not just to something belonging to the artist's hand. Rather it names that site where the artist has awakened "form into substance, where substance has awakened into form"; it is the point of contact between inertia and action, the place where the artist's tool, in its violence or delicacy, has been itself transformed by what Focillon calls "the formal vocation of the substances of art" (something not simply inherent *in* those substances but also lent to them by the artist and by tradition).[8] But a study of sculptural touch might also appeal to certain

passages in Rainer Maria Rilke's book on Rodin, for example, his appreciations of the phantasmagoric, erotic energy of the sculptor's modeling techniques and his account of how some of Rodin's complex, if often fragmentary, composite sculptures seem to arrest in their passing the autonomous, unowned entities that emerge at the points where one living body touches another. Rilke also comments on Rodin's compulsion to model an endless number of small, separate hands, hands that are animated by an energy and even a peculiar subjectivity at once alien to and yet passing back into the hands of their maker.[9] The main interest of such texts, I think, is that they read touch not as a merely empirical thing, or as a metaphysical certainty, or as a guarantee of mastery or self-possession, but rather see it as an often volatile quantity shaped at a place where one's touch is at once one's own and not one's own.

At this point let me turn to Ovid's account of Pygmalion (*Metamorphoses* 10.243–97), pausing only briefly to suggest that it might provide a sufficiently speculative author with a basis for subtler genealogy of sculptural touch. This fable, which appears among a number of stories of tragic and erring love sung by the mourning Orpheus, is one of the urtexts in the history I am somewhat eccentrically tracing, and its inner difficulties become paradigmatic for those that follow.

Ovid describes Pygmalion's work on the statue, we should recall, as implicitly defensive and compensatory. His sculpture is the reflex of a misogynistic horror generated by the spectacle of the debauched Propoetides—in Ovid's tale, the first prostitutes, hardened, shameless, and unblushing women who deny the divinity of Venus, and whom the goddess "with small effort" turns to stone (a punishment "midway between death and exile").[10] Pygmalion's pure and perfect girl of ivory manages, as it were, to reanimate the sculptor's poisoned desire, which leads one critic to suggest a "perfect chiastic relationship . . . between the Propoetides who become stone and the sculpted ivory that becomes a woman."[11] For all her "modesty," however (a quality that in the text is half-ironically figured by the statue's immobility), this "snowy" girl can seem the double as much as the opposite of the petrified Propoetides, which suggests that we could read the sculptor's loathing of these latter as itself a defensive reaction

to repressed desire. The possible perversity of the scene is suggested more immediately, however, by the delicate comedy of the narrative that follows the sculptor's falling in love with what he has made.

Ovid praises the statue (conventionally) as a perfect imitation of life, the product of an art whose aim is to conceal art ("ars adeo latet arte sua" [253]).[12] Yet the narrative calls the bluff of such imagined sufficiency, since it shows us the sculptor vainly trying to humanize the thing, torn between his inchoate wish for its life and his skeptical knowledge of its lack of life. Parodying the rituals of the *Ars amatoria*, he speaks to it, woos it with gifts of shells, flowers, and birds, plants kisses on its lips; we are told that he imagines lending warmth to it, indeed that he touches it delicately for fear of bruising its skin. He also clothes the figure, drapes it with jewels, even takes it to bed with him. Ovid blurs his focus at this point, avoiding any explicit description of this contact of living and fictive nakedness, and hence modulating the impression of fetishism or necrophilia. But there is something no less disturbing in the way the text invites us simply to contemplate the weird, transgressive literalism of a statue's being taken down from its formalized repose on a pedestal and laid down stiffly, even painfully, on the softness of a bed; Ovid asks us also to consider the strangeness of inanimate, fictive flesh covered with real jewels and clothes, things that do their formal and symbolic work mainly insofar as they ornament, organize, and, as it were, make a statue of a living body. What is striking about the text here—part of what we might call its "realism"—is that Ovid's flat comedy also registers the inevitable, phantasmic appeal of the scene. The lures and fascinations, the terrors, homely frustrations, and fetishistic displacements of sexual touch emerge at the same time. The sign in the Getty asked that the form of an ashamed goddess be touched without shame (perhaps in the hopes that she could, like a ritual victim, take upon herself our desire and fear of touch). Ovid's text, by contrast, keeps in suspension many of the myriad taboos and fantasies that can be attached to touch, in a way that is both sympathetic and disenchanting.

Pygmalion's confusion or embarrassment in the face of his wish is perhaps what leads him, in his subsequent prayer and sacrifice in the

Temple of Venus, to ask only for someone "like" the ivory girl—though we are told that Venus knows what the sculptor "really" wants (the presence of the goddess thus registering a corresponding wish for some source of greater certainty about the strange indirections of desire, its problematic origins and fulfillments, which also entails a wish for a clearer sense of what "likeness" amounts to). The sculptor's very evasiveness, then, becomes an additional part of the ambiguous background against which we must view the transformation itself. One might say that Pygmalion wins his wish because of his "faith" in Venus, but both the faith and the gift itself may seem unstable, if not arbitrary.

The initial sign of animation is not a glimpsed movement, a responsive glance, or a murmur, but a sudden sense of the brittle ivory softening: "He kissed her, and with his hands also he touched her breast. The ivory grew soft to his touch, its hardness vanishing, gave and yielded beneath his fingers" (281–84). The vanishing of hardness is wonderful but also wonderfully overdetermined; it is at once a yielding and a breakthrough, at once a loss and a refinding of something lost before; it is both disenchanting and dizzying. The complexity of the wish fulfillments and erotic narratives that cross in this moment demand that we dwell on it carefully, that we find the right way of framing its seduction.

We should first acknowledge the space Ovid leaves open for a number of strongly idealized readings of the scene of humanization, though all of these are not necessarily compatible with one another. Considered broadly, the scene puts Pygmalion in the place of Prometheus, or Deucalion and Pyrrha (who resurrect mankind from stone after the deluge). The text has indeed been read as an essay on the artist's power to create autonomous life in what seems intractable, inanimate matter, implicitly linking that power to both divine and human love. (It is important here that Ovid himself added the explicit element of magic to the story of Pygmalion, a figure who in earlier sources is simply a king who fell in love with an ivory statue of Venus, a statue that remained a statue.)[13] The artifact's coming to life thus becomes a literalization of the dream of mimesis previously expressed only in the text's conventional hyperbole. Read against the

larger field of stories in the poem, this fantasy of the statue's soften-
ing might even seem to project the possibility of reversing the myriad
of other metamorphoses in which living beings are turned *into* stone,
whether through love, grief, terror, or jealousy—including such fig-
ures as Niobe, Aglauros, Echo, and Atlas.[14] The redemptive character
of the artist's work is further enriched if we take seriously its struc-
tural mirroring of the framing story of Orpheus.[15] The feckless,
slightly comic sculptor would thus take on some of the lineaments of
a priestly magus, his animation of the statue recalling the mythic
singer's charming of stones and trees (though without its tragic back-
ground), even projecting something like the successful recovery of
Eurydice from Hades. The statue's life would thus suggest the resur-
rection of someone who had died as well as the animation of some-
thing that had never lived at all.

We need to be alert, however, to the counter-wishes or confusions
of wish that emerge in the text; we need to register the presence of a
more potentially regressive, fetishistic, even violent element in Pyg-
malion's encounter, since such shadows are what help account for
much of the episode's fascination, as well as its embarrassments. We
might bring this out sharply by turning to a late nineteenth-century
rendering of the scene like that of Jean-Léon Gérôme (fig. 8), which
lends it a strongly phantasmic and allegorical character that at the
same time seems strangely literalistic, even pornographic. (The word
"kitsch," however compromised, may be appropriate here.) Or we
might remind ourselves of the allusive gloss on the Ovidian text
provided by the lines from Blake's *Milton* analyzed in chapter 4,
which mark a sense of simultaneous conflict and parasitic mutuality
in the interaction of sculptor and statue.[16] But even leaving aside such
suggestions, it is clear that there is something in Ovid's narrative that
inevitably unsettles any too "empedestaled" picture of the powers of
the human artist, as well as any supposedly stable economy of loss
and restitution. The wishes of art and the wishes of the body are just
too complexly intertwined here, even as we are reminded of how
much is still in danger of being lost (like Eurydice) at the very moment
of supposed restitution.

We can bring such conflicts out by examining a telling simile that

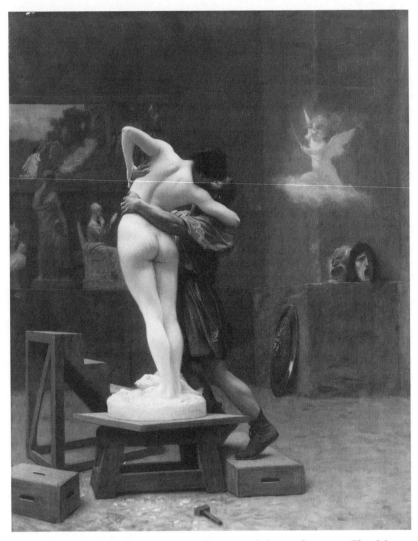

Figure 8. Jean-Léon Gérôme, *Pygmalion and Galatea*. Courtesy The Metropolitan Museum of Art, Gift of Louis C. Raegner, 1927

Ovid strategically deploys to characterize the statue's softening in Pygmalion's hands. Just when the statue is ceasing to be a statue, when it seems on the verge of becoming a desiring, responsive subject, Ovid writes:

subsidit digitis ceditque, ut Hymettia sole
cera remollescit tractataque pollice multas
flectitur in facies ipsoque fit utilis usu.
(284–86)

[the ivory] gave and yielded beneath his fingers, as Hymettian wax
grows soft under the sun and, moulded by the thumb, is easily shaped
to many forms and becomes usable through use itself.

With the lightest and yet most inevitable touch, Ovid reframes this
sexually charged moment. On the one hand, the simile suggests an
image of passive, entropic change, even though taking place under
the authoritative eye of the sun (that power which, we should recall,
tragically undid the artifices of Daedalus [*Metamophoses* 8.225–26]); on
the other, the transformation is compared to a form of change subject
to the conscious work of the hand, even though that work has no
stated aim and is indeed made to seem an end in itself.[17] The second
part of the simile thus effectively thwarts our desire for the image of a
breakthrough beyond art, for an ideal shedding of artistic ideals. The
idea that the statue can become human remains at the level of fore-
play, as it were. But at the same time—and this is part of its seduc-
tion—the first part of the simile renders the picture of Pygmalion's
magical artistry even more equivocal by yielding it to uncontrolled
forces from both within and without. The sexual coding of that "soft-
ening" ivory or wax is ambiguous enough, but Ovid's simile compli-
cates such associations by making us wonder about the different fig-
urative implications of carving and modeling. Moreover, in the
narrative following that simile, the working touch that signifies mas-
tery and use yields to a touch that abides in doubt, fear, exploration,
and experiment, responses that at least complicate our reading of the
pleasure we might imagine there.

The allusive domain of the episode opens up further questions. It
has been argued that the blush of the awakened statue evokes a well-
known topos in which the color of a blush or wound is compared to
the look of reddened and stained ivory.[18] Aside from the reiterated
confusion of the living and the artificial, what is important here is the
dense genealogy of this image. Homer employs it, for example, to

describe Menelaus wounded by Pandarus, the blood on his thigh being said to resemble an ivory cheekpiece for a bridle, stained with purple dye by Maeonian women—a king's treasure and horseman's glory (*Iliad* 4.141–47). This coloring, we could say, bespeaks nobility, craft, and heroic fullness of life. But there is also a tacitly erotic character in Homer's simile, something confirmed and extended by its later, allusive use in Virgil's description of the blush of Lavinia when her mother promises her to the impatient Turnus (*Aeneid* 12.64–69). Here the image of reddened ivory tropes a blush of sexual fear that moves desire mingled with rage, a blush that functions also as a displaced image of defloration.[19] We might even point to other critical blushes in the *Metamorphoses* itself, reddenings that can speak of the violence and frustration that mingle with desire, of anxieties over loss of control, and yet also about a kind of resistant mastery—Narcissus striking his breast in despair (3.480–85), Diana glimpsed by Actaeon (3.183–85), or the fearless Arachne blushing at the sudden unveiling of her rival Athena (6.45–49). Such scattered topoi, microscopic as they may seem, are yet part of a silent system of glosses, even aspects of what we might call the text's historical unconscious. The figurative trajectory at such allusions and images may be oblique; they can, however, speak for wishes that emerge especially at the point when other wishes seem satisfied, or for fears that cannot be excluded from the field of wish-fulfillment, fears that may indeed be the things that drive such wishes.

To pursue the text's resonances more fully, we would have to place this single metamorphic narrative in the light of other stories of misdirected or blocked desire in Ovid's poem. The tale of Narcissus provides the most obvious pendant, tracing the darker consequences of falling in love with a self-created image. The story of Salmacis and Hermaphroditus also comes to mind, as does the story of Pygmalion's own grandson and great-granddaughter, Cinyras and Myrrha, whose incestuous union can be read as a possible, implicit allegory of the sculptor's miraculous encounter with his "creature."[20] The densely worked but often promiscuous mode of combining narratives in Ovid also seems to demand that we read this apparently benign transformation against other metamorphoses in the poem—to take a random sample, Lycaon turned into a wolf, Hyacinth into a flower, Echo into

a stone, the ashes of Memnon into a new species of bird—changes that can seem by turns arbitrary and emblematic, redemptive and punitive, progressive and regressive, both the fulfillment and the loss of a human identity. In examining the Pygmalion narrative in the light of such texts, we would have to consider especially the effect of seeing so many living, human bodies turned into bodies or objects that are not human, transformations that nevertheless displace the more troubling "transformation" of human bodies into corpses, as if they would convert the losses of death into a strange adding or extending of life.[21]

How we regard these strands of association, of internal and external allusion, how we weave them together or use them to *un*weave other weavings, how we understand the wishes they animate or disperse—this will be a fundamental test of our critical tact. We can emphasize the strains of violence, the fetishism, and the curious materialism called up by the story of Pygmalion as Ovid tells it, or else find in these the basis of a more subtly romantic reading. The *Metamorphoses* demands such a rigorous playfulness as a general rule, of course. But such an activity gains further weight if we recall the exemplary character of the Pygmalion story for other writers after Ovid, its use to serve as a picture of the origins of desire, as an allegory of mimesis, as a frame for sexual satire or a meditation on the nature of the real, as a story about the possibility of education and inward transformation. Here I think it is the very overdetermination of Ovid's narrative that accounts for its permanent fascination. One obvious lesson, at least, is found in the difficulty of prying apart the elements of art and eros in the story, its lessons about art as both the object and vehicle of our wishes. It suggests how much the divigations of erotic fantasy haunt their more refined, aesthetic sublimations, but perhaps also how much anything we want to call sexuality or eros is bound to the domain of fantasy itself, to its literalizations and ambivalences, and how much the meaning even of intimate physical contact is conditioned by a fantasy of the body.

At the risk of skewing our perspective on Ovid's text, I want to turn to a distinctly minor passage in the history of its reception, specifically a pair of glosses to be found in George Sandys's mythographic

commentary to his 1632 translation of the *Metamorphoses*. Idiosyncratic and reductive as they are, Sandys's remarks on the Pygmalion story may give us a stronger feeling for the questions and figurative conflicts Ovid's text can provoke, its continuing power to trouble any too idealistic reading of Pygmalion's magic.

In Ovid, the statue blushes at Pygmalion's kiss; it is a sign of her life but also a sign of continuing, if transformed, resistance to his courtship. Sandys's first gloss, taking the part for the whole, suggests that the entire narrative of Pygmalion's gift could be read as a mythic account of the event of blushing, a mythicized picture of a modest woman's "humanizing" response to ardent wooing. This playful naturalizing or domestication of the magic is not alien to Ovid, perhaps. But it is also clear that, in his reading of blushing, Sandys is eager to purify what we have seen is a fairly ambivalent bodily sign (as telling an index of the conflicts of fallen human desire as the unwilled "rebellion" of the sexual organs was for Augustine). He tries to leave his studied praise of Pygmalion's statue uncontaminated by the confusions that Ovid invites. Hence he asserts that in this scene, "the Ivory express[es] the beauty of her body, and her blushes the modesty of her mind" (blushing, after all, being the thing lacking in the hardened Propoetides).[22] This approach in effect makes the blush into a kind of harmonious, natural eloquence, a transparent revelation of mind rather than a color that leaves the mind's responses all the more mysterious. We might want to say, by contrast, that this reading really conceals the potential terror of that blush, or else conceals a deeper fantasy of a wished-for male power to *cause* blushes, to force the exposure of desire—though the Ovidian blush might also show us an image of the *statue's* embarrassment at being treated as a living body.[23] Equally significant is that Sandys, in his attempts at constructing a moralized blazon of the statue, is forced to collapse together the before and the after of its metamorphosis. That is, he must speak of the awakened figure as if she were still half a statue, one whose ideal character is marked simultaneously by an artificial and a "natural" sign, by ivory and blood. There is nothing strange about a Renaissance poet's bringing a magical pagan narrative back to the domain of the physical body, even as he invests it with a purified social moral. What is interesting is how Sandys's gloss avoids dis-

covering in the awakening statue any awakening of sexual desire, even as he keeps his picture of that wakened body tied resolutely to the (idealized) domain of human artifice.

Sandys's second gloss, however, implicitly challenges the sentimental rationalizations of the first reading. It places alongside his picture of female modesty a more ironic, if still moralistic, emblem of masculine frustration, one that grotesquely disenchants the figure of blushing, "historicizing" Ovid's myth, as it were, even as it restores to the narrative a curious element of miracle. Sandys suggests that Ovid's text takes as one of its sources a story found in Pliny and Lucian, among others, about an aristocratic youth from the city of Cnidus, who fell in love with a statue of Aphrodite sculpted by Praxiteles. Sneaking by night into the inner sanctuary of the temple where the statue stood, the youth "imbraced it strictly in his armes, warming the cold marble with his burning kisses." Though in this story the statue *does not* come to life, the violation of the sacred space and stone is marked by a more ironic supernatural sign. For the youth in his ardor is said to have "so contaminated it with his lust, that the stains ever after remained, as a monument of his impiety."[24] That alien stain here replaces the coloring that had marked the possibility of some interiority in the statue, however contested or opaque, or bound to external occasions; that stain does not bring the statue to life, indeed it reinforces its lifelessness, yet nevertheless it magically transforms the statue as a testimony of a different sort of miracle, recreates it as a different sort of monument.

In Pliny this kind of tale can typically both mock the excesses of popular religion and celebrate the mimetic powers of artists (though it works less benignly than the famous story of birds pecking at the grapes of Zeuxis).[25] But placed together with the blushing gloss, it suggests other issues framing the fantasy of the statue's animation in Ovid. It is too simple to say that Sandys's quasi-historical anecdote points to a truth about the encounter that the Ovidian text represses. Still, the paired glosses do suggest that the traces of desire that magically color the statue in the fiction, and that overcome its status as mere artifact, exist mainly as substitutes for, or denials of, a kind of staining associated with fetishism and frustration (one that emerges moreover from a site external to the statue itself). The stain of the

second comment disenchantingly doubles (rather than simply parodies) the blood of the blush described in the first; the latter sign of animation marks the loss, blockage, or misdirection of desire, rather than the achieved grace of human response. It suggests how little the shape of that response may coincide, if at all, with the desire that fantasizes and provokes that response.

Late-medieval and Renaissance poets reveal a complex fascination with Ovid's story. It provides a frame for tracing their often equivocal relations with the domain of artifice, a mythic vehicle for their fantasies of perfect mimetic mastery, even an image of their attempts to revive a dead and frozen past.[26] What is striking is how often such writers' appropriations of the myth, like Sandys's, play subtly over Pygmalion's disappointments. They stress the melancholia as well as the sense of guilt, perversity, or fetishism that attend the sculptor's obsession, dwelling on the blocking or botching of the metamorphosis, or linking the idea of animation with the most equivocal of tropes or fictions. Jean de Meun's retelling of Ovid's story, just before the climactic scene of the *Roman de la Rose,* is exemplary here. The narrative fills a 400-line digression, spurred by the vision of a beautiful statue in a tower of the castle of the Rose into which the company of Amour is about to break, a statue itself described as a kind of gatekeeper and which is also a lock through whose aperture Venus shoots an arrow.[27] In this text the account of the actual awakening of Pygmalion's image is curiously flat, however, even disenchanting. When the statue awakes, the sculptor is afraid for a moment that a phantom or demon has entered his image, but this fear is quickly, rather blithely, answered by the statue's reassurance to him that she is neither of these but simply his *ami.* What the narrative is most intent on elaborating is rather the phase *preceding* the event of animation, the dead statue's provocation in the sculptor of a "suicidal madness" in which he endlessly clothes and reclothes her form in exotic stuffs, plays a mad array of instruments and dances before her like Amphion or Orpheus, even exchanging rings with the image. It is a solipsistic ecstasy in which he does not know (refuses to know) whether she is alive or dead. The narrative entails among other things a travesty of the rituals of both courtly love and Christian marriage,

but the deep fascination of the scene, I think, is in its paradoxical mastery of frustration. The picture of Pygmalion's feeding on his own hovering doubts, for instance, and the account of his reiterated attempts to humanize the statue through the metonymic "life" of human clothing, make one aware of the fragile, inevitable means by which desire is kept alive even by a dead image. It is a desire bound ineluctably to the subterfuges of human fantasy, and yet such subterfuges appear as defenses against both the death of desire itself and its absorption by a static narcissism.[28]

The precarious position of this artist figure is investigated more ruthlessly in the work of later poets such as Petrarch, and others after him, in whom the trials of Pygmalion point implicitly toward the compromised substance of our own romanticisms and modernisms. Poets in this tradition, we could say, endlessly reimagine and relocate the resistant stoniness of the Lady who provokes their poetry, "la dura petra / che parla e sente come fosse donna [the hard stone, that speaks and feels as if it were a woman]," trying at the same time to stave off the reflexive petrification of their own voices.[29] It is a poetic mode that indeed exploits the pathos of a voice or a text that emerges out of that very petrification, out of the loss or silence, the combined feelings of exile and entrapment, imposed by the pursuit of such a resistant, yet often absent or illusory object of desire. One critic has asserted that the muse of this poetry must be recognized as Medusa—read not as the face of inhuman chaos but as the petrifying, seductive face of human artifice and fantasy; she is a muse who presides over texts that know little besides the demands of their own fetishistic invention, that are driven by a solipsistic aesthetic desire that seeks little or nothing beyond itself.[30] But what is stunning are the peculiar if also equivocal blessings made possible by that disenchanted and disenchanting muse, the ways in which this tradition strives to convert experiential loss into poetic gain. The marmoreal body of Pygmalion's statue becomes the substance of poetry. That body often remains imperious and stonelike, a figuration of death and mourning, a divisive shadow, even in its fragmentation.[31] Yet it can also become the most seductively mutable, resiliant, and paradoxically humanizing of materials, provoking ever more subtle explorations of the domain of desire, even as it suggests by contrast the

possible idolatry of any vision that seeks to transcend that domain and that material.

In composing this book, I have often considered working out a rough taxonomy of the different "signs" or tokens of recognition by which various texts mark the animation of a statue. It would be a heterogeneous list at best: an ambiguous reddening; a monitory voice, a clang or hum emerging from an unmoving sculpted face; a soundless, impassive nod; an equivocal glint in what must still be a dead, artificial eye; a trace of dust or blood of uncertain origin on a bronze hand; the closing of the hand over a ring idly placed on its finger; a beckoning wave; a shift of angle on a pedestal—signs that would tend further to be glimpsed uncertainly, subject to conflicting reports. To list them this way gives a melodramatic, as well as a trivializing impression, of course. For one thing it isolates any individual sign from the larger network of signs and narratives that will lend it both weight and intelligibility in any given work. But the list does convey one important general thought: how fragmentary such signs of life can be in these texts, how contingent their sources, how subject to doubt, and how incompletely any one sign will signal a full dimension of human life. That is part of their uncanny magic, perhaps, that the chosen sign of life yet stands in partial isolation from the conventional orders of both the living *and* the dead. If the moving statue is a prime example of what Angus Fletcher calls a "daimonic agent," it is because the signs of a statue's life tend to be imperious synecdoches, parts that at once evoke a larger whole and usurp our view of it.[32]

(There is often a peculiar fascination with signs of life tied to the domain of touch. But it is the illusions and self-alienations of touch, rather than its apparent claim to subjective certainty, that many of the stories dwell on. Touch often seems to divide human and statue as well as connect them. This ambiguity in touch makes for some of the comedy in Ovid, and later in Jean de Meun—whose Pygmalion, thinking the statue pliable and warm for a moment, finds that he is touching himself rather than the ivory.[33] It is public speech as well as silent touch that the gathered witnesses demand at the end of *The Winter's Tale*. The idea that physical touch might offer some "moment

of truth" is played on in various versions of the Don Juan legend, where the hero's fate is often marked most critically at the moment when he takes the "stone guest" by his stone hand. But in such case, the "truth" is obviously a highly figurative one, a moment of trial and crisis, the treading of an eschatological threshold. Even stranger is the slightly satiric, epistemological crisis provoked by touch at the end of Jean-Jacques Rousseau's *scène lyrique Pygmalion:* here the statue of Galatea suddenly awakes, and finds by touch that she both knows herself ["C'est moi"] and comprehends the exteriority of material things like blocks of marble ["Ce n'est plus moi"]; yet curiously, in touching her solipsistic creator she finds only more of herself ["Ah, encore moi!" she sighs].)[34]

Perhaps because such signs of life are rarely quite proper to a lifeless statue—assuming we know what *is* proper to a statue—they tend to have something unnatural, slightly scandalous, or arbitrary about them. Miraculous perhaps, they are for the statue also a wound or violation, rather than a happy restoration of a dead thing to life or human health. Traces of animation in a sculpted body may be disturbing, among other things, because it is the statue's lack of animation that partly accounts for its existence in the first place. But the disquieting effect of such signs may also derive from their reminding us by comparison how volatile the signs of life in actual living persons often are, how uncertain their occasions, how compelled, compulsive, and mechanical their presence; their strangeness as well as seduction depends on a sense of how merely conventional the meaning of such signs can be, how easily they may be misread or allegorized by others. (Note in this context that almost any displacement or idiosyncratic view of a statue can lend it a kind of virtual animation, at least by conveying the sense of some intention at odds with its original situation.)[35] This idea might by extension make one think that the local scandal of a statue that comes to life can be precipitated by, even as it can provoke, some other disorder, breach, wound, or scandal in the fabric of the world. (Though statues that stay in their places, that refuse to speak or move, are not necessarily less scandalous, of course, given what such images, in their lack of animation, may thereby block or reduce.) Still, if the animation of the statue is a form or sign of a scandal, a wound in our picture of the world, that anima-

tion is also a means by which such a scandal may be concealed and explored, a way for the wound to be both reopened and healed.[36]

The sign of life that lends animation to a statue in many cases takes the explicit form of a wound; it can look like a thing that violates, mars, or stains the statue. The idea of a wounded, bleeding, or stained statue indeed has a complex history that I cannot even begin to map out here. Aside from its (often covert) emergence in Pygmalion texts, we could point to what remain among the most resilient, uncanny, if also clichéd sorts of miracle narrative in church tradition—accounts of crucifixes or images of the Virgin that are seen to bleed, weep, even sweat, or else produce some more anomalous oil or fluid from their wounds and eyes (substances that we might think of as forms in which such images speak, tears and blood that can seem at once human and inhuman, that can acquire the power of miraculous balms as well as being signs of pain).[37] The idea of a bleeding monument can also be found ramifying through a play such as Shakespeare's *Julius Caesar*, most clearly in Calpurnia's dream of Caesar's statue spouting blood like a fountain (an incident taken from Plutarch), but also diffused through a covert pattern of images in which Rome is fantasized as a population of marble men, alive enough to tyrannize, plot, and kill, to carve themselves and others, but whose blood seems to flow only in being spilt.[38] Such paradoxical images are also central to the phantasmic cosmos of early Fascism, as Klaus Theweleit has argued, especially insofar as the Fascist ego forms itself around the image of a statuesque, purified selfhood that is yet threatened by contamination from the inside or outside, a hardened collective ego always in danger of being stained by the flood, blood, or mud of history, sexuality, and femininity, or by its own psychic and moral ambivalence.[39] Eccentric as it might seem, the idea of a bleeding or stained statue is in fact exemplary of stresses that shape many versions of the animated statue fantasy. I end this section, then, by looking in detail at a late, and particularly complex, employment of this motif, a text that offers a kind of limiting case for understanding the issues raised thus far.

My text is a prose poem (dated 1930) by Francis Ponge titled "La Loi et les Prophètes." Generically this brief series of fragments might be

classified as an apocalyptic or millennial vision, a picture of things to come, with accompanying exhortations to sinful and virtuous listeners. Yet it is at best a fragmentary, even insouciant apocalypse; it implicitly resists apocalyptic's sublime assurances and secure condemnations, its radical visions of renewal or fall, its ironic voicings of mourning. Here is the opening "vision" of this curiously utopian text:

> "Il ne s'agit pas tant de connaître que de naître. L'amour-propre et la prétention sont les principales vertus."
>
> Les statues se réveilleront un jour en ville avec un bâillon de tissu-éponge entre les cuisses. Alors les femmes arracheront le leur et le jetteront aux orties. Leurs corps, fiers jadis de leur blancheur et d'être sans issue vingt-cinq jours sur trente, laisseront voir le sang couler jusqu'aux chevilles : ils se montreront *en beauté*.
> Ainsi sera communiquée à tours, par la vision d'une réalité un peu plus importante que la rondeur ou que la fermeté des seins, la terreur qui saisit les petites filles la première fois.
> Toute idée de forme pure en sera définitivement souillée.
>
> "It is less a matter of knowing than of being born. Self-esteem and pretension are the principal virtues."
>
> The statues will awake one day in town with a gag of cotton gauze stuck between their thighs. The women will tear theirs away and throw them into the nettles. Their bodies, which used to be proud of their whiteness and of their being without issue twenty-five days out of thirty, will show off the blood as it flows down to their ankles; they will show themselves off *more beautifully*.
> Thus, by the display of a reality a little more important than the roundness or firmness of their breasts, all will sense the terror that seizes little girls the first time.
> All idea of pure form will thus be definitively soiled.[40]

Let us say that these awakening statues—citizens of what may be a necropolis—are apparitions of morning, the opposites of those supernatural creatures who vanish or turn to stone at dawn. It is yet a rather strange picture of such waking up, such a reentry into the world, and not merely because there is no visible enchanter. The surprising thing is that the statues' return to life, their release from

stone, is marked simultaneously by a limitation, by the discovery of a "gag"—a thing that doubles or uncannily supplements the kind of blockage or silencing we might otherwise figure by the image of a silent, unmoving statue. That discovery provokes a further, no less ambivalent trope of their awakening, however—the casting of that gag into the nettles. This act in part mimes an apocalyptic tearing of the veil, or suggests an oracular breakthrough; but it also seems apotropaic, a way of preempting any violence against these idols originating from a source beyond them. In that sense, this scene possesses aspects of both iconoclasm and idolatry. More important, the most visible sign of life, the ungagging of that *issue*—which we must read as a figure of unblocked, unsilenced speech—acts most basically as an obstacle to purification, the statues' resurrection thus entailing a subtle kind of insurrection. What is spoken or "written" by these statues, the figure of their conjured life, is, again, blood. It is not the blood of blushing, however, or the blood of a wound, the blood of modesty, martyrdom, or defloration. It is a blood of sexuality and generation, a sign of fertility, but also a blood that is useless, supplementary, dead, anything but a figure of "essence." It is a tabooed blood, blood to which humans are indebted, and of which they can yet be afraid, a blood ordinarily concealed and discarded. This blood is, we might say, the corpse of blood, the figure for the corpse that is inside, that gives life to, the statue, but that has here broken out of its tomb. Among other things, it makes this community of ironic Galateas take on something of the unsettling aspect of the Medusa.[41]

A friend once suggested to me that the idea of a statue's coming to life suggested to her a phantasmagoria of giving birth—that it figured the traumatic emergence of one life from another—rather than an image of the giving of life to art, or an image of the conjuring in another of desire or shame.[42] If such an intimation can be found in Ponge, however, it appears only as it is pushed to a severely ironic limit. The new life of these wakened and bleeding statues (the *naissance* that is a trope for their *connaissance*) emerges under the image of new life missed, or wasted. Their new "law" emerges under the image of law and taboo transgressed.[43] Their revisionary "beauty" emerges under the signature of staining, disfigurement, and defile-

ment (a process that entails as much the staining of an idea as of a body). The pretension of these statues is, as it were, their lack of shame (like that of the Propoetides in Ovid). In their silent speech the statues become self-transgressive if not self-wounding, scandalously unshameable, perhaps even *un*touchable. This is a vision of what the statue's alienating self-expression, and its disenchanting magic, amounts to.[44]

The flow of blood, however, is only one, partial trope of the statues' life or speech. For the rejected "gag," which seems to appear or be discovered only at the moment of the statues' awakening and is cast away into a barren and thorny field, also represents their words; the piece of gauze marks the uncanny event of each statue's regained life as readily as the bloody *issue* that it stanches—though it is a life that entails participation in an explicitly nonorganic order. As such, then, the poem asks us to conceive of a possible animation in the statue that at once creates, blocks, defiles, and casts out language, a mode of speech that at once stains and silences words, even as it is something that may itself be rejected. We might recall here a contemporary text in which Ponge locates his motives for writing in an almost suicidal disgust with the words we use, the words that inhabit and even silence us. Such words can take on the look of dead public statues, brittle, monumental carapaces, enlarged and abandoned fragments of the human skeleton, but Ponge also describes them as a collection of old rags fouled from being passed from mouth to mouth.[45] The statues' complex gesture of casting out, unblocking, and staining might thus give us an image of the poet's paradoxical effort to "speak against words," *parler contre les paroles*, to resist their ability to silence us. "There is only one way out [*une seule issue*]: to speak against words. Drag them along in shame to where they lead us, and there, they will be disfigured. There is no other reason for writing."[46] As this suggests, such a project depends not on purifying inescapably contaminated words, or on turning against them one's own literal silence, but rather on finding words that acknowledge the impurity, muteness, and failure of the word, and yet reanimate dead cast-out words by finding in them traces of an utterance not yet heard, not yet inevitably silenced, and yet desired (even if it is something that scandalizes our ordinary pictures of what human utterance looks like).[47] If

we need an indication of the uneasy, self-wounding character of the poet's involvement in this process, we might find it in the fact that Ponge's own name is present to us most markedly in the gag of "tissu-éponge" that these living statues have in fact torn away.[48]

It is hard to know how to read the injunction, the "law" or oracular utterance, of these statues, assuming it is that; hard to know whether it represents a human voice, and if so whose, much less to know how we might respond to its call, or consume it. We cannot easily steal a lesson from this minor apocalypse, with its odd, resistant balancings and equilibriums, or know for certain whether we are to see these statues as, say, inspired prophets or whores of Babylon. The work of the poet proceeds by a complex, vital undoing of purities, such that we even wonder what it would be like for any idea of perfection to be "definitively soiled" and who would be there to judge that. Herbert Marks writes that this text suggests "at least two (ethically opposed) ways of parsing the double signature of the statues' life: bleeding statues are wakened representations, or wakened statues are bleeding representations."[49] That is to say, as I read this enigma, the statues show us either the life images have for the deluded idolater, who may think after all that images can awake, who finds testimony to that wish even in the troubling miracle of their blood; or they show us the life the statues have for the skeptical iconoclast, even the skeptical poet, who sees a wound in the awakening of a statue. He sees, that is, a disfigurement, a miscarried (if inescapable) wish in the very attempt to go beyond the limits of representation. It is difficult in practice, however, to keep these two poles from contaminating each other. Describing "what happens" in this text is a trial, since in the poem's doubling of awakening and bleeding, in the statues' casting out of their gags, and in their aggressive display of their stains to an undefined future public, the reader finds an image of awakening that is scarcely recognizable. That image outrages our conventional certainties about the meaning of that diurnal event, and the wishes that can be attached to it. Even the sense of loss or disenchantment that often attends our waking has been here rendered so uncanny that those words scarcely seem adequate. It is tempting to say that these are simply statues that awake *within* a dream. But that itself would be a purification and an evasion. To begin with, we cannot be certain of

who the dreamer is and what the purpose of his or her sleep would be, what kind of ethical life is being lived in such dreams. (What dreams do we imagine statues dreaming?) Also, this particular dream seems eager to convince us that it is more than "sleep's faded papier-mâché," that it might be "like a new knowledge of reality."[50] The poem asks that this dream be carried whole into the light of day, into some daylight that, like the sun on the stone figure of Memnon, can bring a statue to life.[51]

Resisting Pygmalion

In his life of Michelangelo, Vasari transcribes a brief epigram by Giovanni Strozzi, written in praise of the statue of *Night* in the Medici chapel (fig. 9), presumably about the time of its unveiling in 1544:

> La Notte, che tu vedi in sì dolci atti
> dormir, fu da un Angelo scolpita
> in questo sasso; e, perché dorme, ha vita:
> destala, se nol credi, e parleratti.[1]

Night, which you see sleeping in such sweet attitudes, was carved in this stone by an angel; and because she sleeps, she has life. Wake her, if you don't believe it, and she will speak to you.

The wit of the lines is subtle—the play on *atti* (which can refer to acts and motions as well as poses or attitudes), the relegitimation of the artist's given name and quasi-divine power, the Keatsian deduction of life from the mimesis of human sleep, the teasing of the viewer's skepticism. The final line points to a wholly conventional aspiration of Renaissance aesthetics, echoed in the praise of the statue of Hermione in *The Winter's Tale*: "They say one would speak to her and stand in hope of answer." But we need to be careful in weighing such hyperboles, whose claims, as David Summers notes, could be "both serious and consciously removed, artificial, ironic."[2]

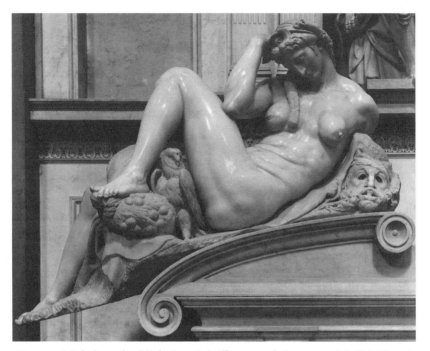

Figure 9. Michelangelo, *Night* (c.1524). Florence, S. Lorenzo, Medici Chapel. Photo by Ralph Lieberman

Strozzi is as concerned with displaying his own literary skill as with "reading" Michelangelo's statue. So it may seem excessive to try and fit the argument of these verses too closely to the technical terms of Italian Renaissance art theory. Still, I think it makes sense, as Leonard Barkan suggests, to catch in these lines some echo of the period's large theoretical project of securing for the visual artist a power—at once technical, imaginative, and intellectual—to produce realizations of essential ideas or metaphysical motions in his work.[3] In such a case, the virtual life of the work might be seen to inhere less in its brilliant illusionism, its perfected mimesis of visible nature, than in the establishment of some link to a potency shared by the imagination of the artist, the processes of nature, and divine creativity. For Michelangelo in particular, as David Summers has argued, the work of the artist occupied an often troubled space of negotiation between what might seem the contingent realms of human fantasy, design,

and rhetorical invention and the essential forms of natural and cosmic order, allowing links between inner and outer reality, eros and reason.[4] (Hence, perhaps, Strozzi's comparison of the statue to the work of an angel.) It was partly in relation to such a desired power that the diverse arts of sculpture, painting, and poetry fought out their always unsettled claims to excellence and superiority. Such a "fight" was in fact formalized in the Renaissance discourse of the *paragone*—which took the shape of critical debate over the relative perfection of the arts, especially painting and sculpture—but we can see it at work even in the slightly contentious, implicitly agonistic praise of a poem like Strozzi's, which suggests that Michelangelo needs him as much as vice versa.[5] Hence, even if we take his hyperbole as largely conventional, we should examine closely how it represents the more than merely formal life of a work of sculpture, what it suggests about the desire for that life.

The fact is, for all its careful wit, especially its paradox of sleeping life, the text's invitation to awaken the statue seems a rather soulless thing, especially when this statue is one whose sleep seems so fatally necessary, the inhabitant of a chapel itself so full of half-awake, half-dormant effigies dreaming of death and resurrection. Michelangelo himself answered Strozzi with an epigram that sharply calls the bluff of the latter's conceit, lending voice to the statue—that voice which Strozzi merely promises—but only so as to silence those who would speak to her:

> Caro m'è il sonno, e più l'esser di sasso,
> mentre che 'l danno e la vergogna dura;
> non veder, non sentir m'è gran ventura;
> però non me destar, deh, parla basso.[6]

My sleep is dear to me, and more dear this being of stone, as long as the agony and shame last. Not to see, not to hear [or feel] is for me the best fortune. So do not wake me! Speak softly.

The statue speaks in a fiction of voice heard above its sleep, like the ghostly voice of an epitaph that enjoins our silence and reflection. With a certain stoic pathos, the *Night* insists on its right not to be

awakened, not to stop being stone, speaks against the theft of both its sleep and its silence. The poem sets up a kind of taboo, demanding a more than aesthetic piety from the viewer, linking our consideration for a work of art to the sympathy we might feel for the invisible pains of a sleeping sufferer. To transform the silence of the statue in this way might perhaps seem an opportunistic trick (like Keats saying that he does not want merely audible sounds from his Grecian urn, which he cannot have anyway, only silent music). But the lines point beyond the bare imitation of natural sleep to something more profoundly paradoxical, for they conceptualize the statue's situation not as sleep but as "l'esser di sasso," the state or the being of stone, a kind of life-in-death, a wished-for but bitterly held oblivion. Michelangelo gives the statue a voice and finds an intention to back that voice, but in a way that cancels both the statue's own speech and the speech of others. The voice points to an emotive core, a self sensitive to inner and outer events, which yet emerges most forcibly in that it asks for a hardening of that core, the closing down of sensation and consciousness, a retreat back into stone, but a stone transformed. The statue's senselessness becomes not merely a given fact of the material, nor even a terrible fate, but a thing desired; it is a fortune, a blessing, a gift, an escape from duress, though one that seems fragile, easily disturbed (as the domain of night is elsewhere described in Michelangelo's poetry).[7] It is as if the statue itself—containing not a corpse but a thought buried alive—were as liable to being violated as the crypt on which it so precariously sits. The fiction of animation thus involves both a negation and a stark acknowledgment of the stillness and opacity of the statue. The silence that Michelangelo lodges in the statue forces us to reconsider its statueness, to reconsider how the statue serves as a figure of human existence and its varying silences, indeed as a mask for the sculptor himself, who makes of the statue the site for his lyric "I." The poem frees us from being too easily enchanted by the idea of a mere mimetic success, whether the stone is imitating a state of waking *or* sleep.

One might see a certain reduction, or a measure of sentimentality, in the quatrain's way of providing a rationalistic genealogy for the statue's situation. This attempt to devise a subjective rationale for its stillness and fictive sleep might remind us of the problematic way

Freud tries to naturalize and narrativize the ambiguous pose of Michelangelo's *Moses* by giving it a detailed psychological prehistory, reimagining the man-statue's prior motions in a series of drawings that can seem literalistic and strangely kitschy (fig. 16; though here too, the statue's immobility is justified by being read as the image of a successful repression, a burying of emotion in opacity).[8] We know that the quatrain, probably written in 1545, comes as much as twenty years after the statue itself was completed, and it has been suggested that the statue's protest is tacitly directed (like the accusations of a pasquinade) against the tyranny and corruption of the Medici dukedom, whose restoration in 1531 brought down the briefly revived Florentine republic, confirming the sculptor's decision to live out his life as an exile in Rome.[9] The poem would thus be Michelangelo's way of throwing his voice back into a political sphere he could no longer inhabit, letting a stone child speak for him in his birthplace. Any aura of inwardness or protest or shame the lines lend to the statue, however moving, would thus be a belated imposition on the statue, cutting it free from its place within the chapel's more systematic iconography of life and death, reflection and action. This iconography, we should add, reflects a clear *idealization* of the Medici rule. An early sketch for the tomb statues in fact contains lines in which the figures of *Day* and *Night* complain mournfully that the order of time has been disrupted by the death of the Medici princes Giuliano and Lorenzo, who are buried in the tombs.[10]

In order fully to weigh the claims of this epigram, one would have to consider the many alternate ways in which we might construct a fiction of the inanimate statue's life, might lend it a voice, a thought, an inner project or *concetto*. At the risk of conjuring up an array of fairly incompatible figures, let me make a few suggestions in this regard. Looking at the statue, we might suspect that this personification of Night in the synecdochic form of a sleeping woman might dream of other things than shame and punishment. Other dreams are at least suggested by the blank-eyed, phallic owl set between her legs; by the grotesque, leering, strangely animate satyr mask behind her back; and by the garland of poppies on which she rests her feet.[11] These and other details, such as the drooping head and the hand she holds against it, might indeed suggest that we could read the figure

as a type of Melancholia, with all of the troubled interiority that character could imply in the period—its strange, often ecstatic detachment from sense experience, its intensified self-consciousness, its susceptibility to feelings of frustrated power and desire.[12] The figure's weary yet still distressed and agonized form, her distended abdomen and breasts, also testifies to the history of a different "interior" life, the life of a body that has brought forth and nourished other bodies, even if it is now barren. Night, Michelangelo wrote, for all its poverty and vulnerability, is the sacred place of man's "planting."[13] Shifting to larger formal dimensions, we might argue that any idea of the interior life of *this* statue is shaped by its silent dialogue with other statues, most immediately those in the chapel itself, with their varied representations of passivity and activity, anxiety and calm, attention and reserve—in some of which, like the *Aurora* on the tomb opposite to *Night*, I find myself as troubled by a statue that refuses to remain asleep as by one that does not awake.[14] Even the idea of a divine life present in the dead stone, so blithely posited by Strozzi, has far deeper and more technical resonances for Michelangelo, especially if we refer to Summers's account of the way in which the complex, double twist of the figure, its *contrapposto*, incarnates the dynamics of what Lomazzo termed the *figura serpentinata*. This conventional curve, which afflicts so many of Michelangelo's forms, becomes a crucial nexus: it is at one level an artificial grace or rhetorical ornament, a product of *fantasia*, an emblem of the movement of human intellect and desire; the body of *Night* is thus in part an externalization of creative intellect itself, of its *furia, energia,* and *grazia*. But that curve also links this possibly impure domain to a more than merely human order, among other reasons because the *figura serpentinata* is the emblem of the supreme and ever-moving element of fire. As the organizing form of Michelangelo's stone figures, "their serpentine movement implies that they are alive from within, undisturbed from without and isolated," not surely "expressing" any mere inner feeling but caught by a form of motion that links the movement of the body and its soul to a larger cosmic destiny.[15]

Diversely formal, iconographic, and symbolic, such attentions might lead us more concretely to place our intuitions of interiority or life in the inanimate statue. Bringing them into play would be part of

a labor of interpretation more concrete, would elicit a more histor-
ically particularized interiority, than the one that emerges from dwell-
ing solely on the poet's lyrical conceit. What remains gripping in
Michelangelo's lines, however, and to my mind paradigmatic, is not
only the specific character of life or speech they attribute to the statue.
Equally crucial are the sculptor-poet's basic refusal to credit any such
attribution too simply, his troubling of any idle apprehensions of
response in the statue, his questioning of Strozzi's courtly magic and
of the allegorical aura invested in the figure by the epigrammatist
(which can seem as much a violation as a mere impertinence). De-
manding the silence of a human viewer before the statue, the poem
attempts to hold onto, even as it transforms, what is deathly, inhu-
man, unknowable, or inaccessible in the stone figure. The poet links
the statue to and distances it from us by means of the fiction of a
concealed life, even as he frees the statue itself from any too literal or
blithely idealistic dreams of animation, of recovered utterance. The
epigram seeks to embrace the facts of sculpture, even as it reminds us
that the sculpture itself cannot take these facts for granted.

The issues raised here could push us toward more pointed ques-
tions about the historical poetics of sculptural praxis itself, helping us
refine our still-imperfect sense of how sculpture aspires to "life" or
"movement," the different ways in which sculptures "read" their
own inanimateness, how they embrace or reject it. Such questions
might require us to rethink the generic self-consciousness of sculp-
tors, to place more accurately the influence of historically shifting
ideas about the nature of the medium, to resee the complex, often
conventional tropes of motion, repose, and expression that evolve
within the history of sculpture. By this I mean such things as how a
sculpted figure stands, sits, reclines, twists, reaches, and sleeps; what
fictions or fantasies of the body's organization and intelligence frame
a statue's relation to pedestal, niche, or architrave, or to the original
marble, bronze, or wood from which it is shaped; what tropes of
finish, what traces of the work that produced it, influence our reading
of its "life." All these issues call for more than merely formalistic
treatment, as do the myriad debates about the use of color in sculp-
ture; about the relative value and meaning of blank, painted, or illu-
sionistically carved eyes; about the decorums that allow or forbid an

artist to carve a statue out of more than one piece of marble. Such a history might also require that we try to describe more carefully the ways different traditions confront, wrestle with, transform, and perhaps invite a certain kind of "death" (as well as life) in sculpture—a death that resides, as Walter Pater argues, less in the inanimate media of stone or bronze than in the tendency of sculptural forms themselves to become rigid, emptied caricatures of human attitudes and ideas.[16] Taking up such questions might teach us a new way of speaking about works like Michelangelo's four *Prisoners,* intended for the tomb of Julius II: we might read those half-finished figures not merely as living bodies, or forms of human destiny, trying to break free from a dead marble crust, or as symbols of the human soul's tragic fight with the material world, but as the figurative relics of a more elusive battle, the sculptor's fight not just with the stone but with the deeper stoniness of the "statuesque."[17]

Some of these matters I take up in my final chapter. Here, more strictly literary issues claim my attention. Whatever else Michelangelo's verses do, they work their magic by questioning, even rebuking, the fictive wish for animation and transformation, by troubling or thickening the fantasized moment of passage from silence to speech, stillness to movement (as the whole chapel thickens and explores the threshold between sleep and waking). In this way Michelangelo's lines play strongly against Strozzi's more conventional, schematic evocation of the idea of awakening stone. One is enchanted by the idea of animation, but equally so by its absence. The lines refuse to obviate too quickly the state or being of stone. They dwell on and in its opacity, if only in preparation for a more complex vision of what the fiction of animation itself entails, making us confront more than one version of it, conjuring up its ironic analogies, as if these too were part of that fiction's overdetermined genealogy and so could help us understand our skeptical or idealistic investments in it. Is animation regression or advance? Natural or unnatural? Whence this uneasy courtship of stony foundations? In what service is this withholding of awakening?

If such questions make sense in relation to Michelangelo's epigram on the statue of *Night*, they can also be brought to bear on the even

more complexly ambivalent staging of a statue's animation that we find at the close of Shakespeare's *The Winter's Tale*. The statue of Hermione unveiled there is, like Pygmalion's, a thing born out of a strange combination of frustration and desire, misogyny and idealization, but it is a statue whose stillness and animation are given an even more complex genealogy. Like Michelangelo's *Night*, it is a statue whose silence speaks out of a paradoxical, resistant inwardness.

To begin with a forceful hyperbole of Stanley Cavell's: if we assume that Hermione is not just imitating a statue—a fantastic enough supposition—but that, within the dream logic of the play, she has been turned *into* one, or has stood *as* one for fifteen years, then it is Leontes who is responsible.[18] It is Leontes who acts as both her Pygmalion and her Medusa. Her blank, stony, painted state is an ironic relic of his violent misconstrual of her subjectivity, the poisoned knowing that is his doubt, the empty, faithless "certainty" about her infidelity that places her life "at the level of [his] dreams." The statue represents the "nothing" that Leontes' empty, madly arbitrary projections of his wife's infidelity turn her into; it stands as a funereal reminder of the corpse he has made of her (or desires and thinks he has made of her). She stands, indeed, as a figure for the nothing he has made of himself, of their shared love, of their children, of the erotic decorums of the social world, of all criteria of value, through his terror and fixation, through his conviction that "all's true that is mistrusted."[19] Reborn as a statue, Hermione is "re-begot / Of absence, darknesse, death; things which are not."[20] Insofar as it is a "something," the statue is a reminder of the living body that had been held up in court as an object of accusation and blame, subjected to a public test of shame and shamelessness; the statue is the image of a face asked to blush or to harden itself against blushing (neither "sign" being unambiguous here), a body subject to the "living death" of imprisonment or the murderous revivals of torture, a figure whom Leontes alternately compels to speak and forcibly silences.[21]

Of course, any such ironic reading is complicated by the fact that the statue, even in its first emergence, reflects Hermione's beauty and steadfastness, becoming an image of her survival and of the play-world's wish for her restitution. It is a statue whose painted eyes, with all their illusory luster, hold out the possibility of restoring a

world in which "all eyes else [are] dead coals" (5.1.68). The statue also has a more gently elegiac air; the scene registers, in fact, especially in its odd interest in the figure's wrinkles, not just the loss of a young bride but the loss of an older woman, that is to say, the loss of a space of time in which a husband and wife could grow old together. These gentler recognitions, however, continue to be troubled by other aspects of the statue scene. The idea of a statue as real as life—an idea "both serious and consciously removed, artificial, ironic"—is tested in ways we might hardly have expected. One is acutely aware, for example, of how much is weirdly reduced or strangely literalized in Shakespeare's initial emphasis on the mimetic magic of the statue. We may be especially troubled by the ways in which this seductive magic seems to catch Leontes—for whom the "dead likeness" of the queen is perhaps easier to dwell on than the thought of her literal return. Leontes, gazing at the painted statue, thinking it nearly alive, claims that "no settled senses of the world can match / The pleasure of that madness" (5.3.72–73). But the play holds out the thought that only a madness and a pleasure both more plain and more unsettling can save him. The statue in whom life is "as lively mock'd as ever / Still sleep mock'd death" (5.3.19–20) needs a different, less conventional, and more resistant awakening—an awakening not necessarily alien to that of real statues but one that will at least transform the ways we speak of their life.[22]

If I seem here to overstress the anxiety that is here attached to the artifices of animation, it helps to recall that Shakespeare's one explicit reference to the Pygmalion fable in his plays identifies the animation of the statue with prostitution. In *Measure for Measure*, the rumor-mongering Lucio mocks the captive bawd Pompey thus: "What, is there none of Pygmalion's images newly made woman to be had now, for putting the hand in the pocket and extracting it clutched?" (3.2.43–45).[23] We could take this merely as an irrelevant analogy belonging to a very different context. But remember that this is a play where both the "coldness" and the "warming" of figures like Angelo and Isabella show curious parallels to the transformation of Leontes. We sense an element of subterfuge in their initial reserve, a defensive chill or hardness driven by both pride and sexual fear. Lucio must virtually force Isabella to do more than "charge [Angelo] coldly"

when she asks that he save the life of a brother condemned for fornication; and insofar as her "warming" voice manages to move the frigid deputy, it is by provoking in him not the warmth of mercy but the heat of desire. This desire so terrifies Angelo that he defends against it by turning himself into his apparent opposite—not a sympathetic human, but a hardened monster (human enough, no doubt) of injustice, duplicity, and sexual blackmail, one who is capable of imagining Isabella herself as a seductress.

The penultimate scene of *The Winter's Tale* presents us with a group of courtiers sharing a set of wondrous events, events known through both rumor and firsthand testimony: how Leontes' lost child Perdita survived as a shepherdess; how her identity was discovered; how the feuding kings were finally reunited; how Antigonus, who had carried Perdita into exile, was killed; and so on. As has often been noted, their language anticipates our view of Hermione by eliciting in more purely figurative form the idea of living stone. We are told that the two kings stood staring at each other as if to "tear the cases of their eyes: there was speech in their dumbness, language in their very gesture" (5.2.12–14). The old shepherd is said to stand like an old gargoyle, a "weather-bitten conduit of many kings' reigns" (5.2.56–57). In the audience, "who was most marble, there changed colour" (5.2.89–90); the eyes of some seemed to bleed tears, while the hearts of others, with all of the strange convertibility of a statue's fluids, wept blood. The complexity of such images, evoking as they do conflicting emotions of sorrow and joy, knowledge and astonishment, prepare us for the difficulties of the statue scene itself.

This last scene invites us to consider the proper distance one should take toward the statue, what stance one should adopt toward its ideal and fetishistic realism, how one should bear Hermione's being a statue at all. It thereby recollects and recapitulates the questions posed in the early scenes of the play about the nature of courtly address, about proximity, piety, and decorum, about what is or is not intrusive and scandalous, what counts as recompense and indebtedness. And while such questions are hardly given definitive answers here, their larger background in the play suggests why even small gestures at this point can acquire considerable moral and parabolic weight. Leontes, for example, risking the mockery of the assembled

company, offers to kiss the remarkable image. We cannot quite tell how innocent or mad he himself thinks this is, but Paulina makes it clear that such a literalization may be unexpectedly dangerous. Hence the curious lines in which she warns Leontes that the color, "the ruddiness upon her lip," is still wet, and that to kiss the figure will only mar the statue and stain his own lips "with oily painting" (5.3.81–83). Here the tincture that supposedly gives the statue life is at risk of becoming a defilement, as if Leontes might repeat his earlier "sullying" of Hermione's (and hence his own) purity and innocence.

Terence Cave, speaking of both the critical and the pragmatic complexity of the idea of dramatic "recognition," notes that "the number and range of predicates that may be assigned to recognition are very great indeed, and inflation in such cases may easily lead to exhaustion or collapse—a *tabula rasa* around which the objects of knowledge hang like disembodied spirits."[24] A similar sense of something hauntingly opaque and overdetermined attends both the viewing of Hermione's statue and the staging of its animation. The idealized pictures of restoration hovering around the statue are infected by more unsettling versions of return and rebirth, not all of which can be keyed exclusively to something in the subjective situation of Leontes himself. As a precipitate of the darkened romance-world, the statue of Hermione is haunted by the kind of fantasies of return that catch the lost Antigonus, who dreams of Hermione as a kind of weeping, vengeful ghost (recalling aspects of Hamlet's father), a ghost whose threatening intrusion is simultaneous with the invasions of the bear and the storm (3.3.1–58). There is also the fantasy proposed by Leontes, and taken up by Paulina, that Hermione's soul would repossess her corpse and return from the grave to terrorize him should he decide to marry again (5.1.56–68). Like other images of monstrous birth in the play, or like Leontes' half-playful, half-guilt-ridden fixation on the statue of slandered innocence, such images are indeed like ghosts that Shakespeare must both conjure and exorcise before any further enchantment or disenchantment of the statue is possible; they are, for one thing, intimations of a tragic economy that the play is eager to renounce. The possibility of such ironic animations and recognitions must at least be confronted in surmise; otherwise, the statue of Hermione might awake only to say, like Michelangelo's

Night, "Non me destar,"—Do not wake me—or like Lear (awakened like Hermione by music), "You do me wrong to take me out o'th' grave."[25] The general fantasy of return is shared by many spectators. But Shakespeare allows us the thought that in seeking to kiss the statue, or in being pleased with merely the image of its breath, Leontes could readily become like Lear holding Cordelia at the end of *his* tragedy, caught between the delusive knowledge of his daughter's reanimation and the absolute certainty of her being a corpse.[26]

This fraught background helps convert the transformation itself into a trial ("I could afflict you farther . . . if you can behold it," says Paulina [5.3.74, 87]), as well as a kind of purificatory sacrifice. The scene is a testing of the terms of wish and the gestures of mourning. It is a testing of the idea of theater, of the conventions of dramatic unconcealment, of the ethical and epistemological burdens of fictions of recognition. Finally, it is a testing of the terms of magic and of the public and private desires that can be articulated by the *idea* of magic. This last issue emerges most directly in Paulina's rather self-conscious protest that hers is a white, rather than an unsanctioned or demonic, magic. But we can also see what is at stake in this scene if we recall how different Hermione's reawakening is from similarly theatricalized miracles and transformations in Renaissance court masque (which critics rightly link to this moment in *The Winter's Tale*). Hermione's restoration and the wonder elicited by it turn on something that is ultimately plainer and yet more hidden than the court masque's stark idealizations of sovereign power, something that leaves more space for both improvisation and failure. The watchers, who had at first simply wondered silently at the statue, are "required" by Paulina to "awake" their faith—as if faith itself had become a frozen statue. The promise of the statue's life, which was after all *not* a promise but a mere hyperbole, is suddenly fulfilled. The statue awakes:

> *Paul.* Music, awake her; strike! [*Music*]
> 'Tis time; descend; be stone no more; approach;
> Strike all that look upon with marvel. Come!
> I'll fill your grave up: stir, nay, come away:
> Bequeath to death your numbness; for from him
> Dear life redeems you. You perceive she stirs:
> [*Hermione comes down*]

> Start not; her action shall be as holy as
> You hear my spell is lawful. [*To Leontes*] Do not shun her
> Until you see her die again; for then
> You kill her double. Nay, present your hand:
> When she was young you woo'd her; now, in age,
> Is she become the suitor?
> *Leon.* O, she's warm!
> If this be magic, let it be an art
> Lawful as eating. . . .
>
> (5.3.98–111)

It seems here as if Paulina must *persuade* the statue to become a wonder, must promise herself to "fill up" a grave as well as a gap of time. Her urging of the statue to make a "bequest" to death suggests that Hermione must die (as a statue) into life, to give up the security of the statue's solitude and solidity, even in the face of the acknowledgment that she will "die again" (at which time, it seems, Leontes will be right to shun her). Paulina's urging has a certain delicate playfulness about it, as if both Hermione and Leontes must learn again the game of courtship. Leontes does indeed enter into this play, but it is markedly hard to read his tone. For a moment the figure of his wife is still an alien object, not yet to be spoken to: "she's warm," he says, not "*you're* warm." She is also a miracle, but a secular miracle. Leontes again raises, if only to dismiss, the question of Paulina's use of forbidden arts, but we might pause over his witty, courtly exculpation. For to say, "let it be an art / Lawful as eating," does not so much declare her magic legal as remove it from the very domain of law and prohibition, even as it strangely recalls a king who once tried to police a realm alien to law, whose authority became a kind of eating and devouring of life.

It is around such equivocal words that the scene spins its "resistance" to the obvious enchantment of animation. But there is something even more crucial in the carefully deployed sentences of the scene, and the parables those silences create. We begin, for instance, with the silence "proper" to the painted stone and the silence that Paulina thinks proper to the astonished viewers (5.3.21–22). But these are quickly replaced or transformed by the silence of the embrace between the husband and wife, who take hold of one another before the statue says anything at all.[27] No matter how mysterious,

this is again a secular silence; its oracles are not those of Apollo at Delphi, consulted earlier in the play, though there is an air of mystery, sacrifice, and miraculous presence here too. It is hard to say what is remembered, forgotten, or passed over in this silence. It is too easy, I think, to say that it is a silence in which nothing can be said. It is rather a silence in which everything we could *imagine* to be said—by way of reproach, confession, acknowledgment, joy, and forgive ness—might *or might not* be said. It is a silence that makes us ask what it might mean to say such things. Now there are many things or thoughts, no doubt, whose mention might fill or break that silence. We could ask about what Hermione thought during her years of absence. We could ask who thought of this final trick. We could ask to have something said about the one still unretrieved loss, the loss of the storytelling child, Mamillius, whose winter's tale of a man dwelling by a graveyard had nevertheless strangely become a version of the tale of the envy-haunted Leontes.[28] We can ask for these, and other things, but we should also remember that no truth revealed at this point could escape our suspicion of its theatricalization. This makes the silence a trial as well as a potential blessing; we do not know how scandalous or reassuring it is, how much it comprehends or leaves out, how weighty, dramatic, or "pregnant" it is. We will tend to think that it is a version of that silence which appropriately attends the fulfillment of wish, as well as a return to life. Still, it is not clear that this silence quite "purifies the disasters of speech" that helped precipitate the catastrophe of the play; we cannot be sure that this late silence makes impossible the coercions of speech, the paranoia about what is said or not said, the conversion of speech into vicious nonsense, that we witness in the jealous Leontes.[29] This uncertainty arises not only because of our questions about the nature of the statue and the wish itself, but finally because this closing silence, humane as it is, also returns us to the blank, ambiguous space in which Leontes' sudden jealousy had emerged. Perhaps the only difference is that this is now a silence in which time is allowed for more speech, or more silence, for a silence that is a gift of the audience as well as of a husband and wife to each other. Can we say of this silence that it could be a gift of the statue as well?

Nothing is ever final in Shakespeare; even his silences resist our desire for closure. There is much to move our doubt and suspicion in Hermione's transformation, much to read into its silences. The scene produces in us an unsettling sense that we can no longer dwell easily within the figurations of life and death that we might once have taken for granted, especially given how much the scene intensifies our awareness of the subterfuges of theater and the unstable nature of our investments in them. Still, while there are no obvious answers to be had, it might be wise to listen to how certain characters on stage interrogate the statue and its silence, what their dramatized forms of doubt and reality-testing amount to.

I am concerned here especially with the responses of two witnesses, the exiled servant Camillo and the wronged friend Polixenes. Paulina has reassured the court that the "actions" of the statue shall be as lawful as her spell (though again the law attendant upon the spell is uncertain, prompting us to ask, Of what is this reassurance a trope or parable? What does it push away?). Yet both Camillo and Polixenes seem to exhibit some anxiety about Hermione's survival and resurrection. Neither one is quite ready fully to accept the statue's stepping down from its pedestal in its emergent, silent guise. The statue-Hermione is not just a question mark but something taboo, and their words suggest a hovering suspicion that this moment of recovery cannot banish the thought of revenge. As if worried that Leontes might be embracing a ghost, a reanimated and vengeful corpse (of the sort Paulina had imagined), even a kind of vampire, Camillo demands of the still-silent figure, "*If* she pertain to life, let her speak too!" (5.3.113, my emphasis). "Pertain" is used in the old sense of belonging to, being held by, but with some connotations of legal rights of ownership, as if Camillo were uncertain not just whether Hermione owned life but whether life really owned her (if only in the way that Hermione seems to own the "numbness" she must "bequeath" to death). Polixenes also demands speech in the face of this silence, demands that the awakened statue enter the world of plausible narratives, "make it manifest where she has liv'd, / Or how stolen from the dead" (5.3.114–15). His words suggest that Paulina is as much a grave robber as a figure of Orpheus, Hercules, or Christ. The chapel, in which the company had gone to sup "with all greed-

iness of affection" (5.2.101–102), threatens to turn into a haunted cemetery, and the statue itself into a monitory, after–dinner visitor like Don Juan's stone guest, if not a dead wife out of a tale by Edgar Allan Poe.

I do not think I am exaggerating the anxiety in Camillo's and Polixenes' words; the sense of threat in the scene is implicitly confirmed by the excess of Paulina's protests that her magic is "good," as well as by her earlier, more gothic fantasies regarding the return of Hermione's ghost (though neither Camillo nor Polixenes can have heard these). Indeed, the two bystanders can be seen as giving voice to *our* anxieties and doubts about how to make sense of the dramatist's mad, or naively romantic, plot device. Their dark surmises thus call into question any too idealized reading of the final scene, leaving a space open for our residual uncertainties. Yet Shakespeare is also tremendously reticent in opening up such a domain of doubt. Faced with a miracle, Camillo and Polixenes, we might say, just don't get it; their questions seem alien, irrational, a little paranoid. To that degree their doubt itself, our doubt, or at least one form of it, is put in perspective. Now, as I suggest below, there is something all but inevitable, and ironically satisfying, about the fantasy of the living statue as a demonic, mortal threat. Among other things, it fits the statue of Hermione's association with vengeful ghosts and resurrected corpses. But Shakespeare's attitude toward this literary and cognitive "pleasure" is ambivalent at best. We might even call his strategy here apotropaic, since he staves off not only the idea of the statue as demon but our very wish for such a demon. Shakespeare distances us from the surmise of the statue's revenge, I think, because it may satisfy us too easily, because its paradoxically superstitious rationalizations reinforce the kind of envious, accusatory skepticism we inevitably direct at such fragile scenes of recognition and reconciliation. By questioning the questioners, the play tacitly suggests that such skepticism, and such a demand for what might seem "poetic justice," may entail distortions of their own. One might say that the dramatist is bent on denying the audience the starker pleasure we might find at the end of a Jacobean tragedy—for instance, Hermione poisoning her husband with a kiss, or Leontes committing suicide over his murderous jealousy. Shakespeare makes of the statue's awakening even more of a trial than we

might expect, since it not only questions a purely comic end but demands that we also relinquish any hidden wish for the specious "realism" of a tragic economy.

The dilemma is basically an ethical one. We are asked to take the transformation scene as an image of a kind of humane grace or condescension, a return to the commonplace, and at the same time a recuperation of theater. The faith to be awakened is partly the faith that the cheap stage trick was performed in good faith. We may, of course, remain troubled by the thought of things still repressed, unconfessed, and unrecognized in this recognition scene, by the sense that the structural conditions of jealousy remain, or by the frustration that one cannot get beyond the coercions of theater—suspicions that can all be focused by our hovering associations of the awakened statue with the roles of demon, ghost, and accuser. The point is that the play frames even these more ironic associations in a way that makes them too seem less than adequate, and not a little melodramatic. The event of animation retains a starker mystery in its having so little dialectical shape. That the closing scene allows us neither self-evident faith in magic nor the quiet comforts of disenchanted irony is its real difficulty. Finally, the enchantment of the scene is in the willfulness of the fiction of disenchantment, the fantasy of the relinquishment of fantasy—the rebirth into a world in which possibly everything, possibly nothing, has changed.

PART THREE

Crossings

In Molière's *Don Juan*, the seducer invades the tabooed domain of a monument raised to the Commander, whom he had slain, and mockingly invites the statue of his victim to supper. The statue later invades Don Juan's abode to invite him in return (in the end carrying him off to Hell). But such reciprocation is at best a parody of communion; neither invitation quite means what it says, and neither supper is shared. These uncertain, ironic, if not purely duplicitous invitations to some degree help us measure by comparison Don Juan's other acts of subterfuge and seduction; they seem indeed to mark the limits of his powers of seduction, or put those powers on trial, even as they help bring about his punishment for such seduction.[1] It is crucial (if obvious) that the invited statue never fully steps over the threshold into life. The living statue of the Commander remains a *stone* guest, untransformed, idealistically dressed as a Roman emperor, stranger than any ghost of himself. The play does not present this statue merely as a private hallucination of Don Juan's. The statue is too solid for that, and Don Juan's servant Sganarelle is always on stage alongside the two of them, mediating between his master and the statue, addressing and even mimicking both by turns. Still, the play makes us aware that this alien, opaque presence is bound to the seducer in intimate ways. The statue was "created" by the don's murdering the Commander; it comes to life only in response to Don Juan's flippant invitation, as if its life were provoked mainly by his refusal to pay conventional homage to the dead; finally,

its animation has the sole function of challenging, and bringing to an end, the terms of the seducer's animation—Don Juan's death lays the statue to rest as well. The scandalous statue stands for that law whose violation constitutes (and punishes) the hero, and yet the statue's presence has the air of a violation itself. Indeed, if their relation seems that of paradoxical doubles, it is because Don Juan himself has become something of a living statue or automaton by the play's end, a cold, rationalistic selfhood—unamendable, unconjurable, blankly unavailable to all prayers, calls, or counterseductions, a figure whose own disenchantments of the world are mirrored in the doubtful, disenchanting presence of the living stone.[2]

Looming through this fiction—even summarized so briefly—I find elements of a dialectical plot or phantasmic pattern shared among numerous versions of the moving-statue story. Although I have touched on aspects of it before, I want to describe the pattern more plainly here. As such, this pattern may have no more than heuristic value, but it helps display some of the hidden threads that tie many of my texts together.

The pattern has two interwined aspects. The first involves a sense that in "coming to life" the statue will always bear about it some residue of its old existence (or nonexistence); that in its "return" to life we find, rather than a radical change of state, some unshakable or unmasterable tie to its origins as a statue. The awakening statue cannot quite "bequeath to death" all its numbness, as Paulina urges, though that numbness may be transfigured in some way. The statue comes to life *as* a statue but not necessarily as the *same* statue, or else it comes to life as something that leaves the threshold between its life and death nearly as troubled as ever. The fiction of its life troubles the categories by which we try to mark the differences between the living and the dead. If the statue's coming to life is a revelation, it may reveal things we perhaps should have seen in the unliving statue itself, and in the statue's less manifest relations to the inanimate, to the grave or the corpse; that animation may recall the fears of things buried, inhuman, or irrational that the solid, immobile statue itself might have tried to master. Hence the statue coming to life tends to have the look of a ghost, a galvanized corpse, a monster (though also, as in Hermione's case, an actor).

The second aspect of the pattern is a corollary to the first: that by virtue of a necessary if ineluctable economy, certain qualities of the statue begin to catch hold of those around it. The statue's problematic mode of being contaminates others who are not statues; in its coming alive we find the living—the lover, the sculptor, or the innocent bystander—drawn toward a state that resembles the statue's own. The condition of "statue" is figuratively unbound by the fiction of animation; there is a sense of release, even something ecstatic in this. But one reflex of such an unbinding is that this condition begins to bind the living, to infect them with the silence, opacity, materiality, or formality that the animated statue has—at least in part—renounced. At its most extreme, the life of the statue takes on the petrifying power of the Medusa. The living statue turns living persons to stone or brings about their death. It is as if the fiction of animation grips us most strongly by virtue of an elusive process of identification and exchange, a sense of magical infection, a necessary crossing between the lending and the theft of life. Giving a statue life becomes a transgression, a piece of violence, an act that must be paid for by a death, or at least (and this can feel deathly enough) a radical transformation of the terms of what we call life. Where the accident or grace lies, there also the curse.

The phantomlike (and phantom-making) presence of this pattern contributes its fascination to a text like Prosper Mérimée's famous short story "La Venus d'Ille."[3] This narrative takes the form of an antiquarian's memoir of mysterious and tragic events witnessed while on a visit to a French provincial town. At its center is a tale—closely imitating a popular medieval legend—of a young bridegroom who hangs his wedding ring on the hand of an ancient statue of Venus, in order to keep it safe during a ball game played on his nuptial day. Returning later to retrieve the token, he finds the statue's hand closed over the ring. When the body of the groom is found strangled and crushed the next morning, we are led to believe that the statue itself had visited him on his wedding night, claiming prior rights of possession on the basis of his "gift."[4] (One thinks of Don Juan, who is foolish enough to think that it doesn't cost anything to invite a statue to dinner.) At the simplest level, we have a story in which a statue comes alive and claims relation to the living, mainly in

order to undo the living, to destroy their rituals, literalizing an otherwise idle and figurative gesture with deathly effect. But the pattern I've sketched works in a subtler fashion as well, helping to invest that tale with both its complex irony and its peculiar shadow of magical compulsion, despite the author's studious reticence about any overt appeals to supernatural agency.

Unlike its medieval model, Mérimée's tale does not point to a pagan demon explicitly at work in animating the statue (a power that in early versions usually renders the bridegroom impotent, rather than killing him); nor is there any appeal to some local priest or magus who is asked to exorcise that demon. The statue in fact exerts its power by both inviting and seeming to frustrate so many conflicting attempts to make sense of it, by calling forth a web of fantasies, rumors, and rationalizations that at once keep the thought of its animation in play and leave it in possession of an essential (if also transformed) opacity.[5] Mérimée's Venus is a larger-than-life Roman statue newly dug out of the grounds of an estate near the provincial town of Ille. Mistaken for a buried corpse on its first being found, the statue "acts" almost immediately by falling on and breaking the legs of a peasant who tries to lift it. The local populus thereafter animates it with their superstitious fears, their vulgar, vengeful apostrophes, even by the stones they hurl at the bronze (and that the bronze statue appears to hurl back at them). The actual owner of the statue, who dismisses such gestures as deluded, continues to invest it with life by his affected displays of praise and connoisseurship, his jests about making a sacrifice to the statue before his son's wedding, even by his crude speculations about the statue's ambiguous inscription (*Cave amantem*). The fictive author of the memoir, a more learned Parisian scholar, lends the statue yet a different life, even against the grain of his own skepticism, by his unsettled response to a cruel, ironic, and mocking energy he finds in the goddess's face. The drunken bridegroom testifies more directly to the statue's having locked its hand over his ring—though the narrator dismisses this as an hallucination; we also hear, repeated through the mouth of a cynical state investigator, the hysterical bride's story about having seen the statue strangling her husband.

The lure of the text, however, is not only that the statue remains at

all times contradictorily if aggressively alive, the focus of violence, accusation, and regressive fear; it is as much that the statue in turn renders uncanny or problematic the life of others that inhabit the world around it. This uncanniness comes out most subtly in the way that the figurations of "statue" manage to infect so many other crucial characters in the story, as if it enfolded their lives, or helped to give them birth (at least within the space of the fiction). Such characters include the lumpish, materialistic bridegroom; his beautiful, seductive bride, whose face the narrator explicitly compares to that of the statue; even a bronzed, vagabond Spaniard, a "giant" who is at first suspected of the murder. It is this covert, undirected sense of infection, as much as the diversity of animations attached to the statue itself, that lends a magical character to the statue's presence within a fable otherwise so guarded against acknowledging any supernatural agency. The unburied, archaic, and seemingly solid statue manages to break apart the provincial world, shattering the rituals that structure its social life, mocking and destroying the institutions that attempt to shape and control the realms of sexuality and generation. Yet the statue also comes to seem like a strange, imploded image of that world's desires, not only insofar as the inhabitants of that world are ambivalently drawn toward it, but also insofar as they themselves seem always liable to take on the form of statues. Hence, perhaps, any attempt to transform or "kill" the Venus's destructive life seems only to perpetuate it. At the end of the fiction we are told that the dead groom's mother had the statue melted and recast into a church bell whose ringing twice brought on a frost that killed the vines.

There is a liability in trying to extract from, or impose upon this story the pattern of contamination and exchange I have described, as if it revealed some hidden truth about that text. To do so is nonetheless tempting because we can be seduced by the illusion that hidden truths take the form of such patterns. (Thinking about my own fascination with such ironic and haunting structures of crossing, I am reminded of the narrator of Henry James's *The Sacred Fount*, who claims an astonishing knowledge of hidden vampirisms lurking in the world and spends the novel in an ecstasy of analysis, explaining how a certain older woman has drawn her youth from her originally more vigorous husband, and how a formerly witless man has stolen his

intelligence from a once clever but now empty-headed lover.) But if this pattern exists at all, it is perhaps only as something that ramifies throughout a narrative like Mérimée's at different levels, affecting a network of heterogeneous figurations, often troubling apparent stabilities of character position, and confusing apparently clear pictures of cause and effect. Watching for evidences of this pattern may thus be mainly useful insofar as it throws into relief certain aspects of a story that might otherwise remain less obvious.

The peculiar fascination and meaning of this pattern may nevertheless still be unclear. There are, indeed, all too many ways to frame or decipher it. Trying to make sense of its presence in the texts of Molière and Mérimée, I am tempted to say that it gives voice to some otherwise unheard demand on the part of the fictive statue itself, that the living statue's unsettling presence embodies a demand for justice, perhaps, or a protest against the living creatures who abuse or misconstrue it. (This idea might help account for the fact that the animated statues so often take on the aspect of vengeful ghosts or revenants.)[6] But that dynamic by which a living statue both remains a statue and petrifies those around it (or the feeling that statues come to life only in a world where the living are always themselves on the verge of turning into statues) suggests that broader issues are at stake here. The pattern reminds us sharply of how contingent and unstable such categories as "life" and "animation" are, how subject our figures of life are to objectification and inversion. These texts project a feeling that there is at once too much and too little of what we call life in the world, that it cannot be distributed in any rational fashion. The pattern suggests that the lending of life cannot quite be distinguished from its theft; that whatever justice the animation entails will have simultaneously the look of injustice, betrayal; that the gift of animation involves a burden that may entangle and divide both giver and receiver.

We could explain the resiliance of the pattern differently, of course, by suggesting simply that it responds to what we might call a rule of persuasion in magical fiction. This rule would suggest that the most compelling fictions of the supernatural are always ballasted by some version of disenchantment; that the illusion of magical causation is paradoxically strengthened by the simultaneous illusion that we can

see through it, or by the feeling that we can find in the fiction some event or recognition onto which we can displace, or in which we can anchor, our doubt and mistrust of magic.[7] The pattern might also tempt us to appeal to the psychoanalytic dictum that the emergence of any given fantasy always tends to call up its repressed opposite. We could even invoke Paul de Man's argument (discussed more fully in chapter 9) that such troubled fictions of animation reflect the fact that we can only give life to dead or absent things by means of a language whose operations are fundamentally arbitrary, privative, and inhuman. I want to leave my account open for the moment, however, not choosing any one of these explanations. The main point is to recognize that the pattern I have described responds to a crisis in the very domain of wish and knowledge that seems to have produced the fantasy of the animated statue in the first place.[8]

The hovering presence of this pattern, as well as the critical use of trying to bring it into the foreground, may be further clarified by looking at the transfiguration of the Pygmalion or the statue's bridegroom plot found in François Truffaut's film *Jules et Jim* (1962).[9] It is a film about enchantment and disenchantment whose structure also reverses that of *The Winter's Tale:* it begins rather than ends with the statue's animation and realizes at its close the possibility of a mutual betrayal between statue and lover that Shakespeare's romance tries to stave off.

The fiction of animation is handled in a distanced way. Jules and Jim are too young writers, German and French, respectively, who find in each other a peculiar, almost flawless, intimacy. Together they become fascinated by a mysteriously smiling stone bust of a woman (glimpsed first in slides), only to meet (a brief time afterward) a flesh-and-blood woman, Catherine, who seems to be the statue's exact double (especially in her smile). Catherine and Jules eventually marry, but the relation is troubled; she wanders, takes other lovers, eventually beginning an uneasy romance with Jim, which collapses when she has a miscarriage. What is important here is Truffaut's subtle way of keeping the statue trope alive. Catherine as a living woman retains some of the opacity, mystery, and severity, as well as the fascination, of the stone. What we might call her "statueness" is visible in the frequent impenetrability of her motives; in her unaccom-

modatable smiles, silences, and glances; in her dangerous leaps, disappearances, infidelities, and attacks. It is apparent in what she thinks of as her moral experiments, her ways of testing a more absolute calculus of freedom (even though these also make her the opposite of a standing, convention-bound statue). The film may ask us to imagine that she is in part a creation of these two men, that they, like Pygmalions, have helped to shape, teach, and change her, among other ways by teaching her smile to become a laugh. But the influence goes more in the other direction. It is her life, uncanny as it is, that becomes a test of theirs—a test of their friendship, a test of their pictures of romantic love, a test of their (and our) categories of success and failure, change and stasis, private and public value, of the nature of the human and the inhuman. Her presence is also a test of how they negotiate the space between private and collective history, a test of the revolutionary values of *liberté, egalité, fraternité*.[10] The complex figurations of this woman's "freezings" and "unfreezings" become a map of, as well as a challenge to, that place in the world where they find themselves. This situation is indeed given parabolic form when the film (as if in ironic cooperation) momentarily "freezes" a number of frames in quick succession, inviting us to study a series of faces Catherine puts on for the two friends, faces that confront them with slightly self-conscious masks of both her past sadness and present happiness.[11]

The film leaves open the questions of what kind of statue she is, as well as what kind of human being, what her subjectivity is like, how the two men construe her "animation," what power she possesses or is lent. She does, in fact, bring about the film's tragic close: at a moment when the two men are idly discussing "unbelievable news" (the burning of books in Nazi Germany), Catherine asks Jim to take a drive with her. Having ordered Jules to "Watch us closely," she drives her car over the edge of an ancient, broken bridge. The film suggests, however, that it is not some blank, alien power in her that brings things to an end so much as these men's plainer failure to make sense of her life—to do otherwise than be struck dumb by her and treat her as queen, demon, "pure woman," or "force of nature," to know her other than through fearful suspicions, hypotheses, and rumors. They seem to know neither how to address her nor how to listen to her.

The living statue whose life eventuates in a suicide and murder attempts a final lesson (saying to Jules, as Medusa might, "Watch us closely"). Yet not only is she mortal but her lesson seems to remain unread; surviving, Jules discovers at the close of the film only a blank, stony sense of relief at the vanishing of her invasive, chaotic presence, at the departure of living occasions for doubt as well as love.

Here the life (and death) of the statue becomes itself an unstable precipitate of the fictive world of the film. Utopian and traumatic at once, that life is offered as a vision of something that might reshape that world, as well as our world, even as it throws into perspective the terms on which those worlds are shaped. In such a fiction, the living statue puts on trial the world in which it is made, regarded, and granted life. At the same time, the larger narrative puts on trial the inherited fiction of the statue's life itself, its imaginative and conceptual claims, its disenfranchisements and responsibilities. Describing the fate of the statue becomes a way for the artist to imagine the fate of his or her power, desire, and work in the world. My pattern as it manifests itself here is thus no fixed mechanism, much less a timeless "archetype," but rather has the status of a question mark, an animating and chilling riddle.

One further, more ironic, illustration of the pattern I have elaborated is found in Peter Greenaway's 1982 film *The Draughtsman's Contract*. I cannot attempt to summarize the complex plot of this savagely grotesque suspense story, set at an English country estate around 1690, filled with diffident, vicious, secretive, gossiping, and fantastically garbed guests all speaking in a pastiche of the dramatic language of William Congreve. Perhaps it is enough to say that the story involves the seduction of a fashionable artist, invited to produce a series of "views" of the estate while its owner is absent. While the artist—himself something of a parvenu—thinks he is coercing both the lady of the house and her daughter into exchanging sexual services for those sterile drawings that will fix their property on paper, in the end it appears that he himself is their victim and tool. Insofar as their aims are decipherable, it seems the daughter has used him to help her beget an heir, while she and her mother together have plotted to make him seem not only the cuckolder but the murderer of the absent lord, the film ending with the invasive draughtsman's sadistic,

even sacrificial, murder by a party of disguised noblemen. Much of this the film leaves vague, however; it is unclear, for instance, whether the owner of the estate (a Mr. Herbert) is dead or alive, or who might have killed him. (What evidence there is often appears in the form of a random array of objects and pieces of clothing that creep into the views of the estate that the draughtsman had imperiously ordered to be kept clear, things that seem to some traces of a crime, to others the material of an obscure allegory.) What is clear nevertheless is the picture of a world in which all persons are spied upon and spying; in which all enchantment, erotic or aesthetic, is fully absorbed by a game of power and status; in which all bodies, if they are not simply mannikins for clothes, become the rawest sort of sexual currency; in which all knowledge is coercive, invasive, bound up with extortion, abjection, and murder; in which jailer and prisoner continually change places with one another. What makes the film relevant here is that wandering through this estate, this garden of the dead, is a silent, slightly grotesque nude male statue.

This figure shows up first at the margins of scenes, appearing and disappearing, distracting our attention, unsettling the balance of the cinematic tableaux. We catch sight of this statue skulking across the real sculptures of a pediment (like some fragment of a sculpted group broken free), posing on a gatepost, or slipping onto the back of a stone horse. He is sometimes seen exchanging conspiratorial glances with a child, struck at with a hat by a guest, or (once) applauded by the company at large as he stands statuesquely and shamelessly on a pedestal and pisses. But this figure is more often than not invisible to all save the viewer. It is clear, in a sense, that the statue is no "automaton" but a living man covered with strange green-brown makeup, at once a kind of court jester, a licensed madman, and a monstrous mascot. (Someone refers to him as "that fool . . . who behaves like a statue when you least expect.") Yet public as he is, the figure's very opacity and mobility lend him the coloring of an unconscious fantasy, even as the makeup that is intended to give the appearance of tarnished, mossy bronze also makes the statue look like something that has crawled out of a swamp, grave, or sewer, smeary, excremental, and obscene. Archaic and infantile, priapic, puckish, and hermetic, this "nonspiritual spirit" yet admits of no supernatural explanation; if

the statue haunts the world of the film, it is not quite in the fashion of a ghost.[12] For all that this figure is a statue, it also has a body that eats and excretes (even while resembling an excretion). This statue also has an eye and a mind, a sense of dramatic gesture and audience. But it has yet no given place or niche, only a variety of ad hoc pedestals; it is always lost and losing its place, both hidden and on display. We do not even know what the statue sees or has seen, what secret it holds. We do not know what kind of witness such a statue could be after all. With no overt purpose in this world, no strategy, no design or partisanship, the statue yet seems endlessly attentive to the trials of plot and to the demands the film makes on *us* of finding and putting things into their literal and figurative places.

If the presence of this statue draws us, however, it is because the figure seems to give form to what is concealed, the scandal that everyone winks at, or thinks they know; the statue is the double and yet the opposite of the corrupt, murderous mannikins who inhabit the estate (something they can never quite own); it is the projection of their endless artifice and concealments, their blank, mechanical seductions, which seem in fact to feed the statue's outrageous intrusions, posturings, and mockeries. Again, the statue gains its life from a world where the living become like statues. Greenaway's treatment recalls, I think, the habitual tricks of a painter like Watteau, whose exotic, pastoral landscapes contain statues that often possess a quality of animation greater than the living figures who gather around them, that show a self-possession, a tacit knowledge, and sexual energy that are concealed in (if also stolen from) the living. But Greenaway is clearly pushing this tactic to an extreme, using the resources of film to literalize such a subtle, fundamentally allegorical play, letting the statue become more directly the form of some hidden desire or force of resentment in the world of the film, the revenge of what is not seen or what is taken for granted.[13]

We as viewers will perhaps identify with the statue intermittently; this creature (as much as the draughtsman) is also clearly a surrogate for the director himself, a translation of his own ironic presence, his invisibility, knowledge, complicity, aggression, and self-disgust. But however we read it, the statue's uncanny presence grows upon us as the film proceeds. The figure emerges first as a marginal joke, per-

haps, like the split-off fragment of a frieze. But its phantasmic centrality is confirmed by the film's closing shot, which focuses on the statue. In the final sequence of the film, which takes place at twilight, the draughtsman is mocked, blinded, and bludgeoned to death while making a last drawing of an equestrian statue. After the murderers depart, the rider—our living statue—suddenly moves, climbs down from the horse, and finds its way to the site of the crime. A kind of grave marker, also a witness and an investigator, the statue seems less concerned with the corpse, which is in fact floating in a nearby moat, than by what it finds on the ground. Lit by the flickering glare of torches, the figure picks up from beside the draughtsman's easel a pineapple, that hothouse fruit or fetish (a trace of colonial exploitation) that is an emblem of the world of the film. Cut together with shots of both the draughtsman's bloodied corpse and burning drawings, we see a close-up of the statue's mouth tearing at the fruit, as if to destroy and yet take inside itself the world in which it lives (smearing its own makeup and staining the fruit in the process). But the final image of the statue, the final testimony to its life, as it were, shows the figure spitting out the fruit in disgust, spitting out the world it inhabits, even though this is a world that ironically gives the statue life as well.

The Space Between

M‌y text in this chapter is Roman Jakobson's essay "The Statue in Puškin's Poetic Mythology" (1937), or rather, to be more specific, the semiological account of the origins of the fantasy of the living statue presented in that essay.[1] Though this account emerges out of a broader analysis of the life and writings of Pushkin—in particular the poet's troubled negotiations with state authority and his ambivalent attitude toward his own fame—we can consider it to a degree independently. Especially if one is prepared to feel the figurative weight of Jakobson's theoretical terms, and ready as well to read them somewhat against the grain, this essay can give us a better purchase on some of the paradoxes and perversities of the animation fantasy.

One basic premise of Jakobson's essay is that the fantasy of the statue's animation is not elicited by a statue alone, no matter how lively its appearance, how subtle its imitation of human gesture, motion, gaze, and so on. The fantasy is not a projection of perfected mimetic illusion. Rather, it is generated by the real or imaginary situation of a living person standing before the statue. Belonging properly to neither, the idea of animation translates the relational life that emerges in the space between the two. The fantasy responds to the way one moves around or glances at the thing; the way the statue one regards accommodates one's body, or demands that one's body accommodate it; the fantasy reflects the way one models, attacks, or touches the statue, copes with its silence, or supplies its lacks; the

idea of its coming to life is shaped by the manner in which the statue plays against one's perception or memory of other statues, not to mention other bodies. (The fantasy in that sense is, in Jakobson's terms, more metonymic than metaphoric, based on tropes of contiguity and contagion rather than on direct resemblance.) Whether the living person before the statue is the artist, the critic, the lover, the model, the admiring citizen, the mere passerby, or even Chaplin's tramp, the fantasy begins in the facing-off of statue and person, in jealousy, love, even indifference. (The one thing Jakobson leaves troublingly vague, perhaps, is the degree to which this relation may seem "triangular" rather than simply oppositional or specular, since it is usually the intrusion of some third entity, or else some excess or lack in the condition of the person or statue, that tends to throw the relation between them into a state of crisis.)

Jakobson frames this point in stricter terms by sketching a picture of the semiotic paradoxes of sculpture itself. As with any "artistic sign," he argues, a statue's main interest for us lies in the way it keeps alive a tension, a frustrating but vivifying gap, between its signifier and signified (partly by forcing us formally and thematically to pay more attention to the conditions of signification itself). In the case of sculpture, the gap that truly counts is that which exists between the human signified and the stone or bronze signifier, between the human body, with its actual or potential motion, and the necessary immobility of the material artifact that represents it. This focus on the human body as the object of sculptural representation is essential to Jakobson's scheme. Sculpture, generally denied the purely fictive or representational space of painting, exists in real space, shares our atmosphere, as it were—despite its ability also to transfigure that space. Given this, Jakobson argues, it is only the representation of a moving or resting *body* that can establish a contrast between the sculptural "signified" and its dead "signifier" strong enough to satisfy our hunger for those internal distances or antinomies that any artistic sign must both include and cancel.[2] The statue of an inanimate or unmovable object, a "still-life statue," is simply too close to the thing represented to stir our interest. We could object to the simplifications of this, of course, or protest that Jakobson's semiosis fails to account for our interest in nonfigurative sculptures, which

mobilize different questions about the material of the sign. But his semiotic analysis aims mainly at providing a background for the moving-statue fantasy, and in this regard it does some remarkable work.

Jakobson proposes that the animation fantasy is a fictional attempt to bridge the ambivalent gap between living signified and dead signifier, producing a composite with aspects of both, especially through a transference of the semantic aspect of the sculptural sign onto the material signifier. By suggesting something like the merging of living being and dead statue, or an interchange of their aspects, the fantasy collapses the troubling but seductive "internal distance" on which the sculptural sign depends. That process may seem obvious or innocuous—especially since, as Jakobson suggests, the interest of an unmoving statue derives from a similar kind of transfer, for example, in the stone figure's way of lending solid, inorganic form to the volatile life and body of a human being. Nevertheless, that imagined collapse gives form to a desire at once literalistic and unrealistic, and it is not surprising that the fictive precipitate of this desire is anything but stably satisfying. For one thing, the desire to close that gap is sufficiently imperious to seek satisfaction even in terms that—in Jakobson's picture—do real violence to both the living and the dead poles of the sculptural sign (though principally through what is itself termed a "meta-sign"). The fantasy of animation is in fact said to objectify or reify the very sculptural sign from which it derives, or at least the fictions on which that sign depends. In the animation fantasy, Jakobson argues, "the negation of dead matter" ironically entails the cancellation of the sign, a sign that depends on that deadness for its figurative life.[3] Indeed, by transferring the life of the signified onto the dead signifier, the fantasy achieves a (figurative) cancellation of the gap between the human world of the sign and the world of inanimate objects; if it brings the dead signifier to life, it also shows us a living creature that has lost its independence of the artistic sign. Hence it may seem that the fantasy that "estranges" the sculptural sign in the form of a living statue also ends up estranging or reifying the living thing as well; the fantasy does violence to the desire set in place by the statue, even as it may seem to fulfill that desire.

It is clear to Jakobson that such an imagined collapsing of that

distance can never be complete, and not just because the desire for that collapse originates in wishes linked to things other than the statue itself. The fantasy is generated by, even as it turns against, the conditions of (sculptural) signification, but the more chilling realization is that the semiotic opposition that constitutes the lure of the statue is resilient enough to survive the fiction that projects its disappearance or collapse. That opposition not only survives but is, as it were, reborn; in the fantasy of animation, we see the semiotic paradoxes of the statue displaced into somewhat more troubling forms, strangely thematized within the narrative itself. In particular, Jakobson observes, the original opposition between the lasting, lifeless artifact and the living, vanishing human gets projected into a story in which a "living" statue kills a human being, or at least drives him out of his humanity—almost out of revenge, one might say, for the statue's being first subjected to the reifying fantasy of animation. Jakobson's prime example of this is, of course, Pushkin's "Bronze Horseman," though by now innumerable other instances should come to mind.

Bound as the animation fantasy is to this transgressive crossing of the living and the lifeless, it cannot escape bearing with it a hovering sense of something deathly, something threatening to both humans and signs (assuming that one has not theorized something deathly in the sign to begin with). Indeed, one can sense that the animation fantasy can entail a tacit critique of any too-simplified account of semiotic dualism itself. Still, we need to hold on to some version of that dualism, at least tentatively, in order to make sense of a last crucial aspect of Jakobson's argument. In his exploration of the meta-fantasy of animation he manages to posit a remarkably economical explanation of the paradox dwelt on earlier: that in many texts the fantasy of a statue's coming to life is joined with the opposing fantasy of a living being's turning to stone. The reason for this is not simply that we tend to weave such stories into sequential or cyclical narratives of freezing and unfreezing, sleeping and waking, death and rebirth. Indeed, Jakobson's explanation troubles any simple distinctions between such opposed narrative movements. The paradox (for Jakobson rendered only an apparent one) derives rather from the fact that both sets of stories, however opposed, manage equally to fulfill a much more basic wish: that of collapsing the distance, the space of

both desire and frustration, between the sculptural signifier and the living signified to which it is semiotically bound. The statue as it exists in the world—always, for Jakobson, "the *immobile* statue of a *mobile* being"—is reconceived by these fantasies as either a moving statue or an immobilized creature, or else as some strange mingling of the two. Both types of story serve to collapse the figurative poles of the complexly double sculptural sign; stories of both animation and petrification end up reifying, objectifying, and literalizing that sign. The two metamorphoses are thus not so much opposed as they are at a deep level equivalent. Both are similarly evasive and utopian; both point to a condition or follow a trajectory that, despite its fantastic appearance, in the end may prove easier to bear than the starker internal distances set in place by the actual sculpture, or by the idea of sculpture. The paired fictions can be similarly reductive and threatening as well, however, as Jakobson makes clear, since in both cases we have a fiction that substitutes a compulsive mobility or a forced *immo*-bility for the more elusive invitations of the original sculptural sign. The fantasy thus risks a possibly nightmarish narrative as a way of mastering what we might think of as the more mundane distances, opacities, and concealments of the actual statue.

Jakobson's argument over all has considerable critical force; his attention to the reifying or objectifying movement within the animation fantasy, its incarnation of a desire to collapse the distance between human and statue, suggests the structural or semiotic motives for certain aspects of the fantasy whose logic might otherwise seem mysterious. His argument makes clear why the fantasy of animation tends to render the life of the statue at once real and unreal, literal and figurative. It also helps explain why, in Pushkin and others, the animation of a statue often coincides with the misdirection or blockage of desire and the catastrophic loss of its objects, rather than its fulfillment. Still, Jakobson's account of the "poetic transformation of semiotic antinomies" points to a number of issues that yet remain unstated, almost requiring that we read his essay more parabolically. For one thing, we need to reflect more on the desire under whose auspices the cancellation of the sign's "internal distances" is achieved; we also need to ask more clearly at whose expense, other than that of the sign, the statue is imagined as coming to life.

Jakobson argues that stories of awakening and petrification grip us

most strongly insofar as they literalize, though only within the space of fiction, those fluctuating fantasies which constitute the relational fascination of sculpture. These stories explore, even as they put at risk, both the difference and the likeness, the metonymic as well as metaphoric links, between person and artifact; within such stories, the statue and the living person can at once fall further apart and yet seem to contaminate one another. But again, we need to remember that what Jakobson calls the fantasy's objectification of the sign, its collapsing of semiotic distance, is always partial and ambiguous, a radical fiction. Any such objectification is a fantasy or parable of objectification, one that tends, moreover, to be abstracted from any literal experience with statues. The fantasy can thus become a vehicle for other realms of concern, other systems of opposition or difference, other pictures of reification or literalization. The posited gap between living body and material statue that the fantasy plays across, transforms, or temporalizes tends itself to be highly allegorical. That gap can become the site around which other frustrations crystallize, a figure for types of incommensurability to which it is harder to give "a local habitation and a name," distances that will be defined, violated, and misconstrued by the very figures through which we attempt to bridge them. The fantasy of animation sets in motion and exposes the internal dynamics of the artistic sign, as Jakobson makes clear; but it can, in part for that very reason, help us explore the complex and asymmetrical relations between what we might think of as private and public signs, between interiority and exteriority, our perception and knowledge of ourselves and our perception and knowledge of others; it can map the complex interactions between present and past, between nature and art, loss and gain, death and life, existence within and beyond the human world. Needless to say, if the idea of a living statue projects the closing of such gaps, it can also expose the subterfuges such a closing must employ, how partial, grotesque, or catastrophic, how full of unexpected reversals the mere idea of that closing can be.

We could pursue these questions by placing Jakobson's essay against later developments within semiotic theory itself—for example, the more unsettling analyses of the signifier/signified opposition that we find in critics like Roland Barthes and Jacques Derrida, or

Jacques Lacan's use of semiotics as a means to complicate and resitu-ate the Freudian account of the subject. But here I want to work through the implications of Jakobson's argument in a different direc-tion. I begin by reflecting on what I previously called the "relational fascination" of sculpture in a way that will at first seem to simplify Jakobson's dialectical scheme.

When we think about the fantasy of animation, our first intuition is probably that the leaping of the gap—which means both the desire for life in the statue and the fiction of animation that incarnates the desire—moves in the direction from living human being to inanimate artifact. It is we who project onto the statue the sensations possible only for us, the living creatures, standing before it. We are the ones who lend sight to its blank eyes and hearing to its ears. It is we who supplement, perhaps violate, the statue's incomplete mimesis of the human, thus transcending the more conventional ways in which a marble statue might accommodate its medium (for example, its way of converting mere immobility into a picture of rest, pause, re-sistance, sleep, or changing muteness into an image of conscious silence). Such lendings of life, of human characteristics, would thus illustrate a basic proposition of Wittgenstein's: "Only of a living human being and what resembles (behaves like) a living human being can one say: it has sensations; it sees; is blind; hears; is deaf; is con-scious or unconscious."[4] But the fictions I have been studying inhabit a more ambiguous circuit and often pointedly refuse the kind of hu-manizing logic Wittgenstein demands, feeding on what would seem a philosophical error. Such fictions often discover indications of life in the statue that perpetuate or feed on its very nonhumanness, or they discover that life reemerging in disturbing, nightmarish forms, as if the attributions of life to the statue are being shaped by forces that do *not* behave like or resemble a human being (even the human being as defined by the statue). We find at work in the fantasy some knowl-edge that the statue will transform us before we have a chance to transform the statue, which may confirm my suggestion that the pressure to bridge the gap emerges from a site alien to both the human viewer and the statue itself (reminding us as well of how allegorical that assumed space of likeness and difference between them can be).

To bring the dilemma out here, we might consider the parable about a secular fall from grace offered in Heinrich von Kleist's "On the Marionette Theatre." It is the story of a young man who, seated and drying himself off at a public bath, catches sight of himself in a mirror and finds that he has inadvertently assumed the pose of the famous ancient statue called the *Spinario*, which shows a boy pulling a thorn from his foot (a plaster cast of which, we are told, can be found in many German museums). He remarks on this resemblance to an older friend (the narrator of the story, in fact), but as either a mockery or a test of the young man's narcissism, the latter pretends not to see it. At this point, the youth finds himself compulsively and unsuccessfully trying to repeat the effect by an act of will, producing ever more comic gestures in the process. Trapped by, but never quite coinciding with, the statue—itself an image of unselfconscious grace—the young man falls from contingent mirroring into a darker, more self-divided specularity; standing for days before a mirror, soon "like an iron net, an invisible and incomprehensible power enveloped the free play of his gestures."[5] It is as if he becomes the ghostly double of the lifeless statue, instead of the statue's being a double of him. He cannot bring the statue to life; rather, the statue brings him to affective death. He becomes himself like a bad copy of the plaster statue; he becomes the statue's marionette, as it were, a figure whose center of gravity is always moved by something outside itself. The shape of this identification is thus highly ambiguous. On the one hand, he submits himself to the statue, which he resembles only contingently; he allows his will to be preemptively shaped by an inhuman, if familiar, image. And yet it may seem as if there is built into that will, or the desire that shapes it, something that makes him complicit in his failure to match the image. Kleist's narrative offers no explicit fantasy of a magical statue, of course. Still, especially given the superstitious hyperbole in the phrase quoted above, that text may indicate something about the situation in which such a fantasy might emerge. As part of its ironizing of human self-consciousness, the text suggests especially the logic by which some dispossessing, alien motion can be imposed on a person by the statue (though often with that person's complicity), rather than such a motion's being imposed on the statue by a living person. It suggests the betrayals or misdirec-

tions of desire that can haunt the space between the human and the sculptural.

Even if we want to think that the fantasy of animation originates from the domain of the human, as Wittgenstein suggests, still the movements a viewer is likely to conjure up before the statue will be those first caught by the statue's strange immobility or opacity; the particular lendings of life that suggest themselves will be those caught by a deadness that entails more than literal inanimateness. The emergent idea of animation will also reflect aspects of the sculptural sign that elicit more obscure, perhaps unconscious, gestures and images, as well as the fears and desires attached to them. Hence ideas of animation thrown outward onto the statue, far from mastering it, are mastered in their own turn. The gestures of the human viewer, perhaps in acknowledgment of their own ambivalent, alien origin, are caught, harrowed, transformed, or blocked by something inhabiting the statue's own more-than-human fixity, a fixity that continues to haunt the fiction of the statue's motion and life.[6]

Again, one's first intuition may be that the fantasy of the living statue depends on a desire to give life to the dead. But the texts I have examined also point to a contrasting recognition (assuming it is even possible to pry the two apart). They suggest that what speaks in the fantasy of an animated statue may be a covert desire for, or trend toward, the *in*animate; that the idea of a living statue arises out of a desire for the inhuman, the material, out of an inchoate demand for a partial or dialectical identification with the condition of stone, the dead literal, the solid or opaque, or whatever else the stone can signify. The fantasy would place the aim of desire (if not the origin of desire) under the spell of the inanimate statue, and what is given by the statue; it might even yield the self more deeply to the fantasy that the statue might secure something that is otherwise bound to be lost. The fantasy would feed on a desire for a state that consumes desire and its burdens, a desire for a condition that defends against the divagations and disruptions of desire (even by aiming at a pleasure that desire would ordinarily reject). While refusing too absolute a transcendence of the domain of the body, hence of that phantasmic sense of self shaped by the body, the fantasy would give form to a wish to inhabit, or to impose on others, a state that holds desire,

motion, and life within the precincts of something dead, a state in some measure passive, inert, inorganic, stonelike. The fantasized, if not wholly montrous, meeting of human life with the state of the inanimate statue would thus project an existence freed at once from the brutal inanimateness and dissolution of death and from the frustrations of embodied life. It might plot our desire to escape the intractable divisions between inner and outer, body and mind, public and private wish, or from the failure of these always to coincide, or to coincide at the proper time; it would give form to our desire to escape self-dividing calls, demands, and needs, or it would preempt our inevitable failure to resist these. The fantasy of an animated statue would thus inhabit an uneasy middle ground between contradictory desires, competing identifications. It could, for example, answer to a hunger for both a more absolute stillness and a more absolute or automatic form of motion. It might present a form of life, an image of voice, that tried to marry a more radical form of secrecy and hiddenness with a mode of expression more radically external, superficial, depthless. It might project a form of survival that somehow included a death. Attempting to figure such acts of crossing, stories about animated statues might at the same time make clear their costs, their implicit violence, as is the case in the fictions of Pushkin and Mérimée.

Such a trend within human desire will only be glimpsed allegorically in the fictions I have studied, especially given how overdetermined the figures of petrification and animation are.[7] But to allow such a surmise may at least help clarify some of the fluctuating intuitions one has about statues coming to life. That there exists something like a desire for the inanimate may explain the sense of betrayal haunting the idea of a statue's entry into life, as if something important were thereby lost or renounced. (Living statues, we might observe, tend to retreat rapidly into stone, as if in flight from their own animation—perhaps because it is, after all, never quite their own.) It may explain why the statue's life entails the living turning to stone, as if in recompense or as a way of taking up the slack. It may also explain some of our ambivalent terror at the statue's motion or forms of life and why its speech can be more troubling than its silence, since this motion or speech holds onto aspects of the statue's

stoniness in different forms and exposes more resolutely both our desire for and fear of that stoniness, things often concealed in our experience with actual statues. Our imaginary identification with so alien a creature as a moving statue or an automaton can be profoundly satisfying, partly because that identification may spare us diverse anxieties about our place in the world, in our own bodies, about the proper location of the human. The freedom entailed by that identification lies not just in the idea of a turn against the blockage or oblivion figured by the stone, but in the fact that the living statue, for all its motion, yet tends to remain a statue, untroubled and unselfconscious (or at least we hope it does). Yet if the living statue does not disappoint us by becoming all too human (as Shaw's Eliza Doolittle disappoints *her* "creator"), the fiction of animation is also likely to remind us of how alien and how disruptive of what we think of as the human are our vital energies, how catastrophic, petrifying, or mechanistic a form the entry into life can assume. Indeed, it suggests the ways in which the fantasy of the animated statue may constitute an implicit critique of our optimistic pictures of human desire, and of our wish that desire and the human could peacefully occupy the same space. The living statue may remind us that there is never any fixed space between.

Among the subtlest parables of this ambivalent trend within human desire (and within the fictions that shape that desire) are certain texts of Kafka, for instance, his fragment, "The wish to be a Red Indian," or "The Cares of a Family Man," which traces a fluctuating identification with a shy, uncanny, deathless thing/child/statue named Odradek.[8] But I close here with something simpler, if no less parabolic—the recollection of a stage performance I saw in 1980, part of the mime show "Mummenschanz." Two black-clad figures came on stage, each wearing large identical masks shaped like those used in Greek tragedy. The masks themselves were made of a flexible, elastic clay, and one of the performers began to re-sculpt his face into something else. With great precision and grace, he formed features which, if somewhat exaggerated, seemed yet to celebrate the very pleasure of fashioning them—a beautifully turned smile, large eyes, elegantly serried lashes. The clay itself seemed to have some of the resilience of flesh, so the figure's modelings also resembled a kind of caress. These

efforts, like a demonic mirror, drove the second figure to competitive imitation. Yet every attempt at copying the first face failed—the mouth sagged, cheeks lumped and fell, eyes twisted; the continuing refinement of the first figure indeed provoked ever more aggressive trials and failures on the part of his companion, who inflicted his deformities on himself with increasing violence, almost masochism. The merely satirical element in this agon of self-fashioning was absorbing enough in itself, but the profoundly poetic effect of the performance came from something else. What caught one was that the failed imitations succeeded despite themselves in becoming powerful expressions of the frustration and sadness that the failure provoked; the mouth did not just sag, it frowned; the distorted eyes had the look of weeping. But the even deeper appeal was in the virtuousity with which failure itself was imitated and troped, the mastery that was entailed by lending to the malleable clay a peculiar power to resist the efforts of work, lending it an autonomy, and an alienness, and yet at the same time a strange sympathy for the one who wrought upon it so clumsily and self-woundingly. The clay had a life of its own, but one that entailed its remaining clay, entailed its clayness being made almost an action, the site of an opposite intention. It was an intention that lent some paradoxical help to human efforts, even absorbed and transformed the violence of those efforts, but only out of a generosity that was strangely inhuman and that extracted a troubling price.[9]

PART FOUR

Talking with Statues

> The self
> Detects the sound of a voice that doubles its own,
> In the images of desire, the forms that speak,
> The ideas that come to it with a sense of speech.
>
> Wallace Stevens

> "Parla dunque! Che chiedi? Che vuoi? . . . Parla, parla, ascoltando ti sto. [Speak then! What are you asking? What do you want? . . . Speak, speak, I am listening.]"
>
> Lorenzo da Ponte (Don Giovanni to the stone guest)

Gathered together in book 9 of *The Greek Anthology*—among many other descriptions of, or fictive inscriptions on, famous works of sculpture—are thirty-four epigrams dedicated to the now-lost bronze statue of a cow by Myron, which stood in the Agora at Athens.[1] These late classical, primarily Hellenistic, texts show a relatively limited interest in the statue's cultic or ritual function, its mythic history, much less its social context. Such concerns survive, if at all, only as faint echoes within poems for which the statue poses a more strictly literary problem: what to say about an inescapably inanimate thing that seems, or that one wishes to seem, alive? The solutions are myriad. Some speak of it as a real cow that has been lost, stolen, or led astray. Some claim it has been magically frozen in place by the sculptor: "Myron did not mould me; he lied; but driving me

from the herd where I was feeding, he fixed me to a stone base" (9.719). Others insist that it has simply ceased moving because of its own laziness, or has "turned into bronze owing to old age" (9.716). Many texts refuse to pretend that it is other than an alien, artificial thing of metal, yet speak of the ways its appearance of life can deceive others, including (with all their diverse "interests") a herdsman, a thief, a lion, a calf seeking milk, a gadfly, and an aroused bull. (Should one recall the cow that Daedalus made for Pasiphae?) One text offers a hyperbolic fantasy of sound, something that seems to promise even further signs of life: "the bronze lows . . . perhaps it will plough" (9.740). Another uses such claims to demonstrate in the artist a quasi-divine transcendence of mere material limitation: "I think the heifer will low. Of a truth it is not Prometheus alone who moulds living creatures, but thou too, Myron" (9.724). Other texts, however, rather emphasize the artifact's unbreakable silence; they insist, that is, on the limits of human mimesis. But they often do so in a way that acquits the artist as much as accuses him; for example, "the bronze hardened before thou couldst put life into it" (9.736). One epigram indeed interweaves these conflicting attitudes within a chiastic riddle, telling us that either we see bronze come to life or a living creature turned to bronze, that "either Nature is lifeless, or Art is alive" (9.793). Often the cow itself is apostrophized, addressed as something that could understand a human voice, while other epigrams let the cow itself speak, sometimes to praise, sometimes to attack its maker. But it is emblematic of the kind of rhetorical mobility within these poems that they move fluidly, almost indifferently from indicative to vocative, from direct if hyperbolic description to apostrophe and prosopopoeia, with little sense that one mode of transfiguring the statue involves a more extreme or more unreal fiction than the others.

These epigrams emerge out of a kind of playful, competitive rhetorical situation in which the writer aims simultaneously to fix and praise the "life" of a work of art and dramatize his own astonishment at it. The epigrams may point by turns to the paradoxes of mimesis (dead material in the shapes or postures of life), and to the work's strange effects on those who look at it; they may also point to the evidence the work gives of the labor of a particular human artist, the

difficulties the maker has overcome. The energetic, often hyperbolic wit of such poems seems aimed at revealing a power intrinsic to the object itself, and yet they also try to valorize the speaker's own right to confer life and value upon that object, to inscribe and animate the material thing by means of the poetic word (hence, perhaps, those texts which seem to remove Myron himself from the process of making the statue). The poetic text thus doubles or supplements the work of the visual artist, taking advantage both of what is visible and of what is invisible in the figure. It is a wonderfully elusive game. The hyperbolic praise of the figure's "life-likeness" entails a conventional appeal to some fantasy of the perfect imitation of natural appearance, but what is astonishing when we examine such texts is how fluid the "life" or "value" in a particular object can be, how changeably it is exemplified, transferred, projected, and reappropriated from one epigram to another, and also how diverse the ways in which the sculpture itself can be given a voice to address the paradoxical conditions of its own making and appearance, even as it transcends these.[2] The object wins life from the poetic text, even as that text seeks to win a different life in turn from the object, as well as from the broader play of each text against the others.

These epigrams will serve as an introduction to some of the conventions, as well as the clichés, of "ekphrasis," by which term I mean formal, literary descriptions of real or fictive works of art.[3] The texts I have been examining are at best fragmentary, hypertrophied echoes of the great, extended, and more strictly mythopoeic ekphrases in classical literature. They have none of the cultural and cosmological resonance found in Homer's description of the shield of Achilles (*Iliad* 18.477–608). The artifact they address acquires none of the violent and talismanic power we sense in Hesiod's *Shield of Herakles*. Isolated as they are, these epigrams cannot describe a picture of heightened conflict between human and divine realms such as we see in Ovid's description of the competing tapestries woven by Arachne and Athena (*Metamorphoses* 6.1–145). But taken as a group, I think, these texts do reveal some of the permanent wishes and resources of the ekphrastic mode—still alive in a modern text like Keats's "Ode on a Grecian Urn" (itself a kind of meta-ekphrasis).[4] As exemplified here, the work of ekphrasis goes beyond mere praise of beauty or mimetic

accuracy. Rather, ekphrastic writing reimagines the character or the contextual situation of the figures represented in the work, often embedding them within a mythic, historical, or anecdotal narrative larger than that immediately provided by the work itself. The ekphrastic poet describes otherwise invisible pasts and futures for the object, or raises questions about motives, contexts, meanings, and forms of artifice beyond what is merely given in the work, to the point of rendering the work itself almost as fantastic as one that is purely imagined. Ekphrastic texts can also offer a rereading, if not a misreading, of the emblematic details of a work, sometimes making an emblem of what might have seemed purely mimetic (though this is less prominent in the texts I have quoted above). They further may submit the inanimate object to languages of seduction, conversion, complaint, or prayer, modes of analysis or decipherment, which may at first seem inappropriate to it. If this strategy manages resolutely to anthropomorphize the artifact, it also turns our attention away from the artifact itself and toward the complex act of reading it and the subtle wrestling match between competing readings. Again, one senses in such texts a tacit claim that what valorizes our interest is not the object proper, its beauty or magical aura, but rather the words of the poet that hang themselves on that artifact.

One should observe that, aside from their relation to epic ekphrasis, these texts recall at moments two other genres of epigram found in *The Greek Anthology*, both of which are literary developments of more archaic forms. The first is the genre of votive or dedicatory inscriptions, that is, texts that represent words actually or fictively inscribed on some object left in a temple as a gift to a god.[5] Inscriptions on statues are common enough in the collection, but one can also find texts that dedicate a warrior's shield to Ares, a mirror to Aphrodite, an anchor or fishing net to Poseiden, a scribe's stylus and ruler or an actor's mask to the Muses. Some describe the gift and the giver, ask a boon, thank the god for past favors, or ask the divinity to take delight in the votive itself. Rather than just describing the object, in other words, they help put it into play, or animate it, as the site of a ritual event; they mark it as a thing in jeopardy, even the focus of a sacred contract or sacrifice. It is perhaps as a reflection of this heightened investment that many of the texts lend a voice to the object

itself, letting the statue, shield, mask, stone, or shell speak for its absent donor. In addition to votive inscriptions, the ekphrastic epigrams also recall the *Anthology's* vast gathering of epitaphs on the famous or not so famous dead—texts concerned with addressing the fame and fate of the dead, securing their memory, speculating on the forms of their survival.[6] Such texts not uncommonly give a voice to the voiceless corpse, and sometimes even to the tomb or cenotaph itself, voices that can ask a passerby to stop and meditate on a tomb, consider its history, keep it free of violation, sometimes even entering into a fictive dialogue with the living. These texts admittedly exhibit a high degree of irony and literary self-consciousness (as witnessed by the frequent epitaphs that mock rather than praise a grave's inhabitant, that competitively imitate other epitaphs, or by epitaphs such as those in which the corpse curses a murderer who left it buried *without* a proper tomb or inscription). But the epitaphs also remind us, as do the votives, of the inevitability of the demand that the poet find a way to lend voice to what properly has no voice; they indicate the curious, spectral ease with which an act of writing can draw us into the fiction that we are at a site of daimonic encounter.

Of course, the ekphrastic epigrams, considered as epitaphs, speak more of the death and life of human artifice than the death and life of human beings; insofar as they recollect votive inscriptions, they mark an exchange or contest between artists and poets rather than between the human and the divine. But these two cognate forms may nevertheless suggest some of the more troubling demands that can haunt the act of describing a visual artifact, even something as simple as the bronze statue of a cow. They may help us sense why it is that the game of ekphrasis always seems to be exemplary of something larger than itself.[7]

The degree to which the literary or rhetorical play of ekphrasis transforms our consideration of an artifact may be clearer when we look at one of the group of longer, prose ekphrases of the fourth-century writer Callistratus. Take, for example, his description of a lost statue of a maenad by Skopas. Here there is elaborate praise for the radical mimesis of wildness in the work of stone, for both the impression of violent physical motion and the suggestion of mental derangement: "though it had no power to move, it knew how to leap in

Bacchic dance . . . we stood speechless . . . so clear an intimation was given of a Bacchante's divine possession stirring Bacchic frenzy though no such possession aroused it."[8] Callistratus also admires the artist's skill at catching, in the same inanimate material, the look of both live flesh (the dancing woman) and dead flesh (the slaughtered faun she carries). By a remarkable allegorical twist, the statue's mimetic wildness is asserted to be a "proof" of the sculptor's own daimonic inspiration, evidence that "the hands of sculptors also, when they are seized by the gift of a more divine inspiration, give utterance to creations that are possessed and full of madness"—as if only one possessed by a god could sculpt a figure possessed by a god. Here the god animates the sculptor, who allows the marble to be animated in turn (even as the statue seems to render its viewers as silent as stone). The climax of the piece, however, is a comparison between the sculptor's ability to give inanimate matter life and the rhetorician's ability to use words to make invisible things appear visible, to create a reality out of words. It praises Skopas (again like the rhetor) for having created a thing that depends upon the artist but that also lives beyond him, something that is both the artist's support and master, and which, though dead, will yet "keep alive its own creator."[9] Here the text makes the life of the statue strangely redundant; that life feeds on itself and on the desire of others for a power like that of both statue *and* sculptor, even as the text seems both to ironize and to hyperbolize the statue's claims on life. The epitaphic background of ekphrasis emerges in this text as well, but it is combined with a strong, self-conscious display of the powers of visual art to deceive, to render reality and the terms of life and death unstable, even as the text displays the power of rhetoric to tease out that uncertainty. The ekphrastic text, in ritualizing our gaze and in submitting it in fiction to the words of the rhetorician, is also reframing and challenging that gaze, embedding it within a situation of curious, unbalancing doubt—"so unbelievable is what you see, so visible is what you do not believe," says Callistratus of the artist's work.[10]

The product of the skeptical milieu of late classical sophism, a text like Callistratus's works playfully within the realm of what is not as much as that of what is; it subjects the artifact to a consciousness of

the volatility of appearances, the presence of absence. Acutely conscious of the gap between word and object, it yet suggests the diverse ways in which one of these may seem to mirror, depend on, or master the other, even as it suggests that such a gap can become the site of more elusive, even ghostly, negotiations.[11] It is clear enough by now that the classical ekphrases I have cited will often reach beyond what is given or visible in the works they "describe." Equally worth attending to, however, are these texts' often oblique ways of returning to the sculpted object, of finding a center of gravity or point of purchase in what is given. These texts often convey a desire, as it were, to repossess, acknowledge, and take responsibility for the silence, stillness, or opacity of the works they address, to make sufficient (even if only ironically) the material conditions of the artifact. This facet of ekphrasis might be illustrated as well by Keats's "Ode on a Grecian Urn," with its catachretic tropes of stilled motion and silent music, or by the appeal to "l'esser di sasso" in Michelangelo's epigram on the statue of Night, but two examples from the *Anthology,* both on Praxiteles' statue of Niobe, will suffice to bring out my point here. The first of these texts seems realistically to confess the artificial limits of the work, and yet does so in a way that reinvents them, indeed, freeing the artist from any culpable failure of skill: "If it is not given to her to have a soul, blame not the artist for this: he portrayed a woman of stone" (16.130). The second is even more striking: "From a living being the gods made me a stone, but Praxiteles from a stone made me alive again" (16.129). This more directly outrages the limits of mimesis, first by giving the artist a power to overturn the deadly punitive work of the gods, and more bluntly by giving the dead statue itself a mind and voice. Both texts may seem conventional enough, of course, but something in their tropes is worth pausing over, for each in its own way struggles to find a voice and a mode of consciousness for the statue that is fitted to its peculiar history, ontology, and use as a statue, rather than simply as the image of a human being. The statue speaks, but it speaks (impossibly) *as* a statue. It would only literalize such fictions to say that they are essentially "truer" to the work of art itself. Nevertheless, both of these epigrams raise the question of how the verbal text, which seeks to animate or go beyond the visual object, may yet register resistances imposed by that object,

or by something in our attachment to that object. Such texts ask us to weigh the counterpressure the material work of art exerts on the flow of words that circulate around it. They also make us ask how much such resistance truly depends on the artifact—in all its materiality and opacity—and how much that resistance may strangely enough be lent to that artifact by the text that describes it.

The play of influence and resistance I have been describing is not the only concern of ekphrastic writing in classical and later texts. (My account neglects, for example, the way that ekphrastic interludes in longer epic, pastoral, or romance texts can serve as allegorical microcosms, or as essential moments of thematic and generic self-reflection.) It is also clear that investments in the "material" conditions of the artifact shift widely through the history of the form. Different periods will see the statue's opacity under a markedly different guise, see a changed seduction or danger there, lend or deny a voice to the artifact in a different way.[12] But the struggle within a text between its adhesion to and transformation of the artifact it describes—even if the artifact is only an imaginary one—continues to absorb poets writing in the tradition. This struggle is indeed crucial to the broader, parabolic character that the gestures of ekphrasis can acquire. That struggle becomes as well the occasion for some of the tradition's most splendidly occult flights of invention.

Before looking at two modern examples of ekphrasis, I need to digress for a moment, to offer some broader reflections on what it might mean to address a statue's opacity, what fascinates us in the common or uncommon activity of attaching words to a work of art, even giving that work an ear or voice of its own. This discussion diverges from issues raised explicitly in such poems themselves, and certainly will take us a great distance from the witty play of *The Greek Anthology.* But it is necessary as a way of enlarging our sense of the situation in which we read ekphrasis and our sense of what can be at stake in the effort to talk with statues.

I begin with a dilemma: we inhabit a world in which the words we speak often silence those who speak to us. Our utterances preempt, block, or deform response. We produce words that convert other speakers into stones without sense or wish, silent statues, empty

masks, or else things returning only the mechanical responses of an automaton or a ventriloquist's dummy. We are silenced as well, not only by the words of others, but by our own words—the words we inherit, overhear, and repeat. We fall silent; silence falls on us, whether out of weakness, terror, ignorance, or subterfuge. We forget our words, or simply have no words. We may or may not know this. It is not easy to categorize such acts of silencing, such interruptions of the flow of discourse. Following Paolo Valesio, we could start by rigorously distinguishing these "transitive" silences both from mere muteness and from what he calls "plenitudinous" or "metaphorical" silences—the silences we imagine in love, in a god, in the world, the silence of unliving things, even a silence we posit at the heart of language itself.[13] The "acts" of transitive silence may look violent, like forms of repression or entrapment, or like repudiations of language, a burying of things beyond memory or expression. Yet such silencings can also be a form of survival, a means of resistance, a way of stilling an invasive clamor, or keeping words already spoken from being drowned out, or of holding open a space in which other words or echoes might be apprehended. Again with Valesio, we might divide the domain of transitive silence into negative and positive poles, separating the silences of prohibition, frustration, exhaustion, oblivion, and panic from the silences of protest, concentration, anticipation, revery, and calm; we might divide silences that disrupt the sense or flow of speech and those that help shape speech, distinguishing the silences of the diplomat, priest, or spy, from those of the prisoner, the aphasiac, or the hysteric. The very listing of these alternatives will suggest the thickness of the presence of silence, and how overdetermined its domain. It should make clear that any human silence is a site of conflict and misrecognition, at once muddled and infectious. The sense of a silence, like the sense of a word, is thus often up for grabs, even when that silence serves as an image of what is *not* up for grabs, what seems to exist beyond the deformations of human language.

In a world crowded with such acts of silence, with so many petrifying words, there is a peculiar force in the act of addressing a thing whose lack of speech, whose muteness, opacity, and obliviousness is so inevitable, where the gap between word and response, word and

object, displays itself so immediately. The attempt to grant a statue an apprehending ear, a voice, even a motivated silence of its own, can become an occasion to redream the possibilities of speech. That attempt puts language and silence (as well as the statue) on trial; it lets us examine what piety or care, what violence or emptiness, words can carry, what bonds or estrangements they create, what they make us blind to, what they can make us remember or forget. Indeed, the very obvious fictiveness of such "dialogue" turns speech with the statue into a parable of speech, the statue's silence into a parable of silence. (Think, simply, of playfully trying to fix different motives to the silence of a certain statue one encounters in a gallery, for instance by asserting that it is hiding something, feigning speechlessness, or waiting for *you* to speak, that it is shy, or under threat of death, or like Keats's urn, speaking words unhearable by mere physical ears.) To probe the fantasy of speech or silence in stone would become an occasion to reflect on what it means to speak within or against other silences, to speak within or against a language that inhabits such silences. It may teach us what our own need or fear of silence may amount to. That probing may help reactivate our hardened ears as well as our jaded eyes.[14]

In many of the poems I have touched on, it is not always simple to say on whose behalf a statue speaks, who owns its silence. But I would argue that ekphrastic texts often incarnate a demand—which can emerge from the poet, the imagined audience, or even, one might say, from the statue itself—that the voice or silence lent to the statue be more than just a narcissistic projection; it is a demand that the statue be more than simply a mirror or a useful mouthpiece, that the text entail more than just translating a statue's language into our own, finding a natural place for its imagined words in the given world. The work of ekphrasis will be as much a matter of allowing the words that a statue speaks to unsettle the words we already seem to know, to recreate, shatter, or reassemble those words. That may entail the poet's or poem's insistence on our hearing words spoken by the statue that are otherwise not to be heard, or that cannot have been intended by its maker, words also different from those provided by other writers, or by other, prior listeners.

Here we enter into an ambiguous domain. The ekphrastic text ap-

pears as a site of odd symmetries and reversals, passages and con-
taminations between opposing realms: the natural and the artificial,
the human and the inhuman, the living and the dead. We might want
to think of ekphrasis as making possible a kind of lyric iconoclasm, a
means of releasing the writer, viewer, even the artifact itself from that
artifact's material, visual, and ideological fixity; but an ekphrastic text
may also discover in the object a curious power to survive that icono-
clastic speech, to resist the predications hurled at it by the poet. Even
if we consider that the aim of ekphrasis is by contrast a way for the
text to identify with and repossess "all of the energy that . . . is re-
flected in the object," we may also find that the inertness or silence of
the object can steal back into the words that are addressed to it.[15] In
his account of the different resources of visual and verbal art in *Lao-
coön*, Lessing warns that the riches of one medium are the poverty of
another; but it may be just that poverty that is being courted in an
ekphrasis.[16] If the words of an ekphrastic text often resist the opacity,
the mute violence of the object by the fantasy of its motion or speech,
even the fantasy of its motivated silence, one may yet find that
muteness and opacity transported back into those words, or covered
over delusively (if not translated into an entirely new dimension).
There is a certain freedom, a sense of liberating doubt implicit in the
work of ekphrasis. But such texts can also convey the knowledge that
no freedom or doubt is pure. At least such purity of freedom or doubt
is not anything that the speaking statue trope will let one imagine.
The sense of freedom gained will always remain fragile and alien,
uncannily bound, while the doubt will remain unstable, its very ob-
jects hard to locate. One finds in the end that it is no stranger for us
to speak to a statue than to speak to each other, or to ourselves,
though it may often take an entire poem to make one feel that this
is so.

What is at stake in this picture of ekphrasis comes out sharply
when we place it in relation to Paul de Man's accounts of the trope of
prosopopoeia, the often hallucinatory figure by which poets lend a
voice, face, or apparent subjectivity to things in themselves inani-
mate, absent, or lost—the wind, a dead child, a past self, an ideal of
liberty. Prosopopoeia is for de Man the paradigmatic figure of lyric,
and of the reader or reading in general. What is most important to

note here is that de Man locates in this trope an unspoken threat, one that he links to the vampirish logic of epitaphic inscription, and that may attend the work of ekphrasis as well. The threat is that "by making the death speak, the symmetrical structure of the trope implies, by the same token, that the living are struck dumb, frozen in their own death" (a death that is still never quite their own).[17] Prosopopoeia in this sense always entails a broken promise, or at least a suspended promise. It suggests that a gap can be bridged, that words can give life to the dead, give to the object a subjectivity that is not merely our own, that our words can restitute the mournful silence of unliving things, or at least master our own silence before such things.[18] But such gestures of bringing the dead to life entail reflexively a bringing to death, or a situation in which it becomes impossible to tell "whether language is what gives life or what kills."[19] Stable oppositions break down, reveal themselves as subject to merely conventional, contingent, and figurative distinctions; in apostrophizing the dead, "one moves, without compromise, from death *or* life to life *and* death."[20] If such a pattern remains seductively enigmatic in de Man's writing, it is also a plain manifestation of the inevitably privative, arbitrary force of linguistic signs, and of the disenchanting failure of such signs to coincide with their putative objects, to guarantee either the existence of those objects or our knowledge of them. This failure serves to motivate the fantasies of prosopopoeia, even as it is something that such a speech act, in its wished-for resuscitations of life, tries to deny. It is the blind violence of that denial that ends up so dramatically undoing the speaker, freezing both the speaker and his or her object into stone, since that speaker thereby participates in, and unwittingly exposes, the lack structured into language. (Shelley gives voice to the West Wind, but it is the voice of a power that destroys as well as preserves, that takes away as much as it redeems the merely human voice of the poet.) With characteristic irony, de Man suggests that if lyric prosopopoeia so regularly finds itself lending voice to things like graves, statues, or inanimate objects, it is mainly because such things manage to preserve or tacitly acknowledge, even in the face of the animating claims of prosopopoeia, the negative power of the linguistic sign (and the negativity crossing the selfhood deploying that sign).[21]

For de Man, all attempts to use language to give form or meaning to the world—to describe a cause, locate an origin, posit a subject, reconstruct a lost wholeness, to mirror a reality—turn our words, and we who use them, into statues, into monuments and tombs.[22] (These are de Man's tropes here, not mine.) This transformation at once exposes the ambition of users of language to create something fixed or whole and reveals the failure and dehumanizing violence of that ambition; the figures and statues that language creates appear in their very origins as broken, mutilated, and defaced (perhaps simply because they *are* statues, not living persons). The attempt at memorialization institutes oblivion. Moreover, any attempt to know or undo the process merely repeats it, since such an attempt will not cease to participate in the violence against which it is directed.[23] There is no restitution, no warming of the dead; even the interiorizations of mourning are deeply suspect. In de Man's account of Rousseau's *Pygmalion,* for example, we see the fictive sculptor move through a series of vascillating negotiations with his "aptly monstrous," immobile statue, negotiations that include sublime bafflement, aggression, adoration, allegorical reading, and self-immolating or self-sacrificing identification. But none of these strategies succeed; even the last, most extreme move reveals itself only as one of an endless chain of substitutible figurations. There turns out to be no escape from the shifting, contaminated antinomies of self and other, death and life, art and nature. If the statue is "brought to life" in the fiction, or finds its lack restored, the fiction of its life "feeds upon colder fires than those burning at sacrificial altars," since it is brought back to life at a radically negative moment by the arbitrary positing power of the signifier.[24]

In the present context, it may suffice to take from de Man a stark reminder that it is as strange to speak to flesh and blood as to speak to a stone, that our language itself refuses to grant us what we wish it to grant us, remains alien to the world it does give to us. If I had space to articulate my own questions about de Man's project here, they might start from a curious suspicion, namely, that de Man gets statues wrong. That is to say, on some occasions when he deploys the trope of the statue as an ironic emblem of our ways of knowing or naming, he tends to conceive of statues as if they were in essence

stiffened, frozen bodies, as if all statues were bad nineteenth-century statues, statues that have forgotten that they were statues or are nothing but statues.[25] Indeed, death itself in de Man tends to resemble something like the conversion of a living being into a statue, rather than an event against which the statue may rather be a defense, if a desperate one. (Perhaps this is the only kind of death that matters, of course, or the only way we really have to figure such a death.) Likewise, the kind of wound de Man speaks about is mainly (to quote a characteristic phrase), "the wound of a fracture," a thing pertaining less to bodies than to marble.[26] The misconstrual of statues in turn infects his use of statues as a figure for the ontology and work of the linguistic sign, for its gift, its law, its mode of memory, that sign that admittedly never succeeds in undoing either its own or the statue's lack of animation. This picture of statues at least points to part of the reason why de Man's account of the signifier can often seem not so much reductive as melodramatic (even if the melodrama is a rather antisentimental, pathos-denying one). De Man's picture of statues assumes we are asking for something we may never really be asking for. If there is something to be brought back, however, from this detour through a theory of the death of the sign, it is a renewed awareness of the care we need in making sense of the trope of petrification itself, and of the fictions of animation by which we equivocally try to undo it. We cannot know what kind of life or death the statue or the sign may bestow; we must distrust even our most rigorous demystifications of those terms, our construction of their disenchantment. But we should nevertheless try to locate ourselves at a site where we are ready to apprehend the call of the statue, even if it will be unlike a call we might want to think of as our own, as pertaining to us. We need to imagine a response to that call or voice, no matter how much that call or voice simultaneously silences or throws off our responses.

Let me turn at this point to one of the most important modern ekphrastic texts, Rainer Maria Rilke's sonnet from the *New Poems* (1907–8), "Archaic Torso of Apollo."

> Wir kannten nicht sein unerhörtes Haupt,
> darin die Augenäpfel reiften. Aber

sein Torso glüht noch wie ein Kandelaber,
in dem sein Schauen, nur zurückgeschraubt,

sich hält und glänzt. Sonst könnte nicht der Bug
der Brust dich blenden, und im leisen Drehen
der Lenden könnte nicht ein Lächeln gehen
zu jener Mitte, die die Zeugung trug.

Sonst stünde dieser Stein entstellt und kurz
unter der Schultern durchsichtigem Sturz
und flimmerte nicht so wie Raubtierfelle;

und bräche nicht aus allen seinen Rändern
aus wie ein Stern: denn da ist keine Stelle,
die dich nicht sieht. Du mußt dein Leben ändern.

We cannot know his legendary head
with eyes like ripening fruit. And yet his torso
is still suffused with brilliance from inside,
like a lamp, in which his gaze, now turned to low,

gleams in all its power. Otherwise
the curved breast could not dazzle you so, nor could
a smile run through the placid hips and thighs
to that dark center where procreation flared.

Otherwise this stone would seem defaced
beneath the translucent cascade of the shoulders
and would not glisten like a wild beast's fur:

would not, from all the borders of itself,
burst like a star: for here there is no place
that does not see you. You must change your life.[27]

Charged with a strange, urgent longing, this poem haunts us most
strongly insofar as it troubles the terms of haunting, even as it puts
into question the shape of our disenchantments; it forces us to mea-
sure more radically the fantasy of the statue's animation, to place the
idea of its past or future life more carefully in regard to our desire,

nostalgia, and skepticism. There is something lost, a head that we cannot know—though this is converted into the lost truth of a legend, rather than merely a lost piece of stone. That loss—of the face with its blind eyes, the archaic inward smile—must be made more than contingent, converted into a form of sufficiency or completeness (a paradoxical wholeness such as Rilke will find in the "fragments" of Rodin).[28] But this demand itself forces us to certain strange, perhaps desperate, questions about what drives such compensatory fictions, what it is they restitute. Is it only because of that absence and fracture that the poet allows himself to imagine the headless torso's acquiring a human visage, finds himself lending it a powerfully erotic feature, a seductive smile, and a gaze that seems to know *us* (knows us in more than our ignorance of it)? And is it only because the stone fragment offers at once so opaque and crystalline a surface, so solid an interior, that the poet can imagine an energy, a wild light breaking out from that interior, from a lamp yet turned down low? Is it only because of that complete opacity that he can imagine the statue as returning our gaze, seeing us ("you," the author, the reader) from every point on its broken surface, like Argus, or the beasts that ferry the apocalyptic chariot, or the Greek statues described in Hegel's *Aesthetics* (figures with no individuating, inward glance but rather with an eye diffused over their entire bodies)?[29] Splendid and innate as it seems, the statue's "life" is no less uncanny, no less strangely lent and displaced, than that of the nameless corpse in "Corpse-washing" ("Leichen-wasche"), also in Rilke's *Neue Gedichte*, where the care, attendant grooming, but also the residual fear, embarrassment, and ignorance of its attendants transform a dead body into a thing that lies in state and "gives commands" (though exactly to whom, and to what larger end, we cannot know).[30] The Apollo sonnet, we could say, has itself cut off the statue's head, has itself frozen this living body; the fragment fascinates us in having absorbed our violence against it and turned it back on us, so that the statue that "draws the self [also] takes on the power to question, displace, evade, estrange, undo, or otherwise disrupt it."[31]

The life Rilke grants to things is endlessly strange, delicately harrowing, since his writing preserves and transfigures the absence of things in their relation to us, preserves their fragile thingness (in

which we may ourselves participate), even as it gives them a life or phantom intentionality alien to our own. We can put against the sonnet on Apollo the poet's essay "Some Reflections on Dolls."[32] Here, trying to define the curious mode of a doll's existence, and the quality of our attachment to that existence, Rilke dwells at length on the moment in the child's history (our history) when the doll suddenly becomes the object of anger and frustration. That point is distinctly not the one Baudelaire describes in his essay on toys, the moment when the child/metaphysician violently twists and turns and shakes the doll in search of its soul, only to find that it has no soul, finds that the doll refuses his or her wish for its life.[33] Rather, Rilke imagines us angry and horrified when we discover the doll's infinite malleability to being dreamed, its endless receptivity to our fantasies of its life, when we discover that stupidity of dolls that lets them be just what we liked, lets them be "fed like the 'Ka' on imaginary food." Where Rilke finds comfort, then, is rather in dolls that have grown old, which have outlived their children. In their very estrangement, Rilke sees these dolls as the earliest guides and markers of our real, skeptical entry into the world, into a world of things that escape our knowledge and desire. "We took our bearing from a doll," he writes, even from the silence it inflicts on us, a silence of which the doll itself makes nothing. This ironic praise is not itself sufficient, however. In search of a rapport with the doll transcending *both* narcissism and skepticism, both projection and opacity, he suggests that the real object of our fascination is what he calls the "doll soul." This is, we must say, a *secular* soul, a "thing-soul," not made by God, rather a gift of things to us, but only if we know how to greet it. That soul is hard to find just because, Rilke suggests, we are liable to destroy it in caring for the doll at all, in trying to lend it a *human* soul. Rilke does lend the doll a fictive life, but it is a life that manifests itself only in the doll's bidding us farewell; that life eludes the material doll almost as much as the child. The poet grants the doll a desire, but only to depart, imagining at the close of his essay a fire into which all dolls fling themselves like moths into a flame, whence "the immediate smell of their burning would inundate us with limitless, hitherto unknown emotions."[34] The fiction of life here scarcely survives Rilke's own skepticism of it, as well as his own romance with the

inanimate. In this late refinement or retrenchment of romance, we have dolls that awaken only in a holocaust, while we awaken only to objects that destroy themselves. He courts both their life and their alienation exactly in lending them an unknowable and an un*usable* subjectivity, making their burning an unusable sacrifice, an unusable loss.[35]

This strange courtship is at work even more starkly in the Apollo sonnet. However "persuasive" it is, the fantasy of the statue's life remains curiously opaque, willful, beyond any common figurations of recompense or pathos, as well as beyond mere hallucination or fetishism—testing how we bear our skepticism as well as our nostalgia toward objects, and toward the language by which we lend them life. Poised as it is, Rilke's posit of life, which cannot bear to acknowledge the statue's deadness, nevertheless could barely survive the fantasy of the statue's actually moving, much less the blunt fiction of its speaking. The description does eventuate in an utterance, a speaking out, indeed a demand addressed apparently to the reader: You must change your life. But the source and authority of that exhortation are hard to specify, the words themselves all but autotelic. It is an imperative situated so that we cannot say whether it emerges from the poet or the statue, whether it translates what the former "cannot know" or what the latter "sees" and "knows." The final words are offered in lieu of a tomb effigy's memento mori or *siste viator*, perhaps. But they also echo closely what the stone guest in Mozart's opera says to Don Giovanni: "Cangia vita," "change [your] life" (an invitation the hero pointedly refuses). You must change your life. By which I read: You must change your ideas of life, how you speak of it; your ideas of wholeness, survival, and knowledge; your relations to the objects and images that shape your life. You must change your response to imperatives about change as well (given the confusion of ethical and metaphysical ideas of compulsion in that mysterious "must"). Let us say that these are versions of the words the statue says to us and that it says them (insofar as this is imaginable) *as* a statue, not just as a mouthpiece for some hortatory, preacherly poet. But they are also words that we might say back to the statue. Finally, they remind us of what we are likely to look like, what we must risk

looking like, what kind of life or death we would need to inhabit, if we were to say these words to another human being.

Rilke's sonnet offers a kind of limiting case here, suggesting how extreme the decorums, the economies, and the accommodations of meaning are that can shape the fictions of ekphrasis. It points to questions that continue to haunt my next example, Richard Howard's poem "The Giant on Giant-Killing—Homage to the Bronze David of Donatello, 1430" (fig. 10).[36] In the background of that poem is Randall Jarrell's famous lyric on the same sculpture—a text whose own argument Howard's poem partly reverses.[37] But it seems to me that the deeper, if still covert, struggle animating Howard's piece finds its object in the Rilkean torso.

Unlike Rilke, Howard risks lending a personal voice to the statue. But it is not lent to its main figure. Rather it is the cut-off and fictively "unliving" head of Goliath at David's feet that "speaks" the poem. Perhaps it is too perverse to suggest that Howard is turning on Rilke by selecting not a headless torso but rather a statue with one head too many, a head which is itself torsoless. In any case, Rilke's precedent may suggest why such a head—a wounded part, a victim, a supplementary thing that the poet reads as more asleep than dead—becomes the site where the poet places a hidden voice in the statue, a voice that articulates a complex, revisionary prehistory for that statue. It is as if the poet wants us to find this admittedly ghostly voice more persuasive than any that another writer might lend to the silent, half-smiling youth, the one with more urgent claims on our attention, the one more proper to its *statuitas*. This voice speaking from the head's troped lifelessness is made to speak for the statue's deepest knowledge of itself, its sense of its own origin and future. It indeed claims to speak as the real "maker" of the bronze *David*, to speak as the statue's founder and foundation and not just part of the pedestal. The head of Goliath speaks as David's victim, but also as his Pygmalion.[38]

"My name in Assyrian means *destroyer*," he begins. "My name is a good word," a thing to serve a universal need, no shameful secret, we are told. Goliath first presents himself as a satisfying type of "the

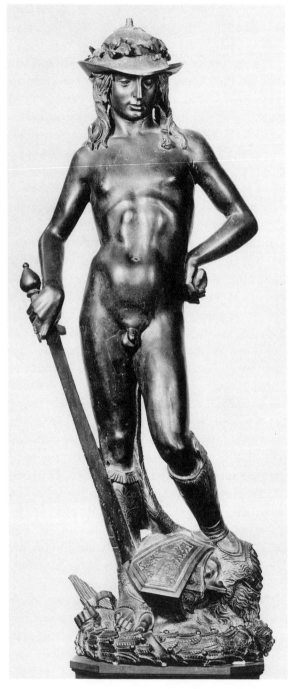

Figure 10.
Donatello, *David*
(c. 1440). Florence,
Bargello Museum.
Courtesy Alinari /
Art Resource,
New York

enemy": human but also monstrous, conscious but also like an idol, or even a robot. He tells us that his name, though a household world, was a power:

> *Goliath!* I shouted, and the sun would break
>> in pieces on my armor.
> The world, as far as I could see, was the sun breaking
> on things, making them break.

A mingling of diffidence and violence, this Goliath denies that even his own death surprised him. Why else, after all, would his head seem to sleep so calmly (as Kafka's Hunter Gracchus expected to sleep)? Indeed, the speaker reverses the terms of defeat; his "end" has made him not the victim but the secret empowerer of his child enemy, the animater of the visible statue:

> You see:
> the triumph is mine, whatever the tale . . .
>
>> my triumph
> inherits me. He holds my sword. He is what I see,
> that is why you see him.

While the head solipsistically declares its powers to master and possess the figure of David, this may seem to conceal (and defend against) a more conventional tone of resentment. Both the claim of mastery and the hidden resentment have a powerfully erotic charge. To some degree Howard plays off Jarrell's picture of the youth's blandly seductive torso as a kind of Medusa, an image of solipsistic, sexless (or at least androgynous), but "efficient" elegance; for Jarrell that torso, though an object of desire, becomes an image of the world's withdrawal and limitation, the youth being most like an indifferent, Rilkean angel with no message *but* its indifference. In Howard, the figure of David is granted no such autonomy. The head of Goliath declares that he has given life to David's body and power to his sword. Goliath's story also "explains" or "motivates" one of the more striking features of the statue, the strangely animate, phallic wing that ornaments the giant's helmet and that slides up the inner thigh of the youth to an end point invisible from the front. This wing becomes

the statue's own trope for the head's word, a bronze type of the knowledge articulated in the speech we overhear. Rilke's sonnet had displaced the knowing, archaic smile of the statue's lost head to its loins, locating that otherwise absent expression at "the dark center where procreation flared." But Goliath's wing/word touches an even more secret place between the youth's beautifully slung buttocks ("that is the boy's sling"). It reaches to "that focus where / nothing resembles a hollow so much as a swelling." That focus is immediately diffused, however, such that Rilke's assertion that "there is no place that does not see you" becomes Goliath's challenge to us to "find one place on his fertile torso / where your fingers cannot feed"—drawing us to the statue (orally as well as tactilely) but also pointing to an excess that thwarts any claim we might make to a knowledge like that which Goliath (rather desparately) claims for himself.

Like Rilke's torso of Apollo, the *David* becomes an image of Eros, the naked god of love without his wings (or rather with his wings strangely displaced onto Goliath's helmet). But the revisionary echoes of Rilke go further. For if the severed head of Goliath in part stands in for the headless torso (and perhaps that torso's lost head), then Goliath's head further "takes its revenges" on his slayer by refusing all importance or power to David's own head. In a strange fantasia of dismemberment, Goliath dissolves that boy's face, dims his strange smile, empties his eyes, makes of the whole head merely accident or absence: "the body is / what is eternal Only / the body sees."

That absence, fictionalized more ironically than even the presences in Rilke, has a limitation, however; there is an eventuality, a form of death-in-life, against which the statue cannot quite defend itself. The bronze boy's downcast eyes *do* see something, not a present image, however, but a shameful future. The "fate" of his body is not an erotic but a cultural and artistic hardening. What the statue sees is another statue. The end of Donatello's giant-killer will be to become himself another giant, to calcify into Michelangelo's *David*, that "marble assertion of a will to wound / against which no man or music can survive." The giant's words are thus also like a memento mori to both the victor and the viewer—as I am now, so you will be. The reflective figure of David, in Howard's startling reconstruction of an artistic genealogy, is himself made to mourn the head he stands on. But David also proleptically mourns his own later, darker manner of being inherited by his

victim, his way of becoming a version of the gigantic "father" he had formerly slain.

Like Wordsworth in "Ode: Intimations of Immortality," Goliath mourns his own disappearance from the later statue, even as he mourns the hardening of a heroic child into a violent giant. Speaking again as the foundation, not just the pedestal, of Donatello's statue, the absence beneath but also the double *of* Michelangelo's giant, this hero of the tyrannical idolaters ends the poem by renaming himself. Having previously preempted the place of the Israelite hero, Goliath makes himself the bearer of the name that is ordinarily the potent (if bitter) inheritance of the children of Israel:

> I am the man Goliath, and my name in Israel
> is also a household word,
> every household needs the word—perhaps there *is* a shame
> in that, a secret about such universal need—
> but it is a good word, my name; try it on your own
> tongue, savor the hard syllables, say *Goliath*
> which in Hebrew means *exile*.

Pausing on these closing lines, I would ask, What makes us accept this last transformation of the giant? What makes this self-naming utterance more strangely persuasive than the voice naming itself "destroyer"? To answer such questions, we must ask further on whose behalf, in whose name, this voice speaks, such that the fiction of its word sticks, has authority? It speaks on behalf of an unremembered history, on behalf of the blind knowledge of bodies, even those bodies victimized in history (unlike the head of Ozymandias). It speaks on behalf of a desire that would be more than simply destructive. It speaks, with an ironic triumph, on behalf of what is left behind, cut off, silenced, and yet recuperated—like the severed wing on the helmet of the severed head, which creeps with desire up David's thigh.[39] It speaks on behalf of an idea of exile wronged by being made secret and shameful, or perhaps by being made into a myth that serves those who conquer (a glance at Nietzsche). It speaks in acknowledgment of its own failure to preserve its fragile triumph, but it also speaks *against* the triumphs of mere statuesqueness, against the

gigantism and monumentalism of the oppressive state, against those who take for granted the statue's standingness, its empedestaled-ness, or its dynamic repose. That voice speaks in defense of the surmises and memories that inhabit and disquiet the idea of the stat-ue; it speaks on behalf of a sculptor (Donatello) who converts the Israelite hero into an erotic object through an art at odds with the classicizing discipline of Michelangelo. The voice of the giant may also implicitly protest the more brilliant romanticism of Rilke—pro-test its overwrought, dehumanizing (if not inhuman) figurations of secrecy and silence, or perhaps simply its failure to make "exile" sufficiently a "household" word. Similarly the giant speaks against the sly distancings, the skeptical aestheticism of Jarrell, who prefers to imagine the *David* as an indifferent, petrifying angel.

Again one can ask, what makes this fiction of voice persuasive, or convinces us that it is "proper" to this statue, if only within the domain of the poem? It is partly that the poem so powerfully re-possesses the voice's own alienness, confesses its own exile, its own ad hoc and desperate fictionality—that the statue so plangently courts the (utopian) blessing of being an alien rather than a destroyer. The gesture of self-naming moves from blithe triumph to a sterner tone of elegy, yet the poem's last words are not simply an epitaph (Here lieth Goliath) nor, as in Rilke, a blank demand for change. The poem does end with an invitation to us, but it is an invitation to pronounce a word, a word that undoes another word, which names the effect of its own passage into another language, a language itself of exile. (Howard's "pun" deftly mimes the kind of covert biblical wordplays we find in Genesis 11, where the name "Babel," "Confu-sion," applied to the failed tower, punningly mocks the original Babylonian meaning of *Bab-ilim* as "the Gate of the Gods.") No mag-ical utterance, this word yet has a special claim on us, providing acknowledgment, challenge, as well as a strange kind of sensual plea-sure. Sound shuts down at the poem's end (along with heroism), but one is left with a word to roll or taste on one's tongue, the breath of a statue that makes one remold one's mouth and thought.

The word is "Goliath." In English, a tongue of second exile that could yield, by dismemberment, "Go!" (as opposed to "Stop, passer-by"), "goal" (a triumph? a death?), "lie" and "lieth" (the act of a

corpse as well as a poet). It is not an order to change one's life. But is it an order to go out and lie, to stave off death with a lie like the poem? Or to die, lie down, exile oneself in the falsehood that is death, desperately ordering what is merely inevitable? No sacred etymon, rather a name that is itself an unnaming, denying property and place, the statue's word draws us back to the awkward contingencies and incommensurabilities of language and history (making the poem a mordant parable of Howard's work as a translator), suggesting the closeness of these contingencies to those that shape the self and the body. This name becomes the site of both resistance and revelation (though different from that provided by the sacrificial crucifixion on "Golgotha"). As in Rilke, what the statue says is something we might say both to the statue and to ourselves. The poem invites us to imagine that all statues are named, or name themselves, Goliath (instead of Galathea), that the word all ekphrases hear or translate is "exile" (even more than "destroyer"). It suggests that "Goliath" is the first and last thing statues will say to us, if they are to say anything at all.

In ekphrasis, the voice of the statue is in exile from the statue. That voice may try to find a proper home there, try to speak for the statue, or make the statue's silence into a form of speech; it may inhabit the statue's fractures, ambiguities, and absences. Still, the statue's voice may survive only as a rumor of voice, an echo whose source is unknown, something unconjurable, and liable to be drowned out by other voices or competing ekphrases. If it seems part of the statue, that "voice" may look more like something scrawled or scratched on its surface by an alien hand, not a votive inscription or an epitaph but only graffiti.

A parable of the dilemmas of ekphrastic voicing emerges in the web of conflicting stories that, starting in the late classical period, are told about a ruined stone colossos standing on a plain near Egyptian Thebes, a statue identified with the hero Memnon, son of Aurora or Dawn, slain by Achilles at Troy.[40] This statue was said to make a sound each morning when struck by the rays of the rising sun. Some writers took the sound of the statue as an empty legend, and even among those who acknowledged it there was little agreement as to its origin or meaning, as to whether it was human, divine, or natural,

trick or miracle, or whether the statue's sound was to be called a voice, a cry, words, music, or simply inhuman noise. The meaning of the sound recedes, the more we try to grasp it. The noise of the statue was often read as a cry of joy, a consolatory greeting of a lost son to his divine mother. Others took it as a diurnal lamentation, the statue's mourning for its own loss, as it were, or asserted like Callistratus that the statue sounded twice, with joy at dawn and sorrow at twilight.[41] Inscriptions scattered over the base of the statue itself—some suggesting that figure's appropriation by a quasi-official Roman imperial cult—not only mark the precise dates and times of the sound, but make of it an oracle, a gift or blessing to those who made a pilgrimage to the site.[42] Other visitors, though, such as the skeptical Greek geographer Strabo, heard only a meaningless thud and suspected that it was the product of priestly subterfuge.[43] Callistratus, too, is guarded in appealing to actual supernatural origins, even as he makes the statue bear witness to the nearly miraculous powers of Egyptian artisans, who put sensation, hearing and speaking, into dead matter.[44] Yet another tradition, denying both pious fraud and acknowledged artifice, asserts that the sound began only after the statue was ruined in an earthquake, hence a voice speaking out of inhuman disruption rather than human design—something proved when the statue stopped sounding after it was repaired.[45] Callistratus spoke of the statue as the sun's lyre; others compared the statue's sound to the breaking of a lyre string, its music marking thus the death of music.

The bare idea of sound struck in a statue by sunlight suggests an uncanny crossing of a threshold; it is an image of mute stone somehow echoing light, its voice a gift of light to the ear, or light giving birth to voice. It is like a dream of our ordinary wakings to light and noise, a dream of our emergence from the opacity of sleep. It also suggests the idea of a voice strong enough to emerge in the face of an overwhelming influence, such that even its mournfulness partakes of a sense of resistance and breakthrough.[46] None of this, however, makes the voice any easier to fix in place or localize in the figure of Memnon. Even if it somehow originates "within" the stone body, it is a voice troublingly bound to cycles of causation outside the statue itself. This makes it hard to say for sure where the sound comes from, who owns it, and hence what the call of the light or the answer of the

statue amounts to. It is hard to say even if we should find any mean-
ing in the statue's silence (despite the inscription of a "sophist" who
insists that the statue of Memnon, like a trained rhetorician, always
knows when to speak and when to say nothing).[47] To inhabit the
stories about this statue in fact demands that we hold onto contradic-
tory recognitions: that the voice of the statue both acknowledges
death and promises survival; that it is the ghostly voice of the dead
and yet the product of an arcane artifice; that it is an inhuman noise
that has human meaning, or a human voice that is nonetheless sub-
ject to both accident and craft; that it is both mechanical and mirac-
ulous; that it is threatened by the very same persons who try to
conjure and repair it. Such paradoxes threaten to block our interroga-
tions, perhaps. But at the same time, they also lend the rumor or
memory of the statue's voice the power to draw us, to draw our
shifting wishes for and identifications with the statue, and hence to
test our desires for its voice. They lend to that possibly meaningless,
and now certainly vanished, sound its oracular or spectral quality,
even where neither god nor demon makes its appearance. (One
wants to say that the conflicted memory and promise of the voice
indeed become the voice.)[48]

Callistratus asserts that Memnon's music was answered every
morning by Echo, that endlessly protean figure, herself a stone,
whose voice can be by turns elegy and parody, a figure of voice's
emptiness, contingency, and secondariness, and yet a promise of
some subtler relation and renewal.[49] This leads one to ask whether
the statue's antiphony could participate in any larger harmonies.[50]
Whom besides dawn might the statue of Memnon answer, console,
tempt, or enlighten? What other voices might it second? Could it not
seem as if its voice strives to drown out another voice that might
emerge from the stone? Perhaps the sound struck out by the sun is a
mask, and the statue gives its true call only in darkness, under moon-
light, or when illuminated by a flash of lightning or struck by a desert
wind—and then only to certain people, maybe to those not trying to
listen.

Such surmises may suggest ways to repatriate the exiled voice of
the statue, to find for that voice a fiction of relation, even as they
acknowledge how partial and contradictory such forms of relation

will be. Like other conflicting rumors, they reflect the voice's mode of survival, indicating what we may invest in that survival. These surmises also suggest why the myth of Memnon can serve us as a tentative myth of ekphrasis. But if they have power for us, it is only insofar as they both respond to and challenge any wish for a voice and continue to open up space for fresh surmise. That is part of the labor of mastering doubt, as well as of keeping alive desire and memory, which may be the only reasons for trying to keep the statue alive.

The Thing Itself
(Which Does Not Move)

Ekphrastic writing turns on statues, makes metaphors out of statues' peculiar mode of being. But statues also turn on themselves. Works of sculpture, like the texts that try to speak about them, can turn on their own character as works of sculpture. Statues can become allegories of themselves, find ways of commenting on their own motionlessness or muteness, their curious violence, their subjection to human craft, even their relation to other statues. In many cases this is part of the means by which a work of sculpture can secure particular illusions of life or movement. But such turnings are also a means by which the work may seek to contain or short-circuit the idea of its having sentience or motion, the potential for human speech or silence.

Part of what I have in mind here is a commonplace. It has long been a basic task of critical writing about sculpture to give an account of how various sculptural traditions manage to accommodate, and sometimes overcome, the necessary stillness of the sculptural medium, how they may develop particular formal and symbolic means of lending what one calls movement or animation to the inanimate shapes of sculpture. It is conventional enough, for example, to point to the evolving exploration within classical sculpture of poses or lines that do not merely suggest arrested motion, arrested life, but that "conserve" life by harmonizing a number of conflicting motions at once, rendering intelligible the body's articulations and dynamics; we can describe how such poses convey a sense of potential motion in

the past or future of the figure, often by being made part of a gradu-
ated series of motions involving other figures; we can sense how the
poses of classical statues offer an image of bodily power, self-posses-
sion, or human freedom in the form of motion withheld, latent, or
suspended in dynamic repose, forms of motion often placed in subtle
harmony with other, nonhuman motions. It is also clear how, in
Renaissance sculpture, for instance, such forms of motion could be
imitated and enriched—whether by embedding individual figures
more fully in a narrative context (often made possible by refinements
of bas-relief), by subtler combinations of naturalism and abstraction,
or by an intensified exploitation of the rhetoricity and theatricality of
sculptural form. We can also see how such sophisticated illusions of
bodily motion were both resisted and profoundly transformed by a
sculptor like Michelangelo, for instance, who binds the fictive move-
ment of individual bodies to more alien, disembodied motions, to
other formal or symbolic orders, or sets in sharper conflict the inher-
ited postures of previous sculpture. Rodin undoes even more radi-
cally the figurations of bodily motion inherited from prior sculptural
tradition, making his figures by turns more intensely grounded or
more impossibly free of gravity, as well as breaking more sharply the
envelope of the individual body, drawing his forms more prob-
lematically back into their material matrix, and enshrining in his
sculptures traces of work, accident, and even violence originating
outside of the figure. Those contemporary scholars who have thought
most deeply about these issues, for example Leo Steinberg and David
Summers, have made it clear that there is much more at stake in such
inventions than isolated matters of form.[1] The question of how sculp-
ture deals with its own stillness and motion is always parabolic of
larger issues. In this regard, we can remind ourselves of the spec-
ulative histories of sculpture one finds in such writers as Winckel-
mann, Hegel, or Rilke, for whom the development of sculpture offers
a series of crystallized moments that lay bare the inner meta-
morphoses of human culture, its shifting and often lapsed quests to
realize previously unapprehended forms of life, repose, freedom, or
consciousness. These authors indeed produce a history of sculpture
that often looks less like simple evolution than a complex series of
deaths and reanimations.[2]

The comments that follow are much indebted to these and many other accounts of the history and conventions of sculpture. But I have also tried to make a place for intuitions that seem to me somewhat alien to the ways others have spoken about sculpture; I have tried, that is, to address questions that other critics neither answer nor indeed really ask. This involves troubling somewhat more over how we understand a piece of sculpture's problematic lack of life, as well as considering the ambiguous nature of those wishes embedded in the often clichéd idea of sculptural movement. I also want to think more carefully about the ways in which, as I have said, a statue can seem to turn on, or trope, its status as a statue, the ways in which a statue can both recognize and fictionalize its own failure to move, for example. Indeed, in taking account of any individual statue, I have found myself trying to describe what I take to be that work's most profound, most resistant trope or vision of itself and its medium, which means describing that aspect of a statue that takes a stand against, even as it also transforms, things other than statues (things that can include, at times, mimetic and symbolic values). Locating such turns and tropes is essential to understanding the claims any particular sculpture has on those who regard it or imitate it; they help us understand the grounds of what we might call a particular statue's authority, its inventiveness. To bring these things out sufficiently, however, demands that one attempt a paradoxical, and in ways fantastical, piece of critical stationing. One must take the side of the statue. That is to say, one should find some possible partisanship with the alien thing of marble or bronze or wood, letting the statue itself speak before other categories intrude. One must speak as if the statue, as statue, had a life of its own, yet a life not necessarily measurable by what we expect a human life to be. I have tried to do this despite the knowledge that what one might call the "statueness of statues" is not given to us plainly or unfiguratively, or made visible outside of a particular history.

For all the difficulty of defining the stance, and the real risk of an empty essentialism or idealism, this strategy has certain advantages. It can help us locate the figurative, phantasmic appeal of a work of sculpture. It also helps us define more accurately any particular statue's relation to a larger tradition of sculpture, as well as the histor-

ically specific character of the manner in which an individual work could be said to transform the living body. It forces us to focus on aspects of the medium, aspects of a sculptor's formal and fictive choices, otherwise overlooked. Taking the side of the statue may also make us more self-conscious—and perhaps more ruthless—about employing the all-but-literalized figurations of "life" or "death" that haunt even the most sophisticated writing about sculpture.

My primary focus here is on two individual works of sculpture: Donatello's *Zuccone,* and the *Moses* of Michelangelo. I discuss the Donatello, as much as possible, in my own terms. In the case of Michelangelo's *Moses,* however, I filter my reading through Sigmund Freud's essay on the statue, suggesting how deeply that text responds to the idea of "the statueness of statues," despite its submitting the sculpture to the work of psychoanalysis. The account of Freud's essay in turn helps underscore the relevance of my argument in this chapter to the larger concerns of this book. But lest the examples of Donatello and the Michelangelo seem idiosyncratic, I want before going on to suggest that what I am calling the self-referentiality of statues plays a role even in more anonymous traditions and formal types and that trying to describe this will help us see them in a different light.

Among the classical figure types well known in the Renaissance, one that gained great popularity was that which is often called the sleeping nymph. One familiar example is the statue now in the Vatican (fig. 11), discovered in 1512; it shows a reclining, perhaps sleeping, woman, fully clad, but with one of her breasts exposed, her legs crossed at the ankle, her head propped on one arm while the other is flung over it. If we start asking after the source of the period's fascination with this figure—which was widely copied from the sixteenth through the eighteenth centuries, and used especially for garden fountains and grottoes—we will light on several possible answers. One fundamental source of the statue's appeal is its double aura of classical antiquity and heightened eroticism—a female figure looking simultaneously at rest and restless, abandoned and seductive. The real ambiguity of the figure's identity may have also provoked an interest; early on, the Vatican statue was identified not as a nymph but as the dying Cleopatra and later (more accurately) connected with

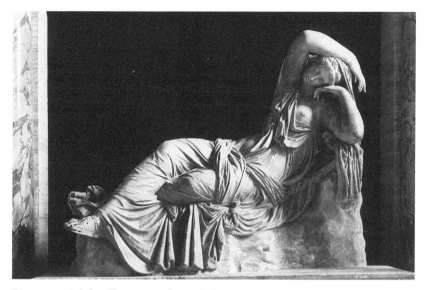

Figure 11. Ariadne (Roman sculpture). Rome, Vatican Museums. Courtesy Alinari / Art Resource, New York

classical images of a maenad collapsed in ecstasy and with literary images of Ariadne, depicted as she was discovered on the Island of Naxos by Bacchus, after her abandonment by Theseus—a subject represented with some frequency on classical sacrophagi.[3] Further adding to the statue's resonance was its association with contemporary legends of an ancient fountain of a sleeping nymph hidden somewhere on the banks of the Danube, on whose pedestal was inscribed a Latin epigram, in which the nymph identifies herself as the keeper of the sacred springs and asks visitors to regard her in silence and spare her slumbers (lines echoed by Michelangelo's *Notte*, a statue whose form also mirrors that of the nymph). In one critic's words, "the naiad's divine beauty, the perennial spell of singing waters, the awe-inspiring silence, all this, combined with the almost religious reverence accorded to every monument of classical antiquity, help to explain the fascination which image and verses were to exercise for three centuries."[4]

Such accounts of pose, iconography, and cultural milieu, however sketchy, will seem familiar, even sufficient. Yet considering the appeal of the figure, as well as one scholar's very poetic question, "Why do

nymphs sleep?" I would want to make one more critical turn.[5] I would argue that part of what grants the figure its authority and charm—even though it was also adopted by painters—is that the sleeping nymph is used in a *statue*. That is to say, the chosen subject and pose serve at once to appropriate the stillness of the stone and to trope that stillness according to the lineaments of a particular human stillness, one belonging to a living body rather than a corpse. The statue type holds onto and yet transfigures the ambiguous grace of the carved stone by means of a posture at once seductive, vulnerable, mournful, and curiously innocent or private. The given opacity or otherness of the stone at once lends itself to—mythicizes, as it were—and is itself reimagined by a species of opacity crucial to the emergence of a sense of human otherness and interiority, even as it suggests ways in which that interiority may be potentially unveiled (in the motions of the body as a whole, or in the words promised by the figure's potential to awake). The statue works because of its implicit figuring of what it means to be a statue (as well as a body) and of what a particular sort of statue might be. In this sense, the figure type offers itself as resonant synecdoche for sculpture in general; it does not just represent a sleeping nymph but suggests that statues themselves *are* sleeping nymphs (also nymphs that are abandoned, lost, vulnerable, come upon by surprise). This suggestion is part of the way in which the statue could be said to know or speak about itself, though also conceal itself.

In *The Nude: A Study in Ideal Form* Kenneth Clark attempts to explain the perpetual fascination and satisfaction derived from recumbent figures in sculpture, "from the pediment of Olympia onward": "Stretched on the ground, the body loses its look of instability, and the sculptor needs no devices of tree stump or drapery to make us believe in its equilibrium. The human race is no longer hoisted above the natural world on stilts, but seems to belong to the earth, like a rock or a root. This closeness to the earth is associated in our minds with the loss of animation, with sleep or death."[6] This intuition catches some aspects of my argument here, but I want to put a slight curve on it, turning against Clark's still mimetic and symbolic emphasis. We do not simply read the statue of a recumbent figure through its associations with loss of animation, sleep, or death; rather, we only

start to know—and to transfigure—repose, sleep, or death through the statue itself; our knowledge (though also our evasion) of death is given to us by the recumbent effigy as much as our knowledge of that effigy is determined by some prior idea of death.

Behind the slowly developing conventions of pose for the standing figure in classical and postclassical sculpture—the variations of tense and relaxed, free and weighted limbs, organizations of bodily axes and planes—we may see more than just manipulations of the body as the form for an ideal subject, as the trope of a culturally determined selfhood. Such "poses" also function implicitly as readings of the sculptural medium itself. They interpret or motivate the immobility of statues, their "standingness," by means of different sorts of human standing, different images of how the body finds, knows, holds, or leaves a place, images that themselves reflect the trials of choosing, knowing, or inventing one's stance and status in the world. Sculptural gravity becomes human gravity, as well as human freedom.[7] Such forms of standing are themselves mythologized, given formal and ideological authority (standardization), by the conventional shape of the statue, even as they can find themselves transformed by the radically nonstandard, often inhuman standing of later sculptures by Rodin, Giacometti, or Brancusi.

I know of no critical history devoted to the pedestal—though pedestals are obviously commented on frequently in histories of sculpture and are the object of intense reinterpretation, especially in modern sculpture. Were I to write such a history, I would want to look at the different ways in which a statue could be said to "know" its "empedestaledness," what fictions control it, what myths the sculpture makes of it, how being on a pedestal is accommodated, questioned, or theatricalized—for all these can help account for the authority of a certain convention.[8] Or take, for example, the logic of equestrian statues. It is not just because the world contains warriors or noblemen who ride horses that such statues exist, nor even just because at certain historical moments equestrian statues became both technically feasible and symbolically interesting as public emblems of power, individual or imperial.[9] If we are thinking in terms of causes, the "cause" of the equestrian statue is as much that it provides a kind of idealizing, sublimating myth *of* the statue, a trope of the monu-

mentality of which it is also an exemplar—especially for the Renaissance, with its emergent idea of the *statua* as something historically resonant, both human and ideal, an emblem of memorable public *virtú*.[10] Since Plato's *Phaedrus*, if not before, the image of a man riding or controlling a horse has participated in a complex but quite adhesive cultural myth of mastery and nobility, a myth of human elevation, a myth of human (also sexual) conflict and difference. This mythicized image involves a human placed in a commonplace, necessary, if sometimes anxious, proximity to an inhuman but still kindred form of natural energy, intelligence, violence, and beauty. It represents human identity and power linked to the ever-present threat of losing control; it recommends a mode of holding, a mode of staying in place that yet entails physical and mental mobility. (In the equestrian statue, we see human freedom imaged not only by a statue's free and willed manner of standing, as Hegel suggests, but by a sculpted figure's manner of sitting as well.)[11] A horse is not exactly a pedestal, nor is a man on a horse exactly like a statue on a pedestal. But the "likeness" there is sufficient that when rendered in bronze or stone and set on another pedestal the pairing of human and horse serves as an implicit, self-referential double or sublimating mirror of the statue's own monumentality and elevation, its own manner of being set on a privileged platform; the equestrian group, that is, thematizes the statue's own claims to nobility, authority, and "high" seriousness. Again, this is how the statue speaks itself. The equestrian statue will speak with a different inflection, as it were, depending on how a particular work relates the postures or motions of the horse to those of the rider (stressing their radical differences, or, as is more common, allowing them to subtly mirror or infect each other) and how these are in turn related to the pedestal itself. But in order to locate the real stakes of any formal, mimetic, or symbolic choices influencing the work, to understand their historical specificity, we need to approach them with a sense of the ways in which the equestrian statue provides a mythic image *of* the statue, a myth of the monument, as well as a myth of humanity, the way it further provides a myth of humanity *as* monument. (Considering this issue might help us see why Wallace Stevens chose the equestrian monument to illustrate how

easily public images of human nobility can degenerate into frozen, lifeless, distorted, and embarrassed versions of such nobility.)[12]

This effort to find a specific knowledge of sculpture (of its medium, its cultural uses) written into the pose or subject of particular statues requires a certain tact, but it is not an idle or merely ad hoc game of description (despite its links to some of the tricks of ekphrasis). The need to find out sculpture's metaphors for itself feels particularly urgent, for example, when one walks through the Piazza della Signoria in Florence, looking at such statutes as Donatello's *Judith and Holofernes*, Michelangelo's *David*, Bandinelli's *Hercules and Cacus*, Cellini's *Perseus and Medusa*, Giambologna's *Hercules and Nessus*—at so many bodies "writhing, twisting, stabbing, dying, on their stately pedestals," as Mary McCarthy describes them.[13] Thinking about these statues, I find myself wondering whether this array of violent and violently entwined figures might not be read as a group of complex tropes of the art of sculpture in general. To read them this way we need not deny the very particular historical sources and uses of such statues. In Renaissance Florence, with its (often compromised) republican myths and its ideology of civic virtue, the statue of a hero, hence the force and freedom of the state the hero supported, was inevitably seen as founded on the destruction of a despotic, petrifying, idolatrous, chaotic, or unfaithful enemy. These triumphant, though often strangely thoughtful, standers are thus pedestaled on the dead, dying, or drunken bodies of murderers and tyrants—Judith standing over the sleeping Holofernes, Hercules straddling the thief Cacus, Perseus propped on the decapitated Medusa, and so on. McCarthy (who describes beautifully the grave interanimations of Florentine sculpture and Florentine politics) suggests we consider such statues as formalized civics lessons; they are like the mythic "pillars" of the city-state, even a group of ideal stone citizens.[14] Such political resonances make it clear why the forms, inscriptions, as well as the precise location of statues in the square could become the subjects of such intense public debate.[15] Still, I would speculate that the peculiar authority of these statues (even their historical authority) derives as well from their posing a related group of parables about the medium and ontology of sculpture itself. They suggest for one thing sculp-

ture's emergence out of an obscure, though potentially redemptive, violence toward human bodies as well as toward inanimate matter, a violence these statues also idealize, whose opportunism and mournfulness they conceal. These statues remind us of sculpture's emergence out of a process that fragments and fetishizes the forms of the human, that works by a mode of repression that is not exclusively political or social.

I want to say that Donatello's Judith (fig. 12) wields a chisel as well as an executioner's sword; that Cellini's Perseus (fig. 13) holds aloft a mass of clay as well as the Gorgon's head. These surmises might seem too idly figurative, however, even if, for example, one recalled that the block of marble out of which Michelangelo carved his giant-killer was called "the giant," or that he compared his sculptor's drill to the hero's slingshot.[16] But consider more closely the fascination of Donatello's and Cellini's heroic decapitators. Both sculptures join two opposing bodies, the first that of the victorious heroine or hero, represented either in the midst of or just after their self-defining acts of violence, the second that of the victim, caught at the threshold of death. In Donatello's statue the second figure is in a drunken stupor, perhaps already dead, or just on the verge of decapitation.[17] In Cellini's, the victim is an already-decapitated trunk, yet a body still clearly in the throes of death (as is suggested by the baroque ropes of blood that spurt from the Medusa's neck and by her vividly rendered, not quite relaxed limbs and torso). In the figures of both Judith and Perseus there is a sense of dramatic pause, a meditative interval, and we may feel an invitation to consider what goes on in the heads of these strangely reflective killers. What strikes me, however, is that the pose of the victors responds to some tacit influence or counterpressure from the victims, that in each statue the victim and the victor, however different, exert a subtle, leveling pull on each other. Their respective imitations of stillness infect each other, that is. For one thing, neither Holofernes nor Medusa is merely inert or passive; they both have a kind of half-life, a threshold animation, that curiously mirrors the poised, suspended attitude of the victors. It is not enough to say that this mirroring is a virtuosic response to the fact that the paired figures, the living and the dead, must after all be

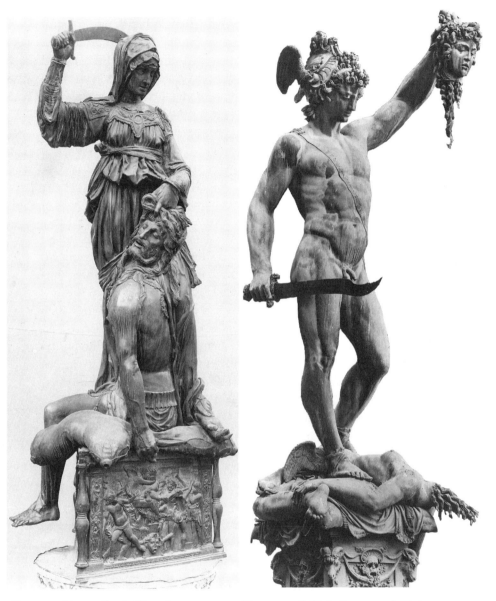

Figure 12. Donatello, *Judith and Holofernes* (c. 1463). Florence, Palazzo della Signoria. Courtesy Alinari / Art Resource, New York

Figure 13. Cellini, *Perseus and Medusa* (1554). Florence, Loggia dei Lanzi. Courtesy Alinari / Art Resource, New York

represented in the same immobile bronze (the kind of thing Callistratus might praise). The more elusive point is that both sculptors have taken advantage of this given stillness and offer us in their paired figures not just dramatic representations of acts of heroic violence but transfigurations of the somewhat different violence, and the different stillness, implicit in these figures' being parts of a statue to begin with. The peace and terror of the figures are tropes of the peace and terror of sculpture. The *Perseus* is particularly striking in this regard, since the victor has taken from the victim's supine, violated body a severed part, a trophy or ornament, which in its separation from the trunk yet becomes a weapon that threatens to turn those who look at it to stone. It is a head whose reflective, unpained gaze remarkably mirrors the downcast, lovely face of Perseus himself. We could indeed argue that Cellini's statue as a whole should be read as a complex, idealized but nonetheless resonant myth of the ambivalent, infectious origins and ontology of sculpture itself.[18]

I am reminded here of Robert Lowell's poem "Florence," in which the poet shrilly and somewhat literalistically suggests that we "always took the wrong side" in our affection for chilling, "lovely tyranicides" like Judith, David, and Perseus.[19] He suggests a change of allegiance, or at least a switching of sympathy. "Pity the monsters, pity the monsters," he cries, especially the "big-bosomed terror" of the Medusa, which seems to speak for an energy otherwise violated, for a pathos that can, more than any heroic youth, "stare the despot into stone." Lowell here seems to opt for a kind of questionable, pseudo-Blakean reversal of partisanship. But his strategy suggests to me a subtler, more dialectical imperative: again, that we listen to or take the side of (if not exactly pity) the statues, that we open our eyes to the myths of making written into them, their myths of standing as conquering, of the pedestal as the victim—that we pay attention to this and to whatever other residual clamor we might imagine emerging from those sculpted, monstered bodies, those heroes and their opponents, who tacitly stand for the claims of sculpture. This effort would be almost like looking at the *Laocoön* and trying to hear in the silence, in the strangled or unheard cry that comes from the father's half-open mouth, a word about marble tortured into the form of tortured bodies, or about tortured bodies frozen into the form of a

sculpture—or at least as much about those things as about any human pain we could imagine in the statue. It might even entail making the serpent that binds, paralyzes, and poisons the father and his sons into an image of the energy that drives sculpture itself.

Donatello's *Zuccone* (literally, "the great squash") (fig. 14), offers a particularly rich and self-conscious example of how a statue can play on its own conditions as statue or sculpture. Frequently identified with the prophet Habakkuk, this figure is one of a group of prophets and patriarchs executed for niches on the Florence Campanile. It is the statue of an iconoclast, but also an iconoclastic statue.

Vasari reports that Donatello used to swear by the *Zuccone*, almost as if it were a guardian angel or saint, and yet cursed it for its stoniness: "This being held a rare and beautiful work, finer than anything else he made, Donato used to say, when he wanted to swear in such a way that people would believe him, 'By the faith which I have in my Zuccone'; And while he worked on it, looking at the thing, he would always say to it, 'Speak, speak, or may you get the bloody shits!' ['Favella, favella, che ti venga il cacasangue!'—more colloquially, 'may bad luck come to you']."[20] In this narrative the statue serves as the mark of a blessing, an object of the Renaissance artist's faith in his own powers, even his "signature".[21] Yet it is also an emblem of his frustration. A mythic picture of the stone he sculpts, the statue serves as both anchor and idol, the object of both love and aggression. That muttered curse marks Donatello as a kind of failed Pygmalion, even as it points to some more violent or regressive investment in the artifact. Perhaps the anecdote tells us little about the *Zuccone* proper. The story is fairly conventional after all, resembling, for instance, a related story about Michelangelo striking his marble *Moses* when the statue refused to rise up and speak. But just as in this latter case—where we can connect the sculptor's act with the biblical Moses' own characteristic gestures of striking and smashing—Vasari's anecdote about the *Zuccone* opens up figurative and genealogical issues of a deeper order. The speechlessness of the statue and the fantasy of its words bear back on us more strangely in the case of the statue of an iconoclast, especially a prophet whose book (if this *is* Habakkuk) contains the following exhortation: "What

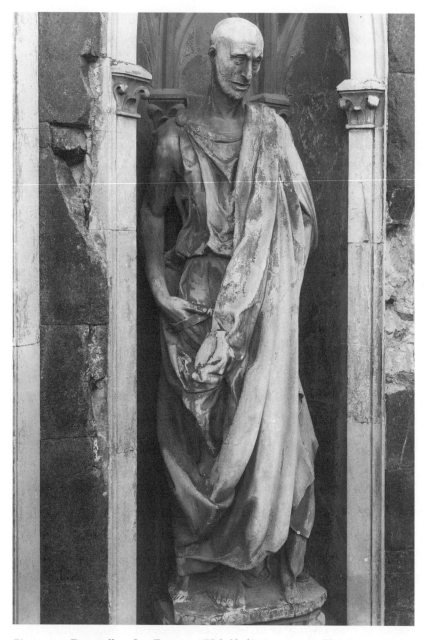

Figure 14. Donatello, *Lo Zuccone* (*Habakkuk*) (c. 1427). Florence, Museo dell'Opera del Duomo. Courtesy Alinari / Resource, New York

profit is an idol when its maker has shaped it, a metal image, a teacher of lies? For the workman trusts in his own creation when he makes dumb idols! Woe to him who says to a wooden thing, Awake; to a dumb stone, Arise! Can this give revelation? Behold, it is overlaid with gold and silver, and there is no breath at all in it. But the Lord is in his holy temple; let all the earth keep silence before him" (2:18–20).[22]

What I would claim is that the *statue* of Habakkuk implicitly responds to such a voice of condemnation and challenge; it accommodates or constructs a mute answer to those rhetorical questions, facing down this mockery of the aspirations of sculptors. Let us first imagine Donatello trying to answer the question, How does one make a statue of an iconoclast? Let us assume that he took seriously the paradox that possibility entails. (Iconoclasm of a sort did find a place in Florentine religious and civic life, both in the literal abuse and desecration of images and in the reforming discourse of preachers like Savonarola, even as Renaissance artists themselves seem to have been eager to shed both the superstition and guilt often attached to images in the period.)[23] It might have seemed too literalistic simply to make a statue of someone breaking an image. Yet how can a statue contain the impulse to break the very idol it may become, or at least refigure its own potential idolatrousness? How could the statue of an iconoclast face down the fact of being one of those things that "have mouths, but do not speak; / eyes, but do not see / . . . ears, but do not hear; / noses, but do not smell" (Ps. 115:5–8)? Donatello's solution, in this case, is to construct a figure whose aspect entails a radical retroping of the merely given wordlessness, blindness, and senselessness of sculpture, a refiguring of the opacity that makes the idol a spiritual threat. It entails a choice of form and feature that radically readjusts our angle of vision on the statue's way of representing life, as well as on its inherent deathliness.

One critic speaks of the statue's "drastic expressiveness," another of its "intense characterization of human emotion," but here we must be careful.[24] One of the reasons why attempts to define the expression of the *Zuccone* are often unsatisfactory is that they fail, I think, to register the figure's crucial inexpressiveness, or at least its drastic troubling of the idea of expression. Renaissance art theory does suggest that it is appropriate to read the face and posture of such

a statue according to a rhetorical code of human character or feeling, an *ethos* or *pathos*, especially when that statue represents the kind of prophetic orator whose gestures were often already assumed to be highly stylized.[25] Still, I do not think I am being merely subjective if I say that I find it hard to locate any "emotions" on that face, to see clear signs of sadness, withdrawal, disdain, or anger—versions of that *terribilità* such as one does see in Donatello's *Jeremiah*. The *Zuccone*'s eyes are sunk into their sockets—not like the eyes of Donatello's *Magdelene*, which seem blind to all except an inner vision, but radically askew, unfocused, and unable to look, without either outer or inner object. The mouth is not so much "open to outrage," to quote one critic, as caught in a kind of idiot grin, neither holding back words in a conscious, tight-lipped silence, nor merely surprised, nor yet on the verge of utterance. As if to preempt our desire to imagine its withheld words, its mouth resembles most strongly the mouth of someone who is mute, the mouth of a stammerer, or an aphasiac, one who cannot speak even if he wanted to. Nor does the famous bald head give any greater purchase to pathos; it offers us no curling or disordered locks as a vehicle of its expression. Likewise, the statue's drapery—that great wedgelike, sacklike sweep of mantle—serves mainly to block any view we might have of the figure's articulate body.[26] Even the deep, asymmetrical furrow on the *Zuccone*'s brow resembles less an expressive, readable trace of inner feeling than a permanent scar.

Graceless, sightless or unseeing, its eyes unfocused and undirected rather than blind, the *Zuccone* is inexpressive, speechless, a "stock." Yet it is by this stockishness that the statue of the prophet masters the irony of its own stoniness. For Donatello makes of this condition not an idolatrous senselessness but a figure of prophetic astonishment. The sculptor is not after any ordinary human expression here, however dramatic. Rather, he carves the image of a prophet with his merely organic, natural senses overwhelmed, flooded, and disorganized by the prophetic crisis; the *Zuccone* is a creature struck dumb, blind, and motionless by his bearing of the Word. It is in this way that the statue of the prophet overcomes the paradox of its being a potential idol, its being a stone.

The *Zuccone*'s stillness is not like that of the *Magdalene*, her body

composed to prayer, her graceful stance figuring an inward peace that can yet suffuse a body wasted by its ascetic withdrawal from the world. In the *Zuccone* there is no revery we can imagine, no consciousness, no feeling even; there is no inner voice to possess, nor any discreet "Word" inside him. Strangely enough, it is as if all "inwardness" were evacuated by the invasion of the prophetic calling. The statue leaves us no space into which to project a mind, a memory, a meditative or anxious consciousness, or an eye that watches, judges, and remembers. All of this is consumed by the inexpressive surface. If we can imagine anything inwardly "felt" by this strange creature, it would be a prophetic version of the dysentery that Donatello is said to have wished on the statue—a malady brought on here by eating a Word "sweet as honey in your mouth," but "bitter to your stomach" (Revelations 10:9). Or to quote Habakkuk: "I hear, and my body trembles, my lips quiver at the sound; rottenness enters into my bones, my steps totter beneath me" (3:16).

I would rest with that: the statue of the prophet redeems its being stone by being the image of a spiritual astonishment. To push this formulation further would require a more developed theory of the ways in which we discern feeling in, or project it onto, the features of a sculpted face, the ways that certain conventional "expressions" can mobilize and satisfy our demand for the illusion of consciousness, mind, and feeling in a statue, and how sculptures can also complicate or short-circuit that demand. We would also have to ask whether it is sufficient to rationalize the *Zuccone*'s form and features by seeing in them only an ironic thematization of the idea of prophetic reception. My idealized account of the statue as an image of a petrified visionary may not sufficiently account for all that we find strange in the statue, for example, its massive cloak, its saurian neck, and its blunt, dimpled nose. The sculptor's suppression of grace and expression may, after all, come less from a pious response to a religious paradox than from a kind of experimental bravura—a way of showing that a more intense sort of "life" can be lent to a stone figure exactly by throwing into confusion all those classicizing and mimetic techniques by which Renaissance sculptors sought to endow their work with realism or drama or charm. And even if the statue does offer a dramatic depiction of the prophetic situation, is it not just as much an index of the

sculptor's attempt to outwit the powerfully antimimetic ideology of the prophetic text?

The question of how a statue may make a myth of its own ontology, hence "know" itself as a statue, is at the heart of Freud's essay on the *Moses* of Michelangelo.[27] Rationalizing and in parts ahistorical as it is, Freud's account of the *Moses* (fig. 15) gains a large measure of its persuasiveness from the attempt to possess more rigorously than his precursors a sense of the statue's stillness, its necessary immobility, its manner of being in place and out of time. Freud indeed spends most of his explanatory zeal in keeping the statue in its place, in keeping the statue from running away, as it were, and in keeping himself from running away as well. He does this by lending to the statue (though also extracting from it) a deepened, more radical *interiority*—an inwardness associated ambiguously with the opacity of the unconscious and with the clarity of conscious acts of renunciation and rational mastery. In finding in the statue a strongly pragmatic refiguring of its own generic and material stillness, its manner of being stone, Freud can help make clear both the heuristic force as well as the limits of my argument in this chapter.

Though I cannot fully weigh its significance here, one should note first the strangeness of Freud's authorial stance in the essay. "The Moses of Michelangelo" was published anonymously in the psychoanalytic journal *Imago* in 1914. An appended note explained that, while an essay in art criticism might seem out of place in the journal, the editors had decided to print it, since the author, "who is personally known to them, belongs to psychoanalytic circles, and since his mode of thought has in point of fact a certain resemblance to the methodology of psycho-analysis."[28] Karl Abraham wondered at the pretense, assuring Freud that the piece would clearly betray "the lion's claw," but Freud himself, who referred to the essay as his "love-child," only acknowledged its paternity in 1923.[29] The speaker's masked status as one on the outside, as an amateur of psychoanalysis rather than its master, founder, and lawgiver, suggests that there is something more than mere scholarly humility behind the essay's way of circling around the *Moses*, perhaps because Freud is trying at once to lay bare and preserve the mystery figured there.

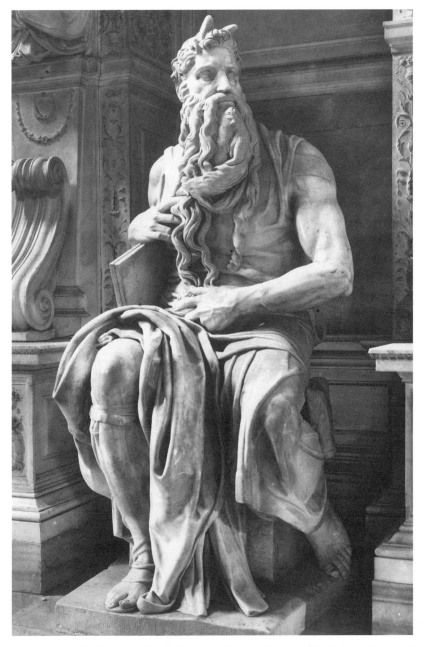

Figure 15. Michelangelo, *Moses* (c. 1515). Rome, S. Pietro in Vincoli, Tomb of Julius II. Courtesy Alinari / Art Resource, New York

Studying this figure of the seated patriarch—a powerful old man looking sternly to his left, grasping a flowing beard between his hands, while the tablets of the Law are held precariously under his right arm—Freud is circumspect. In pursuit of the statue's secret, he begins with a careful survey of previous interpretations. Acknowledging their heterogeneity, as well as the equivocal, even opaque character lent by Michelangelo to the figure itself, he yet sorts out two basic tendencies in the tradition of criticism. The first includes readings that locate the statue within a fairly precise narrative—arguing that it shows the patriarch just having descended from Sinai, on the verge of breaking out in anger at the sight of the Israelites worshiping the golden calf, and smashing the tablets of the Law. In this case the statue would represent a body whose tensed stillness is about to be shattered, its fixity pointing to a pregnant moment of pause before passive anger, astonishment, and shame break out into concrete acts of rage. The second way of reading the statue is less tied to narrative, taking the seated figure as a more generalized image of prophetic authority and prophetic wrath. Yet this reading too tends to assume that the statue is *about* to move, that it shows the form of Moses "animated by the inception of a mighty movement," though in most cases the source of the figure's hesitation is left obscure or unstated. Both of these styles of reading—as fitting as they are to the combination of generalizing and narrative motives in Renaissance sculpture— seem inadequate to Freud. He thus feels pressed to interrogate more deeply both the figure and his own response to it.

Freud recalls the terror he had himself felt before the figure, its accusatory gaze and imminent violence, his occasional fear of its rising up against him, as well as his own feeling of complicity with the backsliding, idolatrous Israelites.[30] But this more primitive anxiety and expectation of motion is in fact consumed, worked over, and mastered in the course of the essay. In the end Freud locates in the statue only a more powerful, perhaps less threatening, and certainly less merely melodramatic, stillness. He insists that reading the statue's pose as representing no more than a momentary resting place in a continuous chain of actions fails to register the "solemn calm" he feels emanating from the figure, his sense that "something was represented here that could stay without change; that this Moses would

remain sitting like this in his wrath for ever," surviving and inheriting that wrath (and not just because he is stone).[31] Like Michelangelo's lines on the statue of *Night*, Freud's reading silences any call for a life other than that which is given by the statue's immobility. It lends to the statue what we might call a Hebraic (if not a Freudian) calm, a repose more curiously haunted, more fraught and opaque than the classical calm, the image of balanced, controlled, and hidden passion of the sort that Winckelmann praised in the *Laocoön*—although this critic's writings on the aesthetics of classical sculpture are an important subtext for Freud here.[32]

It is in trying to untangle the "vague and ambiguous script" traced in the stone and to find the secret sources of its powerful stillness, its resistance to rational or naturalistic categories, that the "anonymous" author claims he will have recourse to psychoanalytic method. He does not, however, undertake what we might think of as the paradigmatic act of psychoanalytic criticism. He does not, that is, look at the figure as a kind of dream text and try to uncover the unconscious content latent in the representation itself (as Freud does, for instance, in pointing to the presence of oedipal ambivalence beneath the text of *Hamlet*, or in discerning a covert identification with a lost maternal presence in the work of Leonardo da Vinci). Despite a sense that he has found the statue's secret, the authority or authenticity that this writer would lay bare in the *Moses* is beyond the illusions of such "unveiling." This is because, I think, the deeper aim of the essay is to offer an image of the veiling itself. If there is a truly psychoanalytic character to the essay, it is less in its exposure of a repressed, unconscious meaning than in the way that, as Freud analyzes the statue, the statue seems to analyze him, that is, in the subtle contamination of the method of investigation by its mysterious object and aim.

Freud prefaces his own commentary by a striking, if ultimately unstable, comparison between the work of psychoanalysis—with its attention to overlooked, marginal, or rejected details in a dream or fantasy—and the methods of empirical connoisseurship developed by the late nineteenth-century scholar Giovanni Morelli. In a way that scandalized some contemporaries, Morelli found a means of "authenticating," of giving "names," to un- or misattributed works of art by studying an artist's habitual treatment of distinctly minor elements—

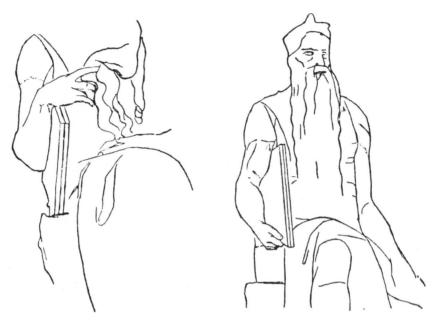

Figure 16. Drawings from Sigmund Freud, "The Moses of Michelangelo." Courtesy Basic Books, the Institute of Psycho-Analysis, and the Hogarth Press

hair, ears, fingers, and halos, things ordinarily cast on the rubbish heap of art history.[33] Freud too, though with a vastly different emphasis, stakes his reading of the *Moses* on things hitherto neglected or misread, traces of repression and sites of resistance invisible to others. He focuses particularly on the right hand, which presses itself within the knotted mass of the patriarch's beard (especially the "despotic finger" pressed "so deeply against the soft masses of hair that they bulge out beyond it both above and below"), as well as on "the riddle of that knot" itself. He dwells also on the right arm, which is draped with such ambiguous, even sacrilegious looseness over the sacred tablets. The argument about the significance of these details is careful and involved, if not wholly convincing. Its ultimate aim, however, is to refute claims that the statue shows the incipience of a *future* motion, and to suggest instead that it displays traces of *past* and highly conflicted movements, a turn and counterturn, which have finally achieved a state of tense resolution.

As it is developed with the help of a series of drawings (fig. 16), the

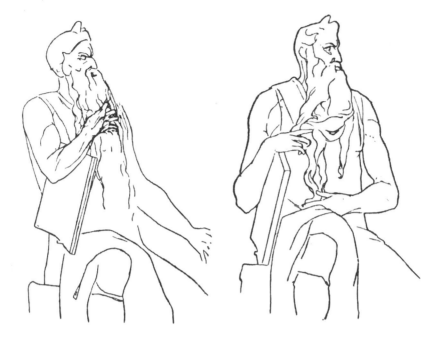

hidden story goes something like this: Having turned his gaze in anger at the sight of the Israelites worshiping the golden calf, tearing in frustration at his own beard and torso, Moses is indeed ready for a moment to leap up in wrath (as the older interpretations suggest). He is ready to "take his revenge" on his people, to abandon or break the sacred tablets of the Law. But in the process of turning to rise, Freud surmises, Moses has loosened his hold on those tablets. As he holds himself back from wrath, he finds that he must simultaneously grasp at the graven stones as best he can to keep them from falling, dragging his clutched beard across his chest in the process, as if he could not quite let go of that either. The legs and body, at first poised to rise, now settle back. Held there, we see a Moses who has chosen to relinquish rather than let loose his justified prophetic wrath against the backsliding children of Israel. He thus becomes for Freud a concrete image of the most powerful of cultural accomplishments—the renunciation of aggressivity, and the repressive flight from desire, in the service of a higher moral aim. He represents the mastering of an inward emotion, the giving up of a disruptive passion, for the sake of the gift of a pathos more inward and obscure.[34] This is a Moses

unknown to the Bible (as Freud himself remarks), a figure driven by the will to renounce iconoclasm as much as idolatry; the statue indeed transforms the ordinarily rash and judgmental patriarch into one who acts more like Yahweh, repenting his anger against Israel. What Michelangelo has invented, Freud claims, is a strangely autonomous, but more fully human, Moses; the statue thus serves among other things as a lesson to the sculptor's dead patron, the *terribile* and warfaring Pope Julius II, suggesting that the "inexhaustible inner force which tames a recalcitrant world" should be directed inward as well as outward.

In one sense, Freud is attempting to cure the statue of any neurotic or psychotic violence, to cure *us* as well of the literalism that lets us imagine the statue as "leaping up from its seat and rushing away to create a disturbance on its own account."[35] (This would put us in a position like Pushkin's Ivgeny.) The subtlety of Freud's analysis is considerable, not least because the questions the statue raises for Freud about how to regard the nature of the sacred and the idolatrous are projected onto the statue's way of bearing *itself*, bearing its own attributes, how the figure of Moses sits or fails to settle, the pressures it exerts on its own body and beard, how it carries or fails to carry the tablets, which are themselves objects of awe, fetishism, and violence. Again, the mode of analysis Freud employs here may not seem particularly "Freudian," since there is no explicit account of any repressed fantasy behind the *Moses*. But it does answer profoundly to the demands of orthodox analysis insofar as Freud's reading locates the crucial sources of meaning in the statue's past, in the traces of impulse repressed rather than released. Freud also characteristically argues in a way that absorbs prior and competing interpretations within his own, for instance, by suggesting that the idea of the statue's being on the verge of leaping up manifests an "unconscious institution" of an earlier, but surmounted phase of the statue's career.

Freud's account of the *Moses* is not without its own contradictions and distortions. He manages to refute the more melodramatic, basically baroque reading of the statue's pose, but his own reading, bound to nineteenth-century habits, still depends largely on placing the statue within a clear narrative framework, identifying in it traces of a specific dramatic or psychological plot.[36] At the same time how-

ever, he does acknowledge the relative obscurity and opacity of the statue's forms, and admits as well that its details may take their meaning from a nonnarrative, nonmimetic, or symbolic framework of meaning. (Freud is thinking of specific allegorical attributes, but we might also consider here how the formal and symbolic demands of the *figura serpentinata* shape the statue.) But to think in both narrative and symbolic terms means more than just negotiating two different readings of the statue. It also means considering two different ideas about the limits of what is intelligible or interpretable in the statue. This conflict is linked in turn to another kind of ambiguity in the text, an occasional uncertainty as to whether Freud is describing a statue or a body. We tend to assume, no doubt, that Freud imagines the statue as the stone representation of a body that underwent its crucial changes of attitude before it was sculpted in stone. But Freud often speaks as if Moses' motions were strangely undertaken or undergone by the stone itself—something suggested both by the accompanying drawings and by his references to the way "the *figure* of Moses" moves or sits. Such ambiguities of reference might seem inevitable in the description of figurative sculpture, in particular the monumental sculpture of the Italian Renaissance. But here they bear a peculiar interest, since Freud seems to be describing a motion and a mode of interiority that are more proper to a statue than a living body. The ambiguity of the description itself becomes emblematic of the ambiguity of the thing he is trying to describe.

Freud's account of the statue's problematic inwardness could be placed in a broader genealogy, I think. For one thing, we could recall Vasari's assertion that the *Moses,* and its never-executed pendant figure Saint Paul, were intended to serve as iconic representations of the union of active and contemplative virtues. We could also observe that Michelangelo himself habitually sculpts figures that seem to exist at a troubled site of intersection between physical and spiritual energies, that he seems obsessed with bodily forms that appear to be moved and restrained, awakened and depressed by forces that are never fully their own, bodies formed into ensembles that often strangely intertwine resistance and yielding, passivity and mastery. These are bodies that, like the *Moses,* we tend inevitably to read both mimetically *and* allegorically, as things expressing their own proper im-

pulses and as symbols of something other than themselves. A further account of the interiority of the *Moses* might even take the form of an "intertextual" argument—which would show that this statue, which contains some quite obvious visual echoes of the central figure in the *Laocoön* group, revises and repossesses that sculpture most fully insofar as it takes *within* itself the supernatural serpent that enwraps the Trojan priest and his sons, relocating the energy of that daimonic reptile within the beard, drapery, and serpentine pose of the isolate figure of the patriarch. It is a revision that furthermore manages to transform an image of entrapment into one of mastery.[37] Suggestive as such contextual arguments are, however, I want for the moment to examine the stakes of Freud's account in relation to questions more intrinsic to his own essay.

Freud's letters, as well as the essay itself, make it clear how much the statue obsessed him. He visited it repeatedly during trips to Rome in 1912 and 1914 and spent time measuring and drawing it, as well as collecting photographs of it. He was both proud and protective of his discovery of its "secret," lending it a weight much in excess of its apparent importance as a brief footnote to the psychoanalytic study of art.[38] One can indeed sense something mildly obsessive, something archaic and dreamlike, emerging through the often rationalistic analysis. This comes through, for instance, in the author's report of his repeated, even ghostly returns to view the statue—"How often have I mounted the steep steps from the unlovely Corso Cavour to the lonely place where the deserted church stands, and have essayed to support the angry scorn of the hero's glance."[39] It appears that, despite his isolation in the church, he sometimes felt as if the statue had found him out among a mob of idolaters. Freud was not simply fascinated by the statue (whether as an artwork, a case study, or a patient). He was fascinated by his own fascination, and one could argue that he wrote the essay in order to take command of what must have seemed a troublingly regressive interest attached to the sculpture. His commitment to laying bare the statue's secret suggests a commitment to framing some picture of his own secrets as well; there are in fact moments when the statue seems to analyze Freud as much as he it.

As a psychoanalytic document, the text requires us to take se-

riously its gaps and contradictions, to weigh the evidence of hidden agendas and repressed ambivalence. We should consider among other things whether Freud's rational "solution" is not itself really a defense against some more profound sense of threat emanating from the statue. It is not easy, however, to know how to proceed here. Clearly, as commentators have noted, the text is suffused in intricate ways with Freud's broader obsession with "the drama of the teaching struggle, death, and posthumous triumph of Moses."[40] We may indeed see in the essay some anticipation of the complex reading of Moses as both rebellious son and alien, sacrificed father figure worked through in *Moses and Monotheism* (1939). We may also feel the shadow of the essay's repression of the more frightening image of Moses as a child who is himself punished by the father god.[41] Drawing on comparisons made by Freud himself in his letters, Ernest Jones connected the tensions in the essay specifically to the master's conflict with the analytic heresies or idolatries of Alfred Adler and C. G. Jung (attacked more explicitly in the contemporary essays "On Narcissism" and "A Short History of Psychoanalysis," both from 1914).[42] This reading, pursued in greater detail by Hubert Damisch, suggests that the statue of this revisionary Moses figured for Freud a wished-for patience and self-control; it provided an image of a father mastering his own just or irrational rage at his errant children, as well as a fantasy of that father's eventual triumph as lawgiver.[43] The statue of Moses phantasmically secures Freud's authority as the creator of psychoanalysis, just as Moses was the "creator" of the Jews. Such suggestions may help, up to a point, in determining the hidden stakes of this essay. But the power of the figure will make sense only if we consider it not just as an image of Moses, but as Moses in the form of a *statue*.

The claims I want to make here are fairly speculative and go well beyond my earlier, simpler comment that Freud's reading compels us insofar as it accommodates and transfigures the statue's literal immobility. Basically, I would argue that Freud is attracted to the statue as a peculiar image of mind, as a representation of reflection and mental work. Angus Fletcher, commenting on Rodin's *Thinker*, suggests that the statue gives us a powerful image of the opacity, the silence, and the solipsistic inaccessibility of what we understand as thought;

hence it appears as a major document in the history of the modern mind's occluded visions of itself.[44] This way of seeing in the statue an "icon of mind" gets at part of what I want to say about the *Moses*, but one important qualification is that what Freud sees in that statue is a specifically *psychoanalytic* picture of mind or interiority. What draws him to the statue is that it gives form to the ontology of mind as described by psychoanalysis, something that includes a particular sense of *how* this mind is or may be discovered. Here we need to go beyond the essay's explicit argument that the statue is a picture of conscious moral mastery over emotion, an image of the troubled calm following an act of rational renunciation. For the essay marks in the gestures of the statue traces of a motive or drive whose force seems in excess of what is purely conscious or rational. Moses' act of renouncing his anger, for example, manifests itself not only in an inward flight, in a letting go of physical anger, but in a turning about of violence against his own body. The statue is self-controlling, yes, but also self-wounding—as Freud's careful analysis of the statue's hands suggests. This analysis in turn suggests that the gestures of the statue have a more ambiguous source. Indeed, it is that very ambiguity, rather than a specific sense of *where* the gesture comes from, that moves me to my conclusion about the figure. Put schematically, my argument is this: Freud in this essay does not invent an unconscious for the statue; rather he *invents the statue itself as the unconscious*. The essay suggests, that is, that the statue lays claim to us by standing as an image of the opacity, the sublime blankness, silence, and burial of the Freudian unconscious, as an image of the domain that is itself at once the product of acts of repression and the originating site of repression, the site of both a defensive fixation and a primal violence against the self. The *Moses*, then, is not just a body in thought; it is an image of the body or thing of thought (the thing/thought of dream, mind, and language) that emerges at the threshold between impulse and the prohibition of impulse, at the threshold between inside and outside, organic and inorganic, even between life and death. The statue is a figure for a form of thought that takes its shape from the gestures of the body, though a body fragmented and internalized. It is an icon of mind in the Freudian sense insofar as that mind can be read as at once an endlessly folded, defensive surface and an inac-

cessible, crystalline depth. Here it is the presence of the unconscious that makes *Moses* a statue, a hardened survivor, even as the opacity of the inhuman stone becomes animated, humanized, by being taken as an image of the most opaquely human thing. Freud's account of the *Moses* thus seems to combine two competing pictures of what a statue can be (especially for Michelangelo): a perfect, opaque *enclosure*, and yet also the solid interior *core* extracted from an enclosing matrix of stone. The statue, like the Freudian unconscious, is at once shell and kernal, to use Nicholas Abraham's suggestive metaphors.[45]

One could go further, I believe, in specifying in psychoanalytic terms the meaning with which Freud invests the statue, his way of using and yet transforming its character as a statue. Consider here both the archaic feel of Freud's returns to the statue and the steady labor with which he constructs its "story," his attempts to place the statue within an authoritative history or a narrative of origins. This history turns out to be highly speculative, yet it is a narrative that nevertheless enters into contest with the original biblical vision of Moses, replacing it with a story not recorded, remembered, or externally authorized. These things suggest to me that the lure of the statue for Freud relates to what he calls the primal scene, or primal-scene fantasy, an originary narrative that constitutes the traumatic substance of what the analytic patient cannot remember and must be made to remember. Freud struggles crucially with this notion in his exactly contemporary case study of the Wolf Man, and it is highly plausible that some version of his concern with it crept into the essay on the *Moses*.[46] In considering Freud's version of the *Moses* as a kind of primal-scene fantasy, I do not mean to suggest that we should see in or behind that statue a retrospectively constructed image of parental intercourse, attended by both castration anxiety and a sadomasochistic identification with the father (as is the case with the primal scene in the Wolf Man volume). Elements of this might be traced there, of course, but I am more interested in linking the *Moses* to the primal scene insofar as the latter is understood as a peculiarly authoritative, analytic fiction. That is, I would argue that the statue reflects the primal scene's status as the most problematic precipitate of the work of analysis, an unspecifiable nexus between memory and fantasy, a speculative bedrock, ghostly and opaque, a belated piece of

narrative that yet courts the specificity of fact as well as the time-lessness of the unconscious, at once the foundation of a neurosis and the key to its overcoming.[47] That ambiguous construction is also the chief site of contestation between the analyst and the analysand, the mutual product of their meeting fantasies, of their opposing memories, seductions, invitations, and interpretations, which makes it the precipitate of their opposing opacities and silences as well. Freud's analysis of the *Moses* is of something emerging at the site of such contest, or rather, that site becomes the place where the statue sits. As with the comparison of the statue to the unconscious, this reading makes of the immobile, opaque statue an image of what is most inaccessible and volatile in the discourse of analysis, most necessary and yet hardest to name.

If the *Moses* has been lent the ambiguous lure and authority of a primal scene, that scene pertains not to some particular person (say, Michelangelo Buonarotti or Sigmund Freud) but rather points to the primal scene of psychoanalysis itself. The statue stands for the ontology and knowledge of the unconscious insofar as the unconscious is Freud's invention and discovery, the foundation of his intellectual authority, even as the statue is simultaneously an image of the ghostly ground on which the battle for that authority is fought. Freud is aware that the *Moses*, grandiose as the statue is, occupies the center of a site of mourning and burial, the grave not so much of Julius II as of Michelangelo's earlier, tragically abandoned projects for the papal tomb. Yet despite its status as diminished relic or fragment, the statue nevertheless becomes for Freud the image of something lent the power to found not just an individual psychic history but a new conceptual tradition. This argument may extend my analogizing past the point where it is useful. But Freud's investment in the statue of Moses is extreme enough to demand that we at least attempt such suggestions. The main thing, again, is to see that Freud "animates" the statue by construing it as a figure that draws on and intensifies our consciousness of the *Moses* as a statue, as an opaque thing of stone, an imagined and yet uncannily solid thing. As he does this, he also forces us to think over again what we may have taken for granted about our investments in other statues.

It is hard to know if we could make a covenant with Michelangelo's

statue. Certainly it shows no love for us. Freud, indeed, locates the statue's life most profoundly in its refusal to regard or judge us, except to the degree that we internalize the statue as an image of how we judge ourselves. This is one of the ways in which, I suppose, the statue avoids becoming an idol. So has Freud himself managed to make a covenant with the statue? Is he even honest with it? The closing paragraph of his essay admits that this sculpture courts the limits of representation, and that many aspects of it simply elude his grasp. To get a sense of what this could mean, we need only think of Freud's scandalous failure to mention the statue's scandalous horns— those hardened signs of divine light, of God's grace to Moses, that lend to the statue so uncanny and feral an aspect.[48] At once organic and inanimate, supplemental and excremental, externalizations of an internal skeleton, these strangely asymmetrical horns are as hard to interpret as the marble matrix or carapace surrounding Michelangelo's *Prisoners*. Like the unfinished stone, even like the patriarch's beard, those horns seem to speak for something both alien to and involved with the human body and the humanness that takes its form from the body. No doubt one could make the horns of the statue speak on behalf of the Freudian unconscious. But the voice of those horns might also inflict a wound, mark a dilemma, which the Freudian reading could not readily accommodate.

An adequate account of the *Moses* essay would indeed specify not only what Freud teaches us about the statue but what aspects of Michelangelo's statue could be said to have constrained, shaped, or transformed the categories of the Freudian text, even by their very resistance to those categories. Such an account would also have to consider those aspects of the statue that, like the horns, perhaps should have worked on Freud, but did not, aspects that he himself overlooked or repressed. To consider how a reading of the statue could transform our reading of Freud would mean, in a sense, imagining the dialogue between Freud and the statue from the side of the statue. That is no doubt a quixotic project and a violation of our ordinary notions of the linearity of historical influence. But to let the statue of Moses force us to reimagine Freud might in the end be the most powerful testimony to the statue's continuing life, as well as a way of better measuring the strength of Freud's own text.

In the preceding chapter I have tried to thicken, to make more doubtful, the still-mysterious stillness of statues. I have suggested the shifting locations of such stillness, how it can be figuratively transformed, the ways in which that stillness we might think of as proper to the stone may infect or be changed by the stillness belonging by contrast to the body represented in stone, and how either of these can impose itself on the other. I have also tried to lend to the statue's self-reflective opacity the character or name of knowledge. Such knowledge is no doubt as elusive a quantity as the fictive surmises of ekphrasis, despite its being written in marble or bronze. Such knowledge is always on the verge of departing from the statue. Perhaps because works of sculpture are such solid wishes, or vehicles of a wish for things that *are* solid, they are more than usually subject to the fate that threatens any work of figuration—that of becoming literalized, reified, emptied, or of being assumed to have a self-presence or transparency alien to the domain of the figurative. A massive stone sculpture like the *Moses* can indeed seem strangely fragile, since it can all too easily start to take on the look of a mere monument, a bad reproduction of itself, or appear to be merely a frozen person. Statues die, too (*Les statues meurent aussi*—the title of a 1953 film by Chris Marker and Alain Resnais). This would mean that the statue not only drops out of dialogue with the world, with history, but drops out of dialogue with itself, with its own traditions and medium, with its own silence, and with the questions that silence poses. (Such a fate is all the more likely given that it is something we wish for in statues.) That a statue should become thus literalized may be an inevitable result of its existing in history, its way of being inherited or imposed on us by culture or tradition. And indeed, such objectification may be serviceable to us—as it is for certain sorts of iconoclast (who may find reason therein to exercise a different knowledge of sculpture), or for certain artists (who may need to see particular artifacts or artistic traditions as dead, as foreclosing certain new possibilities, in order to motivate their own renewals of convention and tradition).[49] But if statues sometimes present themselves to us as dead forms, both mournful and embarrassing in their lack of life, it may be the result of our own distraction, our own ways of yielding to established habits

and ideologies of looking. The dead statue may offer a chilling image of a kind of authority or empty meaning that we inherit without choice; but we should at least wonder how much, to paraphrase Emerson, the blank or ruin we see in the statue is the creation of our own eye.

The death of sculpture being so elusive a thing, so subject to competing occasions and interpretations, it will be correspondingly difficult to find the proper way of bringing the statue back to life, to invite it to re-enter dialogue with history, its audience, itself. For one thing, one has to face the dilemma that haunts all forms of radical criticism, that of claiming to be able to recognize blockages or forms of literalization, types of idolatry and oppression, that others cannot see. For another, the statue is not likely to speak or keep silent as human beings do; the statue's figures of life may indeed work strongly to trouble our conventional ideas of how human beings speak and keep silent. Its life may emerge as a half-life, or an inhuman life. There are no guarantees in the work of animation. Perhaps the only warning to keep in mind is that one must be ready to excavate not just new ideas of speech and meaning in the statue, but new forms of silence and meaninglessness as well, and be ready to locate new thresholds between such things.

Coda: Ordinary Statues

While writing this book, I found myself recalling a passage from Wittgenstein's *Philosophical Investigations:* "Could one imagine a stone's having consciousness? And if anyone can do so—why should that not merely prove that such image-mongery is of no interest to us?" (para. 390).[1] These are not, I think, a poet's questions, which might be more on the order of, Am I that imagine the conscious stone less satisfied? Is it the stone or is it I that experience this animation? Whose dream of life is this?—questions which assume, or dwell within, the fictive surmise of life in stone, even as they set it in motion. The philosopher's questions by contrast seem, if not quite literalistic, then strangely resistant to our commonplace habits of lending life or mind to inanimate objects, our everyday Orphism. Still, Wittgenstein does not tell us that to imagine a stone's having consciousness is impossible; he only suggests that it may not be all that interesting. Or rather, the questions suggest that we do not know quite what is or should be interesting to us, that the category of interesting does not really help us or needs to be rethought. The surprise is that the idea of imagining consciousness in a stone starts to sound like a useless rumor, a bad philosophical picture sold at a public market, just so much image-mongery. What is interesting, or useful, about the idea of a statue's coming to life?

Inquiring after what felt needs are served by Wittgenstein's questions and surmises, or trying to measure the relative naiveté or cunning of his philosophical masks, would quickly take us to the limits of

the text's readability. But we can at least say of the questions in the passage quoted above that they are concerned with the uses of imagination, or the status of imaginability, in our inventions of the world and our way of posing questions about the world. They ask us to measure the costs of certain pictures of the world that we take to be obviously intelligible but that may be both idle and blinding.[2] The questions worry the fact that our language allows us to say (or think? think clearly?) something like "a stone thinks, a stone *has* consciousness" and by extension lets us think we can speak intelligibly of a consciousness inaccessible to public knowledge located in a human stone as well. Wittgenstein suggests that in the end our apparent ability to say or think such a thing amounts to nothing, or to significantly less than we had hoped for. It may indeed potentially impoverish our notion of thought—and by extension our ideas of pain, the soul, and the body. One crucial lesson in which the questions participate is this: if I can imagine I am making sense when I speak of the consciousness of a stone, I can just as well think I am making sense when I imagine its apparent but more troubling opposite—the story in which I speak of the world, other people, as material motion without consciousness, or imagine them as a crowd of automata or disguised machines. In Wittgenstein's reasoning this turns out to be, after all, not so different from imagining others as bodies whose surmised *interior* states are finally (and, one might add, satisfyingly) private, ultimately inaccessible, hence a limit and an effective affront to our desire to master all sites of knowledge. Such a stance leaves me in a situation in which I can no more disprove the supposition that other people are robots than I can disprove the suggestion that they are all really in pain but only artfully concealing it (cf. para. 391). The world is converted thus, as it were, to keep the philosopher at work, to keep him in doubt; such pictures are necessary to sustain what seems the mute, decontextualized astonishment of radical skepticism, grounding and sustaining it most powerfully in the apparent attempt to theorize its overcoming. (Trying to describe the way our use of false criteria for knowledge seems to set us up for a fall into skepticism, Wittgenstein writes, "It is as if we had imagined that the essential thing about a living man was the outward form. Then we made a lump of wood in that form, and were abashed to see the

stupid block, which hadn't even any similarity to a living being" [para. 430].) Placing the question about the consciousness of stones thus in relation to the automaton fantasy, it starts to seem as if the desire to invite the inanimate into the space of the human conceals or mirrors a desire to push the human into the space of the inanimate. The face of objects granted a more than ordinary life becomes the face of Medusa.

There are many moments in the *Investigations* that similarly resonate with the fantasies I have been studying in this book, though I can scarcely do justice to them here. One thing that marks such passages is their ambivalent courtship of the fantasy of animation, the demystifying strain that haunts a mode of description that is yet at home in what looks like animism, that tries at once to question and keep faith with a language of magic:

> We do indeed say of an inanimate thing that it is in pain: when playing with dolls for example. But this use of the concept of pain is a secondary one. Imagine a case in which people ascribed pain *only* to inanimate things; pitied *only* dolls! (Para. 282)

> Couldn't I imagine myself having frightful pains and turning to stone while they lasted? Well, how do I know, if I shut my eyes, whether I have not turned into a stone? And if that has happened, in what sense will *the stone* have the pains? In what sense will they be ascribable to the stone? And why need the pain have a bearer at all here?!
> And can one say of the stone that it has a soul and *that* is what has the pain? What has a soul, or pain, to do with a stone?
> Only of what behaves like a human being can one say that it *has* pains.
> For one has to say it of a body, or, if you like of a soul which some body *has*. And how can a body *have* a soul? (Para. 283)

> But a machine cannot surely think! No. We only say of a human being and what is like one that it thinks. We also say it of dolls and no doubt of spirits too. Look at the word "to think" as a tool. (Para. 360)

> Every sign *by itself* seems dead. *What* gives it life?—In use it is *alive*. Is life breathed into it there?—Or is the *use* its life? (Para. 432)

What use can I make of such texts as these and the ones quoted earlier, with their curious suspensions of disbelief, their unweighable ironies, their odd humor, their mimic naiveté? Some passages sound like a commentary on Rilke's dolls, on his statues, angels, and thing-bodies. They recall the perverse misprisions of Lewis Carroll's looking-glass realm. They can also remind one of those fantastic reductions of the world that animate stories by Kafka or Beckett. It is not that hard, after all, to imagine a world in which one pitied only dolls, or to imagine dwelling in it. Imagine an ekphrasis on a statue of Niobe, or the *Laocoön*, which drew out a question like, Couldn't I imagine myself having frightful pains and turning to stone while they lasted? Imagine a version of the Pygmalion myth, or the golem legend, in which the sculptor was yet "abashed to see the stupid block, which hadn't even any similarity to a living being," a picture of animation that translated, rather than denied, the embarrassments we may feel in the face of the dead, inanimate image, yet in which that death constituted part of the image's seduction. Or read the question about the nature of a sign—"is the *use* its life?"—and recall that in Ovid the life of Pygmalion's statue is compared to a substance that becomes useful through use itself.

Obtuse, delicate, and dreamlike, Wittgenstein's fragments may compel our attention not for any obvious lyric or figurative charm they possess, but rather because of their strange literalism, or whatever we might call their resistance to the ways in which we fictionalize or theorize something like the life of statues (or the life of anything else for that matter), their resistance to the ways we in turn depend on such fictions and theories. The force of the philosopher's questions lies in their peculiar spectral flatness: "What has a soul, or pain, to do with a stone?" Try asking that before the *Laocoön*.

Wittgenstein's questions suggest some of the reasons why we are drawn to the idea of a moving or speaking statue. But they also refuse to let me think that I have come to terms with that idea. They can make me doubt that I have even begun to find the proper names for what drives the fantasy of animation, or what animates me in that fantasy. His questions might also suggest that my explorations of the dream of the moving statue are themselves defenses against certain

unspoken questions—against their unanswerability, against their being posed at all, or against the possibility of an answer that is all too plain. I do not think this is the case. But it is not always easy to trust one's parables, to bear one's distrust of those parables and yet bear with them, to let them give birth to something—a shock, a delight, a confusion, an intractable knowledge.

Notes

1. Signs of Life

1. Wallace Stevens, "Parochial Theme," *Collected Poems* (New York: Knopf, 1954), 191.

2. A useful brief history of the moving-statue motif can be found in Theodore Ziolkowski, *Disenchanted Images: A Literary Iconology* (Princeton: Princeton University Press, 1977), 18–27. See also Ernst Kris and Otto Kurz, *Legend, Myth, and Magic in the Image of the Artist: A Historical Experiment*, trans. Alistair Laing and Lottie M. Newman (German orig., 1934; New Haven: Yale University Press, 1979), 71–84. Jerome Pollitt, *The Ancient View of Greek Art: Criticism, History, and Terminology* (New Haven: Yale University Press, 1974), 63–64, and Bernard Frischer, *The Sculpted Word: Epicureanism and Philosophical Recruitment in Ancient Greece* (Berkeley: University of California Press, 1982), 96–118, point to important classical instances of the idea of living statues. The reader might also look at the selection of literary and graphic depictions of living images in David Freedberg, *The Power of Images: Studies in the History and Theory of Response* (Chicago: University of Chicago Press, 1989) 283–316, which employs such material—along with accounts of votive images, talismans, effigy magic, iconoclasm, and so on—to broaden and complicate many traditional descriptions of our response to works of art.

3. I am thinking here among other things of Elaine Scarry's redescription of the work of human culture as entailing a systematic effort to "deprive the external world of its privilege of being inanimate" (*The Body in Pain: The Making and Unmaking of the World* [New York: Oxford University Press, 1987], 285; see 285–307 more generally). For Scarry, this process involves a kind of necessary, mundane, if also often invisible anthropomorphism through

which objects of use and manufacture are invested with a simulachrum of human awareness and compassion, and even a degree of legal and ethical responsibility.

4. Leo Spitzer, "The 'Ode on a Grecian Urn,' or Content vs. Metagrammar," *Comparative Literature* 7 (1955): 219.

5. On the history and theology of the making of the golem, see Moshe Idel, *Golem: Jewish Magical and Mystical Traditions of the Artificial Anthropoid* (Albany: State University of New York Press, 1989), passim, as well as the classic essay of Gershom Scholem, "The Idea of the Golem," in *On the Kabbalah and Its Symbolism,* trans. Ralph Mannheim (New York: Schocken, 1965), 158–204, to which Idel's book offers a sustained response.

6. See Scholem, "Idea of the Golem," 180–181.

7. Jean Cocteau, *Le sang d'un poète* (Monaco: Robert Marin, 1948), 34, my translation.

2. The Death of Sculpture

1. See Roland Barthes, *Camera Lucida: Reflections on Photography,* trans. Richard Howard (New York: Farrar, Straus and Giroux, 1981), 76–80 and passim. Barthes's comments on the photograph are resonant for any account of the ontology of sculpture. I find particularly striking his observations on the strange, fragile opacity of the photographic image, its peculiarly self-authenticating character, its way of both denying and provoking our skepticism about the historical existence of other persons. Equally important is his feeling for the "catastrophic" quality of the way in which the photograph represents both the living *and* the dead.

2. John Keats, "The Fall of Hyperion," lines 382–84, in *The Poems of John Keats,* ed. Jack Stillinger (Cambridge: Harvard University Press, 1978), 487.

3. Jean-Paul Sartre, speaking of statues in his essay on the sculpture of Giacometti, "The Quest for the Absolute," remarks that "we have long been accustomed to smooth, mute creatures fashioned for the purpose of curing us of the sickness of having a body; these guardian spirits have watched over the games of our childhood and bear witness in our gardens to the notion that the world is without risks, that nothing ever happens to anyone and, consequently, that the only thing that ever happened to them was death at birth. . . . Against this, something obviously has happened to Giacometti's bodies" (in *Essays in Aesthetics,* trans. and ed. Wade Baskin [London: Peter Owen, 1963], 101–2; Sartre's essay originally appeared in *Situations III* (Paris: Gallimard, 1949), 289–305).

4. Like other woodcuts in the volume, these can recall contemporary paintings and engravings that could restore or "bring to life" classical statues, placing them in invented architectural or natural settings. See Francis Haskell and Nicholas Penny, *Taste and the Antique: The Lure of Classical Sculpture, 1500–1900* (New Haven: Yale University Press, 1981), 21–22.

5. See David Summers, *Michelangelo and the Language of Art* (Princeton: Princeton University Press, 1981), 397–405, and more generally Bernard Schultz, *Art and Anatomy in Renaissance Italy* (Ann Arbor, Mich.: UMI Research Press, 1985).

6. On the characteristic subterfuges Vesalius's illustrations, see Devon L. Hodges, *Renaissance Fictions of Anatomy* (Amherst: University of Massachusetts Press, 1985), 5–7, and Glenn Harcourt, "Andreas Vesalius and the Anatomy of Antique Sculpture," *Representations* 17 (1987): 28–61. The transformation of dissected cadavers into statues, even living statues, is not exclusive to Vesalius. A well-known illustration in a somewhat earlier anatomical treatise, Jacopo Berengario's *Isagoge brevis* (1522), shows a cadaver/sculpture that steps down from her pedestal and unveils her own partially anatomized torso in order to demonstrate to readers the author's argument that the female sexual anatomy is isomorphic with that of the male. The image is reproduced in Thomas Laqueur, *Making Sex: Body and Gender from the Greeks to Freud* (Cambridge: Harvard University Press, 1990), 78.

7. See Pierre Brunel, *Le mythe de la métamorphose* (Paris: Armand Colin, 1974), 125–65 and passim, on the dialectical structure of fables of metamorphosis, their characteristic interweavings of survival and destruction, impoverishment and recompense, transgression and expiation, of the expression of desire and of desire's death.

8. Quotations from "The Bishop Orders His Tomb" are taken from *Robert Browning: The Poems,* ed. John Pettigrew and Thomas Collins, 2 vols. (New York: Penguin, 1981), 1:413–16. My thanks to Patricia Parker for suggesting the relevance of this poem to the present study.

9. The Bishop's monolog might here be read in the light of a central argument in Philippe Ariès's book *The Hour of Our Death,* trans. Helen Weaver (New York: Knopf, 1981). Drawing on evidence from classical through modern times, Ariès suggests that in many periods the paradoxically deathless bodies of tomb sculpture became the vehicles for tacitly sustaining a deeply rooted, all-but-intuitive eschatology of physical survival, even in the face of radically divergent theories promoted by established orthodoxy (whether religious or rationalistic). Indeed, in a way that Browning seems to grasp implicitly, the forms of waking sleep that sculptors habitually lent to tomb effigies, and that were made possible only by their being statues, eventually transformed even the conventions for displaying and disposing of cadavers

themselves. That is to say, the treatment of the dead body started to take its form from the statue, rather than vice versa, as we almost automatically suppose.

10. Michel Serres, *Statues: Le second livre des fondations* (Paris Éditions François Bourin, 1987).

11. Maurice Blanchot, *The Gaze of Orpheus and Other Literary Essays*, trans. Lydia Davis, ed. P. Adams Sitney (Barrytown, N.Y.: Station Hill Press, 1981), 83.

12. In *L'hermaphrodite: Sarrasine sculpteur* (Paris: Flammarion, 1987), Serres dwells on the idea of the statue as a way of understanding the etymological derivation of the French *chose* (thing) from the Latin *causa* (motive, ground, subject, also pretext and excuse). "Qu'est-ce qu'une statue? Un cause devenue chose et la cause des choses. Phrase obscure encore a élucider" (What is a statue? A cause become a thing and the cause of things. Dark sentence yet to be clarified, 106). Serres's picture of statues in fact often appears to reverse the genealogy, such that the idea of a *cause* takes its origin in the material *thing* that is the statue or the cadaver.

13. See Serres, *L'hermaphrodite*, 106–7 and passim. As it gives birth to the solid statue/fetish, castration thus becomes a figure for the catastrophic origins of anything we call knowledge. Signs of both the phallus and its lack, all statues in Serres's analysis become "hermaphroditic" as well.

14. Jean-Pierre Vernant, *La mort dans les yeux: Figures de l'autre en Grèce ancienne* (Paris: Hachette, 1985). English translation in *Mortals and Immortals: Collected Essays*, ed. Froma I. Zeitlin (Princeton: Princeton University Press, 1991), 111–38.

15. Serres's argument in *Statues* might also help us understand why the unseeable face of the petrifying, statue-making Gorgon itself yet became the object of such perpetual interest for classical artisans, why the face that cannot be seen is visible so widely on coins, pots, shields, ovens, kilns, doorways, and temple fronts—since even this grotesque though often beautiful face still serves as a defense against more indefinable and intimate terrors.

16. Irving Feldman, *All of Us Here and Other Poems* (New York: Penguin, 1986), 1–41.

3. Eating the Statue

1. See Michael North, *The Final Sculpture: Public Monuments and Modern Poets* (Ithaca: Cornell University Press, 1985), 27.

2. See William Gass, "Monumentality/Mentality," *Oppositions: A Journal for Ideas and Criticism in Architecture* 25 (Fall 1982): 127–44.

3. Rhys Carpenter, *The Esthetic Basis of Greek Art* (Bloomington: Indiana University Press, 1959), 69–71, offers a particularly pointed statement of this "empathic" view of our relation to sculptural form.

4. The *locus classicus* for this metaphor is in Plotinus, *Enneads* 1.6.1.

5. I am playing here on the title of Angus Fletcher's essay "Iconographies of Thought," in his *Colors of the Mind: Conjectures on Thinking in Literature* (Cambridge: Harvard University Press, 1991), 15–34. My summary account of internalization, introjection, and internal objects depends especially on Freud's 1919 essay "Mourning and Melancholia" and his 1924 study *The Ego and the Id*, in the *Standard Edition of the Psychoanalytic Works of Sigmund Freud*, ed. James Strachey, 24 vols. (London: Hogarth Press, 1955), 14:239–58, and 19:3–66, respectively (hereafter *SE*).

6. See Richard Wollheim, "The Bodily Ego," in *Philosophical Essays on Freud*, ed. Richard Wollheim and James Hopkins (Cambridge: Cambridge University Press, 1982), 124–38.

7. Freud, *The Ego and the Id*, *SE* 19:29.

8. See Melanie Klein, "A Contribution to the Psychogenesis of Manic-Depressive States," in *Contributions to Psycho-Analysis, 1921–45* (London: Hogarth Press, 1950), 282–310.

9. Freud evokes this metaphor in various places, with various twists, including "Aetiology of Hysteria," *SE* 3:192; the preface to *Fragment of an Analysis of a Case of Hysteria (Dora)*, *SE* 7:12; *Civilization and Its Discontents*, *SE* 21:69–70; and (its sharpest rendering, perhaps) "Constructions in Analysis," *SE* 23:259–60. The image of the mind as a space crowded with statues may also conjure the memory of Freud himself in his own study, where he was as we know surrounded by literally hundreds of small antique statues, gods, and graven images, "an embarrassment of objects" that covered his bookshelves, desk, and writing table (including a copy of the original of *Gradiva*, discussed below). See Peter Gay, *Freud: A Life for Our Time* (New York: Norton, 1988), 170–73.

10. On Ferenczi's original conception of "introjection," and the history of its misprision by Klein and others, see Maria Torok, "Maladie du deuil et fantasme du cadavre exquis," *Revue Française de Psychanalyse* 32 (1968): 715–33.

11. See Freud, "Mourning and Melancholia," *SE* 14:249. See Giorgio Agamben, *Stanze: La parola e il fantasma nella cultura occidentale* (Turin: Einaudi, 1977), 24–27, 39–43, for comments on the curious homology between the fantasies of melancholia and Freud's account of the structure of fetishism. In melancholia, the lost object is saved at the expense of its being made the site of denial and derealization, as well as potentially the aim of aggression. The object's representation through introjection entails both a creation of and a defense against negation or absence. The fetish likewise is both the sign of an (overdetermined, imaginary) lack—the castrated phallus—and a defensive,

compensatory substitution for that lack. As in the case with introjection, fetishism entails both the construction of a sign of loss and a refusal to renounce desire for what is lost; like introjection it involves a binding together of real and unreal, a negation of a negation that Freud sees as grounding our relation to objects of desire. If melancholia attempts to master loss by taking it inside the self, fetishism does so by binding the lost object to something external and manipulable. This is significant for my own speculations in this chapter, since Agamben makes it clear that the statues "inside" and "outside" us are both troubled wholes caught by an elusive negativity. Any nexus between the two, hence between the self and the world, is likely to be bound up with the problematic losses and reifications of fantasy.

I should add that Agamben sees this doubling of melancholia and fetishism as characteristic of all modern theories and ideologies of imagination, especially as these emerge out of what he calls the "pneumofantasmology" of medieval and early modern writings on the pathology of Saturnian Melancholy. The accounts of Melancholy offer a picture in which all relations of mind to the world—intellectual and political as well as erotic and poetic— take their origins in the basically morbid and materialized productions of fantasy life. With no transcendental anchor or ground, the mind's desires inhabit a space between a self-love that denies the world—or, rather, re-creates it as lost in order to secure its own seduction—and a self-emptying fixation on phantasmic images that have yet been granted a purely objective, external status. That is to say, in Agamben's terms, the imagination always inhabits a space between the poles of Narcissus and Pygmalion.

12. See Nicholas Abraham and Maria Torok, "Introjecter-Incorporer, Deuil *ou* Mélancolie," in *Destins du cannibalisme, Nouvelle Revue de Psychanalyse* 6 (Fall 1972): 111–22; English text, "Introjection-Incorporation: Mourning *or* Melancholia," in *Psychoanalysis in France*, ed. Serge Lebovici and Daniel Widlöcher (New York: International Universities Press, 1980), 3–16. In what the authors distinguish as "incorporation," the words of loss are denied, "encrypted," "buried alive." Refused admission to the shared figurations of mournful speech or narrative, and in that sense "literalized," the loss becomes not only speechless but unspeakable. Left in the unconscious like an indigestible stone, the internalized loss exerts an insidious effect on the self, since that self's ongoing public life has been curtailed at the expense of the lost object itself being preserved, installed within the self as an almost vampirish presence.

13. Cf. Giles Deleuze, *The Logic of Sense*, trans. Mark Lester, ed. Constantin V. Boundas (New York: Columbia University Press, 1990), 186–95.

14. This particular consideration is at the center of Adrian Stokes's psychoanalytic reading of the art object, developed in late books such as *Michel-*

angelo: A Study in the Nature of Art (1955), and *Greek Culture and the Ego* (1958), in *The Critical Writings of Adrian Stokes*, ed. Lawrence Gowing, 3 vols. (London: Thames and Hudson, 1978), 3:7–76 and 77–141. Drawing especially on the work of Melanie Klein, Stokes speculates that works of art can reactivate a person's primal fantasies of investigating, devouring, or doing violence to a beloved object and yet show us an image of something surviving that violence; he further argues that works of art can reactivate the ego's inevitable immolation by the splitting of the object into "good" and "bad" forms and at the same time help heal that split. Ideally, such aesthetic artifacts will at once acknowledge the reality of our archaic losses of both self and object, give a form to our mourning for those things, and yet hold out a concrete image of their possible survival and restitution.

15. Sigmund Freud, *Delusions and Dreams in Jensen's "Gradiva,"* SE 9:1–178.

16. See Freud, "Constructions in Analysis," *SE* 23:266–68.

4. Idolomachia

1. Yosef Hayim Yerushalmi, "Postscript: Reflections on Forgetting," from *Zakhor: Jewish History and Jewish Memory,* rev. ed. (New York: Schocken, 1989), 113.

2. See 1 Samuel 5:5, where the mysterious depositing of the severed hands and head on the threshold explains why "the priests of Dagon and all who enter the house of Dagon do not tread on the threshold of Dagon in Ashdod to this day."

3. The subsequent phases of the narrative (1 Samuel 5:6–6:21)—where the Philistine priests urge the king to make seven golden images of the tumors and rats with which Yahweh has plagued their land and to offer them as votives before the ark—add a certain note of farce to the text's surreal vision of idolatrous making, but only by contrast with the superior irony, and the more powerfully internalized disenchantments of Yahweh's actions in the preceding verses.

4. A particularly stark account of the problematic conceptualization of idolatry in the Hebrew Bible is supplied by Yehezekel Kaufmann, *The Religion of Israel from Its Beginnings to the Babylonian Exile,* ed. and trans. Moshe Greenberg (New York: Schocken, 1972), 7–148. I have tried to come to terms with the paradoxes of idolatry and iconoclasm in greater detail in my *Spenserian Poetics: Idolatry, Iconoclasm, and Magic* (Ithaca: Cornell University Press, 1985), 1–77.

5. Here as elsewhere I quote from the Revised Standard Version.

6. See Louis Ginzberg, *The Legends of the Jews*, trans. Paul Radin and Henrietta Szold, 7 vols. (New York: Jewish Publication Society, 1909–38), 3:129–31 and 6:34–35, n. 281, for a survey of Rabbinic glosses on this text. It is worth noting that in Jewish tradition the worship of the golden calf is often read as a kind of second Fall and taken as the cause of all subsequent sorrows that befall the people of Israel.

7. Gerhard von Rad, *Old Testament Theology*, trans. D. M. G. Stalker, 2 vols. (New York: Harper and Row, 1965), 2:311–13.

8. See Angus Fletcher, *Allegory: The Theory of a Symbolic Mode* (Ithaca: Cornell University Press, 1964), 368 and passim.

9. *Pesikta de-Rab Kahana*, trans. W. G. Braude and I. J. Kapstein, 2 vols. (Philadelphia: Jewish Publication Society, 1975), 2: para. 25. My thanks to Herbert Marks for bringing this text to my attention.

10. For Augustine's treatment of pagan idolatry and demonic magic, see Books 8 and 9 of the *City of God*, trans. Henry Bettenson (London: Penguin: 1972), 343–426. See also the shrewd comments in Peter Brown, *Augustine of Hippo* (Berkeley: University of California Press, 1967), 311.

11. *Shelley's Poetry and Prose*, ed. Donald H. Reiman and Sharon B. Powers (New York: Norton, 1977), 103.

12. H. M. Richmond, "Shelley and the Travellers," *Keats-Shelley Journal* 9 (1962): 65–71, points out that Shelley seems to have based the sonnet on a passage from Diodorus Siculus's *Historical Library* (I.iv), quoted in R. Pococke, *A Description of the East and Some Other Countries* (London, 1743), 1:107. Diodorus describes the tomb of Ozymandias as having three gigantic, ruined statues made by the sculptor "Memnon Sicnites," and reproduces the inscription on the base of one as "I am the King of Kings, Ozymandias: If any would know how great I am, and where I lie, let him exceed the works which I have done" (Richmond, 68). There is some scholarly debate about other sources, stemming from various discrepencies between Pococke's text and Shelley's, and Richmond argues that in fact Shelley combined aspects of the account of Ozymandias's image with details drawn from Pococke's nearby description of another statue, the colossal stone figure known as "Memnon" that stood on a bare plain at some distance from the city of Thebes and its temples. Richmond does not mention the complex legends surrounding this other statue— which was said to make mysterious noise when struck by the light of dawn— but the collocation of Ozymandias and Memnon, if plausible, suggests some fascinating directions for interpretation. For further comments on Memnon, see chapter 9.

13. *Shelley's Poetry and Prose*, 91.

14. Quotations from Pushkin's poem are from the translation by D. M. Thomas, in *The Bronze Horseman and Other Poems* (London: Penguin, 1982), 247–57.

15. Pushkin, *Bronze Horseman*, 252. See Waclaw Lednicki, *Pushkin's "Bronze Horseman": The Story of a Masterpiece* (Berkeley: University of California Press, 1955), 77–78, 81–82, on Pushkin's use of the word *kumir*, "idol," or "graven image," and its censorship by the czar, as well as more general background on Pushkin's attitude toward the monument to Peter.

16. Wallace Stevens, *The Collected Poems* (New York: Knopf, 1954), 123.

17. On Pushkin's need to distance himself from the armed violence of the Decembrist rebellion, even as he struggled to keep open a space of creative and intellectual independence from the regime to which he was outwardly capitulating, see Roman Jakobson, "The Statue in Puškin's Poetic Mythology," in *Language in Literature*, ed. Krystyna Pomorska and Stephen Rudy (Cambridge: Harvard University Press, 1987), 331–33, and the more general analysis of the poet's ideological allegiances in Sam Driver, *Pushkin: Literature and Social Ideas* (New York: Columbia University Press, 1989), 7–10, 30–39. See also Henri Troyat, *Pushkin*, trans. Nancy Amphoux (New York: Doubleday, 1970), 289–304.

18. See Jakobson, "The Statue in Puškin's Poetic Mythology," 341.

19. See n. 15 above.

20. See *Pushkin on Literature*, ed. and trans. Tatiana Wolff, rev. ed. (Stanford: Stanford University Press, 1986), 349–51, for the text of the poet's unpublished essay in defense of censorship, and 179, 323, 325, and 341 for letters of the poet that comment on the issue.

21. Ibid., 325.

22. The phrases in quotation marks are from Jakobson, "The Statue in Puškin's Poetic Mythology," 333.

23. Jean Cocteau, *Le sang d'un poète* (Monaca: Robert Marin, 1948), 63–64, my translation.

24. Stevens, *Collected Poems*, 395.

25. For a shrewd survey of Stevens's treatment of statues and monuments in his poetry, see Michael North, *The Final Sculpture: Public Monuments and Modern Poets* (Ithaca: Cornell University Press, 1985), 207–27.

26. Stevens, *Collected Poems*, 400.

27. Plates 19.1–14, 20.7–12. The text is from *The Complete Poetry and Prose of William Blake*, ed. David V. Erdman, commentary by Harold Bloom, rev. ed. (Berkeley: University of California Press, 1982), 112–14.

28. Nancy M. Goslee, *Uriel's Eye: Miltonic Stationing and Statuary in Blake, Keats, and Shelley* (University: University of Alabama Press, 1985), 29–67, provides a useful account of various eighteenth-century and pre-Romantic ideas and ideologies of sculpture that may have influenced Blake's narrative. Besides Goslee's evocation of the competitive discourse of the *paragone*— formal debates about the relative excellence of different media, which were especially popular during the High Renaissance—two aspects of her re-

searches seem pertinent here. First, she makes clear that the art of sculpture often served as a synecdoche for classical art in general, whether visual or literary, whereas painting was associated specifically with romantic art and literature. Second, she points to the peculiarly divided character of eighteenth-century discussions of sculpture, which focused by turns on its abstract, idealizing character and on its power as an art with an especially direct appeal to physical feeling, especially touch.

29. See the commentary in *Genesis*, trans. and ed. E. A. Speiser, The Anchor Bible, vol. 1 (Garden City: Doubleday, 1964), 252–57, and Gerhard von Rad, *Genesis: A Commentary*, trans. John H. Mark (Philadelphia: Westminster, 1961), 314–16.

30. Harold Bloom, *The Breaking of the Vessels* (Chicago: Chicago University Press, 1982), 52–55.

31. See Herbert Marks, "The Double Cave: Biblical Naming and Poetic Etymology," forthcoming in *Journal of Biblical Literature*.

32. See ibid. and Stephen Geller, "The Struggle at the Jabbok: The Uses of Enigma in a Biblical Narrative," *Journal of the Ancient Near Eastern Society* 14 (1982): 37–60.

33. Quoted in von Rad, *Genesis*, 319n.

34. John Milton, *Complete Shorter Poems*, ed. John Carey (London: Longman, 1971), 123.

35. Cf. Irene Taylor, "Blake's *Laocoön*," in *Blake: An Illustrated Quarterly* 10, no. 3 (1976), 72–73.

36. Blake implicitly confirms a number of readings of the Pygmalion myth as an allegory of the poet's erotic and agonistic relation to the images he inherits from prior tradition, and as a picture of the poet's struggle to reclaim or reawaken that inheritance. See Douglas Bauer, "The Function of Pygmalion in the *Metamorphoses* of Ovid," *Transactions of the American Philological Society* 93 (1962): 13–21; Kevin Brownlee, "Orpheus' Song Re-sung: Jean de Meun's Reworking of *Metamorphosis, X*," *Romance Philology* 36, no. 2 (1982): 204–5; and Leonard Barkan, *The Gods Made Flesh: Metamorphosis and the Pursuit of Paganism* (New Haven: Yale University Press, 1986), 183.

5. You May Touch This Statue

1. I saw this statue in Spring of 1989. It has since been moved, and at present (1992) stands in a niche in a corner of the museum's outdoor arcade, without identification or invitation. I am grateful to Karen Manchester, Assistant Curator of Antiquities at the J. Paul Getty Museum, Santa Monica, California, for providing me with a transcript of the text of the original sign.

2. T. W. Adorno, *Aesthetic Theory*, trans. C. Lenhardt (London: Routledge and Kegan Paul, 1984), 16, comments that "the most important taboo in art is the one that prohibits an animal-like attitude toward the object, say, a desire to devour it or otherwise to subjugate it to one's body. Now the strength of such a taboo is matched by the strength of the repressed urge."

3. Walter Pater, *The Renaissance: Studies in Art and Poetry. The 1893 Text*, ed. Donald L. Hill (Berkeley: University of California Press, 1980), 177.

4. "I looked at nothing else in the gallery. I returned to it several times and at last I kissed the armpit of the swooning woman who stretches her long marble arms towards Love. And the foot! The head! The profile! May I be forgiven. It was my first sensual kiss in a long while. It was also something more; I kissed beauty itself. It was to genius that I dedicated my ardent enthusiasm" (Gustave Flaubert, *Oeuvres complètes* [Paris: Louis Conard, 1910], 9:44; cited in Fred Licht, *Canova*, [New York: Abbeville, 1983], 272).

5. Bloom conceives the idea for this visit while he is having lunch at Davy Byrne's Pub: "His downcast eyes followed the silent veining of the oaken slab. Beauty: it curves: curves are beauty. Shapely goddesses, Venus, Juno: curves the world admires. Can see them library museum standing in the round hall, naked goddesses. Aids to digestion. They don't care what man looks. All to see. Never speaking. I mean to say to fellows like Flynn. Suppose she did Pygmalion and Galatea what would she say first? Mortal! Put you in your proper place. Quaffing nectar at mess with gods golden dishes, all ambrosial. Not like a tanner lunch we have, boiled mutton, carrots and turnips, bottle of Allsop. Nectar imagine it drinking electricity: gods' food. Lovely forms of woman sculped Junonian. Immortal lovely. And we stuffing food in one hole and out behind: food, chyle, blood, dung, earth, food: have to feed it like stoking an engine. They have no. Never looked. I'll look today. Keeper won't see. Bend down let something drop. See if she." (James Joyce, *Ulysses*, ed. Hans Walter Gabler [New York: Random House, 1986], 144–45.)

6. James Merrill, "Dream (Escape from the Sculpture Museum) and Waking," in *From the First Nine: Poems 1946–76* (New York: Atheneum, 1982), 69.

7. See Henri Focillon, *The Life of Forms in Art*, trans. Charles B. Hogan and George Kubler (New York: Zone Books, 1989), 109–10.

8. Ibid., 106, 108.

9. See Rainer Maria Rilke, *Rodin and Other Prose Pieces*, trans. G. Craig Houston (1954; repr. London: Quartet Books, 1986), 18–19.

10. To be accurate, Venus's description of metamorphosis as a punishment "midway between death and exile" applies to Cerastae, who are turned into cattle in the immediately preceding narrative in book 10. Quotations of Ovid's text are from the Loeb Classical Library edition of the *Metamorphoses*, trans. Frank Justus Miller, 2 vols. (Cambridge: Harvard University Press, 1976).

11. Leonard Barkan, "'Living Sculptures': Ovid, Michelangelo, and *The*

Winter's Tale," ELH 48, no. 4 (1981): 644. The same observation is made by Hermann Fränkel, *Ovid: A Poet between Two Worlds* (Berkeley: University of California Press, 1945), 93–97, as well as other critics.

12. Brooks Otis, *Ovid as an Epic Poet* (Cambridge: Cambridge University Press, 1966), 189, observes that Ovid is here echoing the conventional language of late-classical aesthetic criticism.

13. Clement of Alexandria refers to this story in his *Exhortation to the Greeks*, chap. 4 (51P), as does Arnobius in *Adversus Gentes* 6.22, both citing as authority a lost history of Cyprus by the Greek author Philostephanus. (See Otis, *Ovid as an Epic Poet*, 389.) Clement repeats the story among many others that illustrate the power of pagan statues to arouse prohibited desires and deceive their worshipers. Douglas Bauer, "The Function of Pygmalion in the *Metamorphoses* of Ovid," *Transactions of the American Philological Society* 93 (1962): 13–18, suggests that Ovid is very much displaying his transformations of this rather colorless, often satiric tradition.

14. Bauer, "The Function of Pygmalion," 2–9, surveys in detail Ovid's numerous variations on the idea of petrification, both literal and figurative, though his interpretation of the "theme of stone" remains underdeveloped.

15. See Simon Viarre, "Pygmalion et Orphée chez Ovide (*Met.* X. 243–297)," *Revue des études latines* 46 (1965): 235–47.

16. One thing at stake in Ovid's account of the interaction of Pygmalion and the statue is brought out by Stephen Owen, *Mi-Lou: Poetry and the Labyrinth of Desire* (Cambridge: Harvard University Press, 1989), 69–73, who considers the degree to which the text participates in a diffuse but culturally powerful binarism that idealizes the notion of female "softening" and the power of the lover to bring about such softening as symbolic means of securing a fantasy of male mastery or hardening. Owen's broader meditations on the poetic topos of woman or man as "stone" (*Mi-Lou*, 69–110) have been helpful to me in this chapter.

17. J. Hillis Miller, *Versions of Pygmalion* (Cambridge: Harvard University Press, 1990), 3–7, offers an interesting discussion of Ovid's equivocal treatment of the idea of use and usability in this narrative.

18. Frederick Ahl, *Metaformations: Soundplay and Wordplay in Ovid and other Classical Poets* (Ithaca: Cornell University Press, 1985), 245–70, argues that the prevalence of this image in Latin poetry was reinforced by the mirroring of the words *ebur* (ivory) and *rubere* (to redden).

19. Cf. Theresa Krier, "Sappho's Apples: The Allusiveness of Blushing in Ovid and Beaumont," *Comparative Literature Studies* 25, no. 1 (1988): 5–7.

20. Cf. Miller, *Versions of Pygmalion*, 9.

21. Cf. Pierre Brunel, *Le mythe de la métamorphose* (Paris: Armand Colin, 1974), 151.

22. See George Sandys, *Ovid's Metamorphoses Englished* (Oxford, 1632), 361–62.

23. On the history and poetics of blushing, see Christopher Ricks, *Keats and Embarrassment* (New York: Oxford University Press, 1974), 1–68.

24. Sandys, *Ovid's Metamorphoses*, 361.

25. Ernst Kris and Otto Kurz, *Legend, Myth, and Magic in the Image of the Artist: A Historical Experiment*, trans. Alastair Laing and Lottie M. Newman (German orig., 1934; New Haven: Yale University Press, 1979), 61–84, discuss a number of such stories about magical realism in Greek painting, arguing that they serve in part as rationalistic, if still idealizing, substitutes for older myths of the artist's magical capacities.

26. On this last issue, see Leonard Barkan, *The Gods Made Flesh: Metamorphosis and the Pursuit of Paganism* (New Haven: Yale University Press, 1986), 123.

27. Guillaume de Lorris and Jean de Meun, *Roman de la Rose*, ed. Felix Lecoy, 3 vols. (Paris: Champion, 1970) 3:125–38, lines 20787–21212.

28. On this aspect of the narrative, see Roger Dragonetti, "Pygmalion ou les pièges de la fiction dans le *Roman de la Rose*," in *Orbis Mediaevalis: Mélanges de langue et de littérature médiévales*, ed. Georges Guntert, Marc-René Jung, and Kurt Ringger (Bern: Francke, 1978), 89–111, as well as Giorgio Agamben, *Stanze: La parola e il fantasma nella cultura occidentale* (Turin: Einaudi, 1977), 73–84.

29. I quote from Dante's Sestina "Al poco giorno e al gran cerchio d'ombra," one of the "rime petrose," *Dante's Lyric Poetry*, ed. K. Foster and P. Boyde, 2 vols. (Oxford: Oxford University Press, 1967), 1:162.

30. See John Freccero, "Medusa: The Letter and the Spirit," in *Dante: The Poetics of Conversion*, ed. Rachel Jacoff (Cambridge: Harvard University Press, 1986), 119–36. Freccero notes that some manuscripts of the *Roman de la Rose* contain an additional passage that contrasts the image in the castle of the Rose not to Pygmalion's image but to the Medusa, stressing that the image gives those who look at it new life, whereas the face of the Medusa brings only death.

31. On the complex issue of Petrarchan poetic subjectivity and its objects, see (among many interrogations) Giuseppe Mazzotta, "The *Canzoniere* and the Language of the Self," *Studies in Philology* 75 (1978), 271–96, and Nancy Vickers, "Diana Described: Scattered Woman and Scattered Rhyme," *Critical Inquiry* 8 (1981), 265–78. Mazzotta argues that the subject or self projected in Petrarchan lyric is a self bound to loss, to an erotic and linguistic object with which it can never coincide, an object that seems at once to freeze and evacuate the self that strives to recover and fix that object in place, or that disperses the subject and the desire that constitutes it through a network of textual signs. Vickers also notes the traumatic breach in the poet's subjectivity tied to both the loss of and the attempt to recover the presence of Laura. But

she reminds readers that in Petrarch's mode of lyric description, which becomes normative for poets who follow him, it is the body of Laura herself as well as the self of the poet that is frozen, reified, fetishized, dismembered, textually scattered, and silenced in the process of reconstruction.

32. Angus Fletcher, *Allegory: The Theory of a Symbolic Mode* (Ithaca: Cornell University Press, 1965), 85–88.

33. De Lorris and de Meun, *Roman de la Rose*, 3:132, lines 20926–30.

34. Jean-Jacques Rousseau, *Oeuvres complètes*, ed. Bernard Gagnebin and Marcel Raymond, 4 vols. (Paris: Gallimard, 1964), 2:1230–31. This scene clearly echoes and parodies a crucial passage in Condillac's *Traité des sensations* (1754), which describes how that philosopher's experimental subject, a "living statue" whose portals of sensation are opened in careful sequence, first gains knowledge of its own material body and of its division from the world of extended things and causes solely on the basis of touch. See Condillac, *Oeuvres philosophiques*, ed. Georges Le Roy, 3 vols. (Paris: Presses Universitaires de France, 1947), 1:257–58. Here, Condillac suggests that in touching both itself and external objects the statue can be said at once to form itself and to form things not itself—as if it were its own Pygmalion and Prometheus. Yet as Rousseau seems to have understood, in Condillac's text what looks like a finding of the world is simultaneous with the statue's entry into doubt, self-loss, and false reasoning. See additional comments on Condillac below, chapter 7, n. 7.

35. Stanley Cavell, *The Claim of Reason: Wittgenstein, Skepticism, Morality, and Tragedy* (New York: Oxford University Press, 1979), 401, comments that "a statue may not (no longer) fit the place it is in. This compromises its intactness, imposes a false presence or animation upon it. But not everyone is to be expected to sense this."

36. In writing this, I am thinking among other things of James Merrill's brief closet-drama and puppet show, "The Image Maker," in *The Inner Room* (New York: Knopf, 1988), 23–36, which takes as its focus a maker of magical images, or *santos*, in Brazilian Santería. A main argument of the piece is that in his creation and repair of such images the image maker secretly acts to hold the community together, even as the almost inevitable decay and misuse of such images causes them to become the sites of mischievous and disruptive (even self-destructive) animation and magic.

37. Part of the fascination of such miracle stories is that the very blood or tears that humanize the statue, lend it traces of vulnerability, also undo its humanness, compromise our sense of its contingent vulnerability, or at least transform it radically. Such images, after all, survive their wounds, and in a rather peculiar way. (One does not pity bleeding or weeping images.) It is hard to imagine that the blood or tears witnessed as flowing from the image

or statue emerge from "inside" it, or at least not in the way they come from inside human beings; such blood or tears appertain all too obviously to alien orders of meaning and intention, something that contributes to one's sense of the kind of utterance or knowledge they constitute. The scandal and the blessing is that the blood becomes curiously inhuman blood, miraculous but ideological blood; the tears become unknowable but potentially symbolic, ideological tears (as they can become in human beings, too, of course). They are thereby all the more able to mobilize faith, focus or displace a guilt, speak for an otherwise unexpressed need. The power and danger of such miracles (which are routinely mocked by Catholics themselves as well as nonbelievers) lie in the intensity and ambiguity of the desires they can mobilize. I should add here that accounts of bleeding or weeping statues represent only a small facet of the vast complex of miracle stories attached to images in Christian tradition. In the great collections of the high Middle Ages, such as the *Dialogus miraculorum* by the Cistercian Caesarius of Heisterbach (1180–1240) (available in English as *The Dialogue on Miracles*, trans. H. von E. Scott, and C. C. Swinton Bland, 2 vols. [London: Routledge, 1929]) or *Les miracles de Nostre Dame* of Gautier de Coincy (1177–1236) (available in a modern critical edition, ed. V. Frederic Koenig, 4 vols. [Geneva: Droz, 1955–70]), we can find stories of images that are able to nod or smile, embrace a worshiper or turn away in embarrassment, trick and convert infidels, scare away demons, terrorize thieves and iconoclasts, slap sinful nuns; there are images of the Virgin that can manage to save a falling painter, steal a young man's wedding ring and seduce him into entering a monastary, even wipe the sweat from the brow of a jongleur who performs in praise of Mary; there are other images with enough self-consciousness to instruct the carver who works on them, sufficient resourcefulness to find their way home after being stolen, lost, or hidden. A useful gathering of such stories can be found in Michael Camille, *The Gothic Idol: Ideology and Image-Making in Medieval Art* (Chicago: Chicago University Press, 1989), 220–41, who discusses their importance for understanding the broader cultural conditions surrounding the production of sacred art in the late Middle Ages. See also the selection in David Freedberg, *The Power of Images: Studies in the History and Theory of Response* (Chicago: University of Chicago Press, 1989), 283–316. Both authors are aware of the acute conflicts that could be provoked by stories of magical images. Such stories could serve medieval preachers as wonderous exempla or signs of divine power, mercy, and wisdom (often because of their typological echoes), or help reinforce the charisma of a particular cult. But even compilers such as Gautier and Caesarius seem troubled by suspicions that the miracle of a particular image might be mistaken for the product of human subterfuge or demonic illusion, or point to a potentially idolatrous confusion of the power of an image with

that of its divine prototype. See Benedicta Ward, *Miracles and the Medieval Mind: Theory, Record, Event, 1000–1215*, rev. ed. (Philadelphia: University of Pennsylvania Press, 1987), 3–32 and passim, and Peter Brown, "Society and the Supernatural: A Medieval Change," in his *Society and the Holy in Late Antiquity* (Berkeley: University of California Press 1982), 302–32, for relevant general background on the theory and use of the miracle in medieval culture. For a compelling account of the crucial, if often problematic, place of sacred images in the history of Christian pilgrimage, see Victor and Edith Turner *Image and Pilgrimage in Christian Tradition* (New York: Columbia University Press, 1978). See also Michael Taussig, *Shamanism, Colonialism, and the Wild Man: A Study in Terror and Healing* (Chicago: University of Chicago Press, 1987), 188–209, for an exemplary and absorbing account of how the power or charisma of one miraculous image of the Virgin in a rural church in contemporary Colombia is in effect stolen, recast, and repossessed by means of a network of stories, rumors, and counter-histories that transform the "official story" of its origins and miracles promoted by the church itself. Taussig speaks of the life of this image as residing most starkly in its very impurity, in its way of circulating in the promiscuous narratives of a mixed population of Indians, mestizos, blacks, and whites. It is a process through which the image "comes alive" in order to speak on behalf of histories of terror or oppression, or aspirations for renewal and healing, which are otherwise silenced or left without a voice (though often at a cost).

38. I am here summarizing a remarkable analysis by Harold Fisch, *Hamlet and the Word: The Covenant Pattern in Shakespeare* (New York: Frederick Ungar, 1971), 224–30. Fisch's picture suggests that the tragedy of *Julius Caesar* transforms the Renaissance fantasy of ancient Rome as a kind of ghostly city of statues, even as it plays off Roman history's status as a warehouse or museum of heroic exempla. Caesar, Brutus, Cassius, and Antony appear here as grotesque joinings of stone and blood, brittle egos whose integrity is secured only by repression or violence. If they seem to survive death, it is only by becoming statues in another's gallery or political theater. For more general background on the period image of Rome as a city of statues, especially as an emblem of the Renaissance sense of history and historical distance, see Leonard Barkan, "Rome's Other Population," *Raritan* 11, no. 2 (1991): 66–81.

39. See Klaus Theweleit, *Male Fantasies*, trans. Stephen Conway, 2 vols. (Minneapolis: University of Minnesota Press, 1987), especially vol. 1, *Women, Floods, Bodies, History*.

40. French text from Francis Ponge, *Tome premier* (Paris: Gallimard, 1965), 181–83. The translation is adapted from that of Richard Rand, included in his translation of Jacques Derrida's *Signéponge/Signsponge* (New York: Columbia University Press, 1984), 104–6.

41. Ponge's images here might illuminate Neil Hertz's arguments in

"Medusa's Head: Male Hysteria under Political Pressure," in his *The End of the Line: Essays on Psychoanalysis and the Sublime* (New York: Columbia University Press, 1985), 101–93. This essay points to the way that images of women scandalously baring their genitals in public become parts of a recurrent, if anecdotal, iconography of revolutionary terror in nineteenth-century France, something Hertz sees as involving a defensive projection of male sexual fear into a political dimension. He links these images in turn to the popular use of the Medusa's head as a symbol of revolutionary violence, employing Freud's essay "The Medusa's Head" (*SE* 8:273–74), which sees in that petrifying entity both an emblem of and a phantasmic defense against the fear of castration elicited by the child's sight of the genitals of the mother.

42. The idea of the statue's animation as a figure of giving birth was suggested to me by Linda Zwynger. We might consider this analogy further in the light of Barbara Johnson's essay "Apostrophe, Animation, and Abortion," *Diacritics* 16 (Spring 1986): 29–47. Johnson here considers the problematic, often apparently self-defeating ways in which the trope of apostrophe seeks to animate what is inanimate, or not clearly animate, and meditates on how this plays a part in our often conflicted ways of speaking about the life and personhood of unborn children. After a brief analysis of some of the better-known uses of apostrophe in Shelley and Baudelaire, she examines how the resources of apostrophe are tested and complicated in poems about abortion and miscarriage by a number of contemporary woman poets.

43. Cf. Derrida, *Signéponge/Signsponge*, 17.

44. Jean-Paul Sartre observes that Ponge's poetry reclaims for words and things a mode of being "like that of an enchanted statue, a marble haunted by life" and that the internal shifts and disjunctive tropes of his texts resemble more than anything else "the abortive effort of stone toward organized life" (*Critiques littéraires [Situations I]* [Paris: Gallimard, 1947], 334–35, my translation). Ponge's "La Loi et les Prophètes" itself reads like a strange commentary on Sartre's remark, making clear just how troubled and precariously human is the substance of the "life" that haunts the marble, and just how literally abortive it may be. Ponge's text would make clear also our troubled but inescapable complicity with such life.

45. Ponge, *Tome premier*, 84, 185.

46. Ponge, *Tome premier*, 186. English rendering from Francis Ponge, *The Power of Language*, trans. Serge Gavronsky (Berkeley: University of California Press, 1979), 67.

47. My own understanding of what is at stake in Ponge's project of "speaking against words," and in his complex attitude toward silence, is indebted to Elissa Marder's reflections on Ponge in "Human, None Too Human: Readings in Literature, Psychoanalysis, and Film" (Ph.D. diss., Yale University, 1989), especially 148–60.

48. Derrida devotes much of *Signéponge/Signsponge* to this and similar onomastic puns in Ponge's work, reading the "tissu-éponge" as the poet's most crucial figure for the possibility and limits of writing and figuration in general—since it represents a thing that is both endlessly resiliant and infinitely rejectable, without proper inside or outside, a thing that both fouls and purifies, that at once inscribes and effaces the poet's name.

49. Herbert Marks, in a letter to the author.

50. Wallace Stevens, *Collected Poems* (New York: Knopf, 1954), 534.

51. On the statue of Memnon, see chapter 9.

6. Resisting Pygmalion

1. The text is from Giorgio Vasari, *La vita di Michelangelo nelle redazioni del 1550 e del 1568*, ed. Paola Barocchi, 5 vols. (Milan: Ricciardi, 1962), 1:63, my translation.

2. David Summers, *Michelangelo and the Language of Art* (Princeton: Princeton University Press, 1981), 203.

3. See Leonard Barkan, " 'Living Sculptures': Ovid, Michelangelo, and *The Winter's Tale*," *ELH* 48, no. 4 (1981): 639–67. I should note here my indebtedness in this chapter to Barkan's subtle meditations on the trope of living sculpture.

4. See Summers, *Michelangelo and the Language of Art*, passim.

5. On the *paragone*, see ibid., 203–33, and Leatrice Mendelsohn, *Paragoni: Benedetto Varchi's "Due Lezzioni" and Cinquecento Art Theory* (Ann Arbor, Mich.: UMI Research Press, 1982), passim.

6. I reprint the text from Michelangelo, *Rime*, ed. E. N. Girardi (Bari: Editori Laterza, 1967), 117, my translation.

7. See Michelangelo, *Rime*, poems 101 and 104.

8. The drawings accompany Freud's essay, "The Moses of Michelangelo," *SE* 13:226–27. See the fuller discussion of this essay below, chap. 10.

9. The political reading of the poem is discussed in Robert J. Clements, *The Poetry of Michelangelo* (New York: New York University Press, 1965), 99–100, as well as in commentary to Vasari, *Vita di Michelangelo* 3:1032, note 512.

10. Michelangelo, *Rime*, 8. Creighton Gilbert, "Texts and Contexts of the Medici Chapel," *Art Quarterly* 34 (1971), 397–99, comments usefully on the importance of this text for an understanding of the chapel's program. He also makes some shrewd observations on other aspects of the chapel—for instance, the fictive movement of the statues of the two dukes, and their anomalous, pupil-less eyes—and offers a tacit critique of the more idealized,

Neoplatonic readings of such scholars as Charles de Tolnay, *Michelangelo*, 5 vols. (Princeton: Princeton University Press, 1943–60), 3:63–75, who sees the chapel as a microcosmic model of the universe, its three levels representing in succession the ghostly world of the dead, the terrestial sphere, and the celestial realm of ideal forms and immortal fame. (De Tolnay's description of the statues in the chapel as material and yet immortal ghosts is nonetheless evocative.)

11. The meaning of such emblematic props (unique to Night among the statues in the chapel) seems intentionally ambiguous. The owl may be both a sign of evil fortune and a figure of nocturnal vigilance, the companion of Athena. The mask may be an emblem of falsehood or fallacy cast off in sleep (as suggested by de Tolnay, *Michelangelo*, 3:67, on the authority of Ripa's *Iconologia*) or a symbol of death derived from ancient funerary monuments (as Edgar Wind argues in *Pagan Mysteries of the Renaissance*, rev. ed. [New York: Norton, 1968], 165n). One uncanny effect of these gathered emblems is that they intensify one's questions about what goes on in the head of the solitary sleeping figure, to whom they remain invisible, and yet ask to be read simultaneously as *externalizations* of her thought.

12. I am thinking of the classic discussion of humanist ideas of poetic or genial Melancholy in Raymond Klibansky, Erwin Panofsky, and Fritz Saxl's *Saturn and Melancholy: Studies in the History of Natural Philosophy, Religion, and Art* (London: Thomas Nelson, 1964), especially 217–74 and 286–90. Here, Melancholy becomes a peculiarly contradictory quality of mind, a capacity that can produce an almost pathological sadness and dementia even as it is associated with heightened powers of intellect and enthusiasm; it is a condition in which a sense of uncanny compulsion, of bondage to alien, often astral influences meets with an intensified sense of mental freedom. See also Giorgio Agamben's account of Melancholy in *Stanze: La parola e il fantasma nella cultura occidentale* (Turin: Einaudi, 1977), 5–35, which stresses the erotic and phantasmic as well as the intellectual and astral sources of this condition or power. I am aware, of course, that the association of *Night* with Melancholy may merely displace rather than clarify the statue's mysteries.

13. Michelangelo, *Rime*, poem 103.

14. The figure of *Night* also exists in tacit, allusive dialog with more conventional aspects of Florentine Renaissance tombs, in particular their use of realistically carved "sleeping" effigies of the dead. See Erwin Panofsky, *Tomb Sculpture: Four Lectures on Its Changing Aspects from Ancient Egypt to Bernini*, ed. H. W. Janson (New York: Abrams, n.d.), 71–73, on the development of such effigies, and 76–80, on "the activation of the effigy" in later Renaissance monuments.

15. Summers, *Michelangelo and the Language of Art*, 87.

16. See Walter Pater, *The Renaissance: Studies in Art and Poetry. The 1893 Text*, ed. Donald L. Hill (Berkeley: University of California Press, 1980), 50–54. Pater's comments on the ways in which different traditions of sculpture manage to overcome this kind of figurative death—whether by subtle idealization of form, refinements of low relief, or, as in Michelangelo's case, lack of finish—would repay the careful scrutiny of critics writing on sculpture.

17. Defining the nature and meaning of the "unfinish" in Michelangelo's works is a perpetual dilemma. One critic may stress its tragic and agonistic character, its way of showing that the artist's search for an informing *concetto* has reached its limit (Charles Seymour, Jr., *Michelangelo's David: A Search for Identity* [Pittsburgh: Pittsburgh University Press, 1967], 74–75); another may see it as a reflection of a cultural crisis brought on by a deepening sense of the irreconcilability of Christian and classical world-views (Erwin Panofsky, *Studies in Iconology: Humanistic Themes in the Art of the Renaissance* [New York: Harper and Row, 1962], 177); and yet another may argue that it simply grows out of Michelangelo's inveterate habits of experiment and revision (Juërgen Schulz, "Michelangelo's Unfinished Works," *Art Bulletin* 57 [1975]: 366–73). (See also the sources gathered in the notes to Vasari, *Vita di Michelangelo* 4:1645–71.) Despite many attempts at its rationalization and demystification, however, the matter still seems to me as obscure as ever. This is perhaps because our relation to the fracture and finish of stone is so inescapably overdetermined, and furthermore because Michelangelo's unfinished works force us to hold together often incompatible figurations of stone, or allow the figurative and the literal aspects of stone and sculpture to intersect with each other in a truly uncanny fashion.

18. Cavell makes this suggestion explicitly in a digression from his longer analysis of *Othello*, in *The Claim of Reason: Wittgenstein, Skepticism, Morality, and Tragedy* (New York: Oxford University Press, 1979), 481–82. The speculation is wholly characteristic of a writer whose work is haunted by the image of the woman as living statue, an image that for him is a synecdochic figure for the vision of the world produced by the murderous knowledge of skepticism. I should add that the image of Hermione as reawakened statue receives less attention in Cavell's longer essay on *The Winter's Tale* in his *Disowning Knowledge in Six Plays of Shakespeare* (Cambridge: Cambridge University Press, 1987), 193–221, where the chief "figure" of the problem of skepticism is rather Leontes' uncertain acknowledgment of his son Mamillius's paternity. Cavell sees Leontes as secretly terrified by the fact that he has a son at all, partly because of his disappointment with those criteria that would allow him to know for certain that his son is truly his. Cavell also understands Leontes as caught by a vengeful fear of how the mere fact of having a son testifies to his own inescapable embeddedness in a world where giving birth entails both separation and indebtedness.

19. William Shakespeare, *The Winter's Tale*, ed. J. H. P. Pafford (London: Methuen, 1963), 2.1.48. All quotations are from this edition. Cf. Cavell, *Disowning Knowledge*, 206. Leontes, in a central passage, queries Camillo,

> Is whispering nothing?
> Is leaning cheek to cheek? is meeting noses?
> Kissing with inside lip? stopping the career
> Of laughter with a sigh (a note infallible
> Of breaking honesty)? horsing foot on foot?
> Skulking in corners? wishing clocks more swift?
> Hours, minutes? noon, midnight? and all eyes
> Blind with the pin and web, but theirs; theirs only,
> That would unseen be wicked? is this nothing?
> Why then the world, and all that's in't, is nothing,
> The covering sky is nothing, Bohemia nothing,
> My wife is nothing, nor nothing have these nothings,
> If this be nothing. . . .
>
> (1.2.284–96)

20. John Donne, "A Nocturnall upon S. Lucies Day, being the shortest day," lines 17–18, in *The Elegies and the Songs and Sonnets of John Donne*, ed. Helen Gardner (Oxford: Oxford University Press, 1965), 85.

21. The threat of physical torture seems to hover throughout the play, alongside the idea of bodily revival. The two come together most strangely at the moment when Autolychus, dressed as a courtier, tells the shepherd's son that he will be "flayed alive, then 'nointed over with honey, set on the head of a wasps' nest, then stand till he be three quarters and a dram dead; *then recovered again with aqua-vitae or some other hot infusion*" (4.4.785–89, my emphasis).

22. In a strangely compelling commentary (one not wholly incompatible with Cavell's), René Girard argues that Leontes' jealous certainty about Hermione results from his need to find an external, projective mirror for his own desire and love in a fantasy of Hermione's affair with Polixenes—a projection that is, in one sense, the origin of his desire, even as it is what descredits and destroys the real grounds of their love both for him and each other. (See Girard, *A Theater of Envy: William Shakespeare* [New York: Oxford University Press, 1991], 308–42, especially 334–35). If nothing else, Girard's argument makes it clear why what may seem a slightly precious, even comic attention to the details of the statue's perfect mimesis of life in this scene yet reminds us of questions about desire and knowledge that are at the heart of the tragic plot.

23. Quotations are from *Measure for Measure*, ed. J. W. Lever, New Arden

Edition (London: Methuen, 1965). Shakespeare may also be recalling John Marston's satirical epyllion, *The Metamorphosis of Pygmalion's Image* (1598), with its virtually pornographic treatment of the statue's coming to life, though Marston offers no explicit comparison of the awakened statue to a prostitute.

24. Terence Cave, *Recognitions: A Study in Poetics* (Oxford: Oxford University Press, 1988), 226.

25. William Shakespeare, *King Lear*, 4.7.45. I quote from the New Arden Edition, ed. Kenneth Muir (London: Methuen, 1972).

26. Lear's fixation on "proving" the redemptive chance of Cordelia's life by seeing if her breath will "mist or stain the stone" of a crystal or stone mirror (*King Lear* 5.3.261) has a peculiar resonance with the final scene in *The Winter's Tale*, which focuses on a stone whose lips are spoken of as both breathing and stained (5.3.81–83).

27. Hermione's own first words are not directed to Leontes, but to Perdita, when she speaks not as an *object* of wonder but rather as one enrolled in an audience of those who themselves wonder at Perdita.

28. On the importance of the lost child, and on the play's larger fascination with "telling"—storytelling, counting, taking account of—see Cavell, *Disowning Knowledge*, 205–10.

29. Barkan, " 'Living Sculptures,' " 659, interestingly compares the silence at the end of the play—which, he says, "purifies the disasters of speech"—to the compelled or poisoned speech of the opening acts, in particular Leontes' various attempts to command or coerce speech from Hermione, as well as to silence all those who would speak *against* him.

7. Crossings

1. See Shoshana Felman's *The Literary Speech Act: Don Juan with J. L. Austin or Seduction in Two Languages*, trans. Catherine Porter (Ithaca: Cornell University Press, 1983), which understands Don Juan's seductions and broken promises as parables about the seductions and broken promises, the compromised pleasure and knowledge, of literary and philosophical language.

2. See Michel Serres, "*Don Juan* au palais des merveiles: Sur les statues au XVIIe siècle," *Les Études Philosophiques*, no. 3 (1966): 385–90. Serres argues that Molière's original audience would have seen nothing miraculous or irrational in the statue of the Commander, nothing uncanny or enigmatic. Exorcised of any taint of the superstitious, even of the residual mystery attached to a figure like Hermione, this statue would have appeared as nothing but an

automaton—a thing comparable both to the clockwork marvels visible in the gardens of Versailles and to the more ghostly machine into which Descartes and Leibniz had speculatively converted human beings. It is in this sort of statue that the skeptical and materialistic Don Juan meets his double.

3. Prosper Mérimée, *Romans et nouvelles*, ed. Henri Martineau (Paris: Gallimard, 1951), 409–36.

4. The medieval versions of this immensely popular tale are discussed in detail in Paul Franklin Baum, "The Young Man Betrothed to a Statue," *PMLA* 34 (1919): 523–79, as well as in Theodore Ziolkowski, *Disenchanted Images: A Literary Iconology* (Princeton: Princeton University Press, 1977), 18–77. Ziolkowski also discusses its transformations by later authors like Mérimée, as well as Henry James in "The Last of the Valerii" (on which, see also J. Hillis Miller, *Versions of Pygmalion* [Cambridge: Harvard University Press, 1990], 211–43). Baum also notes the curious secondary life the tale acquired in ecclesiastical miracle stories, where a statue of the Virgin Mary was substituted for the statue of Venus. No longer a demonic love goddess, in this context the statue's "invasive" power worked to save men from secular marriage for the sake of the church and monastery.

5. See Michel Serres's meditation on Mérimée's story, "Un dieu du Stade: Monsieur Alphonse," in *Alphonse Juilland: D'une passion l'autre*, ed. Brigitte Cazelles and René Girard (Saratoga: Anma Libri, 1987), 7–31.

6. Both the Don Juan legend and the story of Venus and the ring are linked to a European folktale type known as "the double invitation." The story has many variants, but its basic shape can be represented by the following late nineteenth-century French version, which I summarize from the text reproduced in Jean Rousset, *Le mythe de Don Juan* (Paris: Armand Colin, 1978), 109–10: A young man makes a round of visits to his friends, in order to invite them to his coming wedding. Returning through a churchyard, drunk after many congratulatory toasts, he sacrilegiously kicks at a skull lying in his path, and then mockingly invites it to his wedding as well. A skeleton arrives at the feast, but refuses to eat, and invites the groom to join *him* for dinner the next night. The groom arrives at the graveyard, only to find three skeletons sitting at an empty table. One leads him through a grave to an underground chamber, where he is shown the burning torches of individual human lives, among them his own, nearly burnt-out flame. Returning to the world, the youth dies within two days.

7. The curious articulations or dramatizations of doubt made possible by the moving statue can be brought out (at least in part) by a text of Denis Diderot's, in the dialog between himself and Jean Le Rond d'Alembert that prefaces "La rêve de d'Alembert." Here Diderot offers an ironic recipe for giving animation to the substance of a marble statue and proving that there is

little difference between stone and flesh: break the statue into pieces, grind it to dust, mix it with humus and let it rot "un an, deux ans, un siècle." Next, plant in the soil beans, cabbage, and so on, which, when grown, will be converted into vital physical and intellectual energy in those humans who eat them. (See Diderot, *Oeuvres philosophiques*, ed. Paul Vernière [Paris: Garnier, 1964], 260–64.) This idea both mocks and naturalizes the fiction of the animated statue, reinforcing the philosopher's attempts to provide a materialist account of the relations of mind and body, hence to deny the ideal substance of intelligence as it was defined by Descartes. The humor in this text, however, interests me less than the apparent ease with which we can turn the enlightened skepticism of the anecdote against itself by imagining a coda in which those persons who eat the vegetables grown in the statue-enriched soil find themselves strangely turning to stone. The inevitability of such a twist may have something to do with the way that Diderot has preemptively read human beings as themselves stonelike or wholly material or else may result from the presence of some more elusive fantasies of magical infection, though it is not clear to me that these two explanations are not related in some way.

The writing of Diderot's contemporaries is especially rich in animated statues. (For basic background, see J. L. Carr, "Pygmalion and the *Philosophes:* The Animated Statue in Eighteenth-Century France," *Journal of the Warburg and Courtauld Institutes* 23 [1960], 239–55.) In the light of my own concerns in this section, it would be interesting to set beside Diderot's fantasy the different, but equally rationalized, living statue of Condillac's *Traité des sensations* (*Oeuvres philosophiques*, ed. George le Roy, 3 vols. [Paris: Presses Universitaires de France, 1947], 1:219–319). Condillac's text undertakes the project of giving a fully secular account of the origins of the human mind in sensation. In order to do this, Condillac imagines a marble statue, constructed internally like a living human being, provided with various "stops" in his stone carapace for each of the senses, stops that the philosopher can open at will. The statue also has a capacity to register pleasure and pain, as well a minimal capacity for receiving impressions from the realm of the senses. Starting with smell and ending with touch, Condillac opens the statue's senses and fictively "observes" in the statue which categories of consciousness are created in the statue on the basis of one particular sense alone, as well as different senses in combination (e.g., habits of attention, imagination, comparison, judgment; ideas of satisfaction and dissatisfaction, duration and change, possibility and impossibility; feelings of hope, fear, terror, surprise). The issue that intrigues me here is how the choice of the fiction of an animated statue shapes, and perhaps deforms, Condillac's account of the human, how it affects his argument, his examples, even his tone. One notes while reading, for instance,

how strangely solicitous and yet ruthless Condillac is toward his philosophical child; he seems at times to be educating it as well as observing it, worried
over its pleasures, frustrations, incapacities, and errors. There are moments
that combine a startling lyricism with the kind of fierce reductions of experience that animate the fictions of Samuel Beckett. When limited only to smell,
for example, the statue smelling a rose simply becomes the smell of the rose
(part 1, chap. 1, sec. 2); limited to hearing, and listening to both a song and
the noise of a brook, the statue becomes the song and the noise of the brook
(part 1, chap. 8, sec. 2), its consciousness a mere echo of the sounds of the
external world. Even in his own terms, Condillac never quite succeeds in
granting to the statue, or discovering within it, a sufficiently full human life.
The statue gains basic tools of practical thought, learns to survive, as it were,
even gains through motion and touch some sense of a self and a body distinguished from the external world (see above, chapter 5, n. 34). But the
statue remains something of a pleasure/pain machine. It is in fact a strange
combination of solipsist and automaton, at once bereft of any real knowledge
of, or contact with, a world beyond itself and yet wholly bound to that world,
almost entirely its creature or precipitate (becoming a kind of Blakean monster). It is worth noting too that despite some minimal capacity for deictic
utterance (an ability to say, for example, "this is me," "this is still me" [part 2,
chap. 5, sec. 4]) the statue, like a golem, never really gains the use of language. This might mean, as Hans Aarsleff argues, that the statue can never
attain either self-reflection or reason, or establish that connection with the
world of external objects and persons that is given to us by the voluntary,
arbitrary signs of human language ("Condillac's Speechless Statue," in
Aarsleff, *From Locke to Saussure: Essays on the Study of Language and Intellectual
History* [Minneapolis: University of Minnesota Press, 1982], 210–24). But one
may wonder whether Condillac's suggestions of the limitations of the statue
don't point to dilemmas that continue to play a part even in the subjectivity of
those who do speak a language. The question of how human or inhuman this
statue is thus remains open.

8. We might test our understanding of this pattern—its seduction and
inevitability—by looking at its emergence in a central text such as canto 10 of
Dante's *Purgatorio*. Here, having ascended through a wandering fissure from
the base of the mountain of Purgatory, Dante and Virgil find themselves
standing on a deserted plain, the circle of Pride. They are confronted with
three, divinely made bas-reliefs, each showing an emblem of humility: an
angel giving Mary news of the incarnation, King David dancing naked before
the ark under the disapproving eyes of his wife, Michal, and the emperor
Trajan holding back the departure of his army in order to give justice to a poor
widow whose son had been murdered. More important than the typological

complexities in this context is that these reliefs evoke a series of different, often subtly equivocal versions of the conventional tropes of living stone. For example, Dante offers hyperbolical praise of an artistry greater than either "Policleto" or Nature; he registers the latent presence of words as they are seen "impressed" on the postures and attitudes of the silent figures; and he suggests that the images occasioned an internal debate between his sight, which could truly "see" music in the stone, and his hearing, which apprehended only silence. (Such paradoxes have their own typological resonances, of course, for instance in the way that Dante's reference to the stone's *visibile parlare*, "visible speech," evokes comparison with the *verba visibilia* of Christ.) After an apostrophe that speaks of the deforming powers of human pride, Dante catches a glimpse of the inhabitants of the circle: a line of sinners borne down under gigantic boulders, such that they are almost indistinguishable from them. This leads to the famous simile in which Dante compares the look of these souls to the appearance of the kind of grimacing grotesque that one can still see placed under roofs and corbels in medieval buildings, and fictively borne down by the weight of what it supports, "la qual fa del non ver vera rancura/nascere 'n chi la vede" (which unreal begets real distress in one who sees them). (*The Divine Comedy*, ed. and trans. Charles S. Singleton, 3 vols. [Princeton: Princeton University Press, 1972], 2: part 1, 106–7, lines 133–34.) Here the complex unfolding of narrative—stone coming to life yielding to living souls turning into or absorbed by stone— stretches out over the course of the canto exactly that pattern of contamination and exchange I have been discussing; the text in fact rationalizes and moralizes that pattern by giving it an eschatological and allegorical "site," even as that pattern lends an ironic character to the allegory. I still wonder, though, whether a fuller understanding of this pattern or master plot in itself might transform our sense of what is at stake in Dante's use of it. This is especially important insofar as critics have seen in canto 10 an allegory of Dante's own poetic ambitions, his quest for a supermimetic form of representation, as well as a reflection on his still-equivocal relations with the contaminated, illusory, and idolatrous realm of fallen artifice. (See, for example, Giuseppe Mazotta, *Dante, Poet of the Desert: History and Allegory in the "Divine Comedy"* [Princeton: Princeton University Press, 1979], 237–54, and Teodolinda Barolini, "Re-presenting What God Presented: The Arachnean Art of Dante's Terrace of Pride," *Dante Studies* 105 [1987]: 43–62.) Worth noting here is Dante's way of playing in this canto on the physical, moral, and philosophical meanings of the word *atto* (act, action, attitude), as well as his attention to the pilgrim's need at times to avoid letting his sight rest too statically on a single image and at others to fix it pointedly on a hard-to-decipher object (such as the sinners absorbed by stone). Equally crucial, I think, is that the dramatic postures of the figures of humility Dante describes—combining

elements of activity and passivity, motion and stillness, resistance and yielding—seem peculiarly appropriate to creatures who *remain* part of an immobile, inanimate piece of sculpture, even as these postures become emblems of ethical and spiritual acts as well.

9. The screenplay of the film was adapted by Truffaut and Jean Gruault from a 1956 novel of the same title by Henri-Pierre Roche. The film cuts and conflates many parts of Roche's text and adds some newly invented material, but the basic plot and mood adhere to the novel very closely.

10. The references to the French Revolution in the film are many and subtle. To take just one example, Catherine is repeatedly compared to Napoleon, and at one moment mugs with a small bust of the general, explaining to Jules and Jim that she used to dream of having a child by him.

11. See Stanley Cavell's suggestive commentary on this passage, and on Truffaut's film in general, in *The World Viewed: Reflections on the Ontology of Film,* enlarged ed. (Cambridge: Harvard University Press, 1979), 137–42.

12. I borrow the phrase in quotation marks from Stanley Kauffmann's review of Greenaway's film, reprinted in *Field of View: Film Criticism and Comment* (New York: PAJ Publications, 1986), 220. In an interview in *L'avante scéne du cinéma,* no. 333 (October 1984): 7–8, Greenaway himself says that he thought of the statue as a figure like Puck, or the "green man" of English folklore. This issue also contains a complete script of the film, together with a number of brief commentaries on eleven of the draughtsman's drawings (all executed by Greenaway).

13. Greenaway's statue reminds me not only of Watteau but of the literary form known as the pasquinade, which flourished in Rome during the fifteenth and sixteenth centuries. It was a mode of usually anonymous satire in which the fierce, scurrillous voices of popular political and anticlerical protest chose to speak—in the face of silence or censorship—through the "mask" or voice of a misshapen, nearly faceless relic of antique sculpture nicknamed "Mastro Pasquino," a statue to whose base the texts themselves were commonly attached. My Roman guidebook (*Roma e dintorni,* Touring Club Italiano Guide [Turin: Il Mulino, 1965]) in fact lists six *statue parlanti* in its index, including (besides Pasquino) the huge river-god "Marforio" on the Capitoline Hill, who was often represented in dialogue with Pasquino, and a number of other broken, faceless pieces of ancient and medieval sculpture, many given colloquial nicknames like Abbate Luigi, Babuino, and Madama Lucrezia. One gets a sense that these ambiguous citizens of the Italian capitol were imagined as being peculiarly privy to the city's hidden corruptions and could also safely make them public. For texts and historical background, see *Pasquinate romane del Cinquecento,* ed. Valerio Marucci, Antonio Marzo, and Angelo Romano, 2 vols. (Rome: Salerno Editrice, 1983).

8. The Space Between

1. Roman Jakobson, "The Statue in Puškin's Poetic Mythology," *Language in Literature*, ed. Krystyna Pomorska and Stephen Rudy (Cambridge: Harvard University Press, 1987), 318–67.

2. Jakobson, "The Statue in Puškin's Poetic Mythology," 353.

3. Ibid., 360.

4. Ludwig Wittgenstein, *Philosophical Investigations*, trans. G. E. M. Anscombe (New York: Macmillan, 1968), para. 281.

5. Heinrich von Kleist, "On the Marionette Theatre," trans. Christian-Albrecht Gollub, in *German Romantic Criticism*, ed. A. Leslie Willson (New York: Continuum, 1982), 242. See the analysis of this anecdote in Paul de Man's essay, "Aesthetic Formalization: Kleist's *Über das Marionettentheater*," in *The Rhetoric of Romanticism* (New York: Columbia University Press, 1984), 278–81, to which my own commentary is indebted.

6. One of the most complex instances of this play of identification, possession, and self-wounding transformation can be found in book 5, canto 7 of Spenser's *The Faerie Queene*, which contains an account of the heroine Britomart's visit to the "Isis Church," including a strange dream of her transformation into a statue of the goddess. Here, one portion of the statue, a demonic crocodile on which the goddess stands, comes alive to put out a fire that threatens the statue and temple, but then turns on the figure of Britomart/Isis herself. Subdued in turn by this statuesque authority figure, the reformed crocodile turns into a lover, indeed impregnating the goddess, who gives birth to a roaring lion. A priest in the temple subsequently interprets this as a dream of Britomart's eventual possession by an imperial destiny, though there is space for other, less idealized readings as well. I have commented further on this text in my *Spenserian Poetics: Idolatry, Iconoclasm, and Magic* (Ithaca: Cornell University Press, 1985), 174–80.

7. As may be obvious, I am thinking in part here of Freud's late metapsychological concept of the death drive, or repetition compulsion, a peculiarly contradictory, indeed nearly invisible, impulse whose representations are always contaminated with the defenses against it. As described in *Beyond the Pleasure Principle* (*SE* 18:35–61) and *The Ego and the Id* (*SE* 19:40–47), this drive is most basically a conservative force tending to the reduction or evacuation of all animating tensions in the psyche, which both aligns it with earlier accounts of what Freud calls the pleasure principle and sets it perpetually at odds with the synthesizing, life-perpetuating impulses of Eros. The unsettling element in Freud's account is that the death drive tends to manifest itself in forms of pleasure and mastery that, partly because of their masochistic or traumatic character, do violence to the conventional aims of

the pleasure principle, and hence undermine its authority. (See the careful unravelling of these contradictions in Leo Bersani, *The Freudian Body: Psychoanalysis and Art* [New York: Columbia University Press, 1986], 50–67.) To this degree, thinking about the death drive may help one understand, or better describe, some of the peculiar contradictions and conflicting aims of the animation fantasy. That this is more than a merely ad hoc analogy is suggested to me by Freud's essay "The Uncanny" (*SE* 17:217–52). Here Freud argues that the sense of strangeness or alienated recognition that we call the "uncanny" (*unheimlich*) is the result of the veiled return of images, impulses, or forms of consciousness hitherto suppressed or surmounted. Two points are important here. First, while Freud invokes at least two other causes for the uncanny, including the return of either primary process fantasy or infantile castration anxiety, one of its chief sources is said to be the covert re-emergence of the death drive, or rather the repetition compulsion. (The first rubric is curiously, even uncannily, suppressed in this essay.) Second, Freud finds many of his most suggestive examples of the uncanny in stories about speaking dolls or automata, animated images, or galvanized corpses, entities that confuse the conventional boundaries between animate and inanimate. The uncanny also manifests itself in descriptions of bodies whose motion or expression seem tied to mechanical or inhuman energies, subject to tics, epilepsy, or autism, or in descriptions of fragmented parts of bodies that survive their own severance from the body, which achieve a kind of autonomy and life of their own. Especially insofar as they disrupt our normative notions of the circuit of life and desire, such stories can be seen to reflect the breaking through of the repetition compulsion. It might be argued, however, that it is just such stories that themselves help constitute that drive, or at least lend it apprehensible conceptual and narrative shape in Freud's essay.

8. See Franz Kafka, *The Complete Stories*, ed. Nahum Glatzer (New York: Schocken, 1971), 390 and 427–29.

9. The skit ended, as I recall, with the two performers slamming into each other mask to mask, obliterating both the perfect and the imperfect faces simultaneously, after which the two backed away a distance, so that a bridge—however formless and catastrophic—finally emerged between them. My thanks to Lee Dassler for helping me to piece together my recollection of this performance.

9. Talking with Statues

1. Book 9, poems 713–42 and 793–98. All quotations are from *The Greek Anthology*, trans. W. R. Paton, 5 vols. (London: Heinemann, 1917).

2. "The words make the still work of art move, and in the process they remind us that the art of the image is always frozen in multiplicities and changes" (Leonard Barkan, *The Gods Made Flesh: Metamorphosis and the Pursuit of Paganism* [New Haven: Yale University Press, 1986], 9). Barkan argues that such texts implicitly depict the act of representation as a form of metamorphosis, a process at once natural and unnatural, at once bringing the dead to life and yet transcending life, the real, and nature, in that very triumph (10–11).

3. I use the term "ekphrasis" to refer both to the formally descriptive writing that Jean Hagstrum calls "iconic" and to those poems in which the work is fictively lent a voice, or "speaks out," the etymological sense of "ekphrasis." See Hagstrum, *The Sister Arts: The Tradition of Literary Pictorialism and English Poetry from Dryden to Gray* (Chicago: University of Chicago Press, 1958), 17–18, 18n. Hagstrum's history of ekphrastic writing through the eighteenth century and his history of the idea of *ut pictura poesis* (*Sister Arts*, 1–170), are still extremely valuable. John Hollander, "Poetics of Ekphrasis," *Word and Image* 4, no. 1 (1988): 209–19, suggests that we also make a pragmatic distinction between "notional" ekphrases, which describe nonexistent, imaginary works of art like Achilles' shield, and those describing works or objects that actually exist. If the latter mode tends to render even "real" works of art imaginary it is because, as Hollander notes, such ekphrases often draw on literary resources first explored in notional ekphrases, especially their attention to both the contextual origins of the object and the drama of describing it, and their fascination with what is *not* explicitly visible in the object.

4. Leo Spitzer describes Keats's complex reexamination of the conventions of ekphrastic writing in "The 'Ode on a Grecian Urn,' or Content vs. Metagrammar," *Comparative Literature* 7 (1955): 203–25.

5. The dedicatory inscriptions can be found primarily in book 6 of *The Greek Anthology* (Loeb Classical Library Edition, vol. 1). See also the discussion of the origins and conventions of the form in Paul Friedlander, *Epigrammata: Greek Inscriptions in Verse Form from the Beginnings to the Persian Wars* (Berkeley: University of California Press, 1948), as well as Andrew Stewart, *Greek Sculpture: An Exploration*, 2 vols. (New Haven: Yale University Press, 1990), 1:22–24. Stewart is particularly interesting insofar as he makes use of votive inscriptions to help construct a fuller picture of Greek sculpture itself, suggesting that the inscriptions illuminate both its thoroughgoing animism and the competitive spirit that drove sculptural practice.

6. The largest gathering of epitaphs is in book 7 of the *Anthology* (Loeb Classical Library Edition, vol. 2). Richmond Lattimore, *Themes in Greek and Latin Epitaphs* (Urbana: University of Illinois Press, 1942), provides a rich survey of the ways in which such texts depicted the different forms of immor-

tality available to the dead, their modes of memorialization, reflection, invocation, warning, curse, and so on. See also Sonya Lida Tarán, *The Art of Variation in the Hellenistic Epigram* (Leiden: E. J. Brill, 1979), 132–49. I cannot begin to do justice to the complex poetic history of the epitaph here. It is important to note, however, that model of epitaphic inscription has become a crucial object of interest in recent criticism. Influenced in part by Wordsworth's remarkable essays on epitaphs, some critics have indeed taken the epitaph as a synecdochic model for the complex displacements and the subtle, secular hauntedness of literary writing in general. One important text in this regard is Geoffrey Hartman's essay "Wordsworth, Inscriptions, and Romantic Nature Poetry," in his *Beyond Formalism: Literary Essays, 1958–70* (New Haven: Yale University Press, 1970), 206–30, which speculates on the emergence of romantic nature poetry out of the model of epitaphic inscriptions on a natural scene. Equally significant has been Paul de Man's "Autobiography as De-Facement," in *The Rhetoric of Romanticism* (New York: Columbia University Press, 1984), 67–82, in which he discusses the epitaph's dependence on the rhetorical figure of prosopopoeia. I have commented more fully on this question in de Man later in this chapter.

7. Murray Krieger, "The Ekphrastic Principle and the Still Movement of Poetry; or *Laokoön* Revisited," in his *The Play and Place of Criticism* (Baltimore: Johns Hopkins University Press, 1967), 105–28, and W. J. T. Mitchell, "Ekphrasis and the Other," *South Atlantic Quarterly* 9 (Summer 1992): 695–719, both argue that the paradoxes of ekphrastic writing can be taken as emblematic of dilemmas that affect all forms of literary expression. Krieger focuses especially on the way in which ekphrasis fictively transforms moving and mutable entities—especially arbitrary words—into fixed, formally patterned, and self-sufficient verbal artifacts. Mitchell, by contrast (in many places responding directly to Krieger's essay), suggests that the trials of ekphrasis can be seen as synecdochic instances of our troubled forms of engagement with alterity and otherness, arguing further that the visible traces of this struggle in ekphrastic texts always compromise the supposed fixity and iconicity of literary writing.

8. See Callistratus, *Descriptions,* printed together with Philostratus's *Imagines,* trans. Arthur Fairbanks (Cambridge: Harvard University Press, 1931), 380–83.

9. Ibid., 385.

10. Ibid., 383.

11. Barkan, *The Gods Made Flesh,* 8–13, argues that ekphrastic texts like Callistratus's reflect the skeptical fascination of late-classical thought with the mutability of appearance and reality, the interminglings of the authentic and the deceptive in both nature and the activity of the artist. "In the world of late

antiquity, ekphrasis, like metamorphosis, becomes a key to the complex and celebratory rhetoric concerned with the instabilities of matter and uncertainty of reality" (10).

12. A more comprehensive history than my own would map the ways in which medieval and Renaissance ekphrases, especially in the wake of church teaching, reflect a greater distrust of the blandishments of visual and verbal art and hence place a greater stress on allegorizing or spiritualizing the images described; they try, that is, to anchor the visual power of objects, and the power gained in the act of describing them, to a particular moral or theological agenda. Later ekphrases also show the influence of the more elaborate and troubled myths of individual artistic prowess and the more subtly subjectivizing rhetoric found in poetry after Petrarch.

13. Paolo Valesio, *Ascoltare il silenzio: La retorica come teoria* (Bologna: Il Mulino, 1986), 341–426 especially.

14. Cf. Geoffrey Hartman, *Saving the Text: Literature/Derrida/Philosophy* (Baltimore: Johns Hopkins University Press, 1981), 147.

15. Northrop Frye, *Spiritus Mundi: Essays on Literature, Myth, and Society* (Bloomington: Indiana University Press, 1976), 140.

16. See Gotthold Ephraim Lessing, *Laocoön: An Essay on the Limits of Painting and Poetry*, trans. Edward Allen McCormick (1962; repr., Baltimore: Johns Hopkins University Press, 1984), 60, 71.

17. De Man, *The Rhetoric of Romanticism*, 78.

18. Paul de Man, *Allegories of Reading: Figural Language in Rousseau, Nietzsche, Rilke, and Proust* (New Haven: Yale University Press, 1979), 43.

19. Barbara Johnson, "Apostrophe, Animation, and Abortion," *Diacritics* 16 (Spring 1986): 34.

20. De Man, *The Rhetoric of Romanticism*, 74.

21. De Man makes this clear especially in his discussion of Rilke in *Allegories of Reading*, 38–39.

22. In his essay "Shelley Disfigured," for example, describing the deceptive terms that structure our literary history, de Man comments that critics tend to write as if "Shelley or romanticism are themselves entities which, like a statue, can be broken into pieces, mutilated, or allegorized (to use Hardy's alternatives) after having been stiffened, frozen, erected, or whatever one wants to call the particular rigidity of statues. Is the status of a text like the status of a statue?" (*The Rhetoric of Romanticism*, 94–95; cf. also 121–23).

23. De Man, *The Rhetoric of Romanticism*, 118–19.

24. De Man, *Allegories of Reading*, 187.

25. See above, n. 22.

26. De Man, *The Rhetoric of Romanticism*, 121.

27. German text, Rilke, *Sämtliche Werke*, 6 vols. (Frankfurt am Main: Insel-

Verlag, 1955–66), 1:557; English trans., *Selected Poetry of Rainer Maria Rilke*, trans. Stephen Mitchell (New York: Random House, 1982), 62.

28. See Rainer Maria Rilke, *Rodin and Other Prose Pieces*, trans. G. Craig Houston (1954; repr., London: Quartet Books, 1986), 19.

29. See G. W. F. Hegel, *Aesthetics: Lectures on Fine Art*, trans. T. M. Knox, 2 vols. (Oxford: Oxford University Press, 1975), 2:732–33.

30. Rilke, *Sämtliche Werke* 1:588, *Selected Poetry*, 63.

31. Rilke, *New Poems: The Other Part (1908)*, trans. and intro. by Edward Snow (San Francisco: North Point, 1987), xiv.

32. Rilke, "Some Reflections on Dolls," in *Rodin and Other Prose Pieces*, 119–27.

33. The entire passage in Baudelaire's essay is worth quoting, since it leads in the end to an irony at least as sharp as, and markedly less sentimental than, Rilke's in the doll essay: "The overriding desire of most children is to get at and *see the soul* of their toys, some at the end of a certain period of use, others *straightaway*. It is on the more or less swift invasion of this desire that depends the length of life of a toy. I do not find it in me to blame this infantile mania; it is a first metaphysical tendency. When this desire has implanted itself in the child's cerebral marrow, it fills his fingers and nails with an extraordinary agility and strength. The child twists and turns his toy, scratches it, shakes it, bumps it against the walls, throws it on the ground. From time to time he makes it re-start its mechanical motions, sometimes in the opposite direction. Its marvellous life comes to a stop. The child, like the people beseiging the Tuileries, makes a supreme effort; at last he opens it up, he is the stronger. But *where is the soul?* This is the beginning of melancholy and gloom. . . . There are others who immediately break the toy which has hardly been put in their hands, hardly examined; so far as these are concerned I must admit that I do not understand the mysterious motive that causes their action. Are they in a superstitious passion against these tiny objects which imitate humanity, or are they perhaps forcing them to undergo a kind of Masonic initiation before introducing them into nursery life? *Puzzling question!*" From "A Philosophy of Toys," in *The Painter of Modern Life and Other Essays*, trans. Jonathan Mayne (London: Phaidon, 1964), 202–203; French text, "Morale du joujou," in Charles Baudelaire, *Oeuvres complètes*, ed. Y.-G. Le Dantec (Paris: Gallimard, 1961), 524–30. Giorgio Agamben, *Stanze: Parola e fantasma nella cultura occidentale* (Turin: Einaudi, 1977), 65–70, reads Baudelaire's and Rilke's essays together as exemplary documents in the emergence of a modern picture of the human self in its troubled relation to objects of meaning and value in the world, arguing that Rilke's essay should be read as a response to Baudelaire.

34. Rilke, "Reflections on Dolls," 119, 123, 126.

35. I borrow the idea of "unusable subjectivity" from Maurice Blanchot, *The Space of Literature,* trans. Ann Smock (Lincoln: University of Nebraska Press, 1982), 134–42.

36. Richard Howard, *Fellow Feelings* (New York: Atheneum, 1976), 53–55.

37. Randall Jarrell, "The Bronze *David* of Donatello," in *Randall Jarrell: The Complete Poems* (New York: Farrar, Straus and Giroux, 1969), 273–75.

38. "The Giant on Giant-Killing" is one of a number of extended ekphrastic texts in Howard's work. In the present context, however, I am more struck by the resemblance between the idea of Goliath's words and those of the historical selves conjured up in Howard's numerous dramatic monologs. These poems present a fantastic array of curious, studiously unmonumental voices stolen from, or reimagined within, the recorded lives of famous poets, composers, historians, politicians (voices that may "belong" to these individuals, but often as well to their less famous widows, secretaries, visitors, enemies). Such poems tend to imagine lost or marginal moments in these historical lives; they address, say, passages in the biography of artists like Browning, Rossetti, Rodin, Proust, or Stevens that serve to undo common myths about the origins and perfect seriousness of their work, passages that bring together the banal and the outlandish, sanity and madness. The "alien oracles" of these monologs are characteristically refused any great pathos or authority; they are denied the moralism of epitaphs or the hortatory power of angels; they speak no great secrets. And yet they are voices that (like Goliath) seek to "set the record straight," that lodge minor, unacknowledged protests, restore small bits of justice; they are speakers who work mainly to make minor adjustments in the field of praise and blame, to help sort out the lies told by others and the fictions we tell to ourselves. More than anything else, Howard's imaginary speakers seem obsessed with marking those accidents of thought and history, those unwilled "findings," which condition invention, those moments when the poet is found by a life or a death *not* his own. ("For things to have a shape," one speaker says, "they must include a death.") I would argue in fact that the speaking head of Goliath offers not just an instance but a self-reflexive emblem of such fictive resurrections; that is to say, it offers an image of what such imagined, marginal, and ghostly speakers look like, where they might speak from—representing them ironically in the voice of a statue that, in its monumentality, might otherwise be a figure for the failure of biography.

39. One might think of that wing as a displaced, eroticized version of those snakes that entangle Laocoön and his sons.

40. According to legend, Memnon was an Ethiopian or Egyptian prince, a gigantic warrior, who brought aid to Priam during the Trojan war, and was slain by Achilles after killing the Greek warrior Antilochus. At his funeral,

Zeus transformed the rising ashes of his pyre (or, in some versions, his own troops) into a new species of birds, the Memnonides, who fought above the flames and returned yearly to his tomb. The story is not found in Homer (though Memnon is mentioned briefly in book 9 of the *Odyssey*), but is given extended treatment in book 2 of Quintus Smyrnaeus, *The Fall of Troy*. Memnon's career is retold more briefly by Philostratus in *Apollonius of Tyana*, book 6, chap. 4, which also describes the famous colossus, as well as Memnon's own fame as an erector of monuments and statues. Ovid, *Metamorphoses* 13.576–622, describes the origin of the Memnonides. The actual statue identified with Memnon apparently dates from the time of Amenhotep III (N. G. L. Hammond and H. H. Scull, *Oxford Classical Dictionary* [Oxford: Oxford University Press, 1970], 668).

41. Callistratus, *Descriptions*, no. 9, p. 409. See also no. 1, p. 407. The story of Memnon, including both his miraculous funeral and his singing statue, seems to center around questions of loss, mourning, and magical restitution. Sir Francis Bacon makes this especially clear in his mythographic essay "Memnon, or the Early-ripe," from *De sapientia veterum* (in Bacon, *Works*, ed. James Spedding and Robert Ellis, 15 vols. [Boston: Brown and Taggard, 1890], 13:119–20).

42. For the texts of the inscriptions and their history, see André and Étienne Bernand, eds., *Les inscriptions grecques et latines du colosse de Memnon* (Paris: Institute Français d'Archéologie Orientale, 1960). There are over a hundred identified inscriptions on the statue, many quite complex verse epigrams expressing wonder, praise, and thanks, apostrophizing the statue diversely as dead hero, living divinity, and mysterious oracle. They seem to have been inscribed variously by itinerant soldiers, scholars, poets, and imperial officials. Most date from the reign of Hadrian, under whom the statue became the focus of a complexly Hellenizing, imperial cult (*Les inscriptions*, 15–31).

43. Strabo, *Geography* 17.1.46. Loeb Classical Library Edition, trans. H. L. Jones, 8 vols. (Cambridge: Harvard University Press, 1932), 8:123.

44. Callistratus, *Descriptions*, no. 9, p. 411.

45. See Tacitus, *Annals* 2.61, in *Opere*, ed. Albino Garzetti (Turin: Einaudi, 1968), 108.

46. Recall Walt Whitman: "Dazzling and tremendous how quick the sunrise would kill me, / If I could not now and always send sun-rise out of me" ("Song of Myself," sec. 25, in *Leaves of Grass: Comprehensive Reader's Edition*, ed. Harold W. Blodgett and Scully Bradley [New York: New York University Press, 1965], 54).

47. Bernand, *Les inscriptions*, epigram 61, p. 149.

48. I am indebted in these remarks to Geoffrey Hartman's meditations on

Wordsworth's ghostly fictions of voice and presence, in "Words, Wish, Worth," *The Unremarkable Wordsworth* (Minneapolis: University of Minnesota Press, 1987), 90–119.

49. See John Hollander, *The Figure of Echo: A Mode of Allusion in Milton and After* (Berkeley: University of California Press, 1981), 6–22 and passim. Hollander notes the association of Memnon and Echo only briefly (13n.), but his larger discussion of the mythography of Echo suggests numerous resonances with the Memnon myth.

50. As a curious footnote to this issue, I can cite a passage from Athenasius Kircher's encyclopedic *Musurgia universalis* (1650; repr., Hildesheim: Georg Olms, 1970), book 9, p. 356. In this text—among many complex analyses of the nature of echo and "sympathetic music," as well as elaborate accounts of several sorts of echo chambers and musical automata—one finds a description of how to construct a statue that will move in sympathy with the sound of a church bell or pipe organ. Kircher notes the expertise of the ancient Egyptians in this kind of "natural magic" and their use of it to deceive the common people, though he makes no mention of the statue of Memnon.

10. The Thing Itself (Which Does Not Move)

1. See, for example, Leo Steinberg, "Rodin," in *Other Criteria: Confrontations with Twentieth-Century Art* (Oxford: Oxford University Press, 1972), 322–403, and David Summers, *Michelangelo and the Language of Art* (Princeton: Princeton University Press, 1981), 71–96, 406–17. See also Rosalind E. Krauss, *Passages in Modern Sculpture* (New York: Viking, 1977), which offers compelling accounts of how what Krauss describes as the "rationalist" fictions of dynamic repose, dramatized motion, narrative coherence, bodily integrity, and structural transparency that characterize the work of European neoclassical and romantic sculptors are systematically interrogated and dismantled in the work of many modern sculptors, including Rodin, Matisse, Duchamp, Brancusi, David Smith, and Anthony Caro.

2. See Johann Joachim Winckelmann, *History of Ancient Art* (1764), in *Winckelmann: Writings on Art*, trans. David Irwin (London: Phaidon, 1972), 123–26; G. W. F. Hegel, *Aesthetics: Lectures on Fine Art*, trans. T. M. Knox, 2 vols. (Oxford: Oxford University Press, 1975), 1:176, 200; Rainer Maria Rilke, *Rodin and Other Prose Pieces*, trans. G. Craig Houston (1954; repr., London: Quartet Books, 1986), 15–24.

3. On the history of such identifications, see Otto Kurz, "*Huius Nympha Loci:* A Pseudo-Classical Inscription and a Drawing by Dürer," *Journal of the*

Warburg and Courtauld Institutes 16 (1959): 171–77, and Elizabeth B. Mac-Dougall, "The Sleeping Nymph: Origins of a Humanist Fountain Type," *Art Bulletin* 57 (1975): 353–65.

4. Kurz, "*Huius Nympha Loci*," 172.

5. MacDougall, "The Sleeping Nymph," 357n.

6. Kenneth Clark, *The Nude: A Study in Ideal Form* (Princeton: Princeton University Press, 1956), 249.

7. See Hegel, *Aesthetics* 2:739.

8. Related to this, we could examine the different fictions of "bearing" that are present in Greek caryatids and medieval corbel figures, the former undoing any sense of weight, making the body into an echo of the column, the latter more comically anthropomorphizing the stone support by giving it the appearance of a grimacing, burdened grotesque.

9. On the modern history of equestrian sculpture, see H. W. Janson, "The Equestrian Monument from Cangrande della Scala to Peter the Great," in *Aspects of the Renaissance: A Symposium*, ed. Archibald Lewis (Austin: University of Texas Press, 1967), 73–85.

10. On the concept (one might say ideology) of the *statua* in the Italian Renaissance, see Charles Seymour, Jr., *Sculpture in Italy: 1400–1500* (Baltimore: Penguin Books, 1966), 1–10.

11. See Hegel, *Aesthetics* 2:739.

12. See Wallace Stevens, "The Noble Rider and the Sound of Words," in Stevens, *The Necessary Angel: Essays on Reality and the Imagination* (New York: Knopf, 1951), 3–36.

13. Mary McCarthy, *The Stones of Florence* (New York: Harcourt Brace Jovanovich, 1963), 37.

14. McCarthy's *The Stones of Florence* is exemplary in its devotion to the act of "bringing to life" the monuments of Florentine sculpture in order to limn the city's history and political character, even as it lends to the "real" persons she describes something of such sculpture's stony, violent, larger-than-life character. To cite just one example: "The sculpture galleries of the Bargello and of the Works of the Duomo create a somewhat mournful and eerie effect because a civic spirit, the ghost of the Republic is imprisoned, like a living person, in the marble, bronze, and stone figures, which appear like isolated, lonely columns, props and pillars of a society whose roof has fallen in" (40).

15. See, for example, Charles Seymour, Jr.'s account of public debate about the placement of the *David* in *Michelangelo's David: The Search for Identity* (Pittsburgh: University of Pittsburgh Press, 1967), 57–64.

16. Seymour, *Michelangelo's David*, 1–3, discusses at length a famous, if fragmentary, inscription by the sculptor found on an early sketch for the statue: "Davicte cholla fromba / e io chollarcho / Michelagniol [David with

his sling and I with my bow—Michelangelo]," the "bow" here being presumably that instrument which drives the sculptor's drill.

17. Bonnie Bennett and David Wilkins, *Donatello* (London: Phaidon, 1984), 220, note that there is a deep gash represented in Holofernes' neck, suggesting that Donatello has depicted the moment between the two sword blows described in the apocryphal Book of Judith 13:8.

18. Cellini's *Perseus and Medusa* self-consciously shows the decisive completion of the act of decapitation that Donatello's statue shows half-finished, as if Cellini's statue were the later phase of an ongoing narrative. Yet that statue also pointedly reverses the earlier work's opposition between sword-wielding female and unconscious male victim, as if the *Perseus* did not just parallel and continue but also reverses, even takes its revenge upon, Donatello's sculpture. Cellini's statue displays a very personal struggle with the work of a prior master here, but we should also recall that the sculpture of Perseus was commissioned in order to celebrate the triumph of the Medici dukedom over the partisans of the Florentine republic, who would explicitly have identified with Judith, especially given the words inscribed on the figure, which dedicate it to "the liberty and fortitude bestowed on the republic by the invincible and constant spirit of its citizens." (See John Pope-Hennessey, *Cellini* [New York: Abbeville, 1985], 168–69.) Judith thus becomes a Medusa, a creature often used in the Renaissance as an emblem for the petrifying terror of rebellion.

19. Robert Lowell, *For the Union Dead* (New York: Farrar, Straus and Giroux, 1964), 13–14.

20. Giorgio Vasari, *Le vite de' piu eccellenti pittori, scultori, ed architetti, nelle redazione del 1550 e 1568*, ed. Rosanna Bettarini and Paola Barocchi, 5 vols., text and commentary (Florence: Sansoni, 1966), text vol. 3, p. 209, my translation.

21. On the "signature" status of the *Zuccone* for Donatello (like the *David* for Michelangelo), see H. W. Janson, *The Sculpture of Donatello* (Princeton: Princeton University Press, 1963), 40.

22. Bennett and Wilkins note this biblical passage in *Donatello*, 206. The identification of the *Zuccone* with Habakkuk, or alternately with Jeremiah, has often been questioned. See Janson's survey of the available documentation, *The Sculpture of Donatello*, 36–40, and n. 26 below.

23. Richard C. Trexler, *Public Life in Renaissance Florence* (Ithaca: Cornell University Press, 1991), 118–28, comments on the myriad ways in which sacred images could become the objects of abuse, neglect, desecration, and violence in Renaissance Florence, understanding this as a peculiar reflex of the *virtù* with which they were invested by medieval tradition. In his essay "Florentine Religious Experience: The Sacred Image," in *Church and Community, 1200–1600: Studies in the History of Florence and New Spain* (Rome: Edizioni di

Storia e Letteratura, 1987), 37–74, Trexler further argues that this notion of the image was intellectualized and emptied out in humanist aesthetic theory.

24. Janson, *Sculpture of Donatello*, 40; Frederick Hartt, *Donatello: Prophet of Modern Vision* (New York: Abrams, 1973), 93.

25. Michael Baxandall, *Painting and Experience in Fifteenth-Century Italy* (Oxford: Oxford University Press, 1972), 56–71, comments on the often stylized gestures and the complex bodily rhetoric characteristic of Renaissance preachers, arguing we should keep these in mind in interpreting the gestures of figures represented in works of visual art. Baxandall's argument is supported by passages in the writings of Alberti and da Vinci, among others, which use a traditional rhetorical language in insisting that the movements of a painted or a sculpted body must be proper to the mental condition or character of the person they represent. Nothing even remotely resembling a complete "code book" of such gestures survives, however, so such an argument remains in many ways incomplete, as well as speculative. Brian Vickers, *In Defense of Rhetoric* (Oxford: Oxford University Press, 1988), 340–60, comments in more general terms on Renaissance art theory's (often strained) superimposition of the categories and ideologies of classical rhetoric onto contemporary discussions of visual art. Rhetorical terms were used to describe virtually all aspects of the artistic process, including choice of subject, style, decorum, composition and invention, imitation of models, effect on the audience, and so on. On this subject, see also Summers, *Michelangelo and the Language of Art*, 71–96.

26. Patricia Rose, "Bears, Baldness, and the Double Spirit: The Identity of Donatello's *Zuccone*," *Art Bulletin* 63 (March 1981): 31–41, speculates that the statue's oversized mantle, as well as his bald head, link him specifically with the history and iconography of the prophet Elisha (as in 2 Kings 2:9–13 and 23–24).

27. Sigmund Freud, "The Moses of Michelangelo," *SE* 13:209–38.

28. This masking of authorship is discussed at length in a powerful study of Freud's *Moses* essay by Hubert Damisch, "Le gardien d'interprétation," printed in two parts in *Tel Quel*, no. 44 (Winter 1971): 70–84, and no. 45 (Spring 1971): 82–96.

29. See Ernest Jones, *The Life and Works of Sigmund Freud*, 3 vols., (New York: Basic Books, 1955), 2:366, and Peter Gay, *Freud: A Life for our Time* (New York: Norton, 1988), 314.

30. "Sometimes I have crept cautiously out of the half-gloom of the interior as though I myself belonged to the mob upon whom his eye is turned—the mob which can hold fast no conviction, which has neither faith nor patience, and which rejoices when it has regained its illusory idols" (Freud, "Moses of Michelangelo," 213).

31. Ibid., 220–21.

32. For example, "*Laocoön* is an image of the most intense suffering. . . . But in the representation of this intense suffering is seen the determined spirit of a great man who struggles with necessity and strives to suppress all audible manifestations of pain" (Winckelmann, *Writings on Art*, 125).

33. The anonymous Freud is careful to note that Morelli himself, a senator of the Kingdom of Italy, published under the name of a fictive Russian count, Ivan Lermolieff. On Freud and Morelli, see Richard Wollheim, "Freud and the Understanding of Art," *On Art and the Mind* (Cambridge: Harvard University Press, 1974), 209–10, and Carlo Ginzburg, "Morelli, Freud, and Sherlock Holmes: Clues and Scientific Method," *History Workshop* 9 (1980): 5–37.

34. Cf. Harold Bloom, *Ruin the Sacred Truths: Poetry and Belief from the Bible to the Present* (Cambridge: Harvard University Press, 1989), 162–63.

35. Freud, "The Moses of Michelangelo," 220.

36. E. H. Gombrich, "Freud's Aesthetics," *Encounter* 26, no. 1 (1966): 33, observes that Freud also demonstrates a typically nineteenth-century obsession with the "spiritual" content of a work of art.

37. Michelangelo was, as we know, present at the unearthing of the *Laocoön* group in 1506, less than a year after he took up the Julius tomb project in its first form, and·was even involved in an early restoration attempt. Most scholars have suggested the *Laocoön*'s clear importance for his subsequent sculpture, but serious accounts of its deep and complex mode of influence are surprisingly rare. Robert Liebert's otherwise problematic *Michelangelo: A Psychoanalytic Study of His Life and Images* (New Haven: Yale University Press, 1983), 170–73, is useful here; he suggests, for instance, that a statue such as the *Moses*, seen as a revision of the *Laocoön*, manages to transform an image of entrapment into one of mastery. Further parallels between the two statues can be seen if we compare the legs (especially the right knee) of the seated *Laocoön* with those of the *Moses*, or compare the shape and proportions of the seat itself in both statues. But I am interested in the transformations and reinterpretations of the constraining serpents, and these are less immediately "visible." The snakes are meaningful insofar as they are absent, or internalized in the statue's *figura serpentinata*. The only other statues that Michelangelo completed for the 1513 project for the Julius tomb, the Louvre slaves, also contain both obvious and oblique echoes of Laocoön's two sons, as many have noticed. The *Dying Slave*, for example, transforms an image of pain into one of apparent pleasure in a way that parallels the *Moses*' transformation of passive suffering into control.

38. See Jones, *Life and Works* 2:364–69, and Gay, *Freud*, 314–17.

39. "The Moses of Michelangelo," 213. Given the binding fascination the *Moses* had for Freud, it is perhaps appropriate that the statue sits in the church of San Pietro in Vincoli, literally the church of "the sanctified stone in chains."

40. Philip Rieff, *Freud: The Mind of the Moralist*, 3d ed. (Chicago: University of Chicago Press, 1979), 282n.

41. Damisch, "Le gardien d'interprétation," 79, points to a passage in Freud's *The Interpretation of Dreams* (*SE* 5:380) where God's punishment of Moses for angrily striking the ground to produce a well is taken to symbolize a father's punishment of the child for masturbation.

42. See Jones, *Life and Works* 2:366–67.

43. See Damisch, "Le gardien d'interprétation."

44. See Angus Fletcher, *Colors of the Mind: Conjectures on Thinking in Literature* (Cambridge: Harvard University Press, 1991), 25–26.

45. See Nicholas Abraham, "The Shell and the Kernel," trans. Nicholas Rand, *Diacritics* 9 (Spring 1979): 16–28.

46. See Sigmund Freud, *From the History of an Infantile Neurosis* (1918), *SE* 17:1–122.

47. Peter Brooks, "Fictions of the Wolf Man: Freud and Narrative Understanding," in his *Reading for the Plot: Design and Intention in Narrative* (New York: Alfred A. Knopf, 1984), 264–85, offers a lucid analysis of Freud's account of the primal scene, stressing both Freud's acknowledgment of the narrativity or fictionality of the structure of explanation offered by the primal scene (or primal-scene fantasy) and his simultaneous insistence on the peculiar historicity of this narrativity and fictionality. Brooks also makes clear the way in which the primal scene emerges as a shared construct of analyst and analysand, for whom it may yet serve radically different purposes. See also the discussion of Freud's text in Ned Lukacher, *Primal Scenes: Literature, Philosophy, Psychoanalysis* (Ithaca: Cornell University Press, 1986), 136–67.

48. Freud does quote one critic's reference to a "Pan-like Moses," but is otherwise silent about the horns, perhaps because the idea of all Jews having horns like Moses figured strongly in traditional anti-Semitic folklore. The idea of a horned Moses derives from the Vulgate version of Exodus 34:29–34, which describes the glory in Moses' face when he descended from Sinai. Translating literally a Hebrew verb, *qaran*, "to radiate," derived from *qeren*, "horn," the Vulgate says *cornuta esset facies*, "his face was horned" (see *Jerusalem Bible*, gen. ed. Alexander Jones [London: Darton, Longman, and Todd, 1966], 123n.). Images of a horned Moses were common enough in medieval illustrations of the text, though commentators seem nevertheless to have been aware of the mistranslation, or else take it as a figure for "horns of light." I have no concrete evidence to back up the assertion, but I cannot imagine that Michelangelo was not aware of the textual crux, and that there is not something knowingly indecorous and perverse in his giving to his human and "Princely" Moses those very gothic horns. I should add that Vasari too fails to mention the horns, though he covertly alludes to the source text in Exodus when he says that the face of Michelangelo's statue is so

terrible he wishes it were veiled (*La vita di Michelangelo nelle redazioni del 1550 e del 1586*, ed. Paola Barocchi, 5 vols. [Florence: Sansoni, 1966], 1:20).

49. George Kubler discusses this issue in *The Shape of Time: Remarks on the History of Things* (New Haven: Yale University Press, 1962), 62–83.

Coda: Ordinary Statues

1. Ludwig Wittgenstein, *Philosophical Investigations*, trans. G. E. M. Anscombe, 3d ed. (New York: Macmillan, 1968), para. 390. All subsequent quotations are from this edition.

2. See Wittgenstein, *Philosophical Investigations*: "There is a lack of clarity about the role of *imaginability* in our investigation. Namely about the extent to which it ensures that a proposition makes sense" (para. 395). "It is no more essential to the understanding of a proposition that one should imagine anything in connection with it, than that one should make a sketch from it" (para. 396). "Instead of 'imaginability' one can also say here: representability by a particular method of representation. And such a representation *may* indeed safely point a way to further use of a sentence. On the other hand, a picture may obtrude itself upon us and be of no use at all" (para. 397).

Index